Patrick Moore's Practical Astronomy Series

For further volumes:
http://www.springer.com/series/3192

Scientific Astrophotography

How Amateurs Can Generate and Use Professional Imaging Data

Gerald R. Hubbell

Springer

Gerald R. Hubbell
Locust Grove, VA
USA

ISSN 1431-9756
ISBN 978-1-4614-5172-3 ISBN 978-1-4614-5173-0 (eBook)
DOI 10.1007/978-1-4614-5173-0
Springer New York Heidelberg Dordrecht London

Library of Congress Control Number: 2012950859

© Springer Science+Business Media New York 2013
This work is subject to copyright. All rights are reserved by the Publisher, whether the whole or part of the material is concerned, specifically the rights of translation, reprinting, reuse of illustrations, recitation, broadcasting, reproduction on microfilms or in any other physical way, and transmission or information storage and retrieval, electronic adaptation, computer software, or by similar or dissimilar methodology now known or hereafter developed. Exempted from this legal reservation are brief excerpts in connection with reviews or scholarly analysis or material supplied specifically for the purpose of being entered and executed on a computer system, for exclusive use by the purchaser of the work. Duplication of this publication or parts thereof is permitted only under the provisions of the Copyright Law of the Publisher's location, in its current version, and permission for use must always be obtained from Springer. Permissions for use may be obtained through RightsLink at the Copyright Clearance Center. Violations are liable to prosecution under the respective Copyright Law.
The use of general descriptive names, registered names, trademarks, service marks, etc. in this publication does not imply, even in the absence of a specific statement, that such names are exempt from the relevant protective laws and regulations and therefore free for general use.
While the advice and information in this book are believed to be true and accurate at the date of publication, neither the authors nor the editors nor the publisher can accept any legal responsibility for any errors or omissions that may be made. The publisher makes no warranty, express or implied, with respect to the material contained herein.

Springer is part of Springer Science+Business Media (www.springer.com)

Foreword

We are living in a Golden Age of Astronomy when discoveries are made daily by professional and amateur astronomers alike. The measurement of the position, distance, composition, and change of celestial objects is at unprecedented levels, and amateur astronomers, using their modest equipment, are making high-quality measurements that, just decades ago, only their professional counterparts could have made with large observatories and instrumentation that cost millions.

Since the beginning of astrophotography, there has been a continual stream of scientific breakthroughs and discoveries. Indeed, the roots of astrophotography as a scientific tool were pioneered by amateur astronomers in the mid-19th century, beginning with an image of the Moon, the first astronomical image ever, made by chemist and pioneering photographer, John William Draper in 1840.

Twenty years later in 1863, chemist William Allen Miller and amateur astronomer Sir William Huggins obtained the first photographic spectrogram of a star. And 20 years after that, John Draper's son, Henry Draper, took the first deep sky image in 1880 of the Orion Nebula. In 1883, amateur astronomer Andrew Ainslie Common imaged nebulosity and stars that were too faint to be detected through his visual telescopic observation of the Orion Nebula with his home-built telescope.

And from that momentous image of the Moon, taken less than two centuries ago on a daguerreotype plate, to the astroimages made today on modern CCD sensors, advances in imaging technology and instrumentation, and the dedication, skill, and imagination of amateur astronomers have been intertwined to produce countless innovations and discoveries that have affected everyone on Earth. The truly exciting part of all this is that with the affordable modern tools available now, we will see many more breakthroughs and discoveries through astronomical imaging by amateurs—and you can be part of it.

That said, one of the ironies of amateur astronomy today is that while all the equipment, techniques, and access are available to go beyond stargazing and make

Fig. 0.1 The intrepid amateur astronomer (Courtesy of Jedediah Hubbell)

some lasting scientific contribution or even a discovery of a new object, it still seems too far out of reach. This is in part because of the lack of a comprehensive source of information that ties everything together to guide amateurs toward defining and accomplishing their goals. We need a manual that shows how to choose the right combination of components in building the astronomical imaging system (AIS), and to coach us through the methods and skills required to have our data accepted and reviewed. That is precisely what Jerry Hubbell has given us with this book.

The structure and methods described in Scientific Astrophotography provide you with the opportunity to take a fresh approach to this discipline of study and put what you have learned from a book to use in a real-world activity. And because this is a scientific endeavor, you will be learning on a high level that will not only challenge you, but prepare you to collaborate and contribute to science and the scientific community in a meaningful way.

Hubbell lays down a roadmap to penetrate and methodically correct the root causes of problems often encountered when acquiring images that will allow you to obtain high-quality data that can be used in research. But he doesn't stop at critical thinking and problem solving. The book also has detailed descriptions of how to complete each step along the way, full descriptions of how and why things work the way they do (including the math), and forms to record your notes, which are so critical in research.

Overall, Scientific Astrophotography is a compelling work in the history of technical photographic publications, and it is noteworthy that this is Hubbell's first book on the subject, culminating his own learning experience in making astrophotographs,

which began only a few years ago. Even though Hubbell is a relative newcomer, he delivers with the expertise of someone who has practiced for decades. The book is written as though Hubbell were with you, giving you encouragement, inspiration, and all the technical advice you could hope for.

For the beginner, Scientific Astrophotography may seem daunting at first because of the sheer amount of information to digest. But if you read it through completely, and then review and practice in portions, you'll find that this book will help keep the beginner from developing bad habits that have to be "unlearned." For those who are familiar with astrophotography, this book will allow you to compare Hubbell's methods with what you are doing now to find the nuggets of information that will help you improve or become better organized. And for the expert who is tasked to teach research astronomy for a school or astronomy club, you'll find Scientific Astrophotography a worthy addition to your curriculum.

Even if your initial desire is to make beautiful images of celestial objects, the methods described will most certainly give you the foundation to produce professional-quality images that you can later process to make the "jaw dropping" deep sky images that you often see gracing the gallery sections of the astronomy magazines. But these same raw images could be used by a professional researcher who just might need to compare his data, taken of the same area of the sky around the same time that you acquired yours, to verify his finding. And this works both ways…if you see something new in your images that you don't see in the professional reference imagery freely available online, you may have some exciting news to share.

However, making a discovery is not the ultimate aim of this book. Hubbell's philosophy on why we should be engaged in science and why we should become practicing scientists is shared throughout these pages, and is perhaps the most important message of all.

Scott W. Roberts
Founder and President, Explore Scientific LLC
Springdale, AR

Preface

Welcome to *Scientific Astrophotography: How Amateurs Can Generate and Use Professional Imaging Data*. I started developing this book in the summer of 2011 to meet the needs of the Rappahannock Astronomy Club (raclub.org) membership for a practical, how-to guide for learning and using the charge-coupled device (CCD) cameras available today for astrophotography. One of the primary missions of our club is to be an enabler, providing access to tools and educational materials that enhance the members' ability to experience all that is offered today in this "golden age" of amateur astronomy. This book was developed to provide the tools and information to enable the RAClub membership to move into the exciting world of scientific astrophotography. I hope this book fulfills those needs for astronomy clubs and amateur astronomers everywhere.

Intended for the beginner and the experienced astrophotographer alike, this book provides the basic material necessary to understand the factors that contribute to taking excellent astrophotographs for use in collecting scientific data. The book also provides step-by-step procedures and exercises to gain the skills needed to perform at the level necessary to obtain professional level scientific data. For the experienced astrophotographer, this book provides the distilled knowledge and procedures needed to quickly get you up and running with new configurations and instruments in the field with your telescope. I took it upon myself to document the highlights of the myriad books, magazines, articles, Internet sites, and owner's manuals available to the beginning astrophotographer. I also chose to take an engineering approach to the issue of learning how to design, build, and operate an Astronomical Imaging System (AIS) to perform scientific astrophotography. I thought that this approach would provide the necessary discipline and structure to minimize an all-too-frequent result—the frustrated beginning astrophotographer who puts his equipment in the back of the closet after not being able to progress past the initial disappointing levels of quality. It is also important to recognize that

the material and techniques in this book are as applicable to obtaining "pretty picture" astrophotographs as they are to obtaining scientific imaging data.

As I did further research for this book, and adjusted the contents accordingly, I recognized that writing it gave me the opportunity to document my approach to building my own personal observatory and AIS. I had always considered my initial purchases of equipment and tools as a necessity for me to learn the diverse sets of ideas, techniques, skills, and knowledge available to the amateur astronomer today. In this respect, my initial AIS *is* a prototype learning environment for scientific imaging. This book documents my journey over the past few years in learning how to perform astrophotography for scientific purposes. It allows me to focus on what is necessary going forward, the engineering issues associated with designing my observing program, and the AIS needed to cost-effectively implement and pursue that program. I am confident that it will also fill that need for the reader.

My observing experience since my early teens has been mainly in the visual realm. When I first started, I did some very rudimentary astrophotography using eyepiece projection and a Polaroid camera. Because of the very modest instruments that I had acquired, my observing focused on the bright objects in our solar system, such as the Moon, Jupiter, and Saturn. I still fondly remember setting up my 60-mm Tasco on its very impressive manual German equatorial mount (GEM). I graduated to a larger telescope during the late 1980s (a Meade 10-in. 2120 LX5 Schmidt-Cassegrain Telescope (SCT)) acquired through Company 7 (a dealer located in Laurel, Maryland), still only using this telescope visually.

Through all the years since then, I have always wanted to learn how to image minor planets (asteroids), determine their position, and calculate their orbits. That to me was the ultimate in practicing science for the amateur astronomer. It was not until the fall of 2008 that I was able to find the time to get into the latest astronomical technology and start down the path of learning what it takes to track down those wily asteroids and, in the process, learn how to create excellent astrophotographs. So just 4 years ago, I was a beginner as many of you are now. You may have followed the same path as I did or may have started out wanting to do astrophotography as your primary goal. Either way, this book is intended to help you reach your astrophotography goals.

Some aspects of scientific imaging can be unforgiving when trying to reach and maintain a high level of quality. However, although the route to high-quality imaging can be a difficult one, if the road taken is well traveled and a disciplined approach is maintained, then all it takes is a little patience, stick-to-itiveness, and practice. Spectacular success is possible for those who go down that well-traveled road.

Acknowledgments

I want to thank all those who have encouraged me in this endeavor, not the least of which is my wife, Michelle, my best friend and the love of my life. She has put up with my long hours at the computer and the telescope in the middle of the night with all the support and love I could ever wish for. I also want to thank my daughters, Amber Hubbell for her work on the first cut review of the manuscript and Rachel Konopa for doing the illustrations for the book—It was pretty special being able to count on her substantial graphic art skills in illustrating this book.

I want to thank my fellow RAClub members, specifically Linda Billard for her expert editing and valuable feedback on my writing, and Bart Billard for his expert technical review; the quality of the book is due to their hard work. Linda has helped me improve my writing and I am forever grateful for that. I also want to thank David Abbou, Brenda Conway, Scott Busby, and Brian Westby for their reviews of the manuscript. I also appreciate David's image contributions to the book. Thanks also go to another RAClub member, Dr. Myron Wasiuta, for his feedback on various subjects discussed in the book. Myron's insight into this subject, as one who has taught astronomy professionally and also as a very experienced amateur astronomer, was invaluable.

I want to specially thank Scott Roberts for writing the Foreword to this first edition, his review of the manuscript, and valuable feedback on various topics in the book. Scott has a wealth of knowledge of the hardware used by the amateur astronomer and his input contributed greatly to the book. I have come to consider Scott a very good friend; he is a leader and innovator, and I appreciate his insights on the amateur astronomy industry. I have found that he will do just about anything for anyone who is looking to get into astronomy, and he does a substantial amount of outreach work through the Explore Alliance (www.explorealliance.com) and other groups.

I have been very fortunate to meet several other people who are leaders in the amateur astronomy community and have provided me with valuable insight into this wonderful hobby. Chief among them are Professional Astronomer Dr. Mike Reynolds of Florida State College, Mike Simonsen of the American Association of Variable Star Observers (AAVSO), Rich Williams of the Sierra Stars Observatory Network (SSON), and Tom Field the developer of RSpec spectroscopy analysis software. Each of them is a leader in their specific area of expertise, and we are very fortunate to have them among us.

Finally, I would very much like to thank Megan Ernst and Maury Solomon for their help and support. I also want to thank Maury and Springer for giving me the opportunity to have my first book published. I would not have been able to get this book to the high level of quality it is in without the help of the aforementioned people. Regardless, I take full responsibility for any errors that may remain.

Personally, learning and performing scientific astrophotography has enabled me to flex my technical skills and allowed me to combine my love of science and technology with the skills, knowledge, and innovation necessary to make excellent images. This has led me to discover great things about the universe in a very personal way. There is nothing like making that very precise, difficult, and time-consuming observation of a faint 16th magnitude minor planet, or monitoring that dim variable star, with the realization that you are the only one on Earth who has done that measurement that adds to the sum of human knowledge. Learning astrophotography gives you the ability to see further and fainter, and to personally discover the wonderful, subtle aspects of the observable universe. This is a very humbling and profound pursuit on which you embark—I wish all of you the very best in your scientific imaging endeavors.

Clear skies!

Jerry Hubbell
Lake of the Woods Observatory (MPC I24)
Locust Grove, VA
June 2012

About the Author

Jerry Hubbell, currently President of the Rappahannock Astronomy Club (raclub. org), has been an avid amateur astronomer since he was a teenager. However, he developed his passionate interest in astrophotography, and in particular, astrophotography that supports scientific investigation, only about 4 years ago. In that short time, Jerry has become known as a superior astrophotographer, amateur scientist, and mentor to other amateurs who want to foster scientific investigation in the amateur ranks. His career as a nuclear Instrumentation and Controls (I&C) and software engineer for Dominion Virginia Power has trained him well for the attention to detail and precision required for scientific astrophotography. In this book, Jerry refers often to everyday examples from ordinary life, his job, and aviation. He is also a pilot for the Virginia Defense Force Aviation Battalion, the Commonwealth's military reserve. His Six Sigma Black Belt training is evident in his careful but accessible step-by-step explanations of how to build your astronomical imaging system, choose your astronomical targets, design a plan to photograph them, avoid the pitfalls, and apply the appropriate methods to obtain scientifically relevant data suitable for contribution to the larger scientific community. As an active member of the Association of Lunar and Planetary Observers (ALPO) and the American Association of Variable Star Observers (AAVSO), and as the owner of a certified observatory location I24 for the IAUs Minor Planet Center, Jerry practices what he preaches in performing his scientific astrophotography. He has had several images published in the ALPO's Lunar Section newsletter, *The Lunar Observer*, and his work has been acknowledged in *Sky and Telescope* magazine. Jerry's minor planet observations have been published in the scientifically peer-reviewed *Minor Planet Circulars, Minor Planet Circulars Supplement,* and ALPOS *Minor Planet Bulletin.*

Contents

1 An Introduction to Scientific Astrophotography 1
 1.1 Book Organization and Purpose ... 1
 1.1.1 Amateur Astronomy Knowledge and Skills Pathway 3
 1.1.2 Scientific Investigation Example ... 4

Part I Astronomical Imaging System (AIS) Components, Characteristics, and Performance Factors

2 The "Perfect AIS" .. 9
 2.1 In a Perfect World… ... 9
 2.2 The AIS Design Basis ... 11
 2.3 Balancing Expected Results with Budgetary Constraints 13
 2.4 AIS Operations and Maintenance ... 17
 2.5 Are You Up to the Task? ... 19
 Further Reading .. 19

3 The Astrograph: The Imaging Telescope 21
 3.1 What Is an Astrograph? .. 21
 3.2 Astrograph Design Features .. 25
 3.3 A Focus on Focusers ... 26
 3.4 Equipment Available to the Amateur 27
 3.5 Getting the Most "Bang for the Buck" 29
 Further Reading .. 30
 Web Pages ... 30

4 CCD Chip Performance, CCD Camera Basics, and Image Scaling Factors ... 31
- 4.1 The CCD Revolution ... 31
- 4.2 CCD Versus Eye ... 32
- 4.3 CCD Chip Characteristics ... 34
- 4.4 CCD Camera Performance ... 37
- 4.5 CCD Chip Geometry ... 41
- 4.6 Image Scale Basis ... 42
- 4.7 Calculating the Image Scaling Factors ... 47
- 4.8 Changing the Image Scale ... 51
- 4.9 Image Scale Bottom Line ... 52
- Further Reading ... 53
- Web Pages ... 53

5 Telescope Mount Factors ... 55
- 5.1 A Foundation for Excellent Image Data ... 55
 - 5.1.1 Mount Requirements for Deep Sky Imaging ... 55
 - 5.1.2 Mount Requirements for Lunar, Solar, and Planetary Imaging ... 56
- 5.2 Telescope Mount Design Types and Design Basis Effects ... 57
 - 5.2.1 The Mount Tripod or Pier ... 57
 - 5.2.2 The Mount's Tracking Rate ... 58
 - 5.2.3 Mount Types ... 61
 - 5.2.4 Field Rotation Effects ... 62
- 5.3 Mount Adjustment Factors ... 63
- 5.4 Mount Performance Factors ... 64
 - 5.4.1 Periodic Error and Declination Drift ... 65
 - 5.4.2 Auto-Guiding the Telescope ... 65
 - 5.4.3 Mount Load Capacity ... 67
- 5.5 Telescope Mount Support Hardware/Software Subsystems ... 68
 - 5.5.1 Mount Mechanical Components ... 69
 - 5.5.2 Electronic Mount Controller Subsystem ... 71
 - 5.5.3 Mount Drive Correctors ... 72
- 5.6 The Software-Driven Mount: The Astronomy Common Object Model (ASCOM) Standard ... 73
- 5.7 What's Best for Me? ... 75
- Further Reading ... 76
- Web Pages ... 76

6 Imaging Filters and Auxiliary Optical/Mechanical/Electrical Components ... 77
- 6.1 Imaging Through Rose-Colored Glasses ... 77
- 6.2 Photometric; Luminance, Red, Green, and Blue (LRGB); Narrowband Filters; and Filter Wheels ... 77
 - 6.2.1 Photometric Filters ... 78
 - 6.2.2 LRGB Filters ... 79

		6.2.3 Narrowband Filters	81
		6.2.4 Filter Wheels	82
	6.3	Lunar, Solar, and Planetary Filters	83
	6.4	Spectroscopic Gratings	85
	6.5	Focal Reducers	86
	6.6	Barlow Lenses	87
	6.7	Field Flatteners	87
	6.8	Atmospheric Dispersion Correctors	88
	6.9	Coma Correctors	90
	6.10	Focusers	91
	6.11	Mechanical Fittings and Miscellaneous Items	93
	6.12	Flat Field Panels	96
	6.13	Auto-Guider Systems	99
	6.14	Precision RA Drive Correctors	100
	6.15	Power Supply	101
	Further Reading		102
	Web Pages		102
7	**Astrograph and CCD Camera Combinations**		**103**
	7.1	A Marriage Made in Heaven	103
	7.2	A Purpose-Driven Design	103
		7.2.1 Deep Sky Imaging	105
		7.2.2 Lunar, Solar, and Planetary Imaging	109
	7.3	Maximizing Your Results	112
		7.3.1 Example Imaging Train Setup Checklist	113
	7.4	Case Studies: Two Typical Combinations	115
		7.4.1 Case 1: Wide Field Bright Star AIS	115
		7.4.2 Case 2: High-Resolution Lunar Imaging AIS	116
	Further Reading		117
	Web Pages		118
8	**Environmental and External Factors**		**119**
	8.1	The Sky and the Astronomer's Weather	119
		8.1.1 What Are the Best Weather Conditions for Deep Sky Imaging?	120
		8.1.2 What Are the Best Weather Conditions for Lunar, Solar, and Planetary Imaging?	121
	8.2	Sources of Weather Data	121
		8.2.1 General Weather Sources	121
		8.2.2 Astronomy-Specific Weather Sources	122
	8.3	Effects on the Observer	124
		8.3.1 Observer Hot Weather Impacts	125
		8.3.2 Observer Cold Weather Impacts	126

	8.4	Effects on the System..	128
		8.4.1 System Hot Weather Impacts...	128
		8.4.2 System Cold Weather Impacts ..	129
	8.5	The Dedicated Astronomer: Knowing When to Call It Quits for the Evening..	130
	Further Reading ...		132
	Web Pages ..		132

Part II Astronomical Imaging System (AIS) Integration and Operation

9 The Practical AIS: The Sum Is Greater Than the Parts 135
 9.1 How to Integrate the AIS Components into a System 135
 9.2 Permanent or Portable?.. 137
 9.3 Sources of Measurement Error .. 138
 9.4 Maximizing Performance... 140
 9.5 Matching the Equipment to the Science .. 140
 9.5.1 Planetary Imaging .. 141
 9.5.2 Lunar Imaging.. 142
 9.5.3 Solar Imaging... 142
 9.5.4 Deep Sky Imaging.. 144
 9.5.5 Minor Planet Imaging .. 144
 9.6 Typical AIS Configurations ... 145
 9.6.1 Planetary AIS Configuration.. 146
 9.6.2 Lunar AIS Configuration ... 146
 9.6.3 Solar AIS Configuration .. 147
 9.6.4 Deep Sky AIS Configuration ... 147
 9.6.5 Minor Planet AIS Configuration.. 148
 Further Reading ... 148
 Web Pages .. 149

10 Planning and Executing the AIS Data Acquisition Process 151
 10.1 In the Beginning….. 151
 10.2 Initial AIS Setup and System Integration 152
 10.3 Planning Your Imaging Session .. 154
 10.4 Target Selection and Science Goals.. 155
 10.5 The Observing Plan .. 155
 10.6 Imaging Session AIS Setup .. 156
 10.7 Executing the Plan .. 161
 10.8 Phase 1: AIS Alignment and Calibration...................................... 161
 10.9 Phase 2: Data Acquisition... 163
 10.10 Phase 3: Tying Up Loose Ends .. 165
 10.11 AIS Teardown ... 165
 10.12 Post Imaging Session Critique.. 166
 10.13 Ad Hoc Imaging Pitfalls and Successes 167

Contents xix

 Further Reading ... 167
 Web Pages ... 168

11 Image Acquisition and Calibration .. 169
 11.1 Organizing Your Data .. 169
 11.2 Image Naming Conventions.. 170
 11.3 Image Data Formats.. 171
 11.3.1 Flexible Image Transport System (FITS) Format......... 172
 11.3.2 Audio Video Interleave (AVI) Format 174
 11.3.3 Other Image Formats .. 175
 11.4 Image Acquisition Software Applications.......................... 175
 11.5 Image Calibration Basics ... 176
 11.6 Calibration Techniques ... 186
 11.7 Image Acquisition Tips and Techniques............................ 192
 Further Reading .. 194
 Web Pages ... 194

12 Field Practical Exercises: Putting It All into Practice 195
 12.1 Introduction to the FPEs .. 195
 12.2 Common AIS Equipment Setup Procedures...................... 198
 12.2.1 Image Scaling Calculation Procedure 198
 12.2.2 AIS Equipment Setup Procedure 199
 12.2.3 Imaging Train Configuration Procedure 201
 12.2.4 Astrograph Collimation Procedure 202
 12.2.5 Mount Polar Alignment Procedure 204
 12.2.6 AIS All-Sky Alignment Procedure 209
 12.2.7 Flat Frame Acquisition Procedure 211
 12.2.8 Dark Frame Acquisition Procedure 213
 12.2.9 Bias Frame Acquisition Procedure 214
 12.2.10 Light Frame Acquisition Procedure 215
 12.2.11 Astrograph Focusing Procedure.................................. 216
 12.2.12 Guidescope Setup Procedure 218
 12.3 Specific Object Type Observing Procedures..................... 219
 12.3.1 Large Solar System Object Imaging Procedure.......... 220
 12.3.2 Small Solar System Object Imaging Procedure.......... 222
 12.3.3 Large Deep Sky Object Imaging Procedure 225
 12.3.4 Small Deep Sky Object Imaging Procedure 227
 Further Reading .. 230

Part III Scientific Image Data Analysis and Advanced Amateur Scientific Projects

13 Scientific Image Data Uses and Innovations in AIS Components and Systems.. 233
 13.1 Citizen Science and Your AIS ... 233
 13.2 How Useful Is Your Data?... 234

	13.3	Who Can Use Your Data?	234
	13.4	Processing Your Data for Multiple Uses and Users	235
	13.5	Data Accuracy and Uncertainty Considerations	236
	13.6	Long-Term Data Storage and Archiving	239
	13.7	Innovative Professional Imaging Techniques	241
		13.7.1 Lucky Imaging	241
		13.7.2 Time Delay and Integration (TDI)	241
	13.8	Innovation Within the Amateur Community	242
	Further Reading		244
	Web Pages		244
14	**An Introduction to Scientific Image Data Analysis**		**245**
	14.1	Basic Image Feature Analysis	245
	14.2	Astrometry	251
		14.2.1 Software and Reference Data	252
		14.2.2 The Plate Solving Process	254
		14.2.3 Practical Considerations and Typical Results: (1103) Sequoia	257
	14.3	Photometry	261
		14.3.1 Software and Reference Data	263
		14.3.2 Relative and Differential Photometry	264
		14.3.3 Absolute Photometry	265
	14.4	Spectroscopy	269
		14.4.1 Software and Reference Data	272
		14.4.2 Spectroscopic Data Acquisition	273
		14.4.3 Spectroscopic Analysis	274
	14.5	Planetary Topography and Feature Analysis	276
		14.5.1 Software and Reference Data	277
		14.5.2 Lunar Topographic Analysis	278
		14.5.3 Planetary Feature Analysis	282
	Further Reading		284
	Web Pages		284
15	**Your Scientific Imaging Program and How to Submit Your Data to Scientific Organizations**		**285**
	15.1	The Modern, State-of-the-Art (Amateur) Observatory	285
	15.2	Your Science Program Goals	286
	15.3	A Structured Approach	288
	15.4	Recognizing and Measuring Success	288
	15.5	A Disciplined Commitment to Your Program	289
	15.6	Sharing Your Data	290
	15.7	Data Formatting	290
	15.8	Minor Planet Center	291
	15.9	American Association of Variable Star Observers (AAVSO)	291
	15.10	Association of Lunar and Planetary Observers (ALPO)	292

	15.11	MinorPlanet.Info Website	293
	15.12	Society for Astronomical Sciences (SAS)	293
	15.13	British Astronomical Association (BAA)	294
	15.14	International Society of the Mars Observers (ISMO)	294
	Further Reading		295
	Web Pages		295

16 Amateur Astronomer Access to Professional-Level Observatories ... 297

 16.1 The Remote Access Revolution ... 297
 16.2 Professional Telescopes for the Astro-Masses 298
 16.3 Using the Sierra Stars Observatory Network (SSON) 299
 16.4 The Future of Remote Astronomical Observatories 301
 Further Reading .. 302
 Web Pages .. 302

Appendix 1: Acronyms ... 303

Appendix 2: Field Practical Exercises: Training Syllabus 307

Appendix 3: Photometric Uncertainty Calculations 309

Appendix 4: Example Imaging Train Setups and Measurements 317

Appendix 5: Available AIS Software List ... 323

Index ... 325

List of Figures

Fig. 1.1 The Straight Wall, or Rupes Recta, taken April 4, 2009, with the ATIK 314e TEC CCD camera 5

Fig. 2.1 An image of the lunar surface taken by amateur astronomer David Abbou using a Celestron Neximage webcam-based CCD camera on December 31, 2011 (Courtesy of David Abbou) 10

Fig. 3.1 Edwin Hubble at what is now called the 48-in. Oschin Schmidt telescope in 1960 at Palomar Observatory in Pasadena, CA (Courtesy of Palomar Observatory) 22

Fig. 3.2 The Pic du Midi Observatory, located in the French Pyrenees (Courtesy of Pascalou Petit Creative Commons License CC BY-SA 3.0) .. 22

Fig. 3.3 Lunar Aeronautical Chart (LAC) 39 Aristarchus (Courtesy of Defense Mapping Agency, Aerospace Center, 1973) 23

Fig. 3.4 The US Naval Observatory UCAC 8-in. (20-cm) astrograph located at the Flagstaff, NM, station of the USNO (Courtesy of US Naval Observatory) ... 24

Fig. 4.1 The Kodak 8300 CCD chip in the QHY9m TEC CCD camera........ 32
Fig. 4.2 Hipparchos, circa 160 BC (Courtesy of Rachel Konopa) 33
Fig. 4.3 3-bit analog-to-digital conversion (Courtesy of Rachel Konopa) 37
Fig. 4.4 The imaging source (TIS) DMK21AU04.AS video camera............ 39
Fig. 4.5 The QHYCCD QHY9m TEC CCD camera 39
Fig. 4.6 The astrograph focal length (FL) determines the position of the focal point (Courtesy of Rachel Konopa)............................ 43
Fig. 4.7 Pinhole camera (Courtesy of Rachel Konopa)................................. 44
Fig. 4.8 Small-angle image scaling in the pinhole camera (Courtesy of Rachel Konopa) ... 45

Fig. 4.9	Airy disk. The central bright disk contains 84% of the light of the star, and the size of the disk is based on the extent of the first dark ring (Courtesy of Rachel Konopa)	49
Fig. 4.10	The point spread function is measured in units called the full-width-at-half-maximum (FWHM) (Courtesy of Rachel Konopa) ...	50
Fig. 5.1	The celestial meridian is an imaginary line in the sky that passes through the poles and the zenith of the observing site (Courtesy of Rachel Konopa)..	58
Fig. 5.2	Magnetic declination is the difference between the direction of magnetic north (Nm) and true north (Ng) (Courtesy of Rachel Konopa)..	64
Fig. 5.3	The mount performs a meridian flip when the astrograph is in danger of striking the tripod (Courtesy of Rachel Konopa)	68
Fig. 5.4	The AIS mount (Sky-Watcher EQ6 Pro) and support systems	69
Fig. 5.5	The heart of the amateur astronomer's astrograph mount: the worm and wheel (Courtesy of Rachel Konopa)	70
Fig. 5.6	The EQ6 Pro motor controller card and SynScan hand controller ..	71
Fig. 5.7	The EQMOD ASCOM driver for Synta-based EQ mounts............	74
Fig. 6.1	A lightcurve for 16.5 magnitude minor planet (4150) Starr developed from data taken on April 24, 2010, with the Sierra Stars Observatory Network ..	80
Fig. 6.2	The QHY filter wheel..	82
Fig. 6.3	Two types of white light solar filters: Glass and Mylar	84
Fig. 6.4	A narrow-band (10 nm) Solar Continuum filter centered at 540 nm...	84
Fig. 6.5	The Paton Hawksley Star Analyzer 100 (SA100) spectroscopic grating developed by Robin Leadbeater...................	85
Fig. 6.6	A calibrated and sensor normalized spectrum of a type B6 star Epsilon Delphinus (*red*) compared with the reference type B6 spectrum (*blue*)...	86
Fig. 6.7	Field curvature in a 0.2-m Ritchey-Chrétien Cassegrain astrograph ...	88
Fig. 6.8	When stars are low on the horizon, the atmosphere spreads the light of the star out vertically. This is called atmospheric dispersion (Courtesy of Rachel Konopa)...	89
Fig. 6.9	An atmospheric dispersion corrector is a specialty optic used by advanced amateurs (Courtesy of Rachel Konopa).............	90
Fig. 6.10	The Astronomy Technologies precision Crayford focuser delivered with the AT8RC Ritchey-Chrétien Cassegrain astrograph ...	91
Fig. 6.11	The Hartmann mask, and more recently the Bahtinov mask, are used to precisely focus the astrograph (Courtesy of Rachel Konopa) ...	92

List of Figures

Fig. 6.12	The Moonlite 2-in. precision Stepper Motor Crayford focuser with digital readout capable of 4 μm steps used on the AT8RC Ritchey-Chrétien Cassegrain astrograph..........................	93
Fig. 6.13	17-mm and 30-mm T-thread adapters.............................	94
Fig. 6.14	A 1.25-in. nosepiece, 2.0-in. nosepiece, and 1.25-in. barrel adapter ..	95
Fig. 6.15	An individual CCD pixel channel's parameter response curves (Courtesy of Rachel Konopa) ..	97
Fig. 6.16	A flat field image showing the various defects, including vignetting and dust donuts ...	98
Fig. 6.17	The Telescope Drive Master (TDM) encoder-driven, drive rate correction system ..	101
Fig. 7.1	The internals of the Corrected Dall-Kirkham (CDK) Cassegrain astrograph showing the baffling and corrective optics near the focuser (Image Courtesy of Rachel Konopa)..........	108
Fig. 7.2	The effect the Barlow lens has on the position of the focal plane of the astrograph (Image Courtesy of Rachel Konopa)....	111
Fig. 7.3	90-mm x 25-mm and 90-mm x 50-mm extension rings for the Astronomy Technologies AT8RC Ritchey-Chrétien Cassegrain astrograph ..	112
Fig. 7.4	The American Association of Variable Star Observers (AAVSO) Bright Star Monitor (BSM) astrograph (Image Courtesy of AAVSO)..	116
Fig. 8.1	The Lake of the Woods Observatory (MPC I24) clear sky chart (Courtesy of Attilla Danko, creator, Clear Sky Chart, based on Environment Canada data)...	123
Fig. 8.2	Canadian Meteorological Center scintillation-seeing chart for North America with the cursor located at the Lake of the Woods Observatory (Courtesy of and based on Environment Canada data)...	123
Fig. 8.3	The author at 2:30 am on the morning of January 10, 2010, tracking minor planet (1103) Sequoia. The ambient temperature was 21°F (−6°C) (Courtesy of Michelle H. Hubbell)	127
Fig. 9.1	This image of Jupiter taken on November 12, 2011, by amateur astronomer David Abbou demonstrates what is possible with a modest webcam-based CCD camera and an 8-in. SCT (Courtesy of David Abbou)	142
Fig. 9.2	A 30-min unguided exposure (stack of 10×180 s) of NEO minor planet (68348) 2001 LO7 taken July 2, 2011 0436 UT with a 0.13-m refractor, go-to GEM, and encoder-based RA drive corrector ...	145
Fig. 10.1	The small finder scope mounted on the right ascension (RA) axis is called the polar alignment scope (Courtesy of Rachel Konopa) ..	158

Fig. 10.2	CCD declination drift images using Dr. Hall's methodology: (a) before polar alignment (b) after polar alignment	160
Fig. 10.3	The cone error of an astrograph showing the angle (α) difference between the astrograph axis and the mount axis. The difference is corrected using adjustment screws on the astrograph mounting plate (Courtesy of Rachel Konopa)	162
Fig. 11.1	An image of a star stored as a table of 16-bit numbers (0–65,535) as in a spreadsheet	172
Fig. 11.2	Vignetting occurs when light around the edges of the field of view (FOV) is blocked and partially dimmed by baffles in the astrograph (Courtesy of Rachel Konopa)	182
Fig. 11.3	A raw V-band flat frame from a Ritchey-Chrétien Cassegrain reflector	183
Fig. 11.4	A calibrated frame taken with a Ritchey-Chrétien Cassegrain reflector. The plate center is located at RA 16 32 44.89, DEC+28 18 30.7	184
Fig. 11.5	A cropped portion of a bias frame showing the random and systematic errors	185
Fig. 11.6	A cropped portion of a 90-s dark frame showing the random thermal noise, hot pixels, and systematic errors	187
Fig. 11.7	A depiction of the data values for the pixels around a dust donut in a normalized flat frame image	189
Fig. 11.8	A master flat frame from the imaging train of a Ritchey-Chrétien Cassegrain astrograph	191
Fig. 12.1	Field practical exercises (FPE) performance structure	196
Fig. 12.2	Declination drift image	209
Fig. 13.1	Based on your measurement, how certain are you that you have identified the correct star? Is it the red star or the blue star?	237
Fig. 13.2	A precise measurement is a very repeatable measurement over several frames for the same object	237
Fig. 13.3	A precise light source illuminates a fixed location on the CCD camera, providing a constant signal level to the pixels (Courtesy of Rachel Konopa)	238
Fig. 13.4	The frozen defocused image of a star in a reflector astrograph taken at 1/60th of a second	242
Fig. 13.5	A raw individual astrocam image of the lunar surface taken on April 4, 2009	243
Fig. 14.1	The Airy disk cross section (*red*) is estimated using a Gaussian curve (*blue*) to calculate the full-width-at-half-maximum (FWHM) (Courtesy of Rachel Konopa)	246
Fig. 14.2	By calculating the centroid of a star's point spread function (PSF) one can measure the star's position to a high degree of accuracy (Courtesy of Rachel Konopa)	246

Fig. 14.3	A spreadsheet showing the results of the centroid calculation on some example data	247
Fig. 14.4	A photometric aperture around the region-of-interest (ROI). The inset shows how the central circular aperture surrounds the star image and the annulus aperture encompasses the background	249
Fig. 14.5	The photometry aperture annulus and center area sizing	249
Fig. 14.6	A photometric measurement of an artificial comparison star used as a reference for any differential measurements made for an object star	251
Fig. 14.7	A copperplate engraving of the title page of Johann Bayer's Uranometria star atlas published in 1603 (Courtesy of the US Naval Observatory (USNO) Library, public domain image)	252
Fig. 14.8	A copperplate engraving of the Orion constellation chart page of Johann Bayer's Uranometria star atlas published in 1603 (Courtesy of the US Naval Observatory Library, public domain image)	253
Fig. 14.9	The Astrometry.net website	255
Fig. 14.10	An image can be rotated and scaled as desired (Courtesy of Rachel Konopa)	255
Fig. 14.11	The catalog of reference star positions can be plotted, rotated, and scaled to fit the astrophotograph precisely for use in measuring the positions of objects in the image (Courtesy of Rachel Konopa)	256
Fig. 14.12	An astrometric analysis of minor planet (1103) Sequoia using AIP4Win and the UCAC 2 astrometric catalog	258
Fig. 14.13	An astrometric and photometric analysis of minor planet (1103) Sequoia using Astrometrica and the UCAC 3 astrometric catalog	261
Fig. 14.14	The atmosphere acts as several layers of light-absorbing material each with its own characteristics. The total mass of air that the starlight travels through is called the airmass (Courtesy of Rachel Konopa)	266
Fig. 14.15	MaximDL requires a variety of imaging train and astrograph parameters to make astrometric and photometric measurements	270
Fig. 14.16	The colorful barcode spectrum of a G5III type star	271
Fig. 14.17	The Shelyak Instruments Lhires III Slit Spectrograph and the Paton Hawksley Star Analyzer 100 (SA100) Spectroscopic Grating (Courtesy of Olivier Thizy, Jerry Hubbell)	272
Fig. 14.18	A stack of 55 (monochrome) images showing the zero-order star and the raw spectrum of Epsilon Delphinus obtained using the Star Analyzer 100 (SA100)	274

Fig. 14.19	Calibration of the raw image depicted in Fig. 14.18 of Epsilon Delphinus. The image scale of 9.4 Å per pixel is shown at the top	275
Fig. 14.20	The calibrated and normalized spectrum of Epsilon Delphinus. The spectrum (*red line*) was normalized to the instrument response measured via the SA100 and RSpec software. This spectrum is compared with the reference B6 star type spectrum (*blue line*) in the RSpec application	276
Fig. 14.21	The lunar crater Gassendi taken on January 7, 2012, using a 0.13-m refractor	279
Fig. 14.22	The peak at the center of the crater Gassendi measured using the Lunar Terminator Visualization Tool (LTVT). The measured value is 1,365 meters (m). This image was taken on February 3, 2012, 18:33:37 UT	280
Fig. 14.23	The lunar feature Rimae Sirsalis taken on January 7, 2012, 0118 UT using a 0.13-m refractor and the corresponding Lunar Aeronautical Chart (LAC) LAC 74 Grimaldi	281
Fig. 14.24	The lunar south polar region featuring the crater Clavius, Moretus, and a mountain near Cabeus called M3 peeking above the lunar horizon	282
Fig. 14.25	The planet Jupiter taken on November 24, 2011, using a 0.13-m refractor	283
Fig. 15.1	A modern, portable, state-of-the-art amateur observatory located in Locust Grove, Virginia (Minor Planet Center observatory code I24)	286
Fig. 16.1	The Sierra Stars Observatory 0.61-m Cassegrain imaging train (Courtesy of Rich Williams, SSON Founder)	299
Fig. 16.2	One of several 60-s calibrated images of the field containing minor planet (4150) Starr taken by the author using the Sierra Stars Observatory 0.61-m Cassegrain reflector. This image was taken on April 8, 2010, at 10:20:30.72 UTC. The plate center is located at RA 13:06:24.6 DEC −01:24:50.7	301
Fig. A4.1	A typical imaging train setup on an AIS used for scientific imaging	320
Fig. A4.2	A photovisual imaging train setup using a flip mirror	321

List of Tables

Table 3.1	Achromatic refractors	28
Table 3.2	Apochromatic refractors	28
Table 3.3	Schmidt-Cassegrain telescopes	28
Table 3.4	Classical and Ritchey-Chrétien Cassegrain telescopes	28
Table 3.5	Newtonian and Maksutov–Newtonian telescopes	28
Table 3.6	Dall-Kirkham Cassegrain telescopes	29
Table 4.1	Conversion of dynamic range to bit depth and ADUs	36
Table 4.2	Specifications for webcams versus astrocams	40
Table 5.1	CCD frame pointing control factors/effects	60
Table 6.1	Standard star measurements	79
Table 7.1	Image scale for high-resolution imaging using a 200-mm astrograph	110
Table 7.2	Image scale for high-resolution imaging using a 127-mm astrograph	110
Table 7.3	Video camera resolution	110
Table 9.1	AIS components and interfaces	137
Table 9.2	AIS requirements data	137
Table 9.3	Planetary AIS component configuration and imaging notes	146
Table 9.4	Lunar AIS component configuration and imaging notes	146
Table 9.5	Solar AIS component configuration and imaging notes	147
Table 9.6	Deep sky AIS component configuration and imaging notes	147
Table 9.7	Minor planet AIS component configuration and imaging notes	148

Table 10.1	Observing plan sources of information	154
Table 11.1	An example of a device calibration	179
Table 11.2	Suggested temperature settings when imaging	187
Table 11.3	Image acquisition timeline	193
Table 14.1	Available astrometric analysis applications	254
Table 14.2	Listing of recommended astrometric catalogs	254
Table 14.3	Airmass for different altitudes and zenith angles	266
Table 15.1	Observing Program Design Basis (OPDB) checklist	287
Table 16.1	Remote observatories and astrographs	298

Chapter 1

An Introduction to Scientific Astrophotography

1.1 Book Organization and Purpose

This book is designed and organized to be used as a workbook. It contains material both for obtaining knowledge and for learning and demonstrating skills. Optimally, you, the reader, will have or acquire the support of a mentor who has some experience and knowledge of the material and techniques in the book. This workbook approach is likely unique compared with what is generally available in the astronomy book market. This book provides not only a concise and accurate description of the topics and ideas necessary for effectively learning scientific astrophotography, but also a detailed and technically accurate set of step-by-step instructions that allows you to practice your astrophotography skills. The approach to presenting this material is based in part on my experience, over more than 30 years, in attending dozens of initial and continuing training sessions in the nuclear industry on various plant mechanical, electrical, and instrumentation systems. It is also based on what I have experienced reading many thick books on hardware and software use, design, and engineering.

Although this book takes a technically challenging and methodical approach to presenting the information, that information is broken up into small, easy-to-swallow bites. This allows you to easily digest and work through the material. Supporting this approach is the organization of the information and suggested reading. The amount of information presented, and the order in which it is presented, will enable you to reach each succeeding milestone, providing a path to success strewn with your images and data that you will be proud to show off to your friends and family, and present to your colleagues in the professional world.

This book contains 16 chapters, split into three parts that present material to help you acquire knowledge, learn skills, and record your understanding of astrophotography. *Part I* presents the details of the *Astronomical Imaging System* (AIS), delving into how to define requirements for your AIS based on your personal observing program goals. Next is a detailed discussion of the factors that characterize a cost-effective, and efficient AIS, and why you can expect a specific level of performance from the equipment choices you make. You also learn how to make design choices rooted in the way things *actually* work, not the way you think, or wish, they would work.

Part II discusses how to integrate and operate the AIS as designed and introduces the *Field Practical Exercises* (FPE). The FPEs are intended to expand on the practical considerations of the theoretical material presented in the first part of the book. They are presented in a very specific format to maintain a level of discipline and quality, and allow you to understand the impact of individual factors involved in astrophotography. The goal is not to bore you with every tiny minutia of astroimaging. Rather, the goal is to give you the necessary information to build your skills and knowledge in a very methodical way to minimize the frustration level associated with a trial and error approach to learning astrophotography. Another goal is to maximize your success in demonstrating each FPE before moving on to more difficult material. Sections of each chapter present the derivation of the ideas necessary to give you the knowledge to troubleshoot problems with the AIS that may arise. A deep, fundamental knowledge of how things work and why things are the way they are will reduce the frustration level in solving problems.

By building on previously mastered skills and knowledge presented in the earlier chapters, you can progress to the higher levels of quality and difficulty in a straightforward, linear fashion. If you have a mentor to facilitate the use of this material and supplement your training, it would be most beneficial if that mentor works with you in the field at the telescope. The mentor should also provide a peer check on your work to ensure you accomplish each milestone before moving on to the next level (see Appendix 2 – FPE Training Syllabus.) Your mentor should strive to coach you on the correct use of the terms, equations, and equipment, and help you understand the relationship between the specific topic and the higher-level goal. This, again, contributes to minimizing frustration and maximizing your success in realizing your goals in scientific astrophotography.

In *Part III*, you begin to learn how to process the raw data acquired in the field and make measurements using techniques used throughout the astronomical scientific community. You learn the basis of these measurement techniques and how they have developed over the years. You also learn how to use the various professional–level databases and software tools available to the amateur astronomer. Part III also introduces you to the various organizations dedicated to recording amateur observations for use by professionals throughout the world.

One of the overall lessons this book should teach is that as you progress in your skills and knowledge, you will use more and more of your equipment's capabilities. It is important to understand the limits of your equipment and be able to balance the performance level of that equipment with your skills, knowledge, and expectations. Expectations play a major role in your feelings of satisfaction and accomplishment.

The only way you can set realistic expectations is to fully understand the capabilities of your equipment and yourself. One of the side benefits, or some would say issues, with newfound skills and knowledge, is that you may reach the performance limits of your equipment. This forces you to contemplate upgrades that will eat into your disposable income. Coming to grips with how to balance budget, equipment performance, skills, and knowledge is not only required in your own personal observing program, but is also fundamental to running a large professional observatory. When practicing your skills to the best of your ability, you can find and fund the equipment that gives you the most "bang for your buck." This also gives you the high-quality imaging you are striving for to meet your observing program requirements.

Another lesson this book teaches is that the skills and knowledge presented apply equally no matter what the size of your telescope, the capabilities of your mount, the type or expense of your CCD camera, or your overall budget for astronomy. The skills and knowledge you demonstrate as a result of completing the work presented in this book will be similar to those acquired and practiced by undergraduate and graduate level astronomy students. This approach is analogous to the way training is obtained by professional Air Transport Pilots (ATP). These pilots start out as student pilots; progress through private, instrument, commercial, and instructor ratings; and then finally complete their ATP training. The skills and knowledge from each lower level apply to each succeeding level. This training, fleshed out with years of experience, gives the professional the necessary wisdom and judgment to fly safely anywhere in the world. It is the same with amateur astronomers—they use the same or similar knowledge, skills, software, and equipment as professionals do to provide the same level of quality data used at universities around the world. All this is available to you today in this "golden age" of amateur astronomy.

1.1.1 Amateur Astronomy Knowledge and Skills Pathway

To understand where you want to go and how to get there in terms of your knowledge and skills as amateur astronomers, it is useful to have a map. There are several ways to get to where you want to be, but you want to be as efficient as possible. The following discussion helps illustrate the necessary knowledge/skills and their relationships.

Most astronomers, whether amateur or professional, take a basic pathway to understand the astronomical universe:

> Develop an Interest in Astronomy → Pursue Knowledge → Acquire Skills → Make Observations → Analyze Data → Discover New Information → Create Science → Understand the Universe

The → symbol is the "Leads To" indicator. Each of these steps requires a specific level of dedication and discipline not only to replicate the state-of-the-art

results in amateur astronomy, but also to add to the cumulative state of knowledge to understand and innovate in the areas of processes and equipment. This book presents the knowledge and skills necessary to get you from the Develop an Interest in Astronomy stage to the Discover New Information stage. The assumption at that point is that you will have the prerequisite Interest and the basic Knowledge and Skills to continue to the next level. Once you can make effective observations and record and analyze your data, you will be well down the path to the Create Science step. This book will probably only lead you to dip your toe into the Create Science pool when it is appropriate to show you the potential use for the results of your work. It is up to you to explore the numerous possibilities for the use of the New Information you discover with the data you collect and analyze.

The following section discusses an example of the type of question you can answer and the pathway you take to do so. This example involves the use of the knowledge, skills, and equipment available to the amateur astronomer.

1.1.2 Scientific Investigation Example

Lunar Topography: The Slope of Rupes Recta, the Straight Wall

This example involves understanding the topography of a famous lunar feature called the *Straight Wall* (*Rupes Recta*, Fig. 1.1). Upon casual observation, when the *Terminator* is near Rupes Recta, it appears that the feature is a steep cliff perhaps 1–2 km in height and several hundred kilometers long. This is a false impression because the Straight Wall is actually a gradual slope of only about 20° and only a few hundred meters in height. Your task is to measure the slope of this feature to within a certain tolerance to help understand the formation of this feature.

To measure the slope to this tolerance, you need to be able to determine the specifications for the telescope and imaging equipment you need, how to configure your equipment, and how to acquire the data effectively. In addition, you need to learn how to process the data to retain all the precision your equipment will deliver, and finally, how to analyze the data to answer the question. The following list includes the knowledge, skills, and equipment needed to answer this question. Each item supports the corresponding step in the Pathway. An interested, skillful, and knowledgeable amateur astronomer:

– Makes the Observation
 - CCD Camera Basics
 - Telescope/Mount Theory and Operation
 - CCD Image Scaling Factors in Astrophotography
 - Telescope Mount Factors in Astrophotography
 - Telescope (Slow Focal Ratio)/CCD Camera (Webcam) Configuration
 - Target Acquisition
 - Image Acquisition

1.1 Book Organization and Purpose

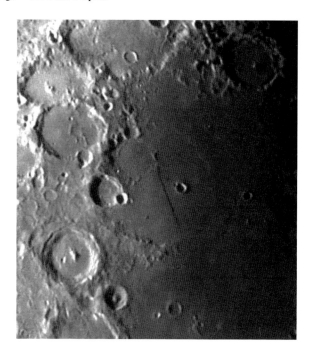

Fig. 1.1 The Straight Wall, or Rupes Recta, taken April 4, 2009, with the ATIK 314e TEC CCD camera

- Analyzes the Data
 - Raw Image Processing Software—AIP4Win, MaximDL, Registax, AVIStack, etc.
 - Image Selection and Analysis
 - Image Scaling and Uncertainty Determination
 - Topographic Measurement Software
- Discovers New Information
 - Determine the Slope of Rupes Recta
 - Hypothesize Based on the Results
- Creates the Science
 - Explain Formation of Rupes Recta

To measure the slope of Rupes Recta, you can see you need to build on your basic skills in operating the telescope, configuring your system for this task, operating the camera and computer system, acquiring the high-resolution images, extracting the data from the images, and finally analyzing the data to determine the new

information you need to formulate how the Straight Wall was formed. These same skills can be used to determine a lot of new information about different features on the Moon and can lead to a greater understanding of the formation of the lunar surface. Each of the higher-level items in the Pathway relies on performing the underlying task to the best of your ability.

Part I

Astronomical Imaging System (AIS) Components, Characteristics, and Performance Factors

Chapter 2

The "Perfect AIS"

2.1 In a Perfect World…

It would be wonderful if you, as an amateur astronomer, had access to equipment that performed flawlessly, was capable of multiple types of data acquisition, was available at the flip of a switch, and not only allowed you to enjoy working directly with your equipment, but also to acquire your data without being out in the inclimate weather. It would also not be too much to ask if you could acquire this equipment at a very low cost, within the next 2 days, and have it up and running tonight. Unfortunately, this last sentence describes what many of us, as beginners, expect when acquiring our telescope, cameras, and accessories. In a perfect world, this would be the expectation; however, while the amateur scientific pursuit of astronomical knowledge is neither quick nor easy, it is very doable by almost anyone who is willing to learn the appropriate skills and obtain the necessary knowledge (Fig. 2.1).

Three fundamental factors must balance each other in astronomical pursuits—Equipment Cost, Available Time, and Skills/Knowledge. As a beginner, you may have some knowledge of the night sky from high school or college classes, and you may have had a small refractor as a child or young adult. Now that you have access to some disposable income, you want to invest in a nice telescope and are *very* interested in these modern charge-coupled device (CCD) cameras people are using today, so you purchase one of those too. Of course, you want to invest in the best equipment you can afford, and you figure that even though you have no experience with the latest equipment, if you buy the "good stuff," it should be able to do things for you that you may or may not be aware of and/or want to do for yourself. You are also very interested in getting into imaging and tracking comets or minor planets. The reader can see where this might lead….

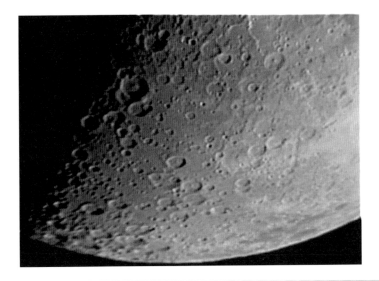

Fig. 2.1 An image of the lunar surface taken by amateur astronomer David Abbou using a Celestron Neximage webcam-based CCD camera on December 31, 2011 (Courtesy of David Abbou)

So, here you are with your big 10-in. Schmidt-Cassegrain telescope on your nice fork mount with your fancy go-to system so you can just point and click to slew to your asteroids. You also bought one of those nice "astrocams" that everyone on the web forum said was the best one to get to image minor planets. You ordered your equipment from one of those nice astronomical equipment web stores online and got your order in less than a week! Yippee! Of course, you received your equipment in the middle of a work week, but that's not going to stop you from getting out this evening. You set up your equipment indoors to see how it all works and want to go out tonight to see if you can find an asteroid. However, you realize you don't know where to look. Uh-oh… Well, no big deal, you can point your telescope and CCD camera somewhere near the ecliptic and maybe catch one of those asteroids in the act.

Of course, as an intrepid amateur, you have a good time messing with your equipment, setting it up, and probably spending half the evening trying to get a good polar alignment because that is what the people on the forum said was important to be able to use that fancy go-to system. So time flies by, and before you have been able to image anything, it's late and you have to go to work in the morning!

Over the next few days and weeks, it dawns on you that you should probably back up and reevaluate what you need to do to get that astrophoto of that asteroid. You probably spend a few sessions getting your equipment to work as it says it should in the manual and learning how to use that software to process the initial images you have acquired. You have a tough time just figuring out where the telescope is pointing because your images do not correspond to the fields where the mount is pointing. You also have problems with focusing on the stars, and the field

of view (FOV) is not as big as you expected. As a result, you have a very difficult time getting those wily asteroids in your pictures at all. You start asking pointed questions on the forums specific to your equipment and techniques; everyone agrees: Yep! You are doing the right thing as you describe it. The results just aren't there. So you continue with several observing sessions over the next few weeks, but still with not much progress.

You get better at setting up your equipment faster so you do not waste as much time, but the results are not any better. There is something missing. You start to wonder if your equipment is bad, or something else. You start to doubt yourself, but you are doing everything the equipment manual says. What is wrong?

This is the point where frustration takes over, and you do one of two things: you sell the equipment at a loss and buy a simple refractor just to enjoy the night sky (if you are up to it), or you sell the equipment and *invest twice as much as before* on new equipment that will "probably" solve all your problems. Of course neither is the correct course because the equipment is not the problem. It is, of course, *you*. You lack the knowledge and skills in the use of the equipment to attain your goal. It is very important to recognize that you absolutely must balance your skills and knowledge with the needs of the equipment you want to use. Once you have attained a certain level of skill and knowledge, it will drive you to operate your equipment proficiently and also allow you to determine the correct equipment for your observing program. This in turn will dictate the budget necessary to run your observing program.

You must also be prepared to invest the necessary time in the endeavor to realize the results you want to see. Do not overlook the importance of dedicating the proper time to obtaining the skills and knowledge to run an effective observing program. Be prepared to spend the better part of 1–2 years (30–40 observing sessions) in learning the basics before you can start being productive in your observing program. This includes investing in the appropriate level of equipment to serve as a learning Astronomical Imaging System (AIS). This book is designed to help you maximize your learning during each observing session.

The goal is to set you on the correct path to avoid the frustrating and expensive lesson described above. There is a lot to learn, but think of it as an investment in yourself—the more you know the more money you can save. There is also another interesting dynamic; when you obtain the proper skills and knowledge, and as your skills/knowledge increase, your *need* for more or better equipment *legitimately* increases. You use your level of skills and knowledge to drive your equipment-buying decisions and therefore make maximum use of your investment…in yourself. This is a much better way to approach your goals in scientific astrophotography.

2.2 The AIS Design Basis

In the nuclear power industry and nuclear plants, all of the reactor's systems have a design basis. The definition of a design basis in a nuclear plant is the totality of the design requirements, goals, expected performance, testing requirements, and

limiting conditions for operation of the structures, systems, and components (SSC) in the plant to provide the maximum margin of safety while obtaining the desired output (results). In the case of the nuclear plant, the results expected are safe, reliable, conservative operations, a high capacity factor, and the desired/expected megawatt output. In the same way, you need to initially examine and jot down the goals for your *Observing Program*. This drives the design basis of your AIS. An Observing Program could have many different goals, but let's focus on the frustrated user from before.

You do not have to be too rigorous or specific at this point; you just want to outline some basic parameters of your program. Some features are common to all observing programs; other features are very specific to an individual program. The following is an example of a minor planet *Observing Program Design Basis (OPDB)*:

Observing Program Name

Minor Planet Observations

Object Characteristics

Solar System Moving Object (predominantly located near the Ecliptic)
Brightness Range of 10th–18th Magnitude

Program Goals

Measure Minor Planet Brightness (Differential Photometry)
Measure Minor Planet Position (Astrometry)
Take Measurements Over Time to Gain Knowledge of:
 Rotation Rate
 Orbital Parameters

Measurement Performance

Differential photometry	±0.1 magnitude
Astrometry residual	±0.2 arcseconds
Absolute time reference	±0.1 s
Rotation rate	±1 min
Orbital parameters	±1% of accepted values

Program Databases

Minor planet center database	Real-time object position
USNO UCAC 3 stellar database	Astrometry/photometry

Program Focus

Near-Earth Objects
Trojan Asteroids
Main Belt Asteroids

Program Implementation

Expected observation production	10 reduced observations/week
Expected opportunities/week	2 sessions @ 5 h each
Total number of images	100 per session
Observation throughput	50%
Weather limits—temperature	20°F–90°F
Wind	< 10 knots

This is enough to start to define the equipment needs of the system once you have learned what is required to take these measurements. This book gets you up to speed on all that is necessary to make intelligent decisions on the specific equipment, procedures, and support data needed to successfully create an Observing Program.

2.3 Balancing Expected Results with Budgetary Constraints

The quality of the results you obtain in your observing program is a combination of the level of performance of your equipment and the skills and knowledge you bring to the table operating that equipment. You should be prepared to understand and set your expectations at a realistic level while you are learning how to take astrophotographs in support of your scientific observing program. The requirements for scientific astrophotography are different than for "pretty picture" astrophotography. In some cases, the needed skills and equipment are not as rigorous for scientific astrophotography. In most cases though, discipline is required to keep track of equipment settings and techniques used. In all cases, there is an absolute need for attention to detail and for understanding the underlying principles that lead to the results observed. This cannot be emphasized enough.

As mentioned previously, once you have acquired a high level of knowledge and skills, you will be better qualified to evaluate any piece of equipment that you need for your observing program. You will be able to judge for yourself whether it is worth the money for the performance expected from the equipment and whether it will add value to your observing program. The goal is to get the best value in performance, regardless of how much or how little you want to spend. The bottom line is that based on your budgeted amount, you should expect a known level of performance whether it is excellent or just fair.

A common question posed on the Internet astronomy forums is how much should I spend on my telescope mount, telescope, or camera, for effective imaging. You should look at it as a total budget evaluation—invest a particular percentage of your budget for each major subsystem of your AIS. It is important to consider that if you have a low initial budget of about $2,500, then you will have a difficult time imaging effectively without going through some growing pains, and frustration. This book is designed to minimize that frustration.

The biggest assumption here is that you already have a computer system capable of running the software, and it has the appropriate interfaces for your hardware. The minimum cost AIS is really only a training system, and its performance is limited in providing quality scientific data. The minimum requirement for an effective scientific imaging system that minimizes the frustration that you will experience is described below as the Midrange AIS. That is not to say that acquiring scientifically valid data is not possible with the lower-cost systems. It just takes a very dedicated amateur who has honed his/her skills and knowledge to a fine edge. The skills and knowledge presented in this book go a long way toward helping you make effective use of these lower end systems.

There are also "experts" out there who say that if you want to get into astrophotography at the midrange level, then you should invest in a high-end mount at the start. Although this makes some sense because you would be purchasing for the long term, it represents false economy on several levels. The main reason is that, as a novice, you need access to all the different basic pieces of equipment to learn how to perform effectively. If you put all your funds into a mount—let's say about 60–70% of a $5,000 budget—then you would have only about $1,500 for the rest of your equipment. Shortchanging yourself at this level means that although your mount is very capable and can handle just about any scientific imaging you would want to do, your astrograph and camera are not up to the task. This is guaranteed to frustrate you.

It is strongly suggested that you approach the task of building your AIS with a balanced view, using your design basis to guide you. For beginners, create your design basis with the goal of learning the *how and why* of performing scientific astrophotography. Once you are done "training," then you can improve the quality of your data by investing in the higher end equipment necessary. You must first gain the necessary experience in using the tools of the trade before expecting to make many scientifically useful observations, although there are amateurs out there who are doing cutting-edge work with lower-end equipment. One good way to minimize your equipment budget is to focus on a very specific object type in your observing program. You can design your AIS specifically for this program and save some hard-earned cash.

In the following cost breakdown tables, each cost area consists of several items, which, when combined, make up the AIS. Listed here are the suggested components for each cost area. It is important to keep in mind that the lower cost systems will not have the full range of components that would be purchased for the midrange AIS and above.

Telescope Mount—a go-to capable mount and tripod system (as a minimum) with a hand controller and computer interface/driver. Software for the mount is either freely available and/or comes with the mount from the manufacturer. The mount also accommodates a standard telescope mounting plate of either a Vixen style or Losmandy style, which is standard for low-cost to mid-range telescopes. Higher end mounts accommodate custom style plates necessary for mounting the heavier, high-end astrographs.

Telescope/Astrograph—the main *optical tube assembly (OTA)* and its mounting rings and/or plate. This element of the system also includes a focuser (2-in. or larger) that is manual in lower end astrographs and may or may not be motorized in higher end astrographs. Other parts may come with your OTA, such as a finder scope, dew heaters, and/or extra eyepieces. These may or may not be useful to you. Several manufacturers of replacement focusers can provide a motorized focuser if that is one of your requirements. Several manufacturers also can provide correcting optical elements for your astrograph to reduce the focal length, flatten the field, etc. These elements are usually considered part of the camera system if not fully integrated into the OTA.

Camera System—the main imaging camera plus any other optical elements meant to help your AIS perform as an effective astrograph. This system also includes those elements necessary to adapt your camera to the focuser and provide the proper spacing of the camera in the imaging train. Filter wheel systems may also be included in the camera system for added capability.

Support System—any external systems that interface to the mount/telescope/camera. These may include a laptop or net book computer system with appropriate hard drive systems, and software used to control the mount/telescope/camera systems. It may also include an auto-guiding system or drive corrector that provides external support to the mount. In addition, the support system may include any data analysis software used to process and analyze your images. Software used to access databases of star, asteroid, planetary, or other type of celestial objects may be included. It is important to recognize that Internet connectivity is an important feature in amateur astronomy today and gives you free access to most if not all the software applications and data that you may need in day-to-day operations of your AIS. The Internet is also an important source of information on the operation and maintenance of your AIS. Here are some suggested budgets and percentages for you to consider (all costs are in 2012 US dollars):

Minimum Cost AIS: Total Budget $2,500		
Telescope mount	40%	$1,000
Telescope/astrograph	25%	$625
Camera systems	30%	$750
Support systems	0%	Freely available

Low-Cost AIS: Total Budget <$5,000		
Telescope mount	40%	<$2,000
Telescope/astrograph	30%	<$1,500
Camera systems	20%	<$1,000
Support systems	10%	<$500

Midrange AIS: Total Budget $5,000–$15,000		
Telescope mount	35%	$2,000–$5,000
Telescope/astrograph	30%	$1,500–$4,500
Camera systems	30%	$1,500–$4,500
Support systems	5%	$500–$750

High-End AIS: Total Budget >$20,000		
Telescope mount	40%	>$8,000
Telescope/astrograph	30%	>$6,000
Camera systems	25%	>$5,000
Support systems	5%	>$1,000

Very High-End AIS: Total Budget >$50,000		
Telescope mount	30%	>$15,000
Telescope/astrograph	45%	>$22,500
Camera systems	20%	>$10,000
Support systems	5%	>$2,500

The basis for this structure is balancing the need for effective, quality imaging with the minimum needed to get useful results. Throwing money at the issue only gets you, at the most, halfway toward the high-quality, near-perfect images you desire. Skills and knowledge get you most of the way there, especially when investing in the low-cost AIS. As you can see, in most cases, the highest percentage of your budget should be invested in the telescope mount. This is explained in detail in Chap. 7, but it should be obvious that the telescope mount is the foundation for excellent, high-quality, astrophotographs.

For the low-cost and high-end AIS system costs, the percentage of the total budget specified for the mount is higher than for the midrange AIS. For the low-cost AIS, this is because the total budget is low, and you must make a minimum level of investment in your telescope mount to obtain the quality astrophotographs necessary for scientific investigation. Also, to overcome a guaranteed level of frustration, it helps to spend a little more cash. No matter the patience, skills, and knowledge you may possess, under-spending on your telescope mount will result in images that will not achieve the necessary level of quality. In the case of the high-end AIS, because a wealth of funds is available, it makes sense to invest for the long term by purchasing a very nice mount. The expectation is that this mount will probably last the rest of your life, giving you trouble-free, excellent service.

Telescopes and astrographs are available at a wide range of prices—Chap. 3 discusses what makes a good imaging telescope. However, most amateurs use telescopes with an objective diameter from 5–10 in. The planetary imagers use

astrographs greater than 10 in. in diameter to obtain the *image scale*, or magnification necessary to perform the super high-resolution imaging desired. There are certainly some tradeoffs you can make in the percentage of your budget devoted to various pieces of equipment, depending on the specific goals of your imaging program. This is no truer than when considering the amount to spend on the telescope or astrograph. The size and focal length of the astrograph is driven by whether you want to do stellar imaging or planetary imaging. Astrophotographers who focus on stellar imaging opt for the wider field, shorter focal length imaging systems, whereas those who do lunar or planetary imaging tend to use the longer focal length AIS. However, there are always exceptions. Some diehard amateurs image the faintest, smallest objects they can find. This is an especially challenging program to pursue.

The choice of camera systems available to the amateur astronomer is vast. We are very lucky to live in an age with so many good choices. Of course, as with most items you choose to buy, you get what you pay for. There are features in camera systems that you may consider a necessity, and others that are nice to have and contribute to comfort in using these cameras. Again, you can spend as little or as much as you choose on a camera system, but you must be prepared to apply your skills and knowledge when using these systems. Future chapters provide plentiful information for making an informed choice.

The small amount budgeted for support systems goes toward the computer systems and software necessary to acquire raw data and process it into a useful form. This amount seems small because there is a wealth of free software available on the Internet that covers most of the processing that you are likely to do in your work. We are very lucky that in the amateur astronomy community, we have people who love to provide the tools and techniques necessary and choose to share them with anyone who wants to learn. The support system also includes any external correction systems you may add to your mount, such as auto-guiding or drive corrector systems. In addition, other professional-level tools that you may want to invest in to add to your support tools will provide an elevated level of quality and certainty in analyzing of your data. Investment in these tools may also give you options that you might not have otherwise. Future chapters cover these tools and discuss why one would consider investing in them.

2.4 AIS Operations and Maintenance

As an observatory director (that sounds impressive, doesn't it), you are responsible for the *operations and maintenance (O&M)* of your observatory. This means learning all there is to know about your equipment and maintenance. You need to be aware of the environmental requirements for storage and operation if it is a portable observatory, or what shelter you need if it is a permanent observatory. To maintain the expected performance of your telescope, mount, CCD camera, and other accessories, you must be able to detect any problems that may arise and keep up with any problems that others have identified, known as operational experience (OE) in the nuclear industry.

The equipment you invest in will provide you with years of service when maintained appropriately and will not become a hindrance to you in reaching your goal of acquiring excellent scientific imaging data. It is important to understand the proper operation of your equipment based on the vendor instructions and on the design of the equipment. There are times when you may be tempted to operate your equipment outside the specified operating range (that can be useful at times), but it is important to understand the limits of your equipment and the impact that operating beyond those limits will have on your data. You may be able to operate certain pieces of equipment outside their limits by compensating in the way you operate other parts of your system. These limits are usually specified in the operating manual that comes with your equipment.

For example, suppose you have invested in a telescope mount that has a load capacity of 40 pounds (lbs) (18 kilograms (kg)). The following chapters recommend that to get the best imaging data, you normally do not want to push the limits of the load capacity of your mount. However, although you do not have the budget to upgrade your mount's capacity, you want to acquire data using your larger 10-in. reflector and your biggest CCD camera (with accompanying accessories). This equipment weighs in at 38 lbs (17 kg) and is at the nominal limit for your mount's capacity. In this case, you must use your judgment and fully understand the impact that pushing the capacity of your mount will have on being able to obtain the data you need. You may be limited in the total exposure time you can expect while maintaining a defined quality of image. You may need to be extra sensitive to any movements around the mount when you are taking images. You may need to take extra care that no cables are loose and present a snagging hazard. You get the idea.

As another example, suppose you want to take the most precise and accurate measurements of the position of a minor planet, but are limited in the resolution. First, you need to balance your FOV to the image scale of your system to ensure you can not only measure the position accurately, but also place the object in your FOV at all. Your goal is to be able to set up quickly and start your imaging, so you do not spend much time getting a "perfect" polar alignment on your mount. In addition, because you want to get the most precise and accurate measurement, you will initially push your equipment's performance by setting the pixel scale to less than 1 arcsecond/pixel. This, in turn, narrows the FOV significantly. The narrow FOV, coupled with the imprecise mount alignment, causes you to spend extra time on every object ensuring that it is placed within the FOV. If, on the other hand, you had spent some time evaluating the situation, you might have opted for spending the extra 15 min ensuring your polar alignment and pointing accuracy were better. There is nothing more frustrating than learning that you have not placed your target in the FOV after spending valuable time imaging that portion of the sky.

You can see that it is important to understand the capabilities and limits of your equipment when setting your goals and operating your AIS. It is also important to balance the capabilities of all the pieces of equipment involved with taking the data of interest. By balancing the various options and performance issues, you obtain that "perfect AIS."

The following chapters discuss in detail the steps to prepare and make your observations—doing it right the first time and every time with your "perfect AIS."

2.5 Are You Up to the Task?

Based on the previous discussion, you may find the whole process of choosing a system somewhat overwhelming…and it is a lot to learn and understand. However just like any other technical subject, if you break down the material into specific topics, and continually review how the individual items relate to your end goals, then it is not as difficult as it may seem. This book leads you down a well-worn path, giving you numerous examples and specific exercises to help you build not only your skills and knowledge, but also your discipline and your sense of excellence, all of which will serve you well into the future.

Remember, frustration is borne of lack of knowledge about cause and effect. All of us have problems that arise during every imaging session. The important point is that you are equipped to identify and understand the symptoms, and are able to identify the root cause of the problem. Sometimes it is necessary to put a workaround or quick fix in place to finish the session, but it is also necessary to evaluate the issue after the session to get to the root cause and permanently remedy it.

If you are up to the task, you will value the skills and knowledge you gain through your diligent work using the disciplined approach outlined within the following chapters. This is an investment in your time that is valuable, so make the most of it!

Further Reading

Arditti D (2008) Setting-up a small observatory. Springer: New York
Berry R, Burnell J (2005) The handbook of astronomical image processing. Willmann-Bell: Richmond
Buchheim R (2007) The sky is your laboratory. Springer: Berlin/Heidelberg/New York
Chromey FR (2010) To measure the sky. Cambridge University Press
Covington MA (1999) Astrophotography for the amateur. Cambridge University Press
Dragesco J (1995) High resolution astrophotography. Cambridge University Press
Henden AA, Kaitchuck RH (1990) Astronomical photometry. Willmann-Bell: Richmond
Smith GH, Ceragioli R, Berry R (2012) Telescopes, eyepieces and astrographs. Willmann-Bell: Richmond

Chapter 3

The Astrograph: The Imaging Telescope

3.1 What Is an Astrograph?

The most basic definition of an astrograph is a telescope that is used to photograph the heavens and is dedicated to that purpose. Of course, not every telescope is considered an astrograph. Several specific characteristics make one telescope a better astrograph than another. Even though not every telescope is considered an astrograph, you can photograph the sky using any telescope you want; you just may not get the quality image that you want or need for your observing program. The main characteristics of a true astrograph are that it provides a wide field of view (FOV) and a flat imaging plane for use with today's large charge-coupled device (CCD) cameras.

Some characteristics make one astrograph more suitable than another for photographing certain objects. The 48-in. Schmidt camera used for the Palomar Observatory Sky Survey (POSS I, and POSS II) is an example of a dedicated-use astrograph. The original Schmidt camera was dedicated to imaging large areas of the sky. Instead of an eyepiece, all it had was a film holder within the body of the telescope between the primary and the correcting plate (Fig. 3.1). The follow-on upgrade to the astrograph replaced the film holder with a large CCD chip camera and the astrograph was renamed the 48-in. Samuel Oschin Schmidt camera.

Another type of astrograph is the long focal length, large refractor, such as the 60-cm refractor located in Pic Du Midi in France (Fig. 3.2). This astrograph is primarily used to take high-resolution photographs of the planets and lunar surface. It (among others) was used in the 1960s to acquire photographs to make the highly detailed Lunar Aeronautical Chart (LAC) series for use in the Apollo Program (Fig. 3.3).

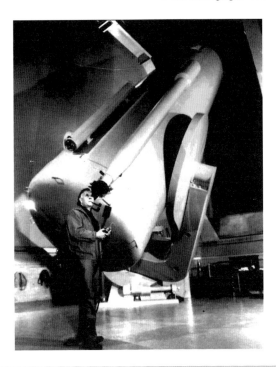

Fig. 3.1 Edwin Hubble at what is now called the 48-in. Oschin Schmidt telescope in 1960 at Palomar Observatory in Pasadena, CA (Courtesy of Palomar Observatory)

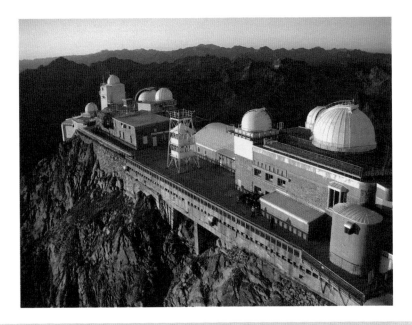

Fig. 3.2 The Pic du Midi Observatory, located in the French Pyrenees (Courtesy of Pascalou Petit Creative Commons License CC BY-SA 3.0)

3.1 What Is an Astrograph? 23

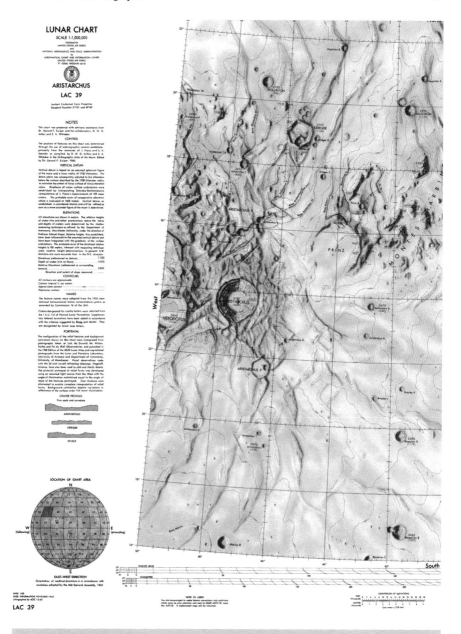

Fig. 3.3 Lunar Aeronautical Chart (LAC) 39 Aristarchus (Courtesy of Defense Mapping Agency, Aerospace Center, 1973)

Fig. 3.4 The US Naval Observatory UCAC 8-in. (20-cm) astrograph located at the Flagstaff, NM, station of the USNO (Courtesy of US Naval Observatory)

Astrometric astrographs are used to make highly accurate maps of stellar positions as well as databases of those stellar positions. They are also used to measure the positions of solar system objects such as the planets, comets, and asteroids or minor planets. The United States Naval Observatory (USNO) Flagstaff Station (NOFS) UCAC astrograph in Flagstaff, Arizona (Fig. 3.4), is used to create highly accurate databases of stars. The USNO is involved with creating several astrometric databases, including the USNO-A1.0, USNO-A2.0, USNO-B1.0, and NOMAD astronomical catalogs. The USNO CCD Astrograph Catalog (UCAC) series of astronomical databases is available to the amateur astronomer in performing astrometry; the UCAC3 is the current version available, and the UCAC4 database became available in fall 2012.

The amateur astronomer can use several types of astrographs for scientific imaging. Astrographs are available in both refractor and reflector types: triplet *apochromatic* (APO) refractors with field-flattening correctors and *Ritchey-Chrétien (RC)* Cassegrain reflectors, also with field-flattening correctors, are typically used by advanced amateur astronomers for taking scientific images. The RC Cassegrain is also the most common configuration used by professionals. Other reflector types are also available to the amateur astronomer; these are covered in the Sects. 3.2 and 3.4.

3.2 Astrograph Design Features

The astrograph has several specific design features that put it in a class of its own. The main two features that define the prototypical astrograph are the image FOV and image field flatness. These two characteristics are somewhat related and interact with each other. To obtain a large FOV, or as it is also known, the *imaging circle*, it is necessary to provide a large flat field whose FOV is in good-to-excellent focus out to its edge. Also, the baffling inside the telescope must allow a large unobstructed FOV. Baffling is important for minimizing the stray light that can impinge on the CCD, but baffling can contribute to vignetting, which may occur in telescopes that restrict the FOV.

Several other secondary characteristics of the astrograph aid in its use and improve the quality of the images you obtain. Most if not all of these features are available to the amateur astronomer. Among the most important of these is that astrographs allow easy access to the imaging plane of the instrument to mount a large variety of *imaging trains*. Astrographs also have very precise focusing systems to permit the user to take the best images possible. In addition, there are astrographs constructed of carbon fiber to combat the focus shift that occurs during the night because of temperature changes. This material has a very low temperature coefficient to minimize the change in objective-to-camera focal plane distance. Astrographs also have systems incorporated to cool down and equalize the temperature of the telescope's objective and secondary to just above the ambient temperature in a timely manner. Anti-dewing systems are also provided with some astrographs to mitigate the effects of dew on the astrograph.

Astrographs are built to maximize their performance in imaging the heavens. The integration of the various features is designed for the sole purpose of obtaining the highest quality, most accurate, astrophotographs possible for scientific purposes. Of course, these features are also conducive to obtaining the best "pretty picture" astrophotograph possible and provide years if not decades of use.

Professional-level astrographs come in two major types, refractors and Cassegrain reflectors. There is only one type of refractor used professionally (a very large one!), but there are two classes of Cassegrain reflectors used professionally, *RC* and *Schmidt cameras*. These three have several counterparts in the amateur realm; the small APO refractor (80–152 millimeters (mm)) is king for wide field imaging when coupled to a field flattener. For larger objectives, the past 20 years has seen the dominance of the *Schmidt-Cassegrain telescope (SCT)*. This instrument is available in sizes from 8 to 16 in. (and larger if necessary) and typically comes with a fork mount, although they are available with large *German equatorial mounts (GEM)* also. The major deficiencies of SCTs include field curvature, coma, focus drift caused by temperature changes, and image shift caused by the standard focusing mechanism's interaction with the main mirror position. The two major manufacturers of SCTs (Celestron and Meade) have released corrected versions of the SCT in recent years that provide better performance and minimize the field curvature, coma, focus shift, and image shift inherent in the classic SCT designs.

In the past few years, other Cassegrain telescopes have become available from the telescope manufacturers, including Maksutov-Cassegrains and RC Cassegrains. Low-cost RC astrographs have brought professional-level optics to the amateur masses that could not previously afford such a high level of performance.

Fast, short focal length Newtonian astrographs are also available that include coma correctors. These Newtonians are available in focal ratios (FR) of less than $f/4$ for very wide field, faint object imaging. Maksutov-Newtonian astrographs are another popular astrograph configuration.

3.3 A Focus on Focusers

The one feature that is almost as important as the type and quality of the optics is the focuser. It positions the CCD camera or eyepiece to the point where the primary objective refracts the light collected at a specific distance. In this way, the focuser achieves a precise and accurate focus at the image plane of the detector whether it is your eye via an eyepiece or a CCD camera's focal plane.

The eye is a very flexible "instrument" in that it can properly view a highly dynamic range of brightness and is very efficient in dynamically adjusting for changes in focus and movement of the object under study. CCD camera systems are not at all like the eye in this respect. The features that make the eye such a flexible instrument must be added to the CCD camera or externally handled for it. The focuser is one of the key elements. The ideal focuser should be motor driven and very precise, i.e., setting its position should be highly repeatable. In addition, it should be accurate over time in its absolute position so that it can be calibrated/set for a specific imaging configuration. The focuser's response to temperature should also be highly repeatable so that the effects of temperature changes on the Astronomical Imaging System (AIS) can be compensated for accurately.

Most high-end astrographs have focusers that meet these requirements as part of the original equipment manufacturer (OEM) package. However, some of the lower-end astrographs, in the price range from $1,500 to $5,000, come with only very good manual focusers. These focusers are good for visual use but do not meet all the needs for excellent, high-quality imaging. That is not to say that these focusers cannot do the job; it is just much more comfortable and less frustrating to use a motor-driven focuser with a precision absolute setting system. Several third-party focuser systems are available to the amateur astronomer that can easily replace the focuser delivered with the telescope or astrograph.

Motor drive systems are also available for purchase to add to the manual focuser that comes with your telescope or astrograph. These can be very cost effective as long as other attributes of the existing focuser are conducive to high-quality imaging. These attributes include a large unobstructed view for the imaging circle desired, ability to handle the load of the camera system mounted on the focuser, zero image shift when focusing, and the precision positioning required.

When considering high-end systems, focusers become very important because they need to be able to support heavy subsystems that include large filter wheels,

active optic systems, field rotators, etc. When integrated with the CCD camera, the total load supported by the focuser can easily exceed 11 pounds (lbs) (5 kilograms (kg)). Precisely positioning an 11-lb (5 kg) load to less than 4 μm, repeatedly, becomes difficult. This level of control is indispensable with astrographs with an FR less than $f/4$.

In summary, even with the best optical systems that are collimated perfectly, your image suffers if you cannot provide the CCD camera with a perfectly focused image placed precisely on the focal plane. This can be a major source of frustration in doing astrophotography. Future chapters cover the techniques necessary to minimize the work involved in obtaining perfect focus.

3.4 Equipment Available to the Amateur

We live in a time of high technology, and that is no less true of the astronomical equipment that we can purchase from myriad manufacturers, most of which were founded by an amateur astronomer. The equipment available runs the gamut from small refractors to large RC Cassegrains, from small manual Alt-Azimuth mounts to large, computer-controlled GEMs, and from inexpensive webcams suited for planetary imaging to very large, very sensitive CCD cameras suitable for the professional as well as the advanced amateur.

A large number and range of astrographs are available for purchase depending on your budget and purpose. There are two tiers of quality in the astrograph marketplace, and the adage "you get what you pay for" applies. Over the past 10 years, the manufacturers in Asia have made very good APO refractors available, and these have improved over the years. Synta is a major manufacturer of telescopes and astrographs in Asia. Third-party distributors sell the Synta-manufactured refractors under their brand name.

Names such as Sky-Watcher, Orion, Astronomy Technologies (AstroTech), D&G Optical, and Explore Scientific are well-known distributors of relatively inexpensive, high-quality achromatic and APO refractors. In the past few years, inexpensive RC astrographs have been made available by Orion, AstroTech, and Guan Sheng Optical (GSO). GSO is a Taiwan-based major manufacturer of astrographs and telescopes. There are two major SCT manufacturers, Celestron and Meade. They have a very wide range of instruments available for all budgets.

There is also a higher quality tier of astrograph manufacturers that includes Vixen, Televue, Astro-Physics, Takahashi, TMB, and APM. These firms offer mostly very high quality APO refractors. Several high-quality Cassegrain manufacturers make several different types, including RC, Classical Cassegrain, Dall-Kirkham, Maksutov, and other designs. These manufacturers include RC Optical Systems (RCOS), Ceravolo Optical Systems, Alluna Optics, PlaneWave, DeepSky Instruments, AG Optical, and Star Instruments.

Tables 3.1, 3.2, 3.3, 3.4, 3.5, and 3.6 show a representative list of telescopes and astrographs over a wide range of performance and prices. These are presented for

Table 3.1 Achromatic refractors

Manufacturer	Objective range (mm)	Focal ratio	Price range ($)
D&G Optical	150–300	$f/10.0$–$f/15.0$	1,700–10,000+
Orion	80–120	$f/5.0$–$f/7.5$	120–500
Explore Scientific	102–152	$f/6.5$	400–700
Astronomy Technologies	72	$f/6.0$	380
Sky–Watcher	90–150	$f/5.0$–$f/7.5$	400–800

Table 3.2 Apochromatic refractors

Manufacturer	Objective range (mm)	Focal ratio	Price range ($)
Astro-Physics	130–160	$f/6.3$–$f/7.5$	6,000–10,000+
Televue	60–127	$f/5.4$–$f/7.0$	900–7,100
Takahashi	60–150	$f/4.5$–$f/7.7$	1,200–11,400
Explore Scientific	80–152	$f/6.0$–$f/7.5$	800–6,500
Meade	80–130	$f/6.0$–$f/7.0$	1,000–3,000
Stellarvue	70–160	$f/6.0$–$f/7.5$	420–9,800
Astronomy Technologies	90–130	$f/6.5$–$f/7.0$	1,300–3,600
Sky–Watcher	66–120	$f/6.0$–$f/7.5$	600–3,500

Table 3.3 Schmidt-Cassegrain telescopes

Manufacturer	Objective range (mm)	Focal ratio	Price range ($)
Celestron	200–500	$f/10.0$–$f/11.0$	1,200–10,000+
Meade	150–500	$f/10.0$	1,200–10,000+

Table 3.4 Classical and Ritchey-Chrétien Cassegrain telescopes

Manufacturer	Objective range (mm)	Focal ratio	Price range ($)
D&G Optical	500	$f/15.0$	20,000
Astronomy Technologies	150–300	$f/8.0$	400–4,000
Orion	200	$f/8.0$	2,000–2,400
RCOS	250–860	$f/4.0$–$f/9.0$	>10,000–100,000+
Star Instruments	317–610	$f/8.0$–$f/16.0$	>10,000–100,000+

Table 3.5 Newtonian and Maksutov-Newtonian telescopes

Manufacturer	Objective range (mm)	Focal ratio	Price range ($)
Sky–Watcher	76–254	$f/4.4$–$f/9.2$	200–600
Orion	115–254	$f/3.9$–$f/4.7$	150–500
Explore Scientific	152	$f/4.8$	1,500
AG Optical	200–400	$f/3.8$	6,700–20,200

Table 3.6 Dall-Kirkham Cassegrain telescopes

Manufacturer	Objective range (mm)	Focal ratio	Price range ($)
Ceravolo Optical Systems	300	f/4.9–f/9.0	22,000–25,000
Takahashi	210–300	f/10.0–f/12.0	3,600–17,000
PlaneWave Instruments	317–700	f/6.6–f/8.0	10,000–185,000

illustrative purposes only, and these specific makes and models may or may not meet your specific needs. These prices are for the *Optical Tube Assembly* (OTA) only and are as of 2012.

3.5 Getting the Most "Bang for the Buck"

In evaluating your observing program goals and projected budget, it is important to maintain a balance among the AIS subsystems. There is a general rule governing the cost of the equipment you purchase and the features available—you should expect to get 70% of the features for less than 50% of the cost. You should also expect to get the same 70% of the performance for less than 50% of the cost. However, this is only true if you are knowledgeable about how the equipment was designed, the materials used in its construction, and the manufacturer's expected performance of the equipment.

The skill and knowledge you bring to the table can boost the performance of your equipment to a high level—almost, but only to a point, regardless of cost. It is important to consider that the investment of time and practice you commit increases the overall value of your AIS. In the home improvement field, it is called "sweat equity." In this case, it is the amount of time and effort you put into getting the most out of your equipment to "add value" to your resulting imaging data. Maximizing the quality of your data includes not only purchasing the perceived "best" equipment available, but also using that equipment in the most effective way you can.

What does this have to do with getting the most "bang for the buck" in purchasing an astrograph? There is a wide range of astrographs available to the amateur astronomer, and it is important to understand what you are getting for your dollar. Is it really worth an extra $500 for that fancy dew heater system integrated into the astrograph? Is it worth that extra $1,000 for that automated focus system? Is it worth the extra $4,000 for a 12-in. RC versus the 10-in. RC? How can you make adjustments to your imaging train to compensate for a smaller diameter telescope objective? How can you make do with what you have purchased in the past to save an extra $200? Are there ease-of-use issues with a given astrograph design in the area of collimation, susceptibility to dewing, or focusing? How does this particular feature add value and allow me to spend more time imaging versus setting up the AIS?

As you can see, there is a lot to consider. You should not expect to be able to answer these questions at this point. The information you gain from reading this book will help you weigh and balance the conflicting requirements of your AIS and observing program to give you the best program possible.

Further Reading

Berry R, Burnell J (2005) The handbook of astronomical image processing. Willmann-Bell, Richmond
Buchheim R (2007) The sky is your laboratory. Springer, Berlin/Heidelberg/New York
Chromey FR (2010) To measure the sky. Cambridge University Press
Covington MA (1999) Astrophotography for the amateur. Cambridge University Press
Dragesco J (1995) High resolution astrophotography. Cambridge University Press
Henden AA, Kaitchuck RH (1990) Astronomical photometry. Willmann-Bell, Richmond
Howell SB (2006) Handbook of CCD astronomy. Cambridge University Press
Smith GH, Ceragioli R, Berry R (2012) Telescopes, eyepieces and astrographs. Willmann-Bell, Richmond

Web Pages

http://www.astro.caltech.edu/palomar/
http://en.wikipedia.org/wiki/Pic_du_Midi_de_Bigorre
http://www.lpi.usra.edu/resources/mapcatalog/LAC/
http://www.usno.navy.mil/USNO/
http://www.focuser.com/
http://www.starlightinstruments.com/
http://www.dgoptical.com/
http://www.telescope.com/
http://www.explorescientific.com/
http://www.astronomytechnologies.com/
http://www.astro-physics.com/
http://www.televue.com/
http://takahashiamerica.com/
http://www.takahashi-europe.com/
http://www.meade.com/
http://www.celestron.com/
http://www.stellarvue.com/
http://www.rcopticalsystems.com/
http://www.star-instruments.com/
http://www.agoptical.com/
http://www.ceravolo.com/
http://www.planewave.com/
http://www.skywatcher.com/

Chapter 4

CCD Chip Performance, CCD Camera Basics, and Image Scaling Factors

4.1 The CCD Revolution

The *charge-coupled device (CCD)* camera has revolutionized the practice of performing astronomical imaging, astrometry, photometry, and spectroscopy. The performance of the CCD chip (Fig. 4.1) far exceeds that of previous technology, i.e., film and photomultiplier tubes, in making scientific measurements and in bringing us the beauty of the night sky. Several aspects, or characteristics, of the CCD camera affect the results you obtain when making images. There are also characteristics that enhance your ability to make very precise scientific measurements. CCDs are suited to *photometry,* which is the science of measuring the flux, or intensity, of an astronomical object's *electromagnetic radiation (EMR)* (light).

At the most basic level, a CCD can be thought of as a large two-dimensional array of photon collectors or buckets. In some respects, you can consider the CCD chip as a multi-million channel photometer. The CCD material converts photons into electrons (charges), and the buckets can only hold so many electrons—much as a bucket can only hold so much water. Of course, the bigger the bucket the more water it can hold—the same applies to CCDs. When you fill a bucket with water, you can measure how many ounces of water you have in the bucket by pouring the water into a measured container and recording the value. The CCD works in a similar manner; you fill up your pixel to a certain level by exposing it to light, and then you empty it and count how many electrons you have in the pixel.

Fig. 4.1 The Kodak 8300 CCD chip in the QHY9m TEC CCD camera

4.2 CCD Versus Eye

Two primary characteristics make the CCD a good scientific measurement device—*linearity* and *quantum efficiency (QE)*. Because CCDs are linear in their response to light, they maintain their precision; however, it is difficult to cover a large brightness range for measurement. On the other hand, both the eye and film have a *nonlinear response* to light. What this means is that when you expose your eye or film to light, the sensitivity changes depending on how much light is received. In addition, the amount of light required to record a given signal level is determined by the QE of the CCD chip. QE is the percentage of photons that are converted to electrons within the CCD chip. Typically, CCDs have a QE value of about 60%; film's equivalent QE is only 1–2%. QE is boosted mainly by including a micro-lens in front of each pixel or by manufacturing the CCD as a back-illuminated chip.

When you are out at night, your eye adapts to the darkness and becomes more sensitive the darker it gets. The opposite is true when you are out in the bright daylight. During the day, your eyes are not as sensitive to subtle changes in brightness as they are at night. This changing sensitivity can be characterized as a *logarithmic function*, allowing description of this nonlinear response in a linear fashion. The magnitude scale for star brightness is a logarithmic function. This is because when Hipparchos (Fig. 4.2) originally conceived the brightness scale of the stars, he relied on his eyesight to develop the scale.

4.2 CCD Versus Eye

Fig. 4.2 Hipparchos, circa 160 BC (Courtesy of Rachel Konopa)

The original visual magnitude scale had values from 1 to 6, with the brightest stars at a magnitude 1, and the dimmest visible stars at 6. It turns out that the brightness ratio from magnitude 1 to 6 (5 magnitudes) is equal to about 100; therefore, the difference between each magnitude and its neighbors is equal to the fifth root of 100, or about 2.5 (2.5119 to be exact). This was formalized by Norman Pogson and is known as *Pogson's Ratio*. The fact that brightness increases by a defined ratio for each step makes it nonlinear.

The main advantage of using a logarithmic scale is that it is easier to make measurements over a large dynamic range. The drawback is that even though you can measure a large range in brightness, the measurement is less accurate the brighter the measured value is. Because of their linearity, CCDs make good scientific instruments, but their precision is achieved at a sacrifice of dynamic range.

One other aspect of the CCD design affects the linearity of the measured value you receive from the CCD. It is related to how full the pixel well becomes when exposed to light. To understand this problem, you must be aware that there are two types of CCDs, a standard pixel well design and one with a feature called an *antiblooming gate* (ABG). Blooming or overexposure of a pixel manifests itself in CCD astrophotographs as a large vertical line of bright pixels going through the middle of the stars in those images. What has happened is that when a pixel is overexposed, the electrons overflow into the adjacent pixels in the rows above and below the overflowing pixel. This continues until a line of bright pixels extends vertically from the original star image.

Manufacturers get around this problem by including, as part of each pixel, a circuit called an ABG. These ABGs bleed off excess electrons so that they are not part of the signal and do not overflow into the adjacent pixels. Unfortunately, this causes the high end of the range of the pixel to be nonlinear. Older ABG CCDs (manufactured before 2009 or so) became nonlinear above 50% of their range. The latest ABG CCDs are linear up to about 90% of their range or greater. The impact of this linearity is discussed in Chap. 11, Sects. 11.5 and 11.6.

4.3 CCD Chip Characteristics

Several characteristics of the CCD chip are related to dynamic range and sensitivity, and affect your ability to make precise measurements: *digitization level (bit depth)*, *full-well depth*, and *noise level*. Bit depth is related to how many discrete values you split the brightness level into to measure it. As an analogy, if you have a weight scale that measures weight from 0 to 200 pounds (lbs), but the scale is marked in 5-lb increments, then you have only 200/5 or 41 different discrete weight values (including the 0 (zero) value) you can measure.

The same is true with a CCD camera. CCD cameras convert photons into electrons, so CCDs measure electrons as an indication of brightness. Each *picture element* or *pixel* can nominally measure brightness values from 0% to 100%. With 12-bit digitization, which in binary notation allows us to encode a total of 2^{12} values, or 4,096 separate levels, you can split that 100% value into increments of 100/4,096 or 0.0244%. With a 16-bit camera, you can split the 100% brightness value into 65,536 different levels, resulting in increments of 100/65,536 or 0.0015%.

Just because you can calculate a very precise number with 16-bit digitization (representation) does not mean that you can measure to that precision. The other factor influencing your measurement, noise, involves a concept called the *signal to noise ratio (SNR)*. SNR is a way to characterize the brightness resolution you can actually achieve with your camera when measuring the brightness of an object. With electronic sensors, when you move electrons, they create heat. Heat adds randomness to the electrons that are collected from the light source by adding in extra electrons from the heat generated in the chip. There are three types of noise of concern in a CCD measurement: *readout noise*, *dark noise*, and *sky noise*. Readout noise is a fixed amount of noise that is added to the brightness value every time the CCD is read out. It is generated by the electronics used to convert the electrons into a value you use in your measurements. Readout noise is usually specified in *Analog to Digital Units* or *ADUs*, and to calculate the electron equivalent, simply multiply the ADUs by the gain (g). Dark noise is generated by the internal heat of the CCD and is cumulative during the exposure time of the image. It has a time-based component called the *dark current* value that doubles when you double the exposure time. Because dark noise is related to heat, having a cooling system helps to alleviate the impact on the SNR. Typically, for every 6° (degrees)

4.3 CCD Chip Characteristics

C drop in temperature, there is a corresponding 50% drop in dark noise. Finally, sky noise is the background noise of the dim sky that adds to any signal you acquire for stellar objects. Sky noise is a result of the amount of haze, smoke, or fog and the light pollution that is in the area caused by poorly designed outdoor lighting. Sky noise will limit the total exposure time you can use while imaging.

The *dynamic range* (DR) is related to the CCD electronics and does not take into consideration external factors that affect the precision of the data acquired by the CCD. DR is easily calculated and is stated in terms of *decibels* or *dB*. The equation is:

$$DR = 20 \, Log_{10} \, (Max \, ADU \, / \, Readout \, Noise \, ADU) \qquad (4.1)$$

Therefore, for a 16-bit camera, the Max ADU is 2^{16} or 65,536, and if the camera has a readout noise of 10 ADU, then the dynamic range is equal to 20 Log_{10}(65,536/10), 20 Log_{10}(6553.6), or about 76 dB. If you use the ratio value 6553.6 to calculate the bit depth equivalent, you arrive at a value between 12 and 13 bits (4,096 and 8,192 ADU). Some cameras actually have readout noise in the 4–6 ADU range, which would boost the bit depth to close to 14 bits (Table 4.1).

In addition to readout, dark, and sky noise, there is one other type of noise to consider. This noise is a characteristic of any type of radiation (light) and is a random noise value that follows a very precise statistical relationship first described by *Siméon Denis Poisson*. This characteristic, *Poisson noise,* is measured statistically and has the relationship: Poisson Noise value=±√measured signal value. If you have a measured value of 10,000 electrons, then the Poisson noise value would be the ±√10,000 electrons, or ±100 electrons.

Consequently, the result of your measurement, when all the different noise factors are taken into account, is really the following:

$$Measured \, Signal = Source \, Signal \pm Signal \, Poisson \, Noise \qquad (4.2)$$
$$+ Readout \, Noise + Dark \, Noise + Sky \, Noise$$

An example for a 60-s exposure would be—

$$Measured \, Signal = 32,332 \pm \sqrt{32,332} + 13 + (60 \times 0.1) + 100 \, electrons \qquad (4.3)$$
$$= 32,332 \pm 180 + 119$$
$$= 32,451 \pm 180 \, electrons$$

What this says is that even though the true value for the signal is 32,332, the measured signal has added noise equal to a range from minus 61 electrons to plus 299 electrons. The total range of noise is equal to 360 electrons, so the SNR for this measurement would be 32,332/360 or 90. In addition, it is important to recognize that in this example, the systematic error is equal to +119 electrons. Overall, you can discriminate between 90 different levels of signal in this measurement. This is a far cry from 65,636 different levels, isn't it? Assuming a CCD gain of 1 electron/ADU, this does not even reach half the digitization level of 8 bits (2^8 or 256 levels),

Table 4.1 Conversion of dynamic range to bit depth and ADUs

Bit depth, dynamic range, and ADUs

Bit depth (bits)	Resolution dynamic range (dB)	Total counts (ADU)	Dynamic range with 10 ADU of readout noise
8	48.2	256	28.2
9	54.2	512	34.2
10	60.2	1,024	40.2
11	66.2	2,048	46.2
12	72.2	4,096	52.2
13	78.3	8,192	58.3
14	84.3	16,384	64.3
15	90.3	32,768	70.3
16	96.3	65,536	76.3

let alone 16 bits. However, you must understand that this calculation applies to the raw, uncalibrated image data. There are several techniques to combat this poor level of measurement; later chapters address these calibration techniques.

Several elements of the CCD construction have an impact on these fundamental characteristics of the CCD performance. The following list summarizes the primary physical characteristics of CCDs:

Resolution—The CCD is a two-dimensional array of pixels constructed in a plane. The resolution is the count of pixels on the x and y axes. A typical CCD array could be made up of 1,024×768 pixels for a webcam CCD, or 3,336×2,496 pixels for a QHY9m with a Kodak 8300 chip.

Pixel Size—Typical pixel sizes range from 4.65 microns (μm) to 24.0 μm. A micron is 1/1,000 of a millimeter (mm).

Full-Well Depth—Each pixel in a CCD can collect or hold only so many electrons (photons) depending on its construction and size. The QHY9m camera uses the Kodak 8300 chip, which has 5.4 μm pixels. The measured full-well depth for these pixels is 25,500 electrons.

CCD Size—The CCD size is simply the physical size of the sensing area. It is calculated by multiplying the pixel size in μm by the resolution in x and y. The QHY9m camera CCD is physically 18.01×13.48 mm. The larger the CCD size, the more area of the sky it can image in one shot.

In addition, electronic characteristics of the camera affect its performance. The following list summarizes the primary electronic characteristics of the CCD camera:

Bit Depth—The CCD measurement bit depth is a function of the analog-to-digital converter (ADC) (Fig. 4.3) used to convert the electrons to ADUs or A to D Units.

A typical consumer camera uses a 12-bit converter. Usually, astronomical CCD cameras use 16-bit converters. A 16-bit converter can calculate 2^{16} or 65,536 levels. These levels are sometimes referred to as counts.

4.4 CCD Camera Performance

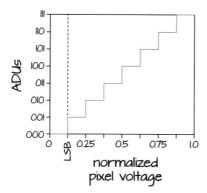

Fig. 4.3 3-bit analog-to-digital conversion (Courtesy of Rachel Konopa)

Gain (g)—CCD camera gain is a value used to scale the maximum number of electrons measured per pixel to the maximum number of ADU counts the camera supports. For a QHY9m camera, the bit depth is 16 bits, and the full-well depth is 25,500. Therefore, to take full advantage of the range of input and output of each pixel, the gain should be set to 25,500 e-/65,536 ADU or a gain value g = 0.389 electrons/ADU.

Readout Noise—The readout noise is a fixed number of electrons added for each time the pixels are read out and converted to ADUs. Typically, this can be 10–15 electrons, but for very good cameras, it can be as low as 5 electrons.

Dark Noise—This noise is based on a time-dependent value called dark current. It is a very temperature-dependent value and can range from less than 1 electron/s for each pixel to as low as 0.005 electrons/s for CCDs that are cooled to −30 °C. The drop in noise is 50% per 6° (degrees) C decrease in temperature. The dark noise is the cumulative noise value that continues to increase the longer the exposure time for the image.

Linearity—Linearity is the input/output response of the CCD in converting photons to electrons. The output electron count should correspond to the input photons in a linear fashion. The linearity is a value indicating how well the CCD performs in this respect. Most modern CCDs are linear (within 1%) up to at least 90% of their output range.

4.4 CCD Camera Performance

The CCD camera is a very precise instrument used to measure the brightness of objects; it can provide a wealth of scientific data and very aesthetically beautiful images of the natural sky. In addition to your choice of objects to image, the characteristics of the CCD camera can help or limit your ability to accurately record what you observe in the night sky. Primary among these characteristics is SNR. Because SNR has a great impact on the quality and aesthetics of the resulting image, it is best

to understand the relationship among the noise sources, sky brightness, exposure times, and pixel sensitivity to get the most from your CCD camera.

Another of the significant characteristics of CCD cameras used for scientific imaging is the *spectral response* of the CCD chip used. Visible light is made up of different frequencies of radiation between violet and deep red. Usually, the eye is sensitive to wavelengths from about 4,000 to 7,000 Angstroms (Å). The CCD is sensitive to a wider range of wavelengths, typically from 3,000 to 10,000 Å, i.e., from the ultraviolet to the infrared. CCD sensitivity is biased toward the red end of the visual spectrum. As stated in Sect. 4.2, *QE* is a value used to measure the efficiency of the conversion by the CCD from photons to electrons. This is highly wavelength dependent, and for typically constructed CCDs used by amateur astronomers, QE peaks at the 50–60% level. What this means is that for every 10 photons that strike the front surface of the CCD, 5 or 6 electrons are collected in the pixel over the peak wavelength sensitivity band.

For unfiltered measurements using a CCD camera, the number of electrons collected in each pixel is the total integrated electrons over the entire wavelength range of the CCD's sensitivity, and you get the maximum signal available from the CCD. When you use filters in front of your CCD, e.g., a *V-band Photometric filter*, you limit the bandwidth in which you are collecting photons, and the total signal is correspondingly smaller. This forces you to take longer exposures to maintain the same signal level of the unfiltered exposure. There are CCD cameras available with a *Bayer filter array (BFA)* installed on the CCD chip, also known as *one shot color (OSC)* cameras. These CCD cameras are very convenient because a filter wheel is not required, and you can take a full-color image with one exposure very much like a consumer digital camera. However, you do give up imaging resolution and sensitivity.

CCD cameras have several systems that support the operation of the CCD. There are electronic amplifiers, ADCs, *thermo-electric cooler (TEC)* systems, and computer interfaces, just to name a few. TECs lower the CCD temperature, which reduces the dark current generated by the CCD. The dark current is typically reduced by a factor of 2 per −6°C change. A wide variety of software is also available to communicate with your CCD camera and process the data acquired from that camera.

Two main types of CCD cameras are used to make astronomical observations: *webcam* type CCD cameras (Fig. 4.4) and long-exposure cameras, or as they are sometimes referred to in this book, *astrocams* (Fig. 4.5). Table 4.2 lists the primary specifications for each type of camera system:

The industry has begun to develop cameras with some overlapping capabilities. Cameras coming to market are both capable of deep sky imaging and reasonably fast frame rates up to 30 frames per second (fps). Camera prices vary, but webcam type cameras can be had for less than $150, and astrocam type cameras start at about $500 and go up to the $10,000–$20,000 range. One of the trends in CCD camera design is combining the capabilities of different camera types. As mentioned, there are cameras designed for planetary, lunar, and solar type imaging as well as deep sky imaging. These cameras include TEC systems to be able to minimize the dark current inherent in the camera.

Simply by looking at the specifications of the two types of cameras, you can see that skills and knowledge, and the telescope/mount equipment necessary to image

4.4 CCD Camera Performance

Fig. 4.4 The imaging source (TIS) DMK21AU04.AS video camera

Fig. 4.5 The QHYCCD QHY9m TEC CCD camera

with each type of camera effectively, is vastly different depending on your needs. The objects imaged by these two types of cameras are different also. The following list of characteristics outlines some of the aspects of your AIS you need to consider when doing astrophotography. Some are related to the telescope/mount you have, and others relate to the object:

Telescope Focal Length
Mount Type
Camera Type

Telescope Type
Mount Drive Type
Camera CCD Size
Telescope Focuser Type
Guiding System
Camera Pixel Size
Tracking System
Camera Cooling System
Solar System Object Type
 Solar
 Lunar
 Planet
 Minor Planet
 Comet
Deep Sky Object Type
 Variable Star
 Exo-Planet
 Nebula
 Star Cluster
 Planetary Nebula
 Galaxy
 Asterism

Table 4.2 Specifications for webcams versus astrocams

Specification	Webcam type	Astrocam type
Bit depth	8–12 bits	16 bits
Resolution	<2 megapixels	1 to >16 megapixels
Color capability	Bayer, filter wheel	Bayer, filter wheel
Readout noise	>30 ADU	<10 ADU
Exposure time	0.001–3,600 s	1 to >10,000 s
Shutter type	Electronic	Mechanical, electronic
Frame rate	15–60 Hertz (Hz)	<1 Hz
CCD cooling	None	TEC, passive radiative
Output	AVI video file	.FITS image file
Interface	USB, FireWire	USB
Preferred object type	Planetary, lunar, solar	Deep sky, minor planet
Mount type	Alt-Az, fork, GEM, guiding not required	Fork, GEM, guiding required[a]

[a]Dependent on exposure time and other equipment available

As you can see, there is much to think about when specifying a system to image a given object in the sky.

Quite a few features and characteristics of CCDs and CCD cameras can help or hinder your ability to take that perfect astro-image. Chief among these is noise. As discussed, the impact of noise on your images can be at once both obvious and subtle. Dark noise and readout noise influence the limits of your exposure time, what type of calibration data you need to obtain for your imaging (covered in Chap. 11, Sects. 11.5 and 11.6), and how deep you can image to detect and resolve very dim objects with your 5-in. telescope. There are tradeoffs in the cost and capabilities of each. Equally important are the capabilities of your telescope mount.

The quality of your images is directly related to the tracking ability of your mount, the quality of the optics, the effects of atmospheric seeing, and the object being imaged. Bright objects naturally require shorter exposure times and therefore limit the level of performance required of your telescope mount. Unfortunately, the brighter objects in the sky (excluding the Sun, and to some extent, the Moon) do require very good optics in your telescope that can support significant image magnification. Even the Sun and Moon require top-notch optics to image the most subtle and smallest of features. Webcams for astrophotography of bright objects are designed to quickly take a large number of image frames to mitigate the effects of atmospheric seeing that can affect long-exposure images.

Later chapters cover the techniques to bring out those subtle and sublime details we all strive for in our images. In addition to optics and cameras, your mount also affects your success in imaging objects that are undetectable to the eye even using the largest telescopes. It is an amazing feat to use images to study the features of very faint nebulae to understand the makeup of their gases and dust. However, taking these images requires you to fully understand your mount's behavior. That information is covered in detail in future chapters also.

In summary, the previous sections explored the basic operation and characteristics of CCD chips and CCD cameras used to perform astrophotography, and explained the various characteristics that can affect not only the type of imaging you can perform, but also the resulting images. You have seen that there are specific ways to calculate the various parameters that describe the characteristics of your measurements and the capabilities of your CCD camera.

4.5 CCD Chip Geometry

If you recall, the CCD can be considered a two-dimensional array of photodetectors that have a specific size and shape. Most astronomical CCD chips (see Fig. 4.1) have square pixels that can range in size from less than 4 micrometers (μm), or microns, to 24 μm. Some astronomical CCD cameras have rectangular pixels. In addition, some webcams and digital single-lens reflex (DSLR) cameras also have rectangular pixels, e.g., 8.2×8.6 μm pixels. You must be cognizant of the pixel configuration of your CCD imager so that you can properly calculate the various values associated with image scaling.

Because the CCD is made up of an array of pixels, the area of the array is solved with the equation:

$$CCD\ Area(\mu m^2) = \left(X_{pixels} \cdot X_{pixelsize}(\mu m)\right)\left(Y_{pixels} \cdot Y_{pixelsize}(\mu m)\right) \quad (4.4)$$

So for example, for a CCD of size 3,336×2,496 pixels, with a square pixel size of 5.4 μm/pixel, the CCD area would be (3,336×5.4 μm)×(2,496×5.4 μm), or 242,805,289 μm², or—after dividing by 1,000,000—242.8 square millimeters (mm²). You are probably asking, what does this number mean to me? Well, this number is related to how much sky coverage your image can include at any one time and is dependent on a couple of other factors related to your telescope.

4.6 Image Scale Basis

Image scale (also known as *plate scale*) deals with how the two-dimensional linear array of the CCD chip is mapped to the sky by the telescope optics. The basic equation for image scale uses the *focal length* (FL) to relate the angular size of the sky covered (field of view (FOV)) to the linear dimensions of the *focal plane*. The focal plane of the telescope is where the image formed by the telescope objective is brought to focus. As shown in Fig. 4.6, the FL determines the position of the focal point, and the focal plane is perpendicular to the axis and is located at the focal point.

Trigonometry is the basis for angular measurements of the sky, including the size of the FOV. There are two common units of angular measurement, *degrees* and *radians*. If you recall from your high school trigonometry, the *unit circle* is a circle with a radius value of 1. Also, the *circumference* of a circle is equal to 2π·R, where R is the *radius* of the circle. Therefore, the circumference of the unit circle is equal to 2π. In the unit circle, the circumference is defined as having a length of 2π *radians*. Now recall that the circle's circumference is also measured in units called *degrees*. There are 360° in the circumference of a circle; therefore, you can equate 360° to 2π radians. Of course, π is just a symbol for a number called pi. Pi is equal to 3.141592654... and is an irrational number that can only be estimated to a certain level. Degrees are also designated with the symbol °. If you want to calculate the degree equivalent of 1 radian, then all you do is solve the equation:

$$1\ radian = \frac{360°}{2\pi} \quad (4.5)$$

$$\approx \frac{360°}{6.28318...}$$

$$\approx 57.3°$$

The result is 1 radian is equal to ≈ 57.3°.

Angular separation is the distance between two objects observed in the sky. It is independent of the physical distance between the objects and is directly related to

4.6 Image Scale Basis

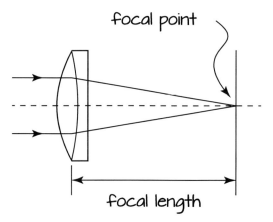

Fig. 4.6 The astrograph focal length (FL) determines the position of the focal point (Courtesy of Rachel Konopa)

the distance between the images of the objects formed on the focal plane, also called the *image plane*. When a CCD or another type of detector, e.g., film, is placed at the focal plane, an image is formed. When the image on the detector is in focus, then you know the distance between the image and the telescope objective is equal to the FL.

The angular separation is related to the physical distance between the images of the objects as formed on the image plane. If you consider how the telescope objective forms the image, and simplify this to how a pinhole camera would form an image, then you can understand the relationship between the angular separation and the physical distance between the images formed on the image plane.

Consider a pinhole camera, as shown in Fig. 4.7. It has two objects in front of it and an image plane A at a distance of FL_A behind the pinhole. The camera happens to be pointed so that one of the objects is on the axis of the camera, where the line from the pinhole to this object makes a right angle with the image plane. It follows that the image locations of two objects and the pinhole make a right triangle as long as one of the objects is at the axis of the camera. The right angle is at the location of the object on the camera axis. The angle at the pinhole, indicated by θ in the figure, is the same as the angular separation of the two objects in the sky because the pinhole camera connects the location of the objects in the sky with the locations of their images by straight lines.

Imagine the camera had a different focal length, FL_B, so that the image plane is a different distance from the pinhole as indicated by the image plane B shown with dashed lines. Again, the image locations form a right triangle. The right angle is at the vertex where the camera axis meets the alternative image plane. This right triangle shares the same vertex angle θ at the pinhole as the triangle formed with the image locations in image plane A.

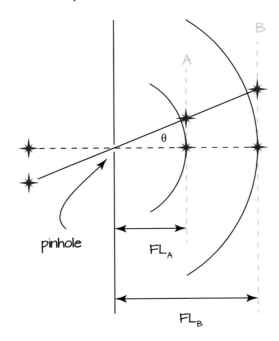

Fig. 4.7 Pinhole camera (Courtesy of Rachel Konopa)

We know from geometry that these two right triangles formed with a common vertex angle at the pinhole are similar triangles, and they have the same ratio between corresponding sides. The separation between these objects' image locations in image plane A divided by the camera focal length FL_A is the same ratio as their image separation in the new image plane B divided by the new focal length FL_B. In the case of these right triangles, this ratio is given by the tangent function, defined as:

$$\mathrm{Tan}\theta = \frac{Length\ of\ the\ Opposite\ Side}{Length\ of\ the\ Adjacent\ Side} \quad (4.6)$$

In this case, the opposite side is the image distance (in image plane A or B), the adjacent side is the FL (FL_A or FL_B), and θ is the angle at the pinhole vertex, the same as the angular separation of the objects. Therefore, by dividing the image distance by the FL, you obtain Tan θ, a number that only depends on the angular separation, not on the FL.

It so happens that for small angles (angles <0.1 radian (< ≈5.73°)), Tan $\theta \approx \theta$ (radians). The consequences for image scaling are illustrated in Fig. 4.8, where the pinhole camera forms images of objects separated by 0.1 radians. Dividing distances by the FL amounts to scaling the drawing so that the image plane could

4.6 Image Scale Basis

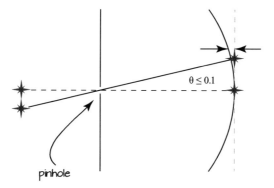

Fig. 4.8 Small-angle image scaling in the pinhole camera (Courtesy of Rachel Konopa)

represent either image plane A or B. The distance from the pinhole to the image plane is 1 unit, and the distance from the image location on the axis to the other object's image location is Tan 0.1 units, which is a little more than 0.1003 units. By dividing the image distance of 0.1003 units by the FL of 1 unit, you get a tangent of 0.1003, which is just 0.3% more than the angle θ in radians. The difference as a percentage decreases for smaller angles.

The solid curve in Fig. 4.8 indicates a curved image plane with radius equal to 1 unit. The image location on the camera axis is the same point for both the curved and flat image planes. The other image point is slightly different on the curved image surface than on the flat image plane. If the objects' angular separation were 1 radian, the dotted line indicates where the second object's image locations would be on the curved and flat image planes. You can see the distance on the flat image plane would be significantly more than the distance of one unit (defining the radian) on the curved surface. The 0.3% difference between the tangent value and the image separation in radians indicates how much better the distance on the flat surface matches the distance along the curved surface when the angular separation is 0.1 radians or less. It turns out that as long as the largest image distance (the diagonal) on your CCD is smaller than 0.0175 times the astrograph FL, the match between the separation on the flat and curved image planes in the scaled drawing is good for any image points, even if neither is on the camera axis.

If you have followed this so far, you are almost to the punch line! The fact that the image plane can be related to θ means that you can define angular separation (AS θ) as:

$$AS\,\theta\,(\text{radians}) = \frac{Distance\ Between\ Objects\,(\text{mm})}{Focal\ Length\,(\text{mm})} \quad (4.7)$$

The value you really want is the image scale. The image scale is usually stated as a value in units of arcsec/unit length, where the unit length is either millimeters

(mm) or microns (μm). Arcseconds (arcsec) (also sometimes written "Arc"), is an angular measurement where 1° is defined to be exactly equal to 60 arcminutes (arcmin), or 3,600 arcsec. The arcsec value here is the value equal to 1 radian, which is approximately 57.29577951°:

$$1 \text{ radian} = 57.29577951° \cdot 3,600 \text{ arcsec}/° \quad (4.8)$$

$$1 \text{ radian} = 206,264.8 \text{ arcsec}$$

The derivation of the image scale equation is thus (from Eqs. 4.7 and 4.8):

$$\text{Image Scale (arcsec/mm)} = \frac{206,264.8}{\text{Focal Length (mm)}} \quad (4.9)$$

If you wanted to calculate image scale in terms of microns (μm), then you would need to scale the equation appropriately (by dividing the numerator by 1,000), and use the following equation:

$$\text{Image Scale (arcsec/μm)} = \frac{206.2648}{\text{Focal Length (mm)}} \quad (4.10)$$

If you wanted to accurately calculate the FL of the telescope objective that was used to take a particular image, you could solve the equation for the FL. All you would need to do is image two objects whose angular separation is well known and use the following equation:

$$\text{Focal Length (mm)} = \frac{206.2648}{\text{Image Scale (arcsec/μm)}} \quad (4.11)$$

An example should make it clear. Your camera has imaged two objects; let's call them Star1 and Star2. You used a reference catalog to look up the coordinates of the two stars and determined through calculation that the angular separation is equal to 353.5 arcsec. You measure the distance on the image and determine that the two objects are 282 pixels apart. The CCD chip has 7.4 μm pixels. So, first you need to figure out the image scale from the data you have. You know that the image scale is measured in arcsec/μm, so the image scale for this example would be 353.5 arcsec/(7.4 μm/pixel × 282 pixels) = 0.169398 arcsec/μm. Now to calculate *measured* FL, you would substitute the values into the Eq. 4.11 above:

$$\text{Focal Length (mm)} = \frac{206.2648}{0.169398} \quad (4.12)$$

$$= 1217.63$$

Typically, your image processing software does this calculation and presents the calculated FL and image scale for you based on the astrometry performed on your

images. It is important that you use the correct values when setting the parameters for your camera and astrograph in your program. Sometimes you get an odd result, or your program does not complete an astrometric solution, so it is important that you can independently verify the various parameters, including image scale and FL, especially when combining your astrograph with focal reducers at other than nominal distances. Large changes in FL and focal plane position can result, causing you no end of headaches if you have not calculated them in advance. This is discussed further in Chap. 7.

4.7 Calculating the Image Scaling Factors

It was important to go through that derivation so that you have a very good understanding and intuitive feel for how the telescope objective forms the image on the image plane, what is really meant by image scale, and how changing the configuration of the imaging train and the FL can affect your images.

The image scale is used to calculate the *angular resolution* (AR) of your CCD when used in a given optical system. Given a CCD that has a pixel size of 5.4 μm, mounted in a telescope with an FL of 952.4 mm, you need to first calculate the image scale by beginning with Eq. 4.9:

$$Image\ Scale\ (arcsec/\mu m) = \frac{206.2648}{Focal\ Length\ (mm)} \quad (4.13)$$

$$= \frac{206.2648}{952.4}$$

$$= 0.2166$$

Therefore, the image scale in this example is 0.2166 arcsec/μm. Now you calculate the actual AR based on a pixel size of 5.40 μm/pixel. All you need to do is multiply the image scale by the pixel size to obtain the AR of the CCD:

$$AR = Image\ Scale\ (arcsec/\mu m) \cdot Pixel\ Size\ (\mu m/pixel) \quad (4.14)$$

Using this equation for this example, you get:

$$AR\ (arcsec/pixel) = 0.2166\ arcsec/\mu m \cdot 5.40\ \mu m/pixel \quad (4.15)$$

$$= 1.17$$

Another term for the AR for your CCD is *pixel scale*. This is one of the fundamental characteristics of your imaging system when you couple a CCD camera to a telescope. This value gives you insight into whether your images will be *undersampled* or *oversampled*.

Before moving into the specifics of the telescope/CCD interaction, you need to see how to calculate CCD FOV (see Eq. 4.4). Now that you know your image scale and pixel scale, you can calculate your FOV simply by multiplying your X and Y axes' CCD pixels by the pixel scale. Therefore, for your CCD camera with a CCD size of 3,336×2,496 pixels, the FOV for the X axis would be 3,336 pixels × 1.17 arcsec/pixel, or 3,903 arcsec, and the Y axis would be 2,496 pixels × 1.17 arcsec/pixels or 2,920 arcsec.

Now these values are not particularly useful because FOV is usually in arcmin or degrees. To convert simply divide the arcsec values by 60 to get arcmin, or by 3,600 to get degrees. For arcmin, the X and Y axes' FOV for this CCD camera would be 65.05×48.67 arcmin. This is a very useful piece of information when you are trying to decide whether M42, the Great Orion Nebula, will fit in your FOV. This is also very useful if you are chasing down a rogue minor planet, and you are not too sure whether your mount position is accurate enough to place the object in the center of your FOV. Having a larger FOV in this case would give you some breathing room for any minor discrepancies in your pointing accuracy.

It is all well and good to know that your high-quality, expensive CCD camera is capable of resolving to 1.17 arcsec, but this is not really true in practice. Several other factors affect and detract from this theoretical image resolution. Chief among these is *atmospheric seeing*. Atmospheric seeing is the bane of astronomers big and small, high-paid and no-paid. It is one of the prices you pay to be able to breathe while spending the night next to your prized telescope and CCD camera. The desire to improve atmospheric seeing causes universities and amateurs alike to build their observing systems on the top of mountains.

Poor seeing takes beautiful pinpoint stars and smears them across the focal plane so they look like bright white *BLOBS* (Big, Lousy OBjectS). Seeing is a time-dependent phenomenon and is a manifestation of an effect called scintillation. Depending on the time scale of your exposure, you can either freeze the object or end up with the blobs in your image. Seeing is measured in arcsec, just like AR; therefore, it is easy to relate the two and understand the effects of seeing on your images. Seeing manifests itself as a random noise-based Gaussian phenomenon. As a result, the stars are rendered as circular blurred images. The intensity distribution forms a Gaussian, bell-shaped curve. This is important to understand, as you will see in Chap. 13 where astrometric and photometric measurements are discussed.

If you were to image stars with a space-based telescope system, the normal star image would manifest itself as an object called an *Airy disk*. The Airy disk (Fig. 4.9) is formed because telescopes are not infinitely large and an image of the star is only gathered through the aperture of your telescope objective. This is a *Simple Matter of Physics (SMoP)*. Calculating the diffraction of a plane wavefront by a circular aperture is not an easy math problem, but it was first solved by the English astronomer *George Airy* in 1831. The theory is that the pinpoint star is rendered as a bulls-eye pattern with 84% of the light falling in the central spot, or disk, and subsequent percentages of light falling in rings around the central disk. The size of the Airy disk is based on the extent of the dark ring that surrounds the central spot, as shown in Fig. 4.9. The size of the Airy disk depends on the diameter of the telescope

4.7 Calculating the Image Scaling Factors

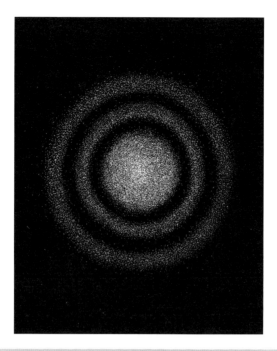

Fig. 4.9 Airy disk. The central bright disk contains 84% of the light of the star, and the size of the disk is based on the extent of the first dark ring (Courtesy of Rachel Konopa)

objective and the wavelength of the light in the Airy disk. The standard wavelength used when calculating and measuring the Airy disk is in the *V-band*, or green light, a wavelength of 5,500 Å. The *Rayleigh Criterion* is used to determine the resolving power of a telescope and is based on the assumption that you can resolve two point sources when you can distinguish two separate peaks in the pattern of the two overlapping Airy disks. The Rayleigh Criterion is calculated using the equation (λ is the wavelength of light, D is the objective diameter, and θ is the angle in radians):

$$Rayleigh\ Criterion\ (radians)\theta = 1.220\ \lambda\ /\ D \quad (4.16)$$

Another closely related and more common way to determine the resolving power of a telescope is to calculate the *Dawes' Limit*. The Dawes' Limit is calculated using the following equation:

$$Dawes'\ Limit\ (arcsec) = \frac{116}{D(mm)} \quad (4.17)$$

Therefore, for a telescope with an objective of 127 mm, the resolving power, according to the Dawes' Limit, is equal to 0.913 arcsec.

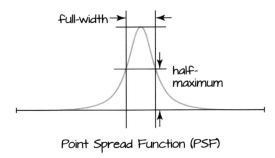

Fig. 4.10 The point spread function is measured in units called the full-width-at-half-maximum (FWHM) (Courtesy of Rachel Konopa)

You now have two resolutions to deal with, even before you factor in the seeing. The telescope objective has an AR of 0.913 (arcsec), and the CCD camera has an AR of 1.17 arcsec. Although they seem to be closely matched, there is one other factor that you need to resolve (pun intended!). The Nyquist Theorem defines a lower limit on how fast (temporally or spatially) you have to sample a signal to faithfully re-create that signal when displaying it. The theorem says that you must sample at least twice (2×) as fast as the highest frequency available in the signal you want to sample or re-create. Therefore, if you based your object resolution on the calculated AR of your imaging train you can only see objects as small as 2.34 arcsec based on your CCD pixel scale of 1.17 arcsec/pixel. This is a very fundamental idea, and you need to understand the implications. This is a primary characteristic of your imaging system, and as such, affects the decisions you make on how to image the objects you have available to you. Based on this explanation, can you now see how atmospheric seeing affects your images, and what undersampling and oversampling mean?

To understand the concepts of undersampling and oversampling, you need to relate the actual atmospheric seeing value to your equipment resolution. One item sidestepped until now, is how seeing and Airy disks are actually measured. Generated by natural processes, atmospheric seeing and Airy disks (diffraction) can be characterized using bell-shaped response curves, or *Gaussian Distributions* when analyzing the data (see Fig. 14.1). The Gaussian distribution formed on the image plane is called the *point spread function (PSF)*. The point spread function is measured in units called the *full-width-at-half-maximum (FWHM)* (Fig. 4.10). This is a measure of how wide the bell curve is at one-half the peak amplitude of the curve. This is usually measured in units of arcsec, but also can be measured in pixels. It is important that you understand that your image processing software assumes that the BLOBS that it is measuring are not over- or under-exposed. Using a Gaussian shape to model the star images is only valid when the stars are properly exposed, i.e., when the SNR of the object is greater than about 5 and the object is not overexposed and clipped at the peak value.

One of the ways that seeing is actually measured is to take a time exposure of a star field and measure the FWHM of a sample of the stars across the CCD image. The FWHM value measured from the image is a good indication of the atmospheric seeing at that location and that point in time, assuming that the image was properly focused. Additional effects need to be considered that affect the measurement of the seeing value, such as atmospheric refraction, and optical effects, such as chromatic aberration and coma. These issues are dealt with in later chapters.

4.8 Changing the Image Scale

If your seeing is forecasted to be in the 3–3.5 arcsec range, then you know that to *critically sample*, you need to sample at least half this value, or 1.5–1.75 arcsec in your imaging system. If you are sampling at 0.5–1.2 arcsec, your images are said to be oversampled. If your system is sampling at 2–4 arcsec, then you are undersampling.

IMPORTANT: It is not necessary to attempt to adjust your system's image scale for every possible change in seeing that you might encounter. The best technique is to base your most frequently used image scale on seeing that is near the best value. That way you do not miss out on those rare nights that you might have excellent seeing at your site.

For example, if your site currently has seeing in the range from 2.5–4 arcsec, but it is typically 3–3.5 arcsec, then it is prudent to size your image scale to 1–1.5 arcsec/pixel. Only in this way can you maximize your potential when the excellent seeing occurs unexpectedly. Slightly oversampling is preferable to undersampling, of course depending on the type of objects you are imaging. If you are imaging extended objects, such as large, close galaxies, then you can tolerate a certain amount of undersampling to adjust your FOV to the large object you are imaging. If you are specifically acquiring data to perform astrometry, it is always preferable to oversample rather than undersample to get the best result.

There are a couple of strategies to optimize your imaging system to the seeing conditions at the time of your observing session. In my opinion, the best strategy is to use *pixel binning*. Most (if not all) astronomical CCD cameras have a facility to perform pixel binning. Pixel binning is used to combine the high-resolution pixels on your CCD camera into medium-resolution pixels. What this does is *electronically* combine groups of pixels (2×2, 3×3, 4×4) into an equivalent single pixel when read out of the camera. Therefore, a $3,336 \times 2,496$ pixel, 5.4 μm pixel CCD camera, when binned 2×2 becomes a $1,668 \times 1,248$ pixel, 10.8 μm CCD camera. Because you have halved the number of pixels on each axis, you have effectively cut the number of pixels in your camera by a factor of 4, but at the same time you have enlarged your pixels by the same factor of 4 to make up for it. If you recall, the full-well depth of a 2×2 binned CCD is equal to four times the full-well depth of the single pixel, i.e., you can go from a full-well depth of 25,500 to a full-well depth of 102,000 electrons (e^-) with the larger pixels. Therefore, the bottom line is

that when you bin your pixels, you can change your pixel scale from 1–1.5 arcsec/pixel to 2–3 arcsec/pixel when seeing becomes about 4 arcsec or worse.

The other commonly used strategy is to change the FL of your telescope. Yes, it is possible to change the FL of your *imaging train* to present a different image scale to your CCD and thus to change the pixel scale. There are two ways to change your FL—you can increase it or decrease it. One way to increase it is to use a Barlow lens, which effectively changes the FL of your imaging system by a factor of 2 or 3. However, Barlow lenses are a little difficult to use because they change the *backfocus distance* of your telescope.

The other way to change your FL is to use a *focal reducer*. Usually, focal reducers also provide a *field flattener* function, which works very well for refractors and some reflectors and reduces your FL by a typical factor of 0.80×, 0.75×, or 0.63×. For Schmidt Cassegrain telescopes (SCT), focal reducers are available in factors down to 0.33×. Again, focal reducers affect the available backfocus distance on your telescope, so be prepared to manage that. More on this topic is presented in future chapters.

4.9 Image Scale Bottom Line

Why is it important to make sure your images are properly scaled and what value does it add? These are important questions to understand and answer, and understanding begins by recognizing that if you want to spend the time imaging these awesome objects, then you always want to do it right. Not only that, but do it right the first time and every time. Your time is valuable, and it is important to you and your family that you get as much satisfaction from your hobby as you can and maximize the return on your substantial investment in this equipment. At a more tactical level, when you scale your images correctly, you maximize the data returned from every image you acquire. You also have a great feeling of accomplishment in knowing that you are acquiring the necessary skills and using professional techniques to accomplish the goals you set for yourself in astrophotography. Anyone can point a camera at the sky and push the shutter. What is the return? What do you get? Taking excellent images requires you to know every detail that goes into the end result, including properly scaling your images. If you do not understand the factors that affect the quality of your data, then you are doomed to getting mediocre images.

At the most practical level, proper image scaling provides a way to maximize the accuracy of the data you obtain from your images in measuring the position of that rogue minor planet (astrometry) or measuring that elusive light-curve of the most recently discovered exoplanet (photometry). It makes those pretty pictures of M42, the Great Orion Nebula, with the pinpoint stars, look that much crisper, three-dimensional, subtle—you choose the adjective. Those are the images people want to see. It makes a difference.

In summary, the previous sections examined the CCD chip, its performance and characteristics, and has explored the basis of image scaling and derived the equations for converting from angular separation to CCD AR or pixel scale. You now know what it means to oversample and undersample, and you understand the importance of FOV. You must understand the factors related to atmospheric seeing and how the different components of your system affect the overall resolution of your images. Finally, you have learned how to optimize the resolution of your system depending on the existing conditions at your observing site, and why it is important that you get this right to maximize the quality of your images.

Further Reading

Berry R, Burnell J (2005) The handbook of astronomical image processing. Willmann-Bell, Richmond
Chromey FR (2010) To measure the sky. Cambridge University Press
Henden AA, Kaitchuck RH (1990) Astronomical photometry. Willmann-Bell, Richmond
Howell SB (2006) Handbook of CCD astronomy. Cambridge University Press, Cambridge
Smith GH, Ceragioli R, Berry R (2012) Telescopes, eyepieces and astrographs. Willmann-Bell, Richmond

Web Pages

http://www.telescope.com/
http://www.theimagingsource.com/
http://www.sbig.com/
http://www.ccd.com/astronomy.html
http://www.truesenseimaging.com/products/full-frame-ccd/56-KAF-8300

Chapter 5

Telescope Mount Factors

5.1 A Foundation for Excellent Image Data

The telescope mount is the most important part of the Astronomical Imaging System (AIS) in terms of obtaining the finest, highest quality images possible. Why is that? Consider how important a good foundation is in contributing to the long life of a home. The telescope mount can be considered the foundation of the AIS. So why is this Chap. 5 in the book and not Chap. 3? There are a couple of reasons. It is important to understand the "customer" of the telescope mount and what "services" the mount provides to the customer before defining what type and level of mount you need for your observing program.

In this context, I use "customer" to refer to the astrograph and charge-coupled device (CCD) camera. The more you understand about the needs of the imaging train, the more you can fine-tune the services provided by the astrograph mount. Once you understand the specific mount characteristics and performance specifications that are most important to achieving the goals of your observation program, you can weigh the cost/benefit of any features that you may want to purchase or obtain for use in your mount. Please note that the following discussion pertains to the Northern Hemisphere.

5.1.1 Mount Requirements for Deep Sky Imaging

When using the mount for deep sky imaging, the most important fundamental characteristic is the ability to track the relative movement of the stars attributable to the rotation of the Earth. The Earth rotates to the east at a constant rate, as measured at

the celestial equator, of approximately 15.041 arcsec (arcsecond) per second; the mount must compensate for this by rotating toward the west at that same rate. Once you have a mount that can track the apparent star movement caused by the rotation of the Earth, then you can make exposures with your camera long enough to be able to detect the dimmer stars in your images. The other requirement is to make sure your mount is aligned in azimuth and altitude with the North Celestial Pole (NCP). This adjustment is called *polar alignment*. Exposures of 10–20 min are possible with a very well aligned mount that has an accurate tracking rate. The polar alignment must be within a very few minutes of arc (3–5) to minimize the declination drift over an exposure time of 10 min. Low periodic error (PE) (defined in Sect. 5.2.2) in your mount is also required to maintain tracking good enough to obtain round stars in your images exposed over a 10-min period. This is typically accomplished using either an off-axis guiding system or a separate guidescope/CCD camera combination. An alternative to guiding is to achieve a well-corrected tracking rate using an encoder system that allows exposures up to 10 min without guiding. This requires a nearly perfect polar alignment.

5.1.2 Mount Requirements for Lunar, Solar, and Planetary Imaging

For solar system objects such as the Sun, Moon, and the planets, short exposures are the norm. Accurate tracking of these objects is a nicety rather than a necessity for beginners. When starting out, a close polar alignment is really all that is necessary. If, after you obtain some experience, you want to do very high resolution imaging, then the mount must be capable of supporting long-exposure astrophotography. With modern webcam-based CCD video cameras, exposures are always less than 0.1 s (100 milliseconds (ms)) and are typically less than 0.01 s (10 ms) if you are using a large reflector, 8 in. (200 millimeters (mm)) or larger in diameter. It is reasonably straightforward to place the object in the CCD field of view (FOV) because planets are always less than 1 arcminutes (arcmin) in diameter, and the FOV of a typical beginner webcam on a beginner's telescope is in the 8–10 arcmin range.

Once that is accomplished then exposure rates of 5–15 frames per second are typical for the basic webcam. As explained above, exposures of 10–100 ms are typical. The required mount performance for the beginner is not that different from what you need for visually observing solar system objects. As long as the mount can maintain the object in the FOV for 30–60 s, then the beginner can acquire 500–750 individual frames of video. The declination drift over a 60-s period does not typically take the object out of a 10-arcmin FOV unless the polar alignment is very far out of specification. Note that after each video clip is acquired, you must re-center the object.

Now, consider the case where you want to do high-resolution solar system object imaging with an astrograph of 8 in. (200 mm) or larger in diameter with a focal

length (FL) of more than 4,000 mm at a focal ratio of more than $f/20$. This yields a typical FOV of less than 3 arcmin and possibly less than 1.5 arcmin in some cases. This requires your mount to be able to maintain its tracking and drift at less than 30 arcsec over a 60-s period—longer if you do not want to have to re-center the object after each video clip is acquired. This is essentially the same requirement as for taking deep sky exposures. Consider the data acquired by the advanced planetary CCD video camera. Typically, for a CCD resolution of 640×480 pixels, frame rates of 60 frames per second are available with exposure times down to 1/10,000 s (0.1 ms) possible. The increased performance of the advanced camera allows you to essentially "freeze" the atmospheric distortions. When performing high-resolution planetary imaging, you want to acquire between 1,000 and 5,000 or more frames during each video clip. This requires exposure runs of up to 90 s or more, so it is obvious that you need a very good polar-aligned mount with an accurate tracking rate to get the best data you can, regardless of the target.

The available software to process these video (typically. avi) files does a better job if the object's position is maintained within a few pixels during the entire video clip. When the object drifts over time, it is more work for the software to keep up, and the result is not as good. It is possible to acquire a video of a planet over a 30-s period without tracking. The object moves at a maximum rate of 15 arcsec per second; therefore, a 30-s exposure would mean that the object would drift 7.5 arcmin without tracking. It might be possible to process such a video clip where the object moves across the whole frame, but it would not produce the best image. Any tracking is better than none at all.

5.2 Telescope Mount Design Types and Design Basis Effects

When imaging a moving object over a long period of time, a couple of components are indispensable to obtain that perfectly resolved, rock solid image with no indications of vibration or movement—a stable tripod or pier, and a mount that provides a constant tracking rate that matches the rotation of the Earth. It is always good to start from the bottom and work your way up. First, you need a stable, solid base, in this case, either a pier or a tripod. Tripods and piers serve a few important functions:

1. Provides a level surface for your telescope mount.
2. Allows you to accurately align your telescope mount to the NCP.
3. Provides a (relatively) immoveable platform to which to attach your telescope mount.

5.2.1 The Mount Tripod or Pier

The pier or tripod must be very stiff and robustly constructed to provide the necessary stability for excellent astrophotographs. As you may recall from your previous

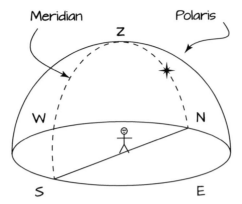

Fig. 5.1 The celestial meridian is an imaginary line in the sky that passes through the poles and the zenith of the observing site (Courtesy of Rachel Konopa)

experience with department store telescopes, the tripods provided were very wobbly, loosely constructed, or very tall, spindly things that vibrated with every step you took near the telescope. When taking astrophotographs, you should strive to set your tripod as low as possible so the center of gravity of your AIS is as close to the ground as possible. Only in this way, can you minimize the vibration transmitted to your image from the ground and maximize the dampening available to shorten the oscillation time. A very substantial pier attached to a large concrete block also provides a very rigid, stiff, robust platform for your mount. That is all there is to say about the tripod or pier. It is probably the easiest part of the AIS to understand. As long as you stick to these basic principles in setting up the tripod or pier, you will not get into trouble.

5.2.2 The Mount's Tracking Rate

In addition to a stable support, a telescope mount fundamentally *must* have a constant tracking rate. To understand the reason, you must understand the apparent motion of the stars in our sky. The Earth rotates on its axis once a day. There are several definitions of a day, or more precisely, the length of a day. The length of a day is, of course, measured in time, and the solar day is defined as 24 h long. One of the reference lines used in the sky to measure time is the celestial meridian. The *meridian* is a line in the sky that passes through the celestial poles and the zenith of the observing site. The celestial meridian intersects the horizon at the south and north points (Fig. 5.1). The Sun crosses the meridian once every 24 h. There are, of course, small corrections to the solar day, but this is good starting definition.

Now, because the Earth circles the Sun, its position in space changes day to day and it completes an orbit in approximately 365-¼ solar days (precisely 365.256363004 days). Because there are 360 degrees (°) in a circle, the Earth

5.2 Telescope Mount Design Types and Design Basis Effects

moves about 1° further in its orbit every day. Because the meridian is fixed on the local horizon and moves with the Earth, the meridian shifts a little more than 1° every day when measured against the stars. This shift in the azimuth is another way of saying that the length of the day according to the stars is different from the solar day, and in fact is about 4 min shorter than the solar day. The length of the day according to the stars is called the sidereal day and is 23 h, 56 min, and 4.100 s. Any given star crosses the meridian once every sidereal day.

To compensate for the Earth's rotation rate against the stars when imaging, you must drive your mount in the direction opposite to that of the Earth's rotation. The time your mount must take to complete 1 revolution is 1 Sidereal Day, or 23 h, 56 min, and 4.100 s. The Earth rotates about an axis that is on a line connecting the North Pole and the South Pole. Because the Earth rotates about an axis projected toward the NCP, the axis of your telescope mount must also be pointed toward the NCP. This axis is called the *right ascension (RA) axis*. There are several ways to point the telescope toward the NCP using different types of mounts, but this chapter focuses on three types: alt-azimuth mount, fork mount, and German equatorial mount (GEM). (See Sect. 5.3, and the Field Practical Exercise (FPE) procedure in Sect. 12.2.5 for a discussion of the alignment process.)

Requiring an accurate, constant tracking rate from your mount is somewhat controversial in that some astrophotographers feel that you can "auto-guide out" any imperfections in the tracking rate. Although you *can* physically do this, it is like trying to solve all your problems with a hammer. A hammer is good at solving some problems, even excellent, but using a single tool does not get to the root of some problems and can complicate others. Sometimes a screw is a better solution than a nail. When you start getting into very high-performance imaging, you must eliminate the most obvious contributors to poor images and then work on reducing the remaining or residual effects. Although these residual effects are small, they are very noticeable when you are pushing the limits of image resolution and mount capabilities. There are atmospheric effects and equipment mounting effects. These effects can be static or dynamic over short and long time periods (Table 5.1).

Because you are using a design basis approach to build your AIS, it is appropriate that you begin to separate your design features and subsystems of your mount to maximize the performance while minimizing cost. Table 5.1 shows the various types of effects that your system needs to control and specifies which can be intrinsically controlled by your mount and which ones need to be controlled by your astrograph or camera. It is important to understand the root cause of the effect and address it accordingly.

The first three effects listed in Table 5.1 should be intrinsically handled by the mount and mount subsystems. Of course, countering the extrinsic effect of the Earth's rotation is the primary design function of the mount. Unfortunately, unless you spend a lot (upwards of $15,000) for your mount, you have a mount that introduces two types of intrinsic errors into the result. Because the Earth rotates at a very, very, (very!) constant rate, you would like your mount to also rotate the astrograph at a very constant rate. However, your mount is not perfect; the manufacturing process introduces periodic and non-periodic errors (PE and non-PE) into the

Table 5.1 CCD frame pointing control factors/effects

Effect	Effect type	Effect frequency range	Impacts
Earth rotation[a]	Static	Constant	Mount
Periodic error[b]	Dynamic	0.01–0.002 Hertz (Hz)	Mount
Non-periodic error[b]	Dynamic	5–0.002 Hz	Mount
Atmospheric refraction[a]	Static	< 0.002 Hz	Mount/CCD
Scintillation[a]	Dynamic	1–30 Hz	CCD
Pointing effects/flexure[b]	Static	< 0.01 Hz	Astrograph equipment

[a]Extrensic effect
[b]Intrinsic effect

drive system and subsequently into the drive rate. The root causes of these drive rate errors are gear run-out issues and uneven meshing of gear teeth from gear tooth differences. Inadequate quality control during manufacturing can also leave foreign material inside the mechanical parts causing non-periodic responses to the slow movement of the axis, which contribute to the non-PE.

By adding a controlling element to the RA axis, where the rubber meets the road so to speak, you can intrinsically correct for the first three effects in Table 5.1. Adding a drive rate encoder and controller can go a long way in addressing these three effects. These devices are discussed further in Sect. 5.5.3.

The fourth effect listed in Table 5.1, atmospheric refraction, occurs because, when you observe objects through the atmosphere, different amounts of atmosphere obstruct your view depending on the altitude of the object. At low altitudes (less than 30° above the horizon), the atmosphere begins to act like a prism in that it bends and spreads the light of the star out into a rainbow of colors. At high altitudes (greater than 60°), the effects of atmospheric refraction can be effectively ignored. The reason is that most of your exposure times are less than 20 min, and the change in atmospheric refraction over that period of time is minimal when tracking from a higher altitude to a lower altitude. Atmospheric refraction effects that affect the RA axis drive rate are directly related to the altitude at which the telescope is pointed.

The drive rate value can be calculated to compensate for atmospheric refraction. In 1902, Harvard astronomer Edward Skinner King described this process in an article, "Forms of Images in Stellar Photography," in the *Annals of Harvard College Observatory*. By using the King rate as calculated, you can compensate for the atmospheric refraction at a given altitude. King suggested that you should adjust the altitude of the telescope mount depending on the altitude of the object being observed because the polar alignment error was minimized while doing so. Of course, this is not practical for any but the largest observatories. In addition, it is generally not practicable to adjust the drive rate continuously dependent on the altitude pointed to by an amateur level mount, so an average King rate value is suggested. This rate is, in fact, provided by one drive rate corrector manufacturer. The *Telescope Drive Master* (TDM), manufactured by MDA-Telescoop, LLC (mda-telescoop.com), provides two RA drive rates, Sidereal and Average King Rate. However, for exposures of less than 10 min, the atmospheric refraction effects are minimal or non-existent. The only time

this effect needs to be managed is when imaging at low altitudes and/or making very long exposures of greater than 20 min.

The fifth effect in Table 5.1, *scintillation,* is a dynamic effect that can only be controlled or minimized using a device generically referred to as an *active optics corrector* (AOC). As shown in Table 5.1, scintillation occurs in the 1–30 Hertz (Hz) frequency range, and for that reason, it is very hard to correct at the mount level. Therefore, it is normally corrected at the input of the optical train to the CCD. The AOC is typically made up of a moveable optical element or lens that is used to shift the incoming light at a frequency of 1–30 Hz so that a given star is fixed on the imaging CCD camera focal plane. To measure the scintillation, a reference star is measured using an off-axis pick-off prism and CCD camera located in front of the moveable AOC. However, although using an AOC is one way to get the very best images, it is usually not necessary when imaging for scientific purposes. Using the AOC may marginally improve your detection of a slow-moving, very dim asteroid when using an exposure of 5 min, but that is not normally needed. The other use may be to perform spectroscopy on dim stellar or minor planet objects. It may help in these cases.

The last effect listed in Table 5.1, *pointing effects/flexure,* may or may not be present in your system depending on how you have designed and integrated your astrograph and CCD camera into your AIS. This topic is very thoroughly covered in later chapters, but suffice it to say that this effect is very much controllable for the amateur astronomer. If you pay special attention to your AIS mechanical interfaces where all your components are attached, then you can mitigate the amount of flexure and cone error that you inadvertently *build into your system.* There are software tools available that enable you to model the flexure of your AIS to correct the pointing of your telescope over the whole of the sky. This is a somewhat tedious exercise, but automation is available to help. Pointing models are incorporated into mount drivers and automatically compensate for flexure when pointing to a given coordinate in the sky. This calculation must be done in real time because this effect is based on the altitude and azimuth that the telescope is pointing, and of course, that is always changing.

The bottom line is that a mount with an intrinsically constant tracking rate takes care of the fundamental contributor to errors in the imaging process. Once this fundamental contributor is eliminated, then you can deal more effectively with the residual effects that remain using other equipment and/or techniques. In this way, you can better characterize and separate the remaining residual effects to tackle them one by one.

5.2.3 Mount Types

Two of the mount types discussed here have the RA axis aligned with the NCP—the fork mount and the GEM. The third type of mount—alt-azimuth mount—has altitude and azimuth axes. These axes are vertical and horizontal as measured locally. This type of mount enables you to point the telescope *vertically*, and

horizontally. To track the stars accurately, the alt-azimuth mount must drive *both* axes at the same time. In the past, this was cumbersome and expensive, but with today's computer systems, it can be done relatively inexpensively. Most beginner go-to mounts are of the alt-azimuth type. Even though these mounts are very capable and provide an excellent tracking platform, they have one glaring problem—field rotation, which is discussed in the Sect. 5.2.4.

GEMs are the preferred mount configuration for the vast majority of astrophotographers. That is not to say that there are no problems to overcome with the GEM. GEMs have a problem when tracking past the meridian called meridian flip. Meridian flip is discussed later in Sect. 5.4.3. GEMs have two axes, of course, one of which is the RA axis, and the other the declination (DEC) axis. The RA axis enables you to point the telescope in the east/west direction. The DEC axis enables you to point the telescope in the north/south direction. It is important to understand that these are the true directions because these axes are aligned to the Earth's axes.

Fork mounts are also a preferred mount configuration for doing astrophotography. However, these mounts have a problem when pointing to the NCP. This and other issues are discussed later in this chapter. As mentioned above, fork mounts have their RA axis aligned with the NCP, as the GEMs do, and they also have a DEC axis. In this way, GEMs and fork mounts are the same.

5.2.4 Field Rotation Effects

Field rotation is an effect that occurs in views in telescopes that use an alt-azimuth mount. If you observe a star field near the NCP, you notice that the stars rotate around the pole. Also, by definition, every direction from the NCP is the *south direction*. What this means is that as time goes by, in the telescope view using an alt-azimuth mount, the south direction is always changing. In contrast, the view in a telescope that is mounted on a mount that has one of its axes *accurately* aligned with the NCP has a constant south direction; in other words, *the FOV does not rotate*. However, it should be noted that when your polar alignment is not close to perfect, long exposure images (greater than 20 min) may show the effects of field rotation even on GEM mounts. Systems called field de-rotators are available for imaging using alt-azimuth mounted telescopes. However, these are rather expensive and are not cost effective for the beginning astrophotographer.

It should be noted that field de-rotators are an effective tool for very large amateur and professional level astrographs mounted on alt-az mounts because the larger a telescope is, the more cost effective it becomes, compensating for the cost of the field de-rotator. However, for astrophotography, GEMs are preferred for refractors and effective for astrographs up to about 12–14 in. (0.3 m). Fork mounts are used effectively with Cassegrain telescopes that have shorter lengths, with diameters from 8 in. to less than 24 in. (0.2–0.6 m), and it is best to use an alt-azimuth mount in telescopes larger than 40 in. (or 1 m). Finally, while several companies are

making field de-rotators available at increasingly affordable prices, they are designed for the serious astrophotographer.

5.3 Mount Adjustment Factors

As stated before, GEM and fork mounts must be polar aligned to track the stars accurately. Various procedures and equipment have been developed to perform an accurate polar alignment. The most basic piece of equipment that several medium to high-end mounts have is a polar alignment scope (See Fig. 10.1.). A polar alignment scope is mounted axially, coincident with the RA axis, and has a reticule etched to depict the stars in the NCP region, primarily the star Polaris. The reticule also has stars of the South Celestial Pole (SCP) region etched on it for those observers in the Southern Hemisphere.

While the GEM and fork mount have main axes aligned with the RA and DEC axes, they also have adjustments in azimuth and altitude. These adjustments are needed to perform a polar alignment. As you can imagine, the NCP is located at a certain direction (azimuth), and at a certain elevation (altitude) depending on the location of the observer on the Earth. Your location on the Earth is measured via two values, the longitude and the latitude. The altitude of the NCP is directly related to the latitude of the observer. For an observer located at the Equator, the NCP is located on the horizon, or 0° altitude. Alternatively, for an observer located at the North Pole, the NCP is located at the zenith, or 90° altitude. Using this rule, the altitude of the NCP is equal to the latitude of your location. For example, if you were located at 38° 20′ 35.1″ N latitude, you would set the altitude of your mount to the same value, 38° 20′ 35.1″. This can be accomplished to within a few minutes of arc using the polar alignment scope.

The azimuth of the mount must also be adjusted to align with true north. Magnetic north, as indicated by a compass, is not accurate and must have a correction applied. Magnetic declination is the difference between true north and magnetic north (Fig. 5.2). For example, in southern California, the magnetic declination is approximately 12°. Therefore, if you align your mount to 348° magnetic azimuth, you should be within 1° of true north. The final adjustment can be made via the polar alignment scope to within a few minutes of arc.

There are other methods to obtain a more accurate polar alignment, namely the King method or drift method of polar alignment. There are a couple of variations, but the main feature is that you align a cross-hair in the FOV to be coincident with the axis lines of RA and DEC in the sky. Begin by watching a star drift along the east/west axis with the mount drive stopped. Then, watch a given star drift along the north/south axis. Once you have determined a direction (north or south) of drift away from the cross-hair, adjust the altitude (for a star in the east or west), or adjust the azimuth (for a star in the south, near the celestial equator) to bring the amount of drift to as close to zero as possible over the time period desired. This procedure is fully explained in FPE procedure 12.2.5. Usually, you should monitor the drift over a maximum period of twice your desired exposure time. Therefore, you would

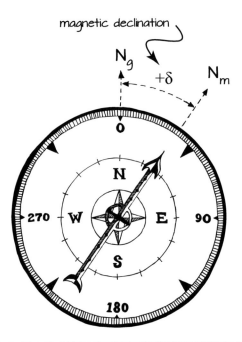

Fig. 5.2 Magnetic declination is the difference between the direction of magnetic north (N_m), and true north (N_g) (Courtesy of Rachel Konopa)

drift-align a star over a 20-min period if you wanted to make 10-min exposures. However, depending on your sky brightness, light pollution, and telescope focal ratio, you may only be able to get an exposure of 5 min before the background becomes too saturated.

5.4 Mount Performance Factors

As with any adjustment, the more accurately you align the mount to the NCP, the less error there is, and the more accurately you can track the stars. As mentioned before, once you have a very robust, sturdy, solid platform for your mount, you can achieve a very accurate polar alignment. However, an issue that practically all mounts have must be dealt with using a variety of techniques. The issue is PE. Most mounts use an RA axis and DEC axis drive configuration with a worm gear and a worm wheel. These gear pieces are usually made of brass and can be very finely machined. Not all mounts use the same quality gear pieces. PE and non-PE are mechanical effects resulting from the machining imperfections in the worm gear or wheel. There are various ways the worm gear and wheel can be imperfect, including out-of-roundness measured by the run out, burrs on the gear face(s), or inconsistent cutting of the gear threads.

5.4.1 Periodic Error and Declination Drift

The imperfections described above reveal themselves through the measurement of the tracking rate. The PE manifests itself in the tracking error (TE) as measured against the stars or a separate standard, such as high-precision encoder. PE causes a small drift in the position of the stars in the east/west direction. This drift, or TE, can be as small as ±3 arcsec for very expensive mounts or as great as ±30 arcsec for inexpensive mounts.

It is obvious from the terminology that PE is time-dependent and mainly focused on the worm period. The worm period is the time it takes the worm to make one revolution. It is typically either 4 or 8 min (240 or 480 s). The PE is a repeating pattern, close to a sine wave pattern on well-behaved mounts. A well-behaved mount means a mount that does not have much, if any non-PE. These mounts are easily corrected because of the sinusoidal error in the tracking rate.

Of course, because you have not one, but two axes, you have two types of errors to deal with, not just the PE. In the DEC axis, when the polar alignment is not perfect, and the rotation axis of the telescope does not match the rotation axis of the stars on the Celestial Sphere (even though the rate of rotation is spot on), an effect called declination drift is produced. Declination drift (without external correction) can be substantially minimized but not eliminated. It is entirely dependent on the accuracy of your mount's polar alignment. There are two methods for making a declination drift correction (and this also applies to PE correction (PEC)). The best one (which I believe is the road to the best possible images) is to align your mount as perfectly as possible and ensure that your mount tracks as accurately as possible, *without any stellar-based feedback*. This is the key to addressing this issue. The second way to correct for declination drift is to optically guide on a star to counteract the drift using stellar-based feedback.

If you can *intrinsically* make your mount perform as perfectly as possible, there is generally no need to layer other subsystems on top of the base system to get the desired performance. The only way to intrinsically correct your telescope mount in declination *without* an external stellar-based feedback system is to perform an excellent polar alignment and make sure your astrograph is mounted with no cone (orthogonal) error. The only way to correct your mount in RA *without* an external stellar-based feedback system is to provide a mechanism to counteract the PE caused by the worm gear and wheel. This is most commonly done using a rate controller and high-precision encoder. These instruments are covered in Sect. 5.5.3.

5.4.2 Auto-Guiding the Telescope

Now, what is this magical stellar-based feedback mechanism? This device is considered an extrinsically applied subsystem because it relies on externally derived data. It is called a guidescope/CCD subsystem. In the "dark ages" of astrophotography, when even professional mounts were not very accurate in tracking rate, the intrepid astronomer would spend hours and hours staring into a small auxiliary telescope with

cross-hairs centered on a guide star. The purpose was to manually monitor the pointing of the telescope via the guide star, and correct the drive RA and DEC in real time. Obviously, it took a highly dedicated astrophotographer to perform this feat and obtain very good (by today's standards) photographs of the dim, subtle objects in the cosmos. Not only was manual guiding tedious, but because film is only 1/10 as sensitive as a CCD, the patient astrophotographer had to expose at a minimum *10 times longer* than today's astrophotographers for the same result. Can you imagine? This had to be sheer torture; I have the greatest respect for the pioneers in the techniques of astrophotography. Be thankful for today's technology and computer power. We truly are building our skills and knowledge on the work of giants. Today, we have guide cameras and guiding software that automates the process of guiding the telescope, which effectively mimics and performs the tedious work the pioneers spent years perfecting.

Having extolled the great performance of today's automated guiding systems, there are still issues that have made me think that it is better to forego the use of such technology. Chief among the reasons is that, for me, anything that gets me to imaging faster, and easier, is a priority. Sadly, using the automated guiding systems of today still requires spending time setting up, calibrating, and using the guidescope CCD subsystem. If you do not have a permanent observatory, anything that gets your portable observatory operational faster is a definite plus, but comes at a greater monetary cost. You spend enough time doing things other than imaging with your systems—setup, polar alignment, configuring cameras, etc.—without adding one more thing to increase inefficiency. In addition, having to interrupt your imaging to recalibrate your guiding system can be tedious.

Now this is definitely not meant to discourage the astrophotographer who cannot afford the price of that perfect mount that has less than 5 arcsec of TE. Excellent polar alignment is just a matter of skill and patience and does not cost anything. You need to polar align your mount anyway; you might as well learn how to do it *accurately!* There is a function in most medium-priced go-to mounts called PE correction (PEC). It allows the astrophotographer to record a PEC curve manually and play it back while tracking an object. It has the capability of cutting your TE in half or better, depending on how good your mount is. This gets you part way there, but is not an ideal solution because the PEC curve is different depending on where you are pointing the telescope. The best a PEC curve can do is get rid of the most glaring error; the residual error still needs to be corrected.

That brings me back to the guidescope CCD subsystem. For those who cannot afford the high-resolution drive rate corrector and encoders available today, this is the next best thing. Even though it takes some skill and knowledge to operate, the guidescope CCD is a good solution to the problem of obtaining round stars. Remember that that is the ultimate goal—round stars.

Through hardware and software, the auto-guiding system keeps a telescope pointed at the same spot in the sky. This is independent of how well the mount is aligned to the celestial coordinate system, which may not be very well at all depending on the accuracy of the polar alignment. As stated previously in Sect. 5.2.4, it is also important to understand that a small amount of field rotation will be apparent on the edge of the image when the polar alignment is not perfect,

depending on the length of the exposure and your FOV. While guiding, the tracking rate is practically perfect in the section of the sky imaged. Therefore, overall, it can be a very effective, if time-consuming, solution.

Bottom line, as an initial condition, it is best to provide an intrinsically high-performing telescope mount that has been properly polar aligned and that provides as close to perfect tracking rate as possible. Any further corrections to this baseline performance will be very refined and subtle, and may be worthy of applying extrinsically derived subsystems. I firmly believe in minimizing the amount of equipment necessary to perform the job and in designing the AIS to do the most, at the highest performance, with the least amount and least expensive equipment possible. There are many manufacturers of equipment available; therefore, do not be afraid to mix and match the most effective equipment available.

5.4.3 Mount Load Capacity

One other characteristic of telescope mounts is their carrying capacity. The *load* that a telescope mount can handle can vary even on the same mount. How can that be? It depends on how you intend to use your mount. For example, for visual use, the eye has a great capacity to focus and track an object within the FOV of the telescope. The PE in the mount is a very slow-changing effect that the eye has no problem correcting. The same is also true for declination drift. Depending on the eyepiece FOV, you can observe for many minutes without any need to correct the position at which the telescope is pointed. In contrast to the eye, the CCD camera is very unforgiving with regard to tracking and correcting pointing errors. The CCD is the unblinking eye that has none of the internal controls the eye has; you must provide those systems externally to the CCD camera as discussed previously.

It is important when considering the amount of equipment you load onto your mount that you take the extra care to balance the weight correctly. When you balance your load, you adjust the counterweight assembly to minimize the bias in the RA axis and in the DEC axis. However, although this is the standard procedure, it has been shown that for those mounts that have significant non-PE in the gear train, having a slight bias in the RA axis balance improves the overall tracking rate.

To lessen the effort your correction systems must expend, minimize the amount of weight your mount has to accurately position and control. It may or may not be obvious, but the less mass you have to move at a constant rate or position accurately, the easier it is, and the amount of error in your correction systems becomes less. Therefore, if your mount is capable of reliably carrying 40 pounds (lbs) (18 kilograms (kg) of equipment (telescope, CCD, etc.) for visual use, you may want to initially limit your weight to 60% of that or 24 lbs (11 kg) for astrophotography. Once you have some experience with the behavior of your mount while employing your drive correction systems, then you may want to bump that up. You probably will find that you can safely carry up to the manufacturer's suggested load and still perform your imaging to your standards.

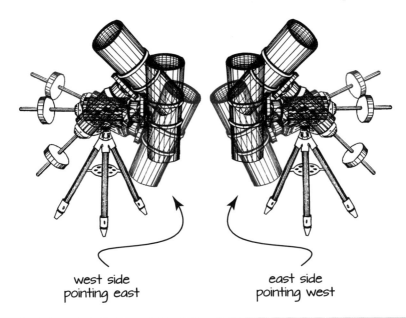

Fig. 5.3 The mount performs a meridian flip when the astrograph is in danger of striking the tripod (Courtesy of Rachel Konopa)

Some astrophotographers have developed methods to compensate for carrying loads heavier than the manufacturer's suggestion and have obtained very fine images. It takes a thorough knowledge of the mount's design and behavior, and the skill and knowledge to apply the correct fixes to compensate for the higher load.

There is one last aspect of operating a GEM that is important to understand when balancing your mount. On a GEM, a meridian flip (Fig. 5.3) is performed when the counterweight assembly is in a high position and the telescope is on the west side of the pier, pointing east. The problem is that the telescope is in danger of hitting the pier or tripod and must be reoriented so that it is on the east side of the pier, pointing west. This allows the telescope to continue to track the target. The result is that the image is flipped east/west after the meridian flip, and the balance shifts to the opposite side of the main RA gear so there may be some initial backlash clearing and pointing error when starting your guiding.

5.5 Telescope Mount Support Hardware/Software Subsystems

The telescope mount is made up of mechanical and electrical/electronic subsystems and components (Fig. 5.4). All these subsystems and components work together to contribute to the best performance possible. However, this is only the case when the

5.5 Telescope Mount Support Hardware/Software Subsystems

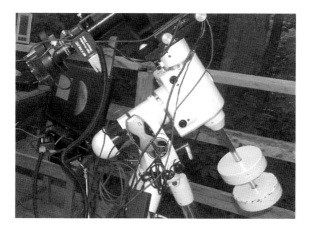

Fig. 5.4 The AIS mount (Sky-Watcher EQ6 Pro) and support systems

design is well thought out and the quality of the materials used is up to the required specifications. These subsystems include the components used to provide the performance required by the astrograph and imaging train. You should make sure that you read the owner's manual that comes with each of your mount systems and understand how each affects the quality of your astrophotographs.

5.5.1 Mount Mechanical Components

Although there are a variety of mechanical drive designs for the RA and DEC, the vast majority of telescope mounts designed for amateur use involve the *worm and wheel* configuration (Fig. 5.5). The worm is a small-diameter, long, spiral gear that resembles a screw. This gear is intermeshed, at a right angle, to the axis with a relatively large ring wheel gear. Typically, the gear ratio is such that one complete RA axis rotation is equivalent to about 180 worm gear rotations. This gear ratio results in a worm gear rotation period of 480 s or 8 min. On amateur mounts, the DEC axis design is typically the same to maximize the use of identical parts on each axis. This simplifies the mechanical design considerably. An additional gear train that drives the axis couples the drive motor to the worm gear. These are usually spur gears that are configured at a 4-to-1 gear ratio (or thereabouts). The result is that the primary motor drives the system at about 0.5 revolutions per minute (RPM).

Other worm and wheel gear ratios are available, such as 360-to-1 worm-to-gear primary ratio. In this case, the worm would turn once every 4 min, and using

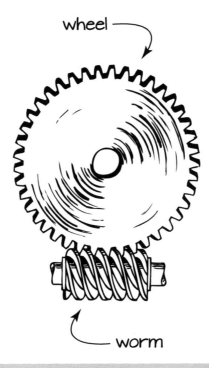

Fig. 5.5 The heart of the amateur astronomer's astrograph mount: the worm and wheel (Courtesy of Rachel Konopa)

the 4-to-1 gear ratio leads to a motor speed of 1 RPM, which was very typical of mounts before the advent of go-to mounts. One-RPM motors are widely available even today. Many amateurs have modified their mounts to use drive belts instead of spur gears in the secondary gear train. They have also modified the gear ratios slightly to eliminate odd harmonics in the overall PE. This helps in making a correction curve for the PE.

Technology development, being what it is today, has made alternative drive systems available to advanced amateur astronomers. *Direct drive* mounts are available from several manufacturers, most notably Astro Systeme Austria ASA (astrosysteme.at). These drives are characterized by high rigidity and zero backlash. They can also slew very fast. There are also mounts that use a drive technology called a harmonic drive. This system is available from ChronosMount (chronosmount.com). This gear system is characterized by a high percentage mesh gearing system made up of a wave generator, a flexspine, and a circular spine. The characteristics of the harmonic drive make for a very accurate positioning, zero backlash drive. Within the mount, this type of drive does not require any counterweights, has no clutches, and has a high load capacity.

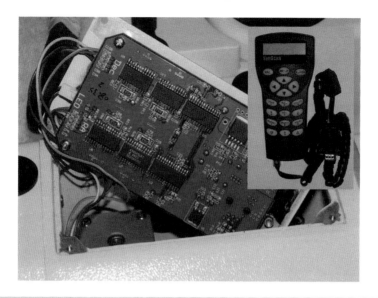

Fig. 5.6 The EQ6 Pro motor controller card and SynScan hand controller

5.5.2 Electronic Mount Controller Subsystem

Most mounts used by today's amateur astrophotographer are *go-to mounts*. The reasons for using a go-to, versus a non-go-to mount are numerous for amateur astronomers pursuing their scientific goals. Acquiring scientific data on the stars and solar system objects requires recording the ancillary data provided by the electronic mount. Chief of these data is accurate position information.

Go-to mounts usually contain two components—a motor drive microcontroller board or *motor controller* (MC), and a *hand controller* (HC) (Fig. 5.6) with a stellar and solar system object database, user interface (keypad and display), and mount utility function firmware that is updateable by the user. The MC provides all the functions to control the RA and DEC motors and communicate with the HC using a basic command language or *application programming interface* (API). Typically, the MC, once commanded, proceeds with the command until interrupted with another command. The MC responds to a parameter string coupled with the command to start executing the desired action. Actions such as Slew to Position, Track at Sidereal Rate, and Park, are implemented at the MC level. The HC can be considered a high-level interface to the MC. It provides the user with a way of directly manipulating the mount using the keypad and display system.

In addition, on all go-to mounts today, you can interface the MC directly to a personal computer using the mount's universal serial bus (USB) or serial RS-232 connectors. Using a *mount driver*, the mount can be controlled by various types of

astronomy software applications, including planetarium programs, scheduling programs, astro-image processing programs, and other types of applications used by the advanced amateur astronomer. Each manufacturer provides a mount driver for use by these different applications.

Before 2001, every piece of astronomy equipment—mounts, focusers, cameras, filter wheels, etc.—had its own specific driver that had to be configured in the specific user applications that used this equipment. At that point, an industry standard was introduced to simplify the integration of different manufacturers' equipment into an AIS in the software realm. This standard is called the Astronomy Common Object Model (ASCOM). It is patterned after the Microsoft COM or Common Object Model standards. ASCOM is discussed in Sect. 5.6.

5.5.3 Mount Drive Correctors

Auxiliary subsystems are available today to increase the performance of your mount. Chief among these is the *drive corrector*. In this context, I am referring to correcting the RA drive rate. In the pre-computer days of telescope mounts, it was not uncommon to have a drive corrector that changed the RA rate of the synchronous AC motor that was the prime mover of the mount. This was mainly used to change the rate slightly to accurately track the Sun and the Moon. In more sophisticated mounts, it was also used by the astronomer to vary the RA rate slightly to counteract PE in the gear train. As discussed previously, astronomers would monitor the tracking rate using a guide star and cross-hair in a guidescope. They would then increase or decrease the rate using the drive corrector.

Today, systems incorporate high-precision rate encoders into the drive systems to maintain a highly accurate drive rate. These drive rate correctors base their corrections on very small changes in RA rate caused by gear imperfections and operate in the 1–5 Hz range. As I discussed in Sect. 5.2.2, drive rate correctors allow a mount to accurately track at a rate that compensates fully for the Earth's rotation. This helps you to effectively reveal and subsequently correct any other minor effects that may hinder obtaining the scientifically accurate images you desire.

As of 2012, a few manufacturers provide high-resolution encoders on their products. A recent entrant into the amateur mount and telescope market is iOptron (ioptron.com). It offers two mounts that use a Renishaw encoder on the RA axis, the iEQ45-GT and the iEQ75-GT. These mounts handle loads up to 45 and 75 lb (20 and 34 kg), respectively.

Astro-Physics (astro-physics.com) also offers an add-on high-resolution encoder on its "El Capitan" 3600 GTO mount. Literature available on its website (http://www.astro-physics.com/products/mounts/3600gto/precision-encoder-complete.pdf) states:

> The advantage of zero-periodic error control is that it allows long periods of unguided imaging, as well as long guide exposures when guide stars are dim, and this is especially useful when operating large long focus instruments. Another application would be in situations where an astrograph (even a short focus fast scope) is used in totally unguided applications…

Astro-Physics has also introduced a new mount to take the place of its AP 1200 called the AP 1600GTO, which includes optional high-resolution encoders on both the RA and DEC axes.

Another innovative company, located in Hungary, MDA-Telescoop LLC (mda-telescoop.com), offers an add-on high-precision encoder and drive rate corrector called the Telescope Drive Master (TDM). This system is available as an add-on device for several different amateur mounts, including—

Astro-Physics 1200
Celestron CGE
CGE Pro
CGEM
Advanced GT
Fornax 50, 51, 100, and 150
iOptron iEQ45
Losmandy G11
Meade LX200GPS/ACF 10-in. and 16-in.
Meade LX200 Classic
Meade LXD 75
Synta EQ6
Orion Atlas EQ-G
Sky-Watcher EQ6 Pro Synscan
Synta HEQ5
Sky-Watcher HEQ5
Orion Sirius EQ-G
Vixen GP-DX and GP-D2

These mounts cover a wide range of types and budgets. Explore Scientific (explorescientific.com) offers the TDM in North America, and Meade Instruments Europe GmbH (meade.de) handles the European market for the TDM. Details about drive rate correctors are covered in Chap. 6.

5.6 The Software-Driven Mount: The Astronomy Common Object Model (ASCOM) Standard

The ASCOM Standard (ascom-standards.org) is a freely available set of documents and software tools developed by the commercial astronomical hardware industry for use by the industry in building software interface drivers for its astronomy equipment. The mission of the ASCOM standards committee is to—

1. Establish a set of vendor-independent and language-independent interface standards for drivers that provide plug-and-play control of astronomical instruments and related devices
2. Provide general requirements and guidance for quality and behavior of drivers
3. Promote the use of these standard drivers from any astronomy-related software

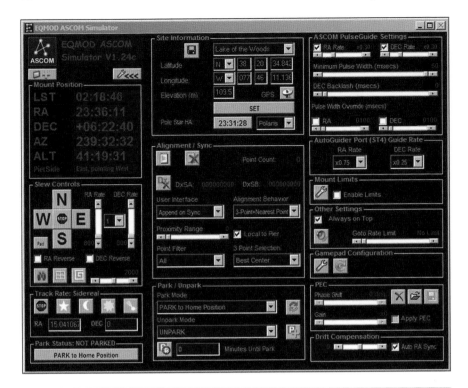

Fig. 5.7 The EQMOD ASCOM driver for Synta-based EQ mounts

4. Ensure that drivers are usable from the widest possible variety of programs and languages, including Windows Active Script languages and Automation based tools
5. Promote (but not absolutely require) open-source implementations of the drivers
6. Promote scriptability of astronomy software without standardizing application level interfaces (which would inhibit innovation)
7. Provide general requirements for quality and behavior of application scripting interfaces, aimed at making astronomy application writers' experiences consistent and robust

The list of equipment with ASCOM drivers available for the amateur astronomer grows every year and includes these types of equipment:

Telescope/Mount
CCD Camera
Filter Wheel
Focuser
Field Rotator
Dome/Roof

As of 2012, ASCOM version 6 and later versions are available for download and are in use today by myriad manufacturers.

The Synta manufactured mounts (Orion Atlas, Orion Sirius, Sky-Watcher EQ5, EQ5 Pro, EQ6, and EQ6 Pro) have an ASCOM driver called EQMOD (eq-mod.sourceforge.net) with a long development history (Fig. 5.7). It is very robust and has a well-developed set of features that add a lot of value to your EQMOD compatible mount. The EQMOD driver has been developed using the open-source software philosophy; therefore, all the source code is available for anyone's use. For some amateurs, the availability of EQMOD drove the decision to purchase one of these mounts.

When considering your mount type, to minimize the obsolescence of your mount far into the future, make sure that the mount manufacturer is using the latest software interface technology. This will have an impact when upgrading your equipment. The ASCOM standard provides an open interface that will surely be around for the next 30 years and ensure that any device you purchase today will be viable from a software point of view for a long time.

5.7 What's Best for Me?

This, of course, is the $64,000 question (not that you will spend that much!). You can see from the previous discussion that you need to fully understand the goals of your scientific imaging program and maximize the performance of your mount to suit those goals. The basic approach is to start from the bottom and work your way up. Make sure that everything you do to your mount design either adds rigidity or removes sloppiness. Buy the best you can afford within the constraints of your AIS budget that will support at least 125% of your designed load. When considering your design load capacity, make sure you add margin for any future growth you may have over the next 5 years. This can be accommodated by adding an additional 5–10 lbs (2–5 kg) to the maximum capacity. Make some room for that *big* CCD camera and filter wheel that you will surely grow into. Give very careful consideration before giving in to "aperture fever"! Get the most out of your astrograph before trading up. You may be surprised what it can deliver with updated techniques, cameras, and other accessories.

In summary, you should consider a number of factors in building a firm foundation for your AIS. The telescope mount is a fundamental building block in the AIS and should represent up to 40% of your system in terms of importance and cost. You must first provide the mount with a robust and sturdy base, whether it is a pier or tripod, that is capable of handling the total load of the AIS. Top that off with a telescope mount that is designed for astrophotography (GEM, or fork mount) with the desired load-carrying capability, alignment, and tracking performance necessary to get the very best images you are capable of obtaining. Add on the software tools that enable you to accurately measure the performance of your mount and to get the most out of your mount. You must be cognizant of all the factors that may

affect the behavior of the mount to minimize the TE and declination drift. Finally, you must also be aware of the cost in setup, imaging, and takedown time that having a guiding system entails, and the alternatives for minimizing the amount of equipment you use in imaging.

Further Reading

Arditti D (2008) Setting-up a small observatory. Springer, New York
Berry R, Burnell J (2005) The handbook of astronomical image processing. Willmann-Bell, Richmond
Buchheim R (2007) The sky is your laboratory. Springer, Berlin/Heidelberg/New York
Chromey FR (2010) To measure the sky. Cambridge University Press
Covington MA (1999) Astrophotography for the amateur. Cambridge University Press
Dragesco J (1995) High resolution astrophotography. Cambridge University Press
Dymock R (2010) Asteroids and dwarf planets and how to observe them. Springer, New York
Smith GH, Ceragioli R, Berry R (2012) Telescopes, eyepieces and astrographs. Willmann-Bell, Richmond

Web Pages

http://www.mda-telescoop.com/
http://www.chronosmount.com/
http://www.ioptron.com/
http://www.astro-physics.com/
http://www.explorescientific.com/
http://www.meade.de/
http://www.ascom-standards.org/
http://eq-mod.sourceforge.net/
http://www.bisque.com/sc/
http://www.meade.com/
http://www.celestron.com/1The ASCOM Mission Statement (ascom-standards.org)

Chapter 6

Imaging Filters and Auxiliary Optical/Mechanical/Electrical Components

6.1 Imaging Through Rose-Colored Glasses

By the first decade of the twenty-first century, there had been an explosion of consumer products based on the high technology developed for military purposes. Fundamental infrastructure technology, such as Global Positioning System (GPS) devices, satellite communications, microprocessors, and the charge-coupled device (CCD), have been adapted for use over the past 30 years by amateur astronomers and have continued to evolve. Chemistry and material science have produced a wealth of new technology. Optical filter technology has grown over the past decade and has allowed the amateur astronomer to make very accurate and precise measurements of light. This is no better demonstrated than by the filter technology that amateurs use every day. You might say that amateurs can finally observe the heavens through rose-colored glasses!

6.2 Photometric; Luminance, Red, Green, and Blue (LRGB); Narrowband Filters; and Filter Wheels

When you look at the sky, you are awash in radiation that has traveled millions and billions of years, as well as radiation that has traveled only minutes or hours from its source. All this radiation has a wide range of wavelengths but is filtered by the Earth's atmosphere. The Earth's atmosphere protects you from the harmful radiation in certain wavelength ranges and allows you to see other wavelengths to which your eyes are sensitive.

Even though you are limited to a small range of the *electromagnetic spectrum*, you can obtain an amazing amount of information just from that limited bandwidth allowed through the atmosphere. That narrow bandwidth can be further divided into smaller and smaller increments to allow close examination of the radiation characteristics of different natural processes. These processes tell you how the universe works in the heavens and on the Earth. Let's examine some of the different filters you can use in your imaging and discuss the processes that they reveal.

6.2.1 Photometric Filters

Photometric filters were developed to provide a standard reference to understand the characteristics of stars. These filters make it easy to measure even dim stars yet still make it possible to divide the spectrum into various pass-bands to characterize a star's type. Think of separating the visible spectrum into three bins and then looking at the difference between the total amounts of radiation collected in each of these bins. The first standardized photometric filter system was the Morgan-Johnson system, or *ultraviolet, blue, visual (UBV)* system developed in 1953 by American astronomers William Morgan and Harold Johnson. The original UBV system is a wideband system developed to characterize star temperatures and chemical properties.

To create a standard system, one only has to create the filters with the desired pass-band and center frequency, and then measure a set of stars selected to provide starlight with the characteristics needed to cover the range of measurements desired. Once they are measured by the designated standard filters, these stars are designated primary standards, and the values measured are fixed and provided as the standard magnitude of each of these stars in the pass-band measured. Just as the meter was defined in 1889 (with the prototype meter bar made of 90% platinum and 10% iridium), so were these standard stars defined to have a specific magnitude value when viewed through each of the standard filters.

The UBV standard was extended in 1976 by adding work by South-African astronomer Alan Cousins in the red and infrared (IR) band, and is now the ultraviolet blue visual red infrared (UBVRI) Johnson-Cousins photometric standard. In 1992, Arlo Landolt published a list of photometric standard stars in the *Astronomical Journal*. Today, professionals and amateurs alike use these stars to calibrate photometric systems between magnitudes 11.5 and 16.0. Many different photometric standards are available today, but the most popular for amateur work is the UBVRI system.

You can purchase a set of photometric filters from various manufacturers and use them right out of the box for most projects. The most popular photometric filter used today by amateurs is the V-band filter; it offers the simplest way to provide a calibrated photometric value that is useful in a wide range of projects.

To give you a taste of what is involved with photometric filter calibration, here is a simplified procedure you can use. (Sect. 15.3 delves more into the subject of photometric calibration). To calibrate your V-band filter, because there may be

Table 6.1 Standard star measurements

Landolt star	Standard V magnitude	Instrumental V magnitude
92 427	14.953	16.332
92 502	11.812	13.162
92 276	12.036	13.378
92 282	12.969	14.354
92 507	11.332	12.675

slight differences in manufacturing, you can obtain the list of *Landolt Reference Stars* and compare your measured *instrumental magnitude* against the standard reference star magnitude. Once you have measured several stars, you can calculate a correction for your instrumental measurement and transform it into the standard magnitude measurement. Because CCDs are linear, you should be able to fit your measurement results to the standard system using the simple linear equation: $Y = mX + B$. In this equation, Y is the Standard Magnitude, X is the Instrumental Magnitude, B is the Offset Magnitude, and m is the slope or ratio of the difference between the Instrumental and the Standard Magnitudes.

Suppose Table 6.1 shows the measurements you took.

The following simplified calculation shows the process for calibrating your filter. Using the data in Table 6.1, the $Y = mX + B$ transformation equation for this data is:

$$\text{Calibrated Magnitude} = (0.9887 \cdot \text{Instrumental Magnitude}) - 1.2014 \quad (6.1)$$

So using your measured stars, you just plug your instrumental measurements into the equation and calculate the calibrated magnitude. Once you have calibrated your images, then you can use the transform to calculate changes in the star brightness over several images compared with a comparison star. The difference between the two stars is called the Differential Magnitude:

$$\Delta \text{mag} = V - C \quad (6.2)$$

Where: V is the variable star magnitude and
 C is the comparison star magnitude

These differential magnitudes (Δ mag) can be plotted to show the brightness changes over time, whether for a minor planet, variable star or an exo-planet (Fig. 6.1).

6.2.2 LRGB Filters

How do you go about obtaining a color image from a monochrome CCD camera? This requires taking separate frames using the three primary color filters and then

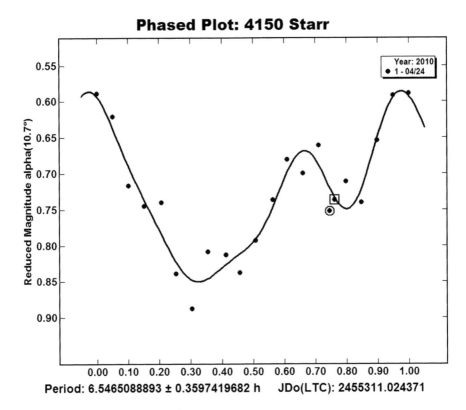

Fig. 6.1 A lightcurve for 16.5 magnitude minor planet (4150) Starr developed from data taken April 24, 2010, with the Sierra Stars Observatory Network

combining them into one image. When making color images that are for display and viewing by the human eye, you need to use filters that accurately obtain data, which when combined, looks the way it might if you were actually out in space viewing the object. Of course, you would usually want to boost the saturation to be able to discriminate and view small changes in tone and hue. The filters used to create such images are the LRGB filters. This stands for Luminance, Red, Green, and Blue filters. Much as consumer cameras use a color filter array (RGB) installed on the front of the CCD chip, you can use the same type of filters with a monochrome camera to create a full color image.

The Luminance image is used to create a monochrome intensity frame to help balance the tones in the completed color image and to provide a true black that the combination of the RGB frames may not provide. Most if not all of the color images that are published of nebulae, galaxies, planets, and other objects were processed using RGB filters. There are CCD cameras for astronomy available with a color filter array (CFA) installed. Sometimes referred to as one-shot-color (OSC)

cameras, they give you a full-color image in one frame. However, you sacrifice sensitivity and resolution when using an OSC camera, so be aware of and understand the tradeoffs between an OSC and a monochrome camera.

6.2.3 Narrowband Filters

Narrowband filters are used to isolate very specific frequency bands related to chemical elements that exist out in space, and to block other wavelengths that are related to light pollution. This light pollution, or *skyglow,* which is a common occurrence in today's environment, poses a real problem when trying to observe objects that emit these wavelengths. There are filters designed to allow only the radiation emitted by hydrogen, oxygen, nitrogen, and sulfur to come through the filter while blocking everything else. There are also filters that block the emissions of the lighting systems used in cities and towns, specifically the sodium and mercury vapor lamp emissions.

Narrowband filters allow you to examine the quantities of different elements in emission nebula and other types of objects. There are filters that allow the observation of emissions in a fairly narrow pass-band in the range of 50–100 nanometers (nm) in width. These filters are commonly marketed as *nebula filters*. The other types of filters available are referred to as *line filters*. They have a pass-band of less than 10 nm and are centered on the wavelength of the element's emission spectrum. Some line filters are specific to one emission line to provide a scientifically valid way to measure these emissions.

The most popular line filter for scientific use, and the one you should consider purchasing first, is the Hydrogen Alpha (H-α) filter. Hydrogen is common throughout the universe and is present in emission nebulae (North American, Pelican), planetary nebulae (Dumbbell, Ring), Wolf-Rayet objects (Crescent, Thor's Helmet), and supernova remnants (Veil). The H-α narrowband filter is centered at 656 nm in the red portion of the visual spectrum. Nitrogen 2 (NII) is also included in most H-α line filters because the NII emission is at 658 nm and is included in the pass-band for H-α filters with a pass-band of more than 2 nm.

The next most popular line filter is the Oxygen-3 (OIII) filter. Oxygen is an abundant element in the universe and can be observed in several different objects. The OIII filter is centered at 500 nm in the blue-green range of the visual spectrum. It is very popular for observing planetary nebula such as the M57 (the Ring Nebula) and others that have OIII emissions as a common feature.

Another popular line filter is the Sulfur-2 (SII) filter, which filters in the deep red portion of the visual spectrum at a wavelength of 672 nm. Sulfur is another element to observe in many emission nebulas.

One other line filter worth mentioning here is the Hydrogen Beta (H-β) line filter. This filter is centered on a wavelength of 486.1 nm in the blue range of the visual spectrum. It can provide some scientifically useful data but using it is problematic because of the low signal level provided by many objects. Typically, CCDs are not as sensitive at the blue end of the spectrum, which only compounds the problem.

Fig. 6.2 The QHY filter wheel

Other narrowband filters are designed to block the harmful emissions of sodium and mercury vapor lamps. These are sometimes referred to as *notch filters*. These filters are marketed as "light pollution" filters and are very useful in combating the effects of skyglow caused by these lamps. Notch filters are made by combining different filters that are designed to block very narrow wavelengths, in much the same way that line filters allow very narrow pass-bands. A common misconception is that these filters increase the brightness of objects. This is false. These filters increase the *contrast* of the objects observed and allow you to view very dim emission nebulae and other objects that are affected by light pollution.

6.2.4 Filter Wheels

When integrating the various types of filters available into your Astronomical Imaging System (AIS) imaging train, you have a couple of choices. If you use 1¼ and 2-in. nosepieces (discussed in Sect. 7.11) you can screw on your individual filters of those sizes directly into the nosepiece adapter. This is a good choice when starting out and minimizes the impact that integrating a filter wheel would impose on your imaging train configuration. You are of course limited to the pass-band of the filter you choose to mount in your nosepiece. For scientific purposes a V-band photometric filter is a cost-effective tool when doing stellar or minor planet imaging and is a good filter to get when starting out. Mounting the V-band photometric filter on your CCD camera's nosepiece will give you an excellent start in the world of scientific astrophotography.

A filter wheel (Fig. 6.2), although more complicated, gives you more flexibility and is a necessity when doing LRGB or photometric imaging in several pass-bands.

There are a couple of choices when obtaining filter wheels for integration into your imaging train, manual and motorized. For those on a budget, a manual filter selector is a good choice. A motorized filter wheel helps you automate your image acquisition when using various pass-bands and can become a necessity if you want to operate your AIS remotely.

6.3 Lunar, Solar, and Planetary Filters

The primary purpose of lunar, solar, and planetary filters is to enhance the contrast of various features that exist on these solar system objects. These filters are broadband in nature and can be quite inexpensive but still provide good service. Planetary filters come in a wide range of colors that can be matched to any number of features. Solar filters are designed to block the vast majority of the light from the Sun (for obvious reasons!) and fit *in front* of the primary objective of the telescope whether it is a refractor or reflector. This is an important concept to understand because you do not want the magnified rays of the Sun to affect any part of your astrograph. The heating alone can cause a lot of problems. Lunar filters are designed mainly to attenuate the light of the bright Moon when making visual observations of the majority of the disk of the Moon.

Most of these filter types are available mounted in 1¼ and 2-in. threaded filter cells that screw onto eyepieces and camera nosepieces. Depending on the type of filter wheel you have, you may be able to mount them onto that device also.

There are also specific cases where filters are used to enhance the prospects for mitigating the effects of seeing when doing high-resolution lunar imaging. Typically, when seeing is fair to good, a red or IR filter can be used to cut some of the effects of the turbulent atmosphere. This is possible because the lunar surface is largely monochrome, with the exception of some very subtle coloring owing to the mineral content of the lunar soil. These filters are particularly effective for lunar imaging because for the most part, lunar images are processed as monochromes. There are studies that discuss how the seeing effect is distributed throughout the visual spectrum. Using a blue filter when doing high-resolution lunar imaging is suggested when the seeing is particularly good because it adds to the discrimination of very small features on the lunar surface, such as small craterlets, rimae, and other linear features.

For Mars, Jupiter, and Saturn, different colored filters can help enhance the contrast of certain features. For Mars, a blue filter enhances the contrast between the predominately reddish soil and the white polar caps. Using a red or orange filter on Mars develops more contrast between any clouds and surface features. On Jupiter and Saturn, using different colored filters helps to discriminate the large oval cloud features and the equatorial bands that exist on the surface. Try out any number of different filters to see what aspects are enhanced when viewing the planets.

The most basic type of solar filter is designed to block the vast majority of the sunlight (more than 99.999%) entering the telescope's primary objective and is broadband in nature and is referred to as a white light filter. This filter is usually

Fig. 6.3 Two types of white light solar filters: Glass and Mylar

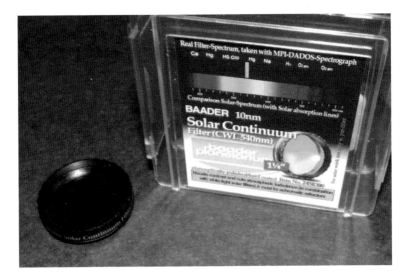

Fig. 6.4 A narrow-band (10 nm) Solar Continuum filter centered at 540 nm

mounted on the front of the telescope. These filters are either made of a fine Mylar film with coatings or may be a large glass filter with coatings (Fig. 6.3). This white light solar filter coupled with a narrow-band (10 nm) filter centered on a wavelength of 540 nm can enhance the appearance of sunspots and the granularity of the surface of the Sun (Fig. 6.4) Baader Planetarium makes this filter and is called a Solar Continuum filter.

Over the past few years, dedicated solar telescopes have been available from a couple of manufacturers, most notably Lunt and Coronado, which is owned by Meade Instruments. Although these instruments are not strictly add-on filters, they

do provide a way to observe and image the Sun. These instruments use a very accurate, tunable line filter with a band-pass of less than 10 nm to look at the Sun in the H-α range. Several features of the Sun are viewable and can be imaged, including prominences, filaments, spicules, plage, solar flares, and the chromosphere.

6.4 Spectroscopic Gratings

Spectroscopic gratings are used to create a spectrum of the star or planet that you want to image, much like a prism, except that they are of a much smaller scale, on the order of 100 lines per millimeter (lpmm) or more (Fig. 6.5). The grooves in a grating scatter the incident light, and through the interference patterns or diffraction, form the spectrum. Gratings can be designed as filter gratings or reflective gratings. Filter gratings do what one would expect; they filter the incoming light to spread the spectrum out just as a prism does. The reflective grating reflects an incident beam of light back toward the desired imaging device or eyepiece.

There are several manufacturers of gratings for scientific use, but there are two major manufacturers that provide filter gratings mounted in a format that is useful to the beginning spectroscopist. Paton Hawksley provides a 100 lpmm grating in a 1.25-in. filter cell suitable for general visual and photographic use, called the Star Analyzer 100 (SA100), which was developed by Robin Leadbeater in the UK. Another filter grating available to the amateur spectroscopist is the Rainbow Optics Star Spectroscope, a 200 lpmm grating spectroscope, which is more suitable for visual rather than imaging use because of its wider dispersion.

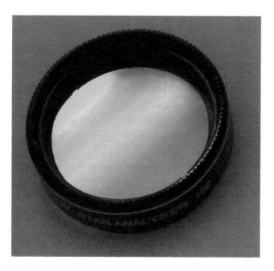

Fig. 6.5 The Paton Hawksley Star Analyzer 100 (SA100) spectroscopic grating developed by Robin Leadbeater

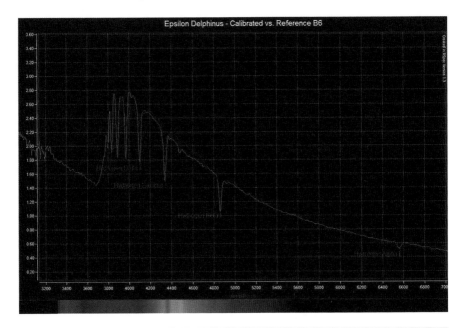

Fig. 6.6 A calibrated and sensor normalized spectrum of a type B6 star Epsilon Delphinus (*red*) compared with the reference type B6 spectrum (*blue*)

Several applications can be used to process your spectrum images, but the two most popular applications available today are RSpec, developed by Tom Field of Field Tested Software, and Visual Spec, developed by Valérie Desnoux of the AUDE Association. Both of these applications enable you to process your raw or calibrated spectrum images to obtain a spectroscopically calibrated graphical representation of the star or other object's spectrum (Fig. 6.6).

Using a filter grating is by far the easiest way to get started with spectroscopic observations, and there is a lot of information available to the amateur online for using these gratings. Several Yahoo groups are available online to converse with fellow astronomers specifically about spectroscopy, notably the staranalyser group and the astronomical spectroscopy group.

6.5 Focal Reducers

Focal reducers are used to adjust the native focal length (FL) of your astrograph's primary objective to widen the effective field of view (FOV), and/or lower the exposure time required to reach a given magnitude for extended objects such as galaxies and nebulae. Focal reducers come in a wide variety of multipliers, and this is typically how they are specified. Two characteristics are important when specifying or using a focal reducer—multiplier value and FL. Focal reducers come

6.7 Field Flatteners 87

in different multipliers, typically ranging from 0.33× to 0.8×. If your primary objective has an FL of 2,000 millimeters (mm) @ *f*/10, and you use a 0.63× focal reducer, then your system has an effective FL of 1,260 mm @ *f*/6.3.

To obtain the nominal multiplier value of the focal reducer, you must space the eyepiece or, in your case, the CCD imaging plane of your camera, at the specified distance required by your focal reducer. This is typically about 70 mm from the front edge of the focal reducer's mounting cell. Therefore, when you place your CCD camera 70 mm from this location, you can ensure that you get the expected performance from your focal reducer.

Some modern focal reducers provide another feature, field flattening. *Field flatteners* are used to minimize the field curvature that exists in various types of astrographs, including refractors and Newtonian and Cassegrain reflectors. Often, you can find focal reducers that are actually a combination focal reducer and field flattener. Including this refractive element in your imaging train defines and improves one of the fundamental characteristics of the astrograph. For more information on field flatteners, see Sect. 6.7.

6.6 Barlow Lenses

A *Barlow lens* is a refractive element that in some respects is the opposite of a focal reducer. This lens was invented in the early 1800s by English mathematician Peter Barlow in collaboration with optician George Dollond. Barlow lenses are specified in terms of multiplication. The classic Barlow comes in the multiplication factor of 2×. This means that if you have an astrograph with a primary FL of 2,000 mm and you use a 2× Barlow in the imaging train, then the effective FL is 4,000 mm. Alternatively, when you use an eyepiece with the Barlow, it is the equivalent of halving the eyepiece FL in terms of magnification. For example, if you use a 26-mm eyepiece with a primary FL of 2,000 mm, then the magnification will be 77×. If you were to add a Barlow lens to the eyepiece, then the effective eyepiece FL would be 13 mm, and the magnification would be doubled to 154×.

For imaging, the Barlow lens, or more modern versions, is very effective in increasing the FL of astrographs to that necessary for high-resolution planetary, lunar, and solar imaging. The more modern versions are available in 2×, 2.5×, 4×, and 5× multipliers. As you will see in the Field Practical Exercises in Chap. 12 that deal with high-resolution planetary, lunar, and solar imaging, a long to very long FL astrograph is a necessity, and this is achieved by using a Barlow lens.

6.7 Field Flatteners

Field flatteners are used to correct the inherent field curvature in different astrograph designs. Most astrographs have some level of field curvature, depending on the focal ratio of the primary objective. As a general rule, the more curved the primary objective (i.e., the faster the focal ratio), the more pronounced the field

Fig. 6.7 Field curvature in a 0.2-m Ritchey-Chrétien Cassegrain astrograph

curvature is (Fig. 6.7). Also, the larger the FOV the astrograph provides, the more field curvature is apparent in your images. Field flatteners are used to correct this common defect in telescopes and are sometimes provided in combination with focal reducers and referred to as a focal reducer with powers of 0.75× and 0.63×. They are also available as 1.0× power only, in which case they are referred to simply as a field flattener. For quality scientific imaging, field flatteners are a required piece of equipment. They should be a standard part of your imaging train whether they are provided as part of a focal reducer or as a stand-alone flattener optical component.

6.8 Atmospheric Dispersion Correctors

Among the more esoteric and dedicated-use pieces of equipment available to the amateur astronomer is the *atmospheric dispersion corrector*. I include this item only to impress upon you that scattered among the more general use components are items that may provide a solution to a very specific problem and are necessary in getting the absolute best quality in your imaging results. Typically, one of the characteristics of this type of equipment is that it is only applicable to a very narrow range of conditions, and there is no better example than the atmospheric dispersion corrector.

As is discussed in more detail in Chap. 8, *atmospheric refraction* can be a problem when imaging objects below 60 degrees (°) in altitude and is very apparent when imaging below 30° in altitude. Atmospheric refraction has two basic effects. The first effect manifests as a change in altitude of the object that you are observing.

6.8 Atmospheric Dispersion Correctors

Fig. 6.8 When stars are low on the horizon, the atmosphere spreads the light of the star out vertically. This is called atmospheric dispersion (Courtesy of Rachel Konopa)

As objects approach the horizon, they seem to shift upward in position compared with their expected position. The atmosphere acts as a refractive element and bends the light from objects that are actually below the horizon up to where they are still visible as though they were above the horizon. This effect can be calculated fairly accurately and affects not only your imaging, but also how you calculate positions for pointing the telescope and how you correct for drift during long exposures. As discussed previously, the King rate is used on telescope mounts to compensate for this first effect.

The second effect is a spreading of the light out into a spectrum by the atmosphere at low altitudes. This is sometimes called *atmospheric dispersion*. In this case, blue light is affected more than red light and is refracted more. In high-quality images, one would observe a smearing of the star in the vertical direction with the blue light above the red light portion of the spectrum (Fig. 6.8). This becomes very apparent when objects are within 5° of the horizon.

It is this second effect that the atmospheric dispersion corrector is meant to combat. An *atmospheric dispersion corrector* for amateur use is available from the German company Astro Electronic. It is a two-prism diopter corrector with anti-reflective coatings that is used similarly to a Barlow or field flattener in correcting your optics (Fig. 6.9). This corrector is designed to be used when visually observing or imaging objects below 30° in altitude. Two adjustable levers rotate and position the

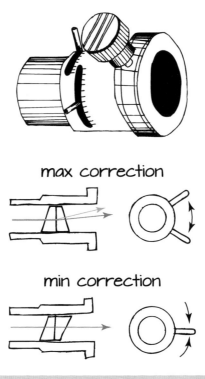

Fig. 6.9 An atmospheric dispersion corrector is a specialty optic used by advanced amateurs (Courtesy of Rachel Konopa)

prism elements within the corrector to counteract the atmospheric dispersion in your image. This component must be adjusted while you are imaging because the amount of dispersion changes with time and altitude. If you must image an object that is low on the horizon, then you may want to purchase one of these devices.

It is important to keep in mind that there are components available to the amateur that are special use and may help you in capturing the highest quality images possible when observing under especially difficult or rare conditions.

6.9 Coma Correctors

Newtonian astrographs use simple parabolic mirrors and a flat secondary. Because of this simple configuration, all Newtonians exhibit *coma*, but it is very pronounced in short FL, fast instruments. Coma is a distortion of a star's image near the edge of the field. It makes the stars appear as comet-shaped objects that limit the FOV and are not very conducive to scientific imaging. There are optical correctors called

coma correctors available to mitigate a lot of this distortion but they typically increase the effective FL of the instrument. Several manufacturers provide coma correctors to the amateur community. If you plan to use a Newtonian astrograph as part of your AIS, you need to invest in a good quality coma corrector matched to the quality of your astrograph. Your vendor of choice should be able to provide a coma corrector matched to your Newtonian astrograph when you purchase it.

6.10 Focusers

The astrograph *focuser* is probably the most underrated and maybe most overlooked piece of equipment by the beginning amateur astronomer. Fortunately, manufacturers of higher quality telescopes have begun fitting their products with precision *Crayford* style focusers (Fig. 6.10) in place of the previously standard rack and pinion focusers. Crayford focusers provide high-resolution, course and fine adjustment for very accurate focusing. Accurate focusing is critical for obtaining the highest quality scientific images. Let me repeat—accurate focusing is critical for obtaining quality scientific images.

I say that not because you will not believe me, but because I want to impress on you the importance of being able to accurately focus the objects you are imaging. Although collimation of your optics is an important process and puts an upper limit on your potential imaging performance, without excellent focus, your images will still be poor. Having the ability to easily and accurately position your CCD's sensor to within 5 μm of the astrograph imaging plane is a key component in minimizing the frustration level and maximizing your efficiency.

Fig. 6.10 The Astronomy Technologies precision Crayford focuser delivered with the AT8RC Ritchey-Chrétien Cassegrain astrograph

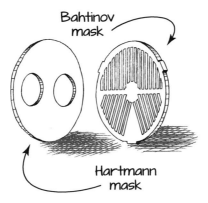

Fig. 6.11 The Hartmann mask, and more recently the Bahtinov mask, are used to precisely focus the astrograph (Courtesy of Rachel Konopa)

So how do you know when you have accurately focused your astrograph? That is an excellent question, and one that has frustrated beginners, as well as more experienced amateur astronomers than you can imagine. You can guess that the primary impediment to excellent focusing is atmospheric seeing. If the seeing is not good, you can give up on accurately focusing your astrograph. The first requirement for accurately focusing an object is that the seeing *must* be good to excellent. If you are focusing your object in anything less, then you are making only an educated guess, and your results will be no better, and more than likely worse, than the nominal seeing level would dictate.

So how *do* you focus accurately? There are several techniques and tools that you can use to focus the object of interest; one of the simplest to use and understand is the *focusing mask*. There are several different types of focusing masks, most notably the *Hartmann mask* and the *Bahtinov mask* (Fig. 6.11).

These masks operate by creating diffraction effects, mainly spikes that are positioned specifically to indicate to you, as you adjust your focus position, when you are perfectly focused. This is typically shown using pairs of diffraction spikes that spread apart or come together as you adjust your focus, coming together as one spike when you have accurately focused the object of interest. Another way to focus accurately is to position your FOV on a bright star and start taking a series of looping images to continuously monitor your star's full-width-at-half-maximum (FWHM) and peak brightness. As you adjust the focus, you find that the FWHM changes, and at the best focus position, it is at the minimum value. At the same time, the peak brightness in the star increases and should be at the maximum value at the same time the FWHM value is minimized. Read and study your image processing program's help file to understand how to display these values while you are focusing.

A coarse and fine focus adjustment on your focuser is mandatory if you are to achieve this level of performance. As mentioned previously, several manufacturers

6.11 Mechanical Fittings and Miscellaneous Items

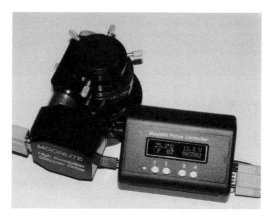

Fig. 6.12 The Moonlite 2-in. precision Stepper Motor Crayford focuser with digital readout capable of 4 μm steps used on the AT8RC Ritchey-Chrétien Cassegrain astrograph

are installing these high-performance focusers as standard on their products, making it easier for the amateur to get into imaging. Look for this option on any telescope or astrograph you plan to purchase.

For very accurate and fine positioning of your focal plane, a motorized focuser is necessary (Fig. 6.12). These systems allow you to position your CCD's imaging plane to within 5 μm of the desired position. There are several manufacturers' focusing systems that you can purchase to replace your existing focusers. Manufacturers such as Moonlite and Starlight Instruments make premium quality electronic focusers, but you can buy add-on motor systems for your existing Crayford type focuser also. Manufacturers such as JMI Mobile and Orion offer such systems. For the advanced imager, software is available to measure the temperature changes in focus position and automatically compensates and adjusts the focus for any temperature change that occurs during the imaging session. Applications such as Maxim DL and FocusMax are examples of software that can handle that task.

6.11 Mechanical Fittings and Miscellaneous Items

Once you have all the major components of your imaging train in hand, then you need to be able to connect all these items together. Sometimes the manufacturer provides the interface components to the telescope or filter wheel that most people commonly use. These include the T-adapter and nosepiece. However, sometimes you need a special adapter to couple the T-adapter to the 2½-in. focuser, or you need a more stable connection than the standard nosepiece and barrel provided. As you will come to realize, having a threaded connection between all your

Fig. 6.13 17-mm and 30-mm T-thread adapters

components in your imaging train goes a long way toward keeping everything square with no tip/tilt in your image and minimizes the flexure in your imaging train/astrograph combination. This is absolutely necessary in obtaining the highest quality scientific images.

The standard T-adapter is a mainstay in the industry and has been around since the *T-mount*, or T2-mount was introduced in the late 1950s as a single lens reflex (SLR) camera mount. To connect the T-mount to other optics, the *T-ring* or T2-ring was introduced. This T-ring is available in several camera-specific styles (e.g., Canon, Nikon, Olympus, Pentax, and others) and has a standard diameter of 42 mm and a thread of M42-0.75. This thread is referred to as T-thread. You can also purchase T-thread adapters with 7, 17, and 30 mm lengths, among others (Fig. 6.13). These adapters enable you to provide the necessary spacing between elements for accurate spacing for focal reducers, Barlow lenses, etc. Optical components usually are the components that have specific distance requirements between them and the CCD focal plane. All other mechanical type components, including filter wheels, focusers, and such, are not as critical in terms of distance between components.

The *nosepiece* is a standard component that is used to interface non-eyepiece components to items that are mainly designed for use with eyepieces. These include components such as diagonals and flip mirrors. There are two standard sizes for nosepieces, 1¼ and 2-in. (Fig. 6.14). A very common adapter for using CCD cameras with a diagonal is a T-ring to 1¼-in. adapter. This has male T-threads that screw into the CCD camera with a 1¼-in. nosepiece that can be inserted into a standard 1¼-in. eyepiece adapter or diagonal. There is also a T-thread to 2-in. nosepiece adaptor for using a 2-in. diagonal.

For larger 2-in. components, such as filter wheels and larger CCD cameras, a 54-mm T-thread is used. You can also find adapters to link up these larger diameter threaded components to the standard 42-mm T-thread components. It is important

6.11 Mechanical Fittings and Miscellaneous Items

Fig. 6.14 A 1.25-in. nosepiece, 2.0-in. nosepiece, and 1.25-in. barrel adapter

to keep in mind that the larger active components of your imaging train are heavy, and for best results, need to be connected with a threaded connection rather than a standard thumbscrew barrel connection. These standard thumbscrew connections, while okay for eyepieces and other relatively lightweight components, are problematic in obtaining the best images when connecting heavier components, including filter wheels, CCD cameras, large focal reducers, or Barlow lenses. Always strive to use a threaded connection when connecting these components together.

Barrels contain at least one, and possibly three thumbscrews for retention of eyepieces and other components that use a 1¼ or 2-in. nosepiece. You should try not to use a barrel that has only one thumbscrew when doing imaging. This may be fine for visual purposes, but it is prone to flexure problems when imaging. Also, it may be the source of tip/tilt errors in the image plane of your CCD camera. Having said that, using a single thumbscrew barrel is sometimes necessary; therefore, in that case, make sure that the barrel and the corresponding nosepiece are tight against each other and mate perfectly before tightening the thumbscrew. The better quality barrels and nosepieces have zero movement and tip/tilt when tightly coupled and clamped via the single thumbscrew. Most, if not all the higher quality barrels have three thumbscrews and a brass compression ring within the barrel where the thumbscrews press to distribute the force evenly around the nosepiece without leaving a mark on the nosepiece or nice chrome eyepiece barrel.

A large majority of poor images are caused by flexure that is often traceable to the physical connections between the imaging train components. Threaded connections are best, followed by three thumbscrew barrel connections with compression rings and tight zero movement contact. If you suspect flexure is the issue with your images, check these component connection points first and make efforts to improve them with better components.

Another mechanical consideration is with the way the electronic connections with the computer system that you use to gather data from your imaging components

are attached to each other. The performance of the cables and their connections has a direct impact on your ability to avoid having to restart your computer systems or deal with any "freezing" of your applications. If you frequent any of the astronomy forums on the Internet, you will learn that many problems with USB-connected equipment are associated with maintaining a tight connection that is properly secured and will not be pulled out when moving the astrograph/mount throughout its entire range of motion. Loose electrical connections contribute to intermittent communications with the electronic devices in your imaging train, i.e., CCD camera, filter wheel, focuser, field rotator, etc. Cables snagging on miscellaneous AIS mechanical parts can also ruin a perfect exposure. This is especially aggravating when making extra-long 10–20-min exposures. Ensure that any cables are properly trained and secured and that the connections have the proper level of strain relief. Ensure that the telescope can be moved about its full range of motion without snagging any cable or other equipment.

6.12 Flat Field Panels

A *flat field panel* is used in calibrating your images. This panel provides a uniform wide-spectrum, low-level light source for creating "flats" for calibrating your imaging system. To help you understand the purpose of the flat field panel, a simplified explanation of an image calibration is introduced at this point. This is discussed in greater detail in Chap. 11, Sects. 11.5 and 11.6, but this introduction makes it clear why a flat field panel would be a very useful device to have around. There are two types of flat field panels. One is sometimes called a flat field light-box; a source of light is reflected around a couple of corners to disperse the light into a uniform illumination, and the device is placed over the end of the astrograph. The other is an electroluminescence panel; it is used to provide a wideband light source directly to the astrograph and is placed at the opening of the astrograph. You can find details on how to construct your own light-box by searching the Internet.

Each pixel in your CCD camera must be adjusted for three characteristics to provide a calibrated value for purposes of photometric measurement: bias, dark current, and span, or as it is referred to in a two-dimensional system, flatness (Fig. 6.15). Consider a single pixel in the array as a channel. This channel is designed to respond to light in a linear fashion and can be characterized by the basic linear equation:

$$Y = mX + b \qquad (6.3)$$

For purposes of the channel calibration, Y is the normalized response, X is the raw count input, m is the relative gain, and b is the bias. There is also the time-dependent term called dark current that is a basic characteristic of CCD chips (see Chap. 4, Sect. 4.3). Dark current is similar to the bias term in that it adds to the output but instead of being a static value, it accumulates depending on the length E of the exposure. Therefore, the equation is really:

6.12 Flat Field Panels

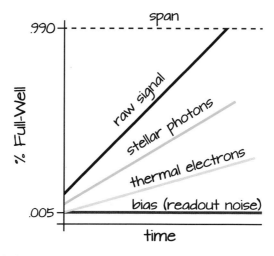

Fig. 6.15 An individual CCD pixel channel's parameter response curves (Courtesy of Rachel Konopa)

$$Y = mX - B - E\,(I_{dark}) \quad (6.4)$$

with the bias and dark current subtracted to correct the normalized output.

The bias term is measured by taking a zero second exposure (or as close as practical) with the camera shutter closed and calculating the mean raw input X_{zero} value of all the pixels:

$$B/m = X_{zero} \quad (6.5)$$

The I_{dark} term is measured the same way by taking a 60-s exposure with the shutter closed and calculating the average dark current per second using the following equation:

$$I_{dark}/m = (X - X_{zero})/60\,\text{seconds} \quad (6.6)$$

The I_{dark} is proportional to the average 60-s exposure raw amount minus the zero-second exposure raw amount divided by the number of seconds for the exposure. I_{dark} is reported in terms of the amount per second. The units of the amount reported are discussed later. That leaves only the m term. To measure the response of each pixel, you need a non-zero signal that provides an input that is close to the upper range of the pixel's response but still in the linear range of the sensor. A flat field panel provides that input light signal to which you expose your CCD to get a value for each pixel.

You make a couple of major assumptions when you use a flat field panel to make your photometric measurement. You will consider these assumptions in the future and compensate for them, but for now, it is enough to treat them as true enough.

Fig. 6.16 A flat field image showing the various defects, including vignetting and dust donuts

First, each pixel in your CCD is considered to have the same response to the wavelength range of interest, mainly 4,000–7,000 angstroms (Å). That means that the response curve for this wavelength range is identical for each pixel. The second assumption is that the output of your flat field panel is absolutely uniform across the panel, and the broadband wavelength output covers the CCD's response range. Future chapters cover techniques to get as close to the second assumption as you can.

Once you have satisfied yourself that these two assumptions are substantially true (within 2%), then you can expose your CCD camera along with the complete imaging train and astrograph optics as it is configured for operation. This is very important because when you do this measurement, you measure the combination of effects that are introduced into your AIS, including vignetting, dust motes, collimation, etc. Only in this way can you compensate for all of these effects on your images.

If you are thinking ahead, you recognize that you need to take these flat frames using your flat field panel every time you set up and configure your AIS. Yes, that is absolutely the case if you want to get the best photometric measurements possible. So how does this calibration actually take place? If you look at the output of each channel or pixel, you see that with a fixed given input value, which you really do not know, the output is slightly different. You see all kinds of effects if you look at the flat field image (Fig. 6.16), including vignetting (a dimming of the edges of the frame) and dust motes in the shape of little donuts if you are using a reflector astrograph.

Each of these defects affects the star images across your "light" frames and needs to be compensated for or removed. This is where you apply your flat frame to your light star image frame. One more thing needs to happen before you apply your flat frame to your light frame to calibrate it. A normalization process needs to take place to the flat frame to apply it to the light frame. Consider two pixels—one is affected by a dust mote, and the other is not. Therefore, the calibrated flat value

for pixel 1 is 43,400 and for pixel 2, it is 44,500. Further, the mean pixel value is 44,000. Remember that because it is assumed that the response of all the pixels is identical, and the source of the light impinging on each pixel is the same, then each of the pixels should have responded with a value of 44,000. Now nothing is perfect, so you should begin to see the purpose of flat fielding the image. You need to compensate for the defects in your image by multiplying or dividing the light image by the normalized flat field image.

You normalize each of the pixels by dividing the individual pixel values by the average value of all the flat field pixels. For pixel 1 in the example, you get a value of 43,400/44,000 or 0.9863, and for pixel 2, you get a value of 44,500/44,000 or 1.0114. This tells you that pixel 1 is low and pixel 2 is high. You need to divide the normalized pixel 1 and 2 values into the light frame pixel values to compensate for the dust motes and vignetting that is common to this specific AIS configuration. To check this, you can take your raw flat frame and divide it by your normalized flat frame and the result should be a uniform frame with all pixels with a value of 44,000. I leave this to you to ponder and perform as an exercise in the future.

In summary, the flat field panel provides a source of uniform light input to your AIS, compensating for all the image defects that exist in any system to provide the best data you can get for making high-precision photometric measurements.

6.13 Auto-Guider Systems

An *auto-guider system* is a support subsystem of the AIS that is used to compensate for right ascension (RA) tracking rate errors, and also when the mount is not perfectly polar aligned for the resulting declination (DEC) and residual RA drift that occurs. This system is made up of an optical input to a *guide camera*—either an *off-axis guider* (OAG) or a separate guiding telescope or *guidescope*. The basic function of an auto-guider system is to quickly image a selected guide star, measure its position on the CCD, calculate the change in position caused by mount alignment and other errors, and provide a correcting input to the mount. The devil, of course, is in the details, and there are several basic inputs and functions needed to make this subsystem perform correctly.

First, you must provide a suitable guide camera coupled to some sort of optical input. A guide camera operates in a video mode that typically provides up to 10 frames per second for monitoring the guide star's position. It also provides an output connection that has a standard *Autoguider Connection* interface to the mount. Alternatively, for some advanced mount drivers, the ASCOM-compliant pulse-guiding signal can be used.

To mechanically support the guide camera, two types of optical input are used. An OAG is a device that is placed between the main astrograph optics and the main CCD imaging camera. A prism inside the OAG picks off a portion of the light from the main astrograph objective that is outside the main imaging frame. The light from a star in the pick-off prism is presented to the guide camera and monitored for movement.

Another way to provide guiding is to couple a separate guide telescope (guidescope) to the guide camera to provide a guide star to monitor. The main disadvantage of a separate guidescope compared with the OAG is that there is a possibility of differential flexure between the main optical imaging train and the guide imaging train. Remember, the mount is tracking according to the guide camera and guidescope in this case, not the main telescope; therefore, any movement between the main telescope and the guidescope results in non-round star images. Therefore, the coupling between the main telescope and the guide telescope must be as tight and flexure free as possible. The OAG bypasses this issue by using the same optical train as the main imaging train. However, the problem with using an OAG is that it may be difficult to find a suitable guide star in the limited FOV of the prism that is bright enough to use effectively as a guide.

The guiding software used provides a way to connect the camera to the computer and also for the computer to calculate and issue guide commands. These commands go through the camera to the mount using the Autoguider Connection, or alternatively by using the pulse-guiding feature of the mount's ASCOM interface directly from the computer system to the mount. When operating the system, you first start your software, make the connections to the camera and telescope mount, and select a guide star. Once that is confirmed, you start the automated calibration routine of the software. This is done so the software can measure the mount's response to guiding inputs and calculate the proper guiding constants to control the mount. Once the automated calibration is complete, the software typically starts the guiding process while locked onto the star selected. There are choices available for using either the Autoguider Connection or the ASCOM pulse-guiding input for controlling the mount, for selecting the various constants to tune the control algorithm of the guiding system, and for setting the frame rate for updating the position of the mount.

Be sure to read and understand the help file provided by the maker of your guiding software and make sure you have all the necessary components before use. It would also behoove you to put the system together during the day to understand fully how it integrates into the rest of your AIS before use.

6.14 Precision RA Drive Correctors

To get the best long-exposure images for faint minor planets, nebulae, and galaxies, you need to have the best tracking available. Usually, this involves a guidescope and camera to lock on and track the sky accurately, as discussed previously. The alternative, necessary for a quicker setup and less hassle during your imaging session, is to make sure you have the best performance from your mount without having to guide. As discussed in Chap. 5, Sect. 5.5.3, the precision encoder-driven RA rate corrector, or drive corrector, is another option to accomplish this (Fig. 6.17).

Most, if not all professional-level mounts use encoders to provide feedback to the RA and DEC axes to ensure sub-arcsecond tracking rate precision. This

6.15 Power Supply

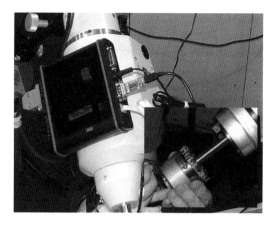

Fig. 6.17 The Telescope Drive Master (TDM) encoder-driven, drive rate correction system

technology has finally made its way down to the amateur level where one can obtain drive rates with a typical tracking error of less than ±1.0 arcsecond. Coupled with an accurate polar alignment, this level of performance allows you to very easily take *unguided* exposures of at least 3 min and up to 5 min. If you want to take images with exposures up to 10 min, then a very accurate polar alignment is required—achievable with about 30 minutes of work if you are practiced in it. Precision polar alignment techniques are discussed in Chap. 10, Sect. 10.4, and in FPE Chap. 12, Sect. 12.2.5.

6.15 Power Supply

Your AIS power supply is a very important part of your system and should not be undervalued as a major contributor to the success of your AIS operations. Using a robust, reliable, power supply means not worrying about intermittent electrical/electronic problems with your AIS, and being able to complete all of your session's goals without premature shutdown of your AIS caused by power issues.

There are three choices for powering your AIS: batteries (12 V direct current (Vdc)), house power (120 V alternating current (VAC)), and portable generator (120VAC). House power is generally the most reliable, but is the hardest to come by unless you are within a 100 ft of your home. Batteries are portable but very heavy, and susceptible to problems at low temperatures, and so must be kept warm for the best performance. Portable generators are very convenient, but are rather expensive for the capacities needed for good operation of all the AIS equipment.

Your power supply's capacity specifications should allow your AIS to operate for 10 h. This means, for example, that if you are using a battery system, and your

AIS equipment (including laptop, external hard drive, cameras, filter wheels, USB hubs, everything electrical/electronic) draws 10 amperes (amp) @12 Vdc, then you need a battery of at least 100 amp-hour capacity. A portable generator for the same system would need to be able to provide a continuous 250–400 W @120 VAC. It is best to oversize your power supply capacity because during the coldest observing sessions, any system only provides at best, 50–60% of its rated capacity.

A reliable power supply goes a long way toward minimizing the frustration that a power problem with any of your AIS electrical/electronic components causes. USB hubs are notorious for their sensitivity to power supply voltage issues, as are mounts and cameras. Along with the proper capacity and voltage, the power connectors that are used to supply the proper voltage to each of your components need to be very robust and secure. If you have any intermittent power issues, you can assume that the connector is the prime suspect. Always check and verify your connections before powering up your components. Also, make sure that the power connectors are secure when you swing your mount throughout the entire expected range of RA and DEC axis movement as part of balancing your astrograph.

Further Reading

Arditti D (2008) Setting-up a small observatory. Springer, New York
Berry R, Burnell J (2005) The handbook of astronomical image processing. Willmann-Bell, Richmond
Buchheim R (2007) The sky is your laboratory. Springer, Berlin/Heidelberg/New York
Chromey FR (2010) To measure the sky. Cambridge University Press, Cambridge
Covington MA (1999) Astrophotography for the amateur. Cambridge University Press, Cambridge
Dragesco J (1995) High resolution astrophotography. Cambridge University Press, Cambridge
Dymock R (2010) Asteroids and dwarf planets and how to observe them. Springer, New York
Harrison KM (2011) Astronomical spectroscopy for amateurs. Springer, New York
Henden AA, Kaitchuck RH (1990) Astronomical photometry. Willmann-Bell, Richmond
Howell SB (2006) Handbook of CCD astronomy. Cambridge University Press
Smith GH, Ceragioli R, Berry R (2012) Telescopes, eyepieces and astrographs. Willmann-Bell, Richmond

Web Pages

http://www.telescope.com/
http://www.astronomics.com/
http://www.optcorp.com/
http://telescopes.net/
http://www.starrywonders.com/equipment.html
http://preciseparts.com/ppmain/index.html
http://www.baader-planetarium.com/

Chapter 7

Astrograph and CCD Camera Combinations

7.1 A Marriage Made in Heaven

Matching your astrograph to your charge-coupled device (CCD) camera and integrating them using the various mechanical, optical, electronic, and software components is a skill that maximizes the efficiency of your Astronomical Imaging System (AIS). It is important not to underestimate the value of this step on your way to excellent imaging and high-quality scientific results. After all, a cost-efficient, well-designed AIS is not only a thing of beauty, but a tool of science that by virtue of its careful design will minimize the frustrations often encountered by the astrophotographer.

Once you have established your observing program using the Observing Program Design Basis (OPDB) discussed in Chap. 2, Sect. 2.2, and in Chap. 15, then you will have a guiding basis for choosing the astrograph and CCD camera suited to your purpose. You also have a good idea what supporting components you need to integrate your system. This chapter includes several rules of thumb to help in selecting your components.

7.2 A Purpose-Driven Design

Every component of the AIS you select should contribute to the overall goal of your observing program. You should not add any component to the system that does not have a purpose or enhance the quality of the data you expect to get. One of the

surest ways to maximize your efficiency and minimize the time you spend adjusting your equipment is to simplify your setup as much as possible. The following example also shows you how a design choice may allow you to accomplish the desired result by changing your technique and thus doing without a component. You make the call.

Suppose your goal is to do high-resolution imaging of planetary nebulae, such as the Ring Nebula M57. In this case, you want to image the faint 14.7 magnitude (mag) central star and do some physical measurements on the size of the ring structure. The structure of the ring's outer shell is about 230 arcseconds (arcsec) across, according to references, but you are interested in measuring how circular the ring really is and measuring its eccentricity. You have decided that you want the uncertainty of the ring measurement to be ±1.0 arcsec, and you want to make measurements every 30 degrees (°) around the ring. There are several assumptions and defining requirements in this measurement, and you have decided to attempt this with your 200-mm Schmidt-Cassegrain telescope (SCT) and 1.4-megapixel thermo-electric cooler (TEC) CCD camera. Here is your list of requirements:

Mount	Excellent intrinsic tracking ability, added guidescope to enable 5-min sub-frames
Astrograph	200-millimeter (mm) SCT, 2,000-mm Focal Length (FL), *f*/10 Prime Focus
CCD camera	ATIK 314e TEC, 4.65 micron (μm) pixels, 1,391 × 1,039 pixels
Filter	V-band photometric
Prime focus image scale	0.48 arcsec/pixel
Field of view (FOV)	667 (arcsec) × 498 (arcsec), 11.12 (arcmin) × 8.30 (arcmin)

The *prime focus* image scale, coupled with seeing of 2–3 arcsec, provides enough resolution to make the astrometric measurement of the central star to within ≤0.1 arcsec. The total exposure time should be adjusted so that the photometric measurement of the central star has a signal-to-noise ratio (SNR) of 100 using the V-band photometric filter.

The difficulties in this setup involve the pointing accuracy of the mount because you are imaging a very small FOV. This can be handled by synchronizing your mount to the star Vega, which is very close to M57. In addition, you need to use a guiding system based on the length of the desired exposures (5 min). An alternative design choice is to take many 1-min exposures if your mount can track accurately over the 1-min period. This would enable you to omit the requirement for a guiding system. You could do this because you are not as concerned about getting the most accurate photometry, where minimizing the readout noise in your images is important. Only minimal calibration of the images is necessary because you are mainly doing accurate astrometry rather than trying to make accurate photometric measurements.

7.2 A Purpose-Driven Design

Flat-fielding may, or may not be necessary depending on the SNR of the faint outer envelope of the shell. Simply subtracting a dark calibration image from your lights should be sufficient. (Chap. 11, Sects. 11.5 and 11.6, discuss how to calibrate your images.) As long as you obtain an SNR of at least 100 on the central star, you have met your requirement. The astrometry is important because you use it to accurately calculate your image scale and the exact FL of your imaging setup. Using this data, you can then make the measurements you desire and easily be able to determine the diameter of the Ring Nebula's outer shell with an uncertainty ≤1 arcsec.

As you can see from this example, the goal has been used to drive the design of the AIS to maximize the quality of the data obtained from the system. The example has also identified the issues and mitigated them through effective techniques or added components. (Chap. 8 deals with the time of year and the weather impacts that you may confront during your observation.)

It is important to recognize that to maximize the quality of your data, you need to be able to configure your AIS specifically for the objects, and/or measurements of interest. Using a fixed configuration that does most things well and some things not so well does *not* allow you to maximize the quality of your data. Of course, maximum flexibility comes from having components available to reconfigure your AIS imaging train, but you can work up to this level of flexibility over time. Start simple with your observing program and AIS configuration, and then over time, as you develop your interests, invest in those components that add value and quality to your data.

7.2.1 Deep Sky Imaging

As you saw in the previous section, there may be specific components you need to configure for the deep sky objects you want to image. There are three different kinds of deep sky imaging you can do: High Resolution, small FOV (less than 10×10 arcmin); Very Large FOV (greater than $1 \times 1°$); and High Resolution, medium FOV (less than 30×30 arcmin). An additional variable is based on the range of magnitudes of the objects you want to image, recognizing that as you image fainter objects, the astrograph objective must be larger, the FL of the astrograph must be longer, and consequently your FOV becomes smaller. So, the first two Rules of Thumb are:

> Dimmer Objects Require: Larger Objectives → Smaller FOV;

however,

> Dimmer Objects Require: Larger Objectives and Shorter FL → Larger FOV

Let's examine a couple of examples. Presented here are the results of calculations that you can do as described in Chap. 5 and illustrate the "what-if" scenarios for different observing goals.

7.2.1.1 Wide Field 200-mm Astrograph

GIVEN:

For an FOV of $\geq 1 \times 1°$, with a magnitude requirement of 13 mag at an SNR better than 100, and a 60-s exposure, a 200-mm $f/10$ objective is required. You want to use your ATIK 314e TEC CCD camera with a pixel size of 4.65 µm, and $1,391 \times 1,039$ pixels if possible, and your 200-mm SCT. Because you know you want an FOV of $\geq 1 \times 1°$, you need to calculate your image scale (using the information in Chap. 4) and from that determine your FL and focal ratio. You need to spread out the long side of your camera chip to equal 1°. One degree divided by 1,391 pixels is equal to 0.0007189°/pixel, or 2.588 arcsec/pixel. (Remember there are 3,600 arcsec per degree.) Now that you know the pixel scale to meet your FOV requirements, you can calculate the required FL from the image scale Eq. 4.11:

$$\text{Focal Length (mm)} = \frac{206.2648 \cdot 4.65}{2.588} = 370.6 \quad (7.1)$$

The focal ratio would be 370.6/200 mm, or $f/1.85$. As you can see, this focal ratio would be very hard to obtain with a 200-mm SCT; therefore, you must change your astrograph design specifications. You have no choice with the camera—it is the only one you have. The best you can do with your 200-mm telescope is $f/3.3$ using a 0.33× focal reducer. So what would your FOV be at $f/3.3$? First, your FL would be 200 mm · 3.3, or 660 mm. By using that value, you get the number you need:

$$\text{Image Scale (arcsec/pixel)} = \frac{206.2648 \cdot 4.65}{660} = 1.45 \quad (7.2)$$

Therefore, your FOV would be 1,391 pixels · 1.45 arcsec/pixel, or 33.6 arcmin on the long side, and 1,039 pixels · 1.45 arcsec/pixel, or 25.1 arcmin on the short side. If you use your f/3.3 system with the ATIK 314e camera, you can expect to get an FOV of 33.6 arcmin × 25.1 arcmin. This is equal to an FOV of only 0.23 degree2, less than a quarter of your desired FOV. Therefore, the only alternatives you have now, if you really want to achieve the $1 \times 1°$ FOV, is to increase the size of your camera by a factor of about four in terms of area and pixels. The ATIK 314e has a total of 1,445,249 pixels, and four times that would be about 6 million pixels. Starlight Xpress makes a very nice CCD camera, model SXVRM25C that is $3,024 \times 2,016$ pixels in size. The pixels are 7.8 µm and are more sensitive than the ATIK 314e pixels. If you were to adjust your calculations for the new camera, you would get the following, sticking with the f/3.3 focal ratio:

$$\text{Image Scale (arcsec/pixel)} = \frac{206.2648 \cdot 7.8}{660} = 2.44 \quad (7.3)$$

Therefore, your FOV would be 3,024 pixels · 2.44 arcsec/pixel, or 122.98 arcmin on the long side, and 2,016 pixels · 2.44 arcsec/pixel, or 81.98 arcmin on the short side. If you use your $f/3.3$ system with the Starlight Xpress camera, you can expect to get a FOV of 123.0 arcmin × 82.0 arcmin. This is equal to an FOV of about

7.2 A Purpose-Driven Design

$2 \times 1.3°$; this FOV is much larger than you wanted, and the image scale is also a bit too large. Now you can see you need to adjust your FL again to better size your FOV and image scale. Let's use a 0.67× focal reducer instead of the 0.33× focal reducer. This changes your FL to 200 mm · 6.7, or 1,340 mm at $f/6.7$. The new image scale is:

$$\text{Image Scale (arcsec/pixel)} = \frac{206.2648 \cdot 7.8}{1340} = 1.20 \quad (7.4)$$

So finally, your FOV would be 3,024 pixels · 1.20 arcsec/pixel, or 60.5 arcmin on the long side, and 2,016 pixels · 1.20 arcsec/pixel, or 40.3 arcmin on the short side. If you use your $f/6.7$ system with the Starlight Xpress camera, you can expect to get an FOV of about $1 \times 0.7°$. This is equal to an FOV of 0.7 degree2, which is much closer to your original design requirement, and which you may be able to live with, as long as you purchase the new camera!

For this camera, it looks like you would need to use a 200-mm telescope with a slightly shorter FL to get an FOV less than $1 \times 1°$. You can calculate the desired FL but you need to figure out what the pixel scale is for a $1°$ length on the short side of the CCD FOV. If you divide $1°$ by 2,016 pixels for the short side of the Starlight Xpress camera, you get 1.786 arcsec/pixel. Substituting that value into your equation for FL, you get:

$$\text{Focal Length (mm)} = \frac{206.2648 \cdot 7.80}{1.786} = 900.8 \quad (7.5)$$

Therefore, for a 200-mm objective, you would need a focal ratio of 900.8 divided by 200, or $f/4.5$. With this configuration, your FOV would be $1.5 \times 1.0°$. This would be a very effective wide field system not only because of the FOV, but also because the image scale is a very good 1.786 arcsec/pixel. This would provide an image scale sufficient for accurate astrometry with fair to poor seeing in the 3–4-arcsec range, which is what you can expect most of the time. In this case, you would need to couple your CCD camera to a different telescope. Several manufacturers make a Newtonian astrograph with the desired focal ratio of $f/4.5$. The Orion 8-in. f/4 Newtonian astrograph may be the perfect beginner astrograph for this case, but it may not have the non-vignetting FOV necessary. Another alternative would be a 200-mm Ritchey-Chrétien (RC) with a 0.6× focal reducer. This would provide an $f/4.8$ focal ratio.

When using focal reducers, you must guard against the effects of vignetting. Depending on the type of astrograph you are using, it is more than likely necessary to use flat field calibration frames to compensate for the vignetting that occurs when using large CCD chip cameras. Some astrographs are more suited to wide field imaging than others are. RC Cassegrains have a larger imaging circle, whereas Newtonians usually have smaller imaging circles. Usually, you find that you have to trade off FOV with field flatness, although you can correct for some of that by using a dedicated focal reducer/field flattener combination. Other astrographs, such as the Corrected Dall-Kirkham (CDK) Cassegrain (Fig. 7.1), are already equipped with an internal optical corrector system.

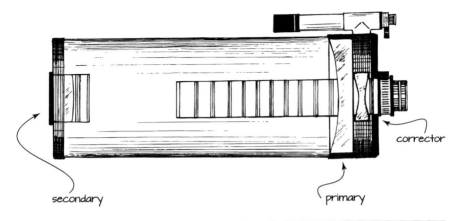

Fig. 7.1 The internals of the Corrected Dall-Kirkham (CDK) Cassegrain astrograph showing the baffling and corrective optics near the focuser (Image Courtesy of Rachel Konopa)

7.2.1.2 Narrow Field 200-mm Astrograph

Let's examine another example. Let's look at what it would take to image a very faint planetary nebula. In this case, you want to use your 200-mm astrograph at a fast focal ratio to get the image scale you need to examine small extended objects.
GIVEN:
For a desired FOV of 12×12 arcmin, with a magnitude requirement of 13 mag at an SNR better than 100, and a 300-s exposure, a 200-mm objective is required. You want to use your ATIK 314e TEC CCD camera with a pixel size of 4.65 μm, and 1,391×1,039 pixels if possible, and your 200-mm SCT. Let's start with a prime focus focal ratio of $f/10$ for the SCT. The image scale using the ATIK 314e TEC CCD camera would be:

$$\text{Image Scale (arcsec/pixel)} = \frac{206.2648 \cdot 4.65}{2000} = 0.48 \tag{7.6}$$

This appears to provide the resolution you need. The FOV would be 1,391 pixels · 0.48 arcsec/pixel, or 11.13 arcmin on the long side, and 1,039 pixels · 0.48 arcsec/pixel, or 8.31 arcmin on the short side. As you can see, the FOV of this configuration is 0.18×0.14°. This is close to your desired FOV of 0.2×0.2°, *but not quite.*

Because you know you want an FOV of 0.2×0.2°, let's figure out what each side would be for square images covering that size and then use that for the short side as a first cut for what you need. The short side of 0.2° is equal to 12 arcmin. The image scale, if you use the ATIK camera short side length of 1,039 pixels, would be 0.6930 arcsec/pixel. Using this value to calculate your FL,

$$\text{Focal Length (mm)} = \frac{206.2648 \cdot 4.65}{0.6930} = 1384.0 \tag{7.7}$$

How would you handle adjusting the FL of this 200-mm *f*/10 SCT from a value of 2,000 mm to approximately 1,400 mm? Is there an optical component available to change the effective FL of this astrograph to meet your design criteria?

7.2.2 Lunar, Solar, and Planetary Imaging

Unlike the deep sky case, when imaging lunar, solar, or planetary objects, three Rules of Thumb have the most impact on your success:

Bright Objects → Fast Exposures → Freezing Atmospheric Distortions

Bright Objects → Smaller Astrograph Objectives → Lower Seeing Sensitivity

Using Large Astrograph Objectives → Higher Resolution Imaging → Small FOV

Your goal of obtaining the highest resolution lunar, solar, or planetary images leads you to balance the need to minimize the seeing effects while boosting the image scale to values less than 0.2 arcsec/pixel.

In the case of deep sky imaging, you wanted a system with a focal ratio as fast as you could manage to help image those dim objects with the minimum exposure time. The opposite is the case with lunar, solar, and planetary imaging. Because you have bright objects to image, your main goal is to maximize the resolution while still being able to minimize the exposure time per frame. What this really means in a practical sense is you want a system with a slow focal ratio to boost the magnification for a given astrograph objective size.

Typically, the world-class imagers use focal ratios of *f*/30 to greater than *f*/45 in locations that have a high percentage of good to excellent seeing a majority of the time. Unfortunately, most of us are not blessed with excellent seeing very often; we are lucky to have it 10% of the time. You can typically count on having good or excellent seeing 40% of the time and fair to poor seeing 60% of the time. This varies during the year; summer is typically much better than winter. (Chap. 8 addresses this subject more in detail.) A focal ratio of *f*/32 is the most that you can comfortably use when seeing is good to excellent. When starting out, use your standard 2× Barlow lens. This typically provides a focal ratio of *f*/15–*f*/20 depending on your astrograph's native focal length.

Without a doubt, the biggest factor in acquiring the highest resolution images possible is the seeing. Excellent seeing of ≤1.5 (arcsec) is required when using the slowest focal ratios. Use Table 7.1 as a conservative guide to what to expect with a 200-mm astrograph.

As shown in Table 7.1, the seeing is rated from top to bottom: Excellent, Good, Fair, and Poor.

If you were to use a 127-mm refractor as your astrograph, Table 7.2 would apply. You can boost the focal ratio because the smaller objective is less sensitive to seeing effects while the image scale matches that of the larger 200-mm astrograph:

Table 7.1 Image scale for high-resolution imaging using a 200-mm astrograph

Suggested image scale (resolution) versus seeing for a 200-mm astrograph

Seeing value (arcsec)	Focal ratio	Focal length (mm)	Image scale[a]
0.5–1.0	>f/45–f/35	>9,000–7,000	<0.12–0.16
1.0–2.0	f/35–f/20	7,000–4,000	0.16–0.28
2.0–3.5	f/20–f/10	4,000–2,000	0.28–0.56
3.5 to >5	f/10–f/7.5	2,000–1,500	0.56–0.75

[a](arcsec/pixel), using a typical 5.4 μm pixel size camera

Table 7.2 Image scale for high-resolution imaging using a 127-mm astrograph

Suggested image scale versus seeing for a 127-mm astrograph

Seeing value (arcsec)	Focal ratio	Focal length (mm)	Image scale[a]
0.5–1.0	>f/50–f/40	>6,350–5,080	<0.15–0.19
1.0–2.0	f/40–f/25	5,080–3,175	0.19–0.30
2.0–3.5	f/25–f/15	3,175–1,900	0.30–0.51
3.5 to >5	f/15–f/7.5	1,900–950	0.51–1.0

[a]arcsec/pixel, using a typical 4.65 μm pixel size camera

Table 7.3 Video camera resolution

High-sensitivity video cameras for lunar, solar, and planetary imaging

Resolution	Frame rate (fps)	Exposure time (s)
640×480	Up to 60	Up to 1/10,000th
1,024×768	Up to 30	Up to 1/10,000th
1,280×1,024	Up to 15	Up to 1/10,000th

Less expensive webcam-based CCD cameras usually have a resolution of 640×480 pixels or 1,024×768 pixels, and a *frame rate* of 15 frames per second (fps). More expensive astro video cameras have much more sensitive CCD chips and come in color or monochrome. Typically, several choices are available from different manufacturers, as shown in Table 7.3. Exposure time is important for freezing the atmospheric seeing, and frame rate is important for minimizing the time between frames so that there is a smooth progression from one frame to the next. This is important for the software you use in processing and stacking your individual frames. The smoother the transition between frames, the more accurately the post-processing software can perform, and the higher quality the stacked frame becomes.

Usually, there are only a couple of ways to obtain the focal ratio necessary for high-resolution imaging—use a Barlow or Barlow type lens, or use a technique

7.2 A Purpose-Driven Design

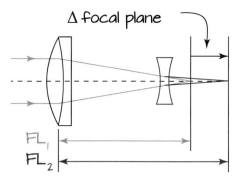

Fig. 7.2 The effect the Barlow lens has on the position of the focal plane of the astrograph (Image Courtesy of Rachel Konopa)

called *eyepiece projection*. Historically, Barlow lenses were limited to 2× or maybe 3× magnification, but technology has improved over the past decades. Improved optical components that provide up to 5× magnification are now available in the marketplace. Televue markets a product called the Powermate in both 1.25 and 2-in. sizes. The 1.25-in. size comes in 2.5× and 5× magnifications, and the 2-in. size comes in 2× and 4× magnifications. These optical accessories are very popular with amateurs doing high-resolution imaging of the Moon and planets.

Using a Barlow lens is not always the easiest method in terms of configuring your astrograph and CCD camera. Figure 7.2 shows how a Barlow lens affects the focal plane position of the astrograph–Barlow lens combination. As you can see, the back-focus position is extended, and the focuser on the astrograph must be able to accommodate the longer distance. Having a couple of extra focuser extensions available for your astrograph helps in working with such long imaging trains (Fig. 7.3).

Eyepiece projection is another technique that uses an eyepiece to project an image into a camera with a lens attached. You may be familiar with this technique, which is easily demonstrated by holding your consumer digital camera up against your telescope's eyepiece when you are visually observing the Moon or planets. This results in a high-magnification image not unlike that achieved by a Barlow lens. There are special mechanical devices you can purchase to attach and fix the spacing between your camera and eyepiece. Although eyepiece projection is not recommended for doing the highest quality imaging because of its very high magnification and somewhat shaky mechanical configuration, it is a fun activity when visually observing to capture a record of what you observed.

When imaging with a video camera, another control is very useful and affects how you process your videos. There is usually a control called gain among the settings for the video camera. This control is commonly used in conjunction with a display called a *histogram*. The histogram is used to ensure that your exposure is long enough to cover the brightness range of your camera. Think about it in terms

Fig. 7.3 90-mm x 25-mm and 90-mm x 50-mm extension rings for the Astronomy Technologies AT8RC Ritchey-Chrétien Cassegrain astrograph

of being able to fill the wells in the CCD pixels. You want the exposure to be long enough that you use most of the dynamic range of your CCD to minimize the amount of noise in each frame. By minimizing the noise in each of your frames, you maximize the SNR and maximize the quality of your video. In addition, when stacking your frames during the processing of your video, you minimize the number of frames you need to stack, using only the very best frames of your video for the final image.

By understanding how you plan to process your video, it becomes evident that you do not want to push the magnification too much, regardless of the excellence of the seeing. You still need to have enough signal, at a high enough SNR, to be able to get good-quality results. The trick is balancing these factors to maximize your performance to get the best, highest resolution images that the conditions allow. One other thought to keep in mind: high resolution is not defined as the absolute highest resolution. It is the highest resolution that the astrograph and CCD camera you are using can achieve. This means being able to resolve features at the *diffraction limit* of the astrograph you are using. In the end, this should always be your goal.

7.3 Maximizing Your Results

Using a defined process and being disciplined and consistent in performing your procedures is key to maximizing your results. When problems occur, understanding your expected results at each step, and being able to detect where in the process the

issue occurs, helps to minimize the time spent troubleshooting the issue. Well-developed checklists help tremendously in this respect. The checklist is meant to help you develop discipline in learning how to configure, set up, and use your AIS. Once the necessary habits and discipline are instilled within you, then the checklists provide a reference, and when necessary, a guide to help troubleshoot problems that may occur in the future.

When considering how to document your process, ensure it is simple and concise, and consists of only those critical steps necessary for success. A checklist offers the best combination of conciseness and completeness in providing instructions for completing the process in a disciplined manner. The checklist should consist of actions and expected results and optionally, recovery actions. It should also contain any supporting data necessary for configuring your system. The following is an example process checklist for configuring and setting up your imaging train. As you can see, it is organized to help you record the necessary information for performing the setup in a consistent manner. Once the checklist has been tested and validated results obtained, it ensures that nothing is left to chance.

7.3.1 Example Imaging Train Setup Checklist

Purpose: To set up imaging for deep sky minor planets

Section I: Components

- ATIK 314e TEC CCD Camera
- Orion 2-in. Flip Mirror Assembly
- AstroTech Focal Reducer/Field Flattener
- Moonlite Precision 2-in. Focuser
- AstroTech 8-in. RC Cassegrain Reflector with 2-in. Extender
- Maxim DL Image Capture and Focus Control Program

Section II: Measurements

- Total Backfocus Distance: 223 mm
- Focuser Length 93 mm
- Extension Length 50 mm
- Focus Position Counts: $\approx 6,500$

Section III: Checklist

Action	Expected result	Actual result
1. Gather and check condition of components	All components are in satisfactory condition	[] Satisfactory [] Unsatisfactory—resolve issue with bad component
2. Assemble components into imaging train (except focuser, which is mounted on astrograph separately)	All components mate up and fit as desired, and the measured length matches the desired length of 80 mm (±2 mm)	[] Satisfactory [] Unsatisfactory—ensure components are mated securely and not cross-threaded or out of place
3. Mount 2-in. extender on AT8RC	Extender threads on smoothly without any hang-ups or snagging. The extender is snugged up firmly without being too difficult to remove	[] Satisfactory [] Unsatisfactory—ensure extender is not cross-threaded
4. Mount Moonlite focuser onto 2-in. extender	Focuser threads on smoothly without any hang-ups or snagging. The focuser is positioned so that the stepper motor is on the right-hand side	[] Satisfactory [] Unsatisfactory—ensure the focuser is not cross-threaded. Use the focus rotate lock to reposition stepper motor
5. Mount assembled components onto Moonlite focuser by loosening the three barrel screws, inserting the 2-in. imaging train barrel, and then tightening the focuser barrel screws snugly. Ensure the imaging train barrel is square to the focuser	Imaging train assembly is square to the focuser and fits completely up against the focuser. The three barrel screws are snug but not overly tightened. The imaging train does not move or come out when astrograph is pointed to zenith	[] Satisfactory [] Unsatisfactory—ensure the imaging train 2-in. barrel is fully inserted and up against the focuser. Ensure the imaging train does not move when astrograph is pointed to zenith by tightening the three barrel screws on focuser

Section IV: Notes/Comments

If it is necessary to reconfigure the imaging train in the dark, try to place the astrograph in a safe condition: Park the mount and move the focuser position to zero (0) counts before disassembly. *CAUTION:* Take care in unthreading and threading the extender(s) and/or focuser on and off the AT8RC astrograph because there is a possibility of cross-threading.

As you can see from the above example, the checklist covers the necessary actions and provides notes on expected results and critical steps to ensure success. Having a documented process, and following it after validation, minimizes the time and effort to set up and use your AIS. Also, of more significance, it helps minimize

the frustration that can come from using a random approach to set up your AIS. Remember, every component and configuration parameter has a specific role in maximizing your results. If you do something just because you like the way it looks, or it's easier, then you are short-changing your performance.

Once you have used the checklist(s) a few times and are very familiar with the various processes, then you do not need to directly follow the checklist(s). At that point, you can refer to them if you need to or if you run into problems. Other checklists are presented in Part II Chap. 12—Field Practical Exercises (FPE). Using these checklists produces consistent results and maximizes your performance.

7.4 Case Studies: Two Typical Combinations

This section discusses two typical astrograph/CCD combinations. No checklist is provided, but the components and their characteristics are specified, as necessary, to calculate the required parameters (FL, image scale, FOV, etc.).

7.4.1 Case 1: Wide Field Bright Star AIS

AIS Purpose: This astrograph/CCD combination is designed to quickly image a large section of the sky and provide data to accurately measure selected bright variable stars. The measurements are made in the photometric V-band. This AIS is capable of measuring stars from 4 to 8 mag with exposures of less than 30 s in the V-band. The SNR is better than 50 at 8 mag. This AIS is also capable of measuring exo-planet transits for selected bright stars with brightness greater than 6 mag at a SNR better than 100.

AIS equipment	
Astrograph	80-mm APO Triplet Refractor
	f/7.5, 600 mm FL, 2-in. Field Flattener
CCD camera	TEC CCD with Kodak 8,300 chip
	3,348 × 2,496 pixels, 5.4 μm × 5.4 μm pixel size
Image scale	= 1.86 arcsec/pixel
FOV	= 103.79 × 77.23 arcmin
	= 1.73° × 1.23°
	= 2.12 degree2

With an average seeing value of 3 arcsec, this system is set up to critically sample at 1.6×. The stars would be spatially under-sampled for accurate photometric measurements. It would be necessary to de-focus the image slightly to sample at the desired 2× to 2.5×. If your seeing is normally in the 4 arcsec range, then the sampling would be about 2.2×, which is perfect for this application.

Fig. 7.4 The American Association of Variable Star Observers (AAVSO) Bright Star Monitor (BSM) astrograph (Image Courtesy of AAVSO)

Now that you have specified the astrograph/CCD combination, you can see that because you have a reasonably large image scale coupled with a requirement to sample only bright stars, you can get by with a mount that tracks accurately for ≤30 s. This means that you may be able to forego using an auto-guiding system and rely only on the intrinsic ability of the mount to accurately track the objects of interest. This is a good thing if you can get away with it because it minimizes your setup time, minimizes the amount of equipment needed to accomplish your goal, and maximizes your effective imaging time.

The AIS described in Case 1 is a good example of a system that is inexpensive and can provide scientifically useful data on stars that are not monitored by the professionals. A large amount of data can be gathered in a reasonably short period of time. A very similar system is used by the Association of Variable Star Observers (AAVSO) in its telescope network AAVSOnet. It is called the *BSM* or *Bright Star Monitor* (Fig. 7.4). This system, which is used as described here, provides a wealth of data for the membership. More on the AAVSO is presented in Chap. 15, Sect.15.9

7.4.2 Case 2: High-Resolution Lunar Imaging AIS

AIS Purpose: This system is used to acquire high-resolution lunar images that record features of the lunar surface down to approximately 1.0 mile (1.6 kilometer (km)). This system enables the accurate measurement of mountain elevations and other topographic features such as crater diameter and Selenographic latitude and longitude.

One of the key aspects of making high-resolution lunar images is the impact that seeing has on the resulting image. One of the main ways to mitigate the effects of less

AIS equipment	
Astrograph	10-in. (250 mm) Schmidt-Cassegrain
	f/10, 2,500 mm FL, 2× Barlow—5,000-mm FL
CCD camera	Webcam-based video CCD
	640×480 pixels, 5.6 μm×5.6 μm pixel size
	60 fps, 1–1/10,000th s exposure
	Image scale=0.232 arcsec/pixel
	FOV=2.46×1.85 arcmin

than optimal seeing when doing high-resolution imaging is to increase the frame rate and decrease the exposure time. Using a large objective, in this case 10 in. (250 mm), helps in that regard by gathering more light than a 6-in. or 8-in. astrograph could provide. The larger objective also provides higher resolution *potential* than a 6 or 8-in. astrograph could provide. That, coupled with the 2× Barlow lens, provides an image scale at an effective *f/*20 focal ratio that ensures you meet your goal of obtaining images that can easily resolve craters down to 1.0 mile (1.6 km).

Because the FOV is very small, about 2×2.5 arcmin, you need to make sure your mount has a very good polar alignment so that any declination drift is minimized over the timeframe you are taking your video. You will also set your right ascension tracking rate to the "lunar rate" versus the "sidereal rate" available on your mount controller. If you do not do this, you will quickly realize that your object of interest is not staying put in your FOV! Typically, if you can maintain your object within the center quarter of your FOV over a timeframe of 60 s, then the polar alignment is sufficient. The goal is to take at least 1,000 frames, or if you can, 1,800 frames or more. This is obtainable at a frame rate of 60 fps, and 30 s total time. Exposure times are probably in the 0.005–0.010 s (5–10 millisecond) range. If the seeing is less than good, then using a red filter will help minimize the effects of the seeing on the resulting image.

As you can see in these two case studies, to get the best imaging data—professional-level imaging data—it is necessary to design your imaging train to fit the needs of the type of object you are studying. It is important that you set the requirements for the type and amount of data you need to accomplish your science goals and configure your AIS accordingly. Think of the AIS as the data acquisition equipment that is designed specifically for the science question you are trying to answer. This is discussed further in parts II and III.

Further Reading

Berry R, Burnell J (2005) The handbook of astronomical image processing. Willmann-Bell, Richmond
Buchheim R (2007) The sky is your laboratory. Springer, Berlin/Heidelberg/New York
Chromey FR (2010) To measure the sky. Cambridge University Press

Covington MA (1999) Astrophotography for the amateur. Cambridge University Press
Dieck RH (2007) Measurement Uncertainty. The Instrumentation, Systems, and Automation Society, Research Triangle Park
Dragesco J (1995) High resolution astrophotography. Cambridge University Press
Harrison KM (2011) Astronomical spectroscopy for amateurs. Springer, New York
Henden AA, Kaitchuck RH (1990) Astronomical photometry. Willmann-Bell, Richmond
Howell SB (2006) Handbook of CCD astronomy. Cambridge University Press
Smith GH, Ceragioli R, Berry R (2012) Telescopes, eyepieces and astrographs. Willmann-Bell, Richmond

Web Pages

http://www.starrywonders.com/equipment.html
http://www.dl-digital.com/astrophoto/TOA-130.htm
http://www.gregpyros.com/html/imaging_train.html

Chapter 8

Environmental and External Factors

8.1 The Sky and the Astronomer's Weather

When we talk about the sky, we are not referring simply to the view of the universe we see, but also to the Earth's atmosphere. When you look out into the universe, you are sitting at the bottom of a sea of gas called air, made up of about 78% nitrogen, 21% oxygen, and 1% argon. Air also contains several other trace gases. The atmosphere is made up of layers classified based on their air temperature and pressure. The various layers of the atmosphere have distinct characteristics and are named accordingly. The Earth's atmosphere extends up to about 100 km to where space begins. The bottom layer, where we dwell, up to about 50,000 ft, is the *troposphere*. The troposphere, which contains 80% of the bulk of the atmosphere, is where all weather takes place and where all the effects occur that you are concerned with as an amateur astronomer.

When you are observing the night sky, you must contend with the conditions that exist on the surface as well as high up into the troposphere. The natural heating and cooling that occurs in the atmosphere during the 24-h rotation of the Earth causes the atmosphere to roil and move. This movement gives rise to the atmospheric seeing conditions that you experience and observe through your telescope. Of course, you must also deal with all the other environmental conditions that the atmosphere produces, including low and high temperatures, wind, clouds, haze, etc. This chapter discusses these conditions and how you can mitigate their effects on your results.

8.1.1 What Are the Best Weather Conditions for Deep Sky Imaging?

When you consider what an astronomer would like the sky conditions to be in a perfect world, no atmosphere would be the best. Of course, as one amateur astronomer quipped about his desire for perfect seeing, "…I could just as well live without the atmosphere, except for the breathing part!" Space telescopes take advantage of this because they are located far above the atmosphere and therefore are not influenced by atmospheric seeing. Locating your remotely operated observatory on the Moon would be a good alternative—if it were not so expensive!

For scientific, deep sky imaging purposes, a very stable, steady atmosphere is a primary requirement, and a very transparent, clear atmosphere is a secondary requirement. This requirement is different when doing "pretty picture" deep sky images—a very transparent, clear atmosphere is necessary to get the longest exposures possible. Transparency in the context of scientific deep sky imaging is not the primary concern because even though a hazy atmosphere may limit the length of your exposures because of the brightness of the sky background, there are image stacking techniques available to minimize the effects of lowered transparency. What you gain by having a more stable, slightly hazy sky is much better seeing, which allows you to get those very tight star images that you desire and contributes to being able to see dimmer objects. Ironically, you may be able to see fainter objects even though the sky is less transparent. This is because you can concentrate more light into a smaller area on your charge-coupled device (CCD), which increases your signal to noise ratio even though the signal may be slightly attenuated because of the lowered atmospheric transparency.

Because you do have to deal with the environmental and atmospheric conditions that are presented to you, you should understand that all is not lost. Occasionally, very good conditions enable you to complete your work effectively. In addition, you can take advantage of certain locations on the planet that help you get above a good portion of the atmosphere, and they are, of course, on top of mountains. The ideal atmospheric conditions include a stable high pressure system; skies that are maybe not perfectly transparent, but have a stable, high altitude haze; and a location where the temperature does not fluctuate or change that much during the 24-h day. A location near a large body of water helps to maintain a steady temperature during the day and evening.

The atmosphere during the summer is typically more conducive to better seeing and better environmental conditions than the winter. The summer temperatures allow the atmosphere to retain more water, which stabilizes it and helps it to resist temperature changes because the energy required to condense and vaporize water is greater. In the drier air of winter, temperatures can change much faster and contribute to the bad seeing you experience during that season.

8.1.2 What Are the Best Weather Conditions for Lunar, Solar, and Planetary Imaging?

Although the approach for obtaining the best lunar, solar, and planetary images (very short exposures, high magnification) is very different from deep sky work, the perfect weather conditions are the same for both. The atmosphere affects your images in the same way by smearing the detailed features you want to capture. If you have a stable atmosphere, you can better resolve those small details that would otherwise be lost. Therefore, the same environmental conditions that you want for deep sky imaging equally apply to high-speed imaging.

In addition, the warmer temperatures that are the source of more stable air contribute to your comfort while sitting out under the stars. You can much more easily tolerate the long sessions when you are comfortable and do not have to struggle to keep your hands and toes warm or to make that adjustment with gloved hands.

8.2 Sources of Weather Data

Today, access to complete, accurate, and up-to-date weather data is easy. Literally hundreds of sources provide weather data applicable to all the different activities we pursue on a daily basis. When choosing a source for your weather information, you need to consider the reputation of the source, the forecasting accuracy, and the specific weather products or information provided and how they apply to your needs. There are specific weather measurements to help you directly understand what impact the environmental conditions will have on the imaging data you acquire.

8.2.1 General Weather Sources

When making plans for your observations, it is good to start early and check the weather forecast a few days ahead of time. Actually, once you start watching the weather, you should do it daily, looking for those future opportunities to observe. Usually, when good observing weather is in the future, it starts showing up in the 5-day forecast. Although several weather services provide forecasts up to 10 days, do not rely on them. They are not accurate enough that far into the future, and they typically miss short-term weather events that occur more frequently in the summer.

The 5-day forecast gives you a general view of weather, including whether the specific day will be cloudy or windy, and provides you a reasonably accurate indication of the temperature range during the day. The forecast high–low temperature range is a good indication of the amount of moisture that the atmosphere may

contain and of the stability of the atmosphere in general. A high–low temperature difference of 15° is generally an indication of a more stable atmosphere compared with a high–low temperature difference of 25°. If the daily high–low temperature difference is more than 30°, then you can probably expect poor seeing and perhaps windy conditions.

When the weather forecast 2 days ahead of your scheduled observations shows sunny conditions, a high–low temperature range of less than 20°, and little to no wind, then you can be confident that it should be a very nice evening for observing. At this point, you can begin to look at the temperature dew point spread to get an idea of the humidity. Generally, the smaller the difference between the temperature and dew point, the more stable the air is and the higher the humidity. Because the bulk air temperature affects the amount of water that the air can contain, as the air temperature drops, the amount of water it can hold drops. Because the amount of water in the air generally stays about the same over a 24-h period, the temperature drop during the evening results in a higher relative humidity value during the evening compared with the middle of the day. A higher humidity value also contributes to a more stable atmosphere.

There are several good sources for general weather information, but the biggest and most used is probably The Weather Channel, available on cable television services, and its Internet counterpart, weather.com. These services are the most widely used and provide a good general overview of the weather conditions and forecasted weather. Weather.gov, Intellicast.com, AccuWeather.com, and WeatherUnderground.com also provide good weather information over the Internet.

If you are located in Europe, Asia, Australia, there are several general weather services available. In Europe, you can use the European Centre for Medium-Range Weather Forecasts (ECMWF) (www.ecmwf.int), also known as the Centre, which is similar to weather.gov in the United States and provides a wealth of weather information. For weather in the Middle-East, Asia, Australia, Africa and South America, the World Meteorological Organization (http://www.wmo.int) provides weather information for cities around the world.

8.2.2 Astronomy-Specific Weather Sources

Although there are very few astronomy-specific weather services, the two that are used the most are very effective and provide all that is necessary for planning the observing session. Attilla Danko provides an excellent service called the Clear Sky Chart (www.cleardarksky.com) (Fig. 8.1). This service aggregates several weather parameters into one color-coded chart that is very easy to understand and reasonably accurate. The information that Attilla uses is from the Canadian Meteorological Center (CMC) (www.weatheroffice.gc.ca/astro/) (Fig. 8.2). The CMC provides the raw data that feeds the Clear Sky Chart. The CMC provides the detailed national charts depicting the various factors as a separate service.

8.2 Sources of Weather Data

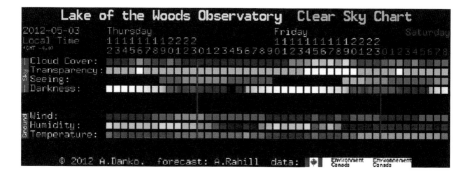

Fig. 8.1 The Lake of the Woods Observatory (MPC I24) clear sky chart (Courtesy of Attilla Danko, creator, Clear Sky Chart, based on Environment Canada data)

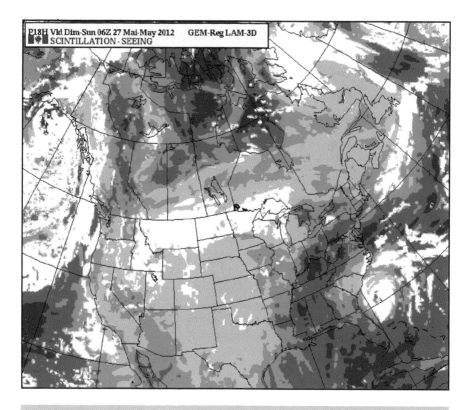

Fig. 8.2 Canadian Meteorological Center scintillation-seeing chart for North America with the cursor located at the Lake of the Woods Observatory (Courtesy of and based on Environment Canada data)

The specific data displayed on the Clear Sky Chart includes Cloud Cover, Transparency, Seeing, Wind, Humidity, and Temperature. Also included is a darkness scale that takes into account the lunar phase and how it affects the sky brightness during the evening. Links are also provided to a light pollution map, Sun and Moon data, satellite images, and other astronomy-related information. Attilla's website provides all you need to understand the observing conditions at sites all over North America; there are more than 4,200 locations available, so there should be one within 15–20 miles of your observing location.

If you are located in North America, it is highly recommended that you become very familiar with The Clear Sky Chart and the CMC services because they provide excellent information when planning your observing sessions. Also, keep up with the various astronomy forums, such as Cloudy Nights (www.cloudynights.com), because they will probably be the first place that new astronomy weather services are announced or discussed. In Europe and Australia, there is the SkippySky Astro-Weather Forecast (skippysky.com.au/Europe). This service is similar to the service the CMC provides for North America. If you are located elsewhere, search the Internet to see whether you have local astronomers providing astronomy weather forecasts for your location.

8.3 Effects on the Observer

The environment affects everything you do in modern life, which is why when you have nothing else to talk about, you talk about the weather. The weather affects how you feel, what you can do when you are not sheltered, how active you are, etc. It is important that you mitigate the impact that harsh weather conditions have on you while trying to acquire the excellent image data you want. It would be great if you could observe only when the weather was good and had the least impact on you physically, but that is not typically the case.

One other aspect that greatly affects your work is the ability to see what you are doing. Because you do the bulk of your work in the dark, being able to see what you are doing when manipulating your equipment and protecting it from impact is important. Most astronomy clubs have documents about proper star party etiquette and what is permissible in terms of using flashlights and such. Because we are digital astrophotographers, we rely on our laptop computers for our work and concentrate on our instruments and not on visually acquiring our targets. It is important to be able to manipulate your equipment correctly and having good light helps in this regard.

I like to compare the difference between visual observers and those who take images to pilots flying visually and those using instruments. There are two sets of rules for flying aircraft, Visual Flight Rules (VFR) and Instrument Flight Rules (IFR). VFR governs flying when you can see the sky and your flight path is unobstructed by clouds and haze, and when you can readily identify any flying objects that you need to see and avoid. Just as you can visually identify and observe many

astronomical objects, the VFR pilot relies on his or her eyesight to do the same thing. It is important for the visual astronomical observer's eyes to be dark adapted and capable of viewing faint objects. However, as the Astronomical Imaging System (AIS) "pilot," you are "flying under IFR," and so because it is important that you see what you are doing, you are not necessarily concerned with maintaining your dark adaption. You can use a flashlight and any other light, as necessary to do your work.

Consequently, imaging work is not particularly well suited to star parties. If you insist on doing your scientific imaging work at a star party, resign yourself to covering up your laptop and any other light-producing gadget or piece of equipment you may have. Just as the IFR pilot is only concerned with his instruments and could really care less about seeing what is outside the windscreen, so is the scientific AIS operator; however, at star parties, he or she needs to be sensitive to the dark conditions needed by visual observers.

To progress in your study of the universe and be able to gain the skills and knowledge over a reasonable period of time, you have to do some observing in less than ideal weather conditions. Although the best imaging conditions may not exist when you are acquiring your imaging data, you can still make good use of the data that you do acquire, not just for meeting your observing goals, but for fine-tuning your equipment, procedures, and skills. Anytime you are out observing, you are one step closer to maximizing your skills through the efficient use of your AIS.

8.3.1 Observer Hot Weather Impacts

Hot weather occurs in most places and will occur during the summer months when the seeing is best. Sometimes the temperature will be very hot and the humidity will be high during the day. A nice day at the beach or pool is just what the doctor ordered to keep cool, but you also need to consider what goes along with it when you are sitting out under the stars in the evening.

The primary consideration if you are setting up your equipment during the late afternoon is to make sure you protect yourself from the Sun. Having a sunburn is not a pleasant experience, and long-term chronic exposure to the Sun without protection (sunscreen, appropriate clothing) can be the cause of skin cancers and other skin conditions. It is best to make plans to protect your skin if you will be doing any work on your equipment during the day out in the sun. Light, breathable clothing should be worn for comfort. A hat is recommended during the day. Eye protection is also recommended.

Hot, summer weather brings with it various bugs and flying insects that can be very annoying. Applying a bug repellent can be effective in warding off these pests, but be careful not to apply it when you are near your delicate mirrors; the repellant spray can coat your mirror and erode and degrade its coatings. There are repellant wipes available now that you should look for as an alternative to using the aerosol bug repellents.

Dehydration is a possibility when spending long hours under the stars; therefore, it is important that you keep plenty of water on hand to help maintain your body's hydration level. Take breaks to drink some water and eat a small snack during the session. If you have never experienced a close encounter between your food and drink and your equipment, I can tell you it is an experience not soon forgotten. It is important to keep any food or drink far away if you want to protect your investment in your equipment. Having soda dumped into an external hard drive or laptop computer keyboard is not a good experience.

If your observing site is at a high elevation, you will find that dehydration is a bigger issue. Drinking alcohol is not recommended during your observing session. Remember the goal is to have a good time acquiring your data and not expose your equipment to any unintended consequences of your partaking of an adult beverage.

If you are observing at a desert location, you will notice that the hot day gives way to a very cool nighttime temperature. Often, temperatures drop 40°F or more; therefore, you need to bring appropriate clothing to keep yourself warm. Deserts have other special issues that you need to address, and it is best to consult amateur astronomers who have experience observing in the desert.

Overall, just do what you can to keep yourself comfortable and protected from the sun and bugs. If you do this effectively, you will have a good observing session acquiring the best images possible.

8.3.2 Observer Cold Weather Impacts

It is interesting that most amateurs consider the wintertime to be the best time to look at the stars. That is still true in my case in that I still prefer the view of the stars on a cold dark winter night, when the sky conditions and the transparency are such that you feel that you can see forever and are connected with the environment that exists in cold, hard space. Unfortunately, this is precisely the season that brings the worst seeing and the hardest conditions to observe and to acquire images. As much as you might enjoy seeing the stars twinkle on a cold winter night, this is the worst time to try to do that high-resolution lunar or planetary imaging. The best you will get is a smudge of an image that is supposed to be Jupiter or Saturn.

When you are imaging, you are usually hunched over your computer screens intently watching as each image is downloaded onto your hard drive and your AIS dutifully does its thing according to your plan. The point is that when you are out in the cold of night not budging from your station, you are not moving around creating body heat to help you stay warm. This makes it feel at least 10–15° colder than it actually is, and you absolutely must dress accordingly if you want to stay comfortable (Fig. 8.3).

The key to staying warm is twofold. First, dress in layers. The goal is to dress such that you create air space between the layers of clothing. The more layers the more air space created, and air space acts as a very effective insulating material.

8.3 Effects on the Observer

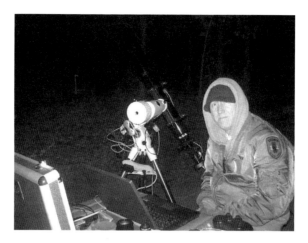

Fig. 8.3 The author at 2:30 am on the morning of January 10, 2010, tracking minor planet (1103) Sequoia. The ambient temperature was 21°F (−6°C) (Courtesy of Michelle H. Hubbell)

Synthetic fibers may be more effective than cotton fibers in this regard. The second issue is a matter of physiology. Your brain requires a lot of blood to operate effectively, and because your blood circulates around your body, it transfers heat from your body to your head. A head covering is absolutely necessary to retain your body heat. Another aspect of staying warm is the opposite of what happens with your head. Your hands and feet are way out at the end of your body and can cool off fast because they do not get much blood flow compared with the core of your body. Of course, because you need your hands to be warm to manipulate your equipment, it is a big deal if you cannot do that. Using chemical hand warmers is an effective solution for maintaining your hands at "operating temperature."

Your feet are probably most vulnerable, and many amateurs say that they can generally continue a session as long as their feet are comfortable. The problem is obvious. You bundle your feet up with two pairs of socks and some thick type of shoe/boot, and your feet stay completely still for hours in that state. Because the blood flow is not sufficient to maintain your foot temperature, it becomes increasingly uncomfortable as the hours pass. Using the best insulated socks goes a long way, but inserting a chemical warmer in your boots helps also. The trick though is balancing the outside temperature with the needs of your feet. Keeping your feet too warm can be just as uncomfortable after a while as being too cold. The best approach is a combination of insulation and keeping your feet active by taking a break every 15–30 min to walk.

The other big issue in the cold weather is the extreme dryness of the air—it is very easy to become dehydrated. Having plenty of water available to drink and taking it regularly during your session will help you stay warm and hydrated.

Warm drinks are also good, but you should take caffeinated drinks in moderation. They help you stay awake but will have a tendency to dehydrate you. If you drink coffee or soda for the caffeine, you should try to alternate it with water to maintain your body hydration.

If you use a portable AIS, then at the end of your session, if you have outlasted your equipment's power supply (I have experienced many sessions where my equipment's power supply gave out before I did), then you will have a reserve of energy to break your equipment down and transport yourself back home. However, if your power requirements have been met (or exceeded), then you will run out of juice before your AIS will. In this case, it is important to schedule your time so you do not tire yourself out and have enough energy at the end of your 8 to 10-h session to break your equipment down. There is nothing worse than finishing your data acquisition only to realize you have to face breaking your equipment down when all you want to do is crawl into bed. It takes discipline and pride in your equipment to treat it correctly and methodically break it down and store it as you should.

As you learned earlier, an effective AIS design can minimize the amount of equipment you need to do the job. Every piece of equipment that is not needed in the session is one less item you have to touch and spend time installing and breaking down at the end of your session. At the end of the day, doing a proper AIS design helps minimize the time spent breaking down your equipment. Of course, the best way to reduce breakdown time is to build a permanent observatory where all it takes is 2 min to shut down your system and then crawl into bed at 5 a.m. However, until you have that luxury, do yourself a favor and plan to save enough time and energy to break down your equipment without too much effort.

8.4 Effects on the System

Just as your body is affected by the environment, so is your equipment. Different AIS subsystems are affected differently, and you must make accommodations for each one. The type of equipment plays a major role in how it is affected by temperature and humidity. Usually equipment does not care if it is cloudy (unless it is raining!) or dark, or whether it has been up all night.

The subsystems can be broken down into two major groups: mechanical and electrical. The electrical group can be further subdivided into two groups: power and electronic. These three groups, mechanical, electrical power, and electronic, have specific characteristics that dictate how they are affected and how they must be managed under hot and cold weather conditions.

8.4.1 System Hot Weather Impacts

The hot weather typical of the summer months brings with it high temperatures. Mechanical systems and metal objects in general expand when their temperature

rises. The mechanical components affected most by high temperatures are the astrograph tube, the mount housing, internal gearing, any small adjustment screws or components, and the focusing system on the astrograph. Typically, if the mechanical parts expand in the heat, the clearance between moving parts gets smaller, and binding could occur when trying to move these parts. Any lubrication is affected by the higher temperature by becoming less viscous. This allows the lubricant to squeeze out when the parts expand. If the component experiences a lot of temperature change cycles, then you should ensure that the lubricant is sufficient to maintain proper operation. When the temperature changes, you will experience focus position changes in the astrograph; this is most noticeable when the evening comes and it cools down after sitting in the sun. Overall, it is preferable to keep any mechanical components shaded to keep them out of direct sunlight. If they are inside, store them in a cool dark environment; a dry basement is an ideal location. The key to minimizing the effects of temperature changes on mechanical components and subsystems is to keep the components as close to the expected operating temperature as possible and minimize any temperature transients.

Electrical power systems are not very tolerant of heat, or cold for that matter. A hot battery or power connection is more apt to fail than one that is kept cool. Electrical systems generate heat during their operation, which helps mitigate the effects of cold but is a detriment in hot weather. Electrical connections should be checked for corrosion and tightness when used in hot temperatures, and batteries should be shaded and kept in as cool a location as possible when in operation. Providing some kind of active cooling system would also help when operating in very hot conditions.

Electronic equipment is very *intolerant* of hot temperatures and needs to be actively cooled to maintain proper operation. Most electronic equipment comes with cooling fans. Computers and most cameras come with active cooling systems that help maintain their operation. Be sure to read and understand the environmental requirements in the owner's manual for your electronic equipment before operation in a high-temperature environment. Miscellaneous electronic equipment, cables, connectors, universal serial bus (USB) hubs, Global Positioning System (GPS) antennas, etc. sometimes respond adversely to high temperatures. Intermittent connections may increase during high-temperature operation. Intermittent operation may also be experienced with older electronic equipment because of bad solder joints that only reveal themselves after the equipment has been powered up and hot for a while.

8.4.2 System Cold Weather Impacts

Mechanical systems and components shrink when cooled down. Often amateurs operate their mechanical equipment in temperatures below or even well below freezing. Most system components purchased by amateurs will tolerate temperatures down to 10 degrees (°) F (−12°C). When moving parts cool down and shrink,

their linkages can become loose and have some sloppiness or play in them. This sloppiness in the connected components reveals itself as less accurate tracking, or positioning, in mounts and focusers. There could be more slippage than normal in any mechanical fasteners that hold components together, such as those in an imaging train. Mirror cells and refractor objectives may become loose and shift during imaging, causing bad data. The gearing within the mount may become loose and cause backlash issues when reversing direction or slewing to a target. Generally, keep in mind what effect the loosening of mechanical parts may have on any function or operation that you intend to rely on for obtaining your data. These parts may need to be readjusted to compensate for any temperature effects that occur. Consult the owner's manual for your equipment or contact the manufacturer for any tips or help on operating your mechanical equipment in the cold.

Electrical power equipment is somewhat tolerant to cold weather up to a point. This is because most power equipment creates internal heat that helps mitigate the effects of cold weather—once it has been warmed up to operating temperature and is working. Starting an electrical power system from stone cold without properly warming it up can be problematic. Try to maintain any power supply equipment in a warm environment before deployment in the cold, and start it up as soon as you are in the cold environment so that it can continue to provide some self-heating.

Electronic equipment is also very tolerant to cold weather operation as long as it is kept dry and is brought to operating temperature gradually. I have successfully operated my laptop computer and external 1-terabyte hard drive in temperatures of 20°F (−7°C) for several hours at a time. This self-heating of electronic equipment provides a good buffer against most temperatures that you can tolerate for any extended period of time. When the temperature drops swiftly in the evening, dewing is a distinct possibility, and you should protect your electronic equipment from this as much as possible. Guard against dew by providing a cover for your equipment during the evening. Try to wipe everything down during its operation if the self-heating does not provide enough dew protection.

To mitigate the warm and cold weather impacts on your AIS components, keep everything as close to the expected operating temperature as possible, protect against fast temperature changes by covering or insulating your equipment when not in use, and avoid exposing your equipment to sunlight.

8.5 The Dedicated Astronomer: Knowing When to Call It Quits for the Evening

There comes a time in almost any imaging session when things are just not going well. It can become very frustrating when, because of various issues, your images are not as they should be. Or, perhaps more likely, you have accomplished all your goals for this session and you want to try something else. Before you start to reconfigure your AIS "on the fly," it is best to recognize that you have tuned this particular configuration for this session. In this case, you would either need to take

8.5 The Dedicated Astronomer: Knowing When to Call It Quits for the Evening

the time to figure out the new configuration or pull from your documentation a pre-designed configuration that meets your ad hoc requirements.

I would urge you to reconsider. Recognize that you have had a successful session, and unless you did not plan enough work for yourself, it is getting late in the morning and you are probably a little tired. This is exactly the time when mistakes occur. Also, even if you are raring to go on, you may not have enough time to complete this new session. This would frustrate you also. You will find, once you have been planning and imaging for a while, that you develop a level of patience that enables you to put off added work and concentrate on completing the work you have started. This is part of the discipline that only comes with experience and knowledge of how things work and your program priorities.

Making an observing plan, executing the plan, and sticking to the plan, gives you a disciplined method to complete your work effectively and the time to do so without feeling overwhelmed at the end of the session. The last phase of your observing plan is the breakdown of your equipment, unless you are fortunate enough to own a permanent observatory. However, having an observatory does not lend itself to ad hoc configuration either. In fact, it may be more difficult because usually, you have configured your system for quick startup and shutdown. Therefore, it has a fixed configuration for a specific class of targets. Unless you have designed into your observatory AIS a quick change feature for different classes of targets, it is difficult to reconfigure it quickly for a different class of target.

Another trap occurs when you are having a very successful session and do not want it to end. You need to have the discipline and the knowledge to know when to call it quits because your body is telling you, "I'm tired, and I want to go to bed." Pushing on despite your discomfort does neither you nor your equipment any good. This is when you make mistakes, and you do not want to regret something that happened at the end of a very successful observing session. Knowing that you have excellent data to process the next day should satisfy you and compel you to complete the session without undue stress and overwork. Sometimes your dedication can get the best of you if you do not recognize it.

Beginning astrophotographers sometimes do not make any specific observing plans and want to make sure they use all their new equipment every time they go out. You should resist this urge. You are excited to learn as much as you can and observe as many objects as you can. However, when you do this, you overwork yourself, and in a short amount of time, it gets to be more work than fun. Slow down and enjoy focusing on the objects of interest. Take the time to plan your session if you are starting on a new object or have a new component to use such as a new spectroscopic grating, or a new high-resolution video camera.

Limit your session to accomplishing one or maybe two major goals focused on your target or component test. If you take the time to understand all there is to know about this one target or component in a couple of sessions, it will save time in future sessions. I know it is frustrating when you think that the interval between observing sessions is too long, and you are not progressing as fast as you would like. Recognize that you should be in this for the long haul if you are a serious scientific imager. Dedication and patience must go hand in hand in this field of work.

The way you have visually observed at star parties and on your own is different from the way you must work when making scientific observations. Star parties are fun in the context of socializing and visiting all the different telescopes. They also allow you to jump from object to object for a brief view and to make ad hoc changes to your equipment. Staying up all night until you drop in this environment is fun. It is how this type of observing is done. Scientific imaging with your AIS is a different animal altogether. In the end, if you are serious about getting the best data from your equipment, listen to your body and your equipment, accomplish your session goals, and then call it quits for the evening. You will thank yourself in the end.

Further Reading

Arditti D (2008) Setting-up a small observatory. Springer, New York
Buchheim R (2007) The sky is your laboratory. Springer, Berlin/Heidelberg/New York
Chromey FR (2010) To measure the sky. Cambridge University Press
Covington MA (1999) Astrophotography for the amateur. Cambridge University Press
Dragesco J (1995) High resolution astrophotography. Cambridge University Press
Dymock R (2010) Asteroids and dwarf planets and how to observe them. Springer, New York
Harrison KM (2011) Astronomical spectroscopy for amateurs. Springer, New York
Warner BD (2006) A practical guide to lightcurve photometry and analysis. Springer, New York

Web Pages

http://www.weather.com/
http://www.weather.gov/
http://www.intellicast.com/
http://www.accuweather.com/
http://www.weatherunderground.com/
http://www.ecmwf.int/
http://www.wmo.int/
http://www.cleardarksky.com/
http://www.weatheroffice.gc.ca/astro/
http://www.cloudynights.com/
http://www.skippysky.com.au/Europe/
http://www.cabelas.com/cold-weather-gear-1.shtml
http://www.coolantarctica.com/Antarctica%20fact%20file/science/clothing_in_antarctica.htm
http://www.survivalx.com/wilderness-survival/regional-survival/desert-clothing/

Part II

Astronomical Imaging System (AIS) Integration and Operation

Chapter 9

The Practical AIS: The Sum Is Greater Than the Parts

9.1 How to Integrate the AIS Components into a System

When you build anything, it is best to start by specifying the design goals and then begin putting the item together on paper using the necessary components; this is also the case when you build your Astronomical Imaging System (AIS). How do you know what components to pick? That's a good question. It starts with your design requirements. For example, set yourself a simple goal. You want to photograph the Moon. That is good as a general statement, but how *good* a photograph do you want? How big? Is it color, or black and white? Do you want to be able to resolve craters down to 50 miles? 10 miles? 1 mile?

You have decided to take a picture of the Moon that resolves craters down to 10 miles in diameter. First, this design goal is very high level. You should take the time to create an Observing Program Design Basis (OPDB) as described in Chap. 2, Sect. 2.2. From that design basis, you can begin to determine the best components to meet your design goals. The OPDB places limits of performance, or performance requirements, on each of your components. This is an important step in that it allows you to focus attention (and budget) on exactly those components you need to meet your observing program goals. Once you have the OPDB on paper, it drives your component needs and gives you a baseline with which to compare when choosing specific components. Remember, the overall goal is to balance budget, skills and knowledge, and time.

What components do you need? You need a telescope of some kind, a mount for the telescope, and a camera. Okay, let's get more specific. You could just buy any old telescope, mount, and camera, but missing from your specification are the

interfaces between the components. Think of components as objects with interfaces. Usually interfaces are specified for *inputs* and *outputs*. A telescope is an object that takes light from the sky and puts out light. However, the light is transformed in a specific way; it is gathered and focused at the focal plane.

The telescope has specifications detailing how well it performs this task. The input interface is just the sky—all you have to do is point it at an object and make sure that object is far enough away. The output interface is a combination of devices, usually a 1¼-in. or 2-in. eyepiece adapter, or it could be a T-mount adapter. The telescope also must interface with its mount; therefore, a specific type of mount adapter must be attached to the telescope. A Vixen style or Losmandy style dovetail rail/plate adapter is usually provided. The key is that it matches the mount's requirement. The mount usually specifies the type of mounting adaptor (or interface) that the telescope must have. You can also change interfaces on some mounts if you prefer one to another.

Finally, the camera input provides both a mechanical interface and an optical interface. The optical interface converts the focused light at the image plane to data, which was discussed in Chap. 5. The mechanical interface to the camera must match that of the telescope. If they are different, then an adaptor component is needed to mate the two.

Table 9.1 shows an overview of the relationship between components and interfaces, and how they are integrated to become a system.

Design your system by specifying the types of components and the interfaces needed to perform a specific task. Next, look at the components that match your design requirements and determine whether they also meet your performance requirements. The mount, for example, has specifications for load capacity, tracking error, telescope mounting type, power requirements, data interfaces, etc. All your components have defined performance criteria based on their mechanical, electrical, and optical characteristics. Simply list the different components in your design and specify their performance characteristics that are relevant to your OPDB design goals. If you spend up-front time doing this, you save a lot of time when physically integrating your system. This is especially true when integrating any custom, one-off equipment, such as a special focuser adaptor or other piece of equipment special to your requirements.

To help you document your requirements, create a reference like Table 9.2. Documenting your AIS requirements helps you to weigh your options and determine for yourself what you need and want to do with your AIS. Documenting your requirements clarifies the scope of your system and determines your budget requirements.

As you can see, once you have defined your observing goals, you can identify and specify your AIS components, interfaces, and performance requirements.

In summary, you need to take time to perform the following four tasks:

1. Create your Observing Program and OPDB (see Chap. 2, Sect. 2.2 and Chap. 15).
2. Identify and specify your AIS components based on your OPDB (see Chaps. 6 and 7).
3. Identify and specify your AIS component interfaces and any special interface requirements for custom-built equipment.
4. Identify and specify the performance requirements relevant to your OPDB.

Table 9.1 AIS components and interfaces

Simple AIS configuration components and interfaces

Component	Function	Mechanical interface	Optical interface
Telescope	Gathers and focuses light	Mount adapter Optical output adapter	Image plane—focal surface
Mount	Carries and points telescope	Mounting plate/dovetail	None
Camera	Converts light into raw data	T-mount or nosepiece adaptor	CCD sensor at image plane

Table 9.2 AIS requirements data

AIS requirements

Component	Mechanical requirement	Electrical requirements	Optical requirements
Telescope	Losmandy type dovetail mounting system	12 Vdc for cooling fans	Schmidt-Cassegrain configuration, long focal length (FL), fast focal ratio
Mount	50-lb load capacity, Losmandy type dovetail	12 Vdc, RS-232 Data	Polar scope for polar alignment
Camera	T-mount adaptor	12 Vdc, USB Data	50-mm image circle, wide field of view

If you follow these four steps, you will be well on the road to a relatively trouble-free AIS integration.

9.2 Permanent or Portable?

This is an easy decision if you have the funds. After several years of portable observing, you find that anything that would make life easier by enabling you to spend less time setting up and configuring your AIS is heartily desired and recommended. Yes, build a permanent observatory if you can. This issue was purposely left out of the equation for figuring your budget (Chap. 2, Sect. 2.3) because you should determine whether you want to do astrophotography long term by trying it out first. In addition, building your first portable observatory and learning how to properly equip it is good experience if you choose to build your dream permanent observatory. After you have some experience, you will know exactly what your observing program needs to be and what equipment you need for your permanent observatory.

Providing a small, permanent housing for your portable setup where you can leave it set up or partially set up is also a good idea, and you are encouraged to do so. On the Internet, there are many examples of small enclosures that are relatively inexpensive (less than $1,500) and that provide a wonderful respite from the routine setup/takedown that we all experience when starting out.

Once you have decided to build a permanent observatory, spend an amount appropriate to your equipment investment. This is not only for ease of use, and to satisfy the complexity of requirements, but also for security. You do not want to house $50,000 worth of equipment in a $2,000 building. It would be reasonable to invest at least 20% of the cost of your equipment into a permanent home. This would include any ease-of-use and performance components, and security equipment. Some might suggest at least 30%; that would be fine also—do what you think is necessary to protect your investment and to make it as easy for you to use as you can. There are many resources on the Internet for building a permanent observatory.

9.3 Sources of Measurement Error

As you begin this section, you are wondering—what does measurement error have to do with building and integrating my AIS? This is a good question. Recall the information in the previous chapters and keep in mind what is important to excellent imaging and scientific data. There are two sources of the problems you will encounter—equipment or a lack of skills and/or knowledge on your part. Hopefully, reading this book will eliminate the second source, but your knowledge and skill can also help you solve those pesky equipment problems when they crop up. However, what you want to mitigate up front are design problems. It is important to be able to recognize when something is a design problem versus a broke/fix type of problem.

Design problems usually reveal themselves either when you take a normal measurement and the data obtained are not up to your expectations, or when you take a very difficult measurement and bump into a performance limit of some kind. However, there is also a big assumption here. These design problems can be identified only when you have verified that you are using your skills and knowledge appropriately, and you are confident that none of your equipment or procedures is at fault. An example might be when you are doing double star observations, and you believe you have calculated the proper image scale to be able to properly measure a given double star separation down to a precision of ±0.2 arcsecond (arcsec), but your images are not giving you that precision. You need to verify that your astrometry procedures and database are correct, and that you have actually calculated the correct image scale. Perhaps you have placed a focal reducer component into your imaging train when none was required. Or you have not taken the existing seeing conditions into account, and they exceed your design limits. The bottom line is there is an answer to the problem; you just need to understand all the components

9.3 Sources of Measurement Error

that go into making that measurement. In this context, I discuss what measurement errors may crop up in your data and where the cause might be.

Because there are only two types of fundamental measurements you are going to make—position (astrometry) and brightness (photometry)—it is good to look at how your design choices affect these two tasks. All other types of measurements derive from these two.

Several equipment-related design problems can contribute to position measurement errors. First, the astrometry database is the standard used to calculate star positions. If you are using an old database, such as the Hubble Guide Star Catalog, where the values for star movement or *proper motion* are inaccurate or non-existent, then large errors can occur. Errors on the level of ±0.3 arcsec can be attributed to using substandard catalogs. Using the most recent, professional-level catalog is essential in making high-precision, accurate position measurements. The United States Naval Observatory (USNO) UCAC3 (USNO CCD Astrometric Catalog 3) catalog is an excellent choice. The UCAC4 database became available in fall 2012.

Once you have a proper standard for measurements, then it is up to you to obtain the data with the least number of errors. One of the factors that you must deal with when using both refractors and reflectors is field curvature. Field curvature contributes not just to star brightness measurement differences across the field of view (FOV), but also in position errors across the FOV. Presenting the flattest optical field at the focal plane to the charge-coupled device (CCD) camera gives you the best chance to make the best astrometric measurements. Field flatteners are essential for maximizing your performance.

In addition, using a wide field optical system, with an FL of less than 700 mm, makes it more difficult to measure star positions accurately. There is a sweet spot of FOV and image scale that maximizes astrometric accuracy and is a combination of your catalog accuracy/number of stars and your configured image scale. Usually an image scale of 1 arcsec/pixel or less and a FOV of at least 20×20 arcminutes (arcmin) is needed to provide the accuracy and number of reference stars for high-precision astrometry.

Design-related photometric measurement errors involve the choices you make about how you perform your image calibration. A sub-par flat field light source is a fundamental source of error. Using a broadband source of low-level light is essential for obtaining good flat fields for use in calibrating your images. Twilight flats are particularly good because the sky is the best source of broadband light. Acquiring twilight flats is discussed in Chap.11, Sect. 11.7. As in your astrometric measurements, an excellent source of reference standards is a requirement when making photometric measurements. In general, when making a single band differential measurement, such as a V-band measurement of minor planet magnitudes, the automated software tools available use the V-band values in your astrometric catalogs. The UCAC3 (or UCAC4), again, is an excellent choice because it provides a good source of magnitude values that, in aggregate, provide an accurate baseline to make your differential V-band measurements when measuring objects. The Landolt Photometric Standards are recognized as *the* standard in Ultraviolet-Blue-Visual-Red-Infrared (UBVRI) measurements of stars and objects. The list of

Landolt stars is available on multiple Internet sites but can also be found in the original scientific papers written and freely available.

Proper technique in doing image calibration is a fundamental requirement for accurate differential and absolute photometric measurements. In this respect, sources of measurement errors are less design related and more procedure related. Validating and using the proper standard stars is fundamental to this process; therefore, verifying your source of data is a necessity.

In general, design choices such as image scale, tracking accuracy (whether unguided or via an auto-guiding system), and mount load capacity (which, if inadequate, leads to vibrations) all contribute to measurement errors. A mount's pointing accuracy can also lead to errors in identifying your targets and reference objects. Knowing where you are pointed is a fundamental skill necessary for any astrometric or photometric measurement. Balancing your required accuracy with the performance of your equipment is necessary if you are to succeed.

9.4 Maximizing Performance

Having come this far, you are well aware of the purpose of this book, and in pursuit of excellent scientific imaging data, you are learning what it takes to get the best bang for your buck. Performance is the name of the game here, and to maximize the performance of your AIS, you need to know everything there is to know about your equipment—the theory behind how everything works and how best to operate it. That is really all there is to maximizing the performance of any equipment you may purchase and use. Once you have learned how your equipment was designed to operate, you can operate it to its maximum potential. You will run into problems at the beginning, but being familiar with the how and why of your equipment's design, construction, and operation gives you a decided advantage in solving those problems and maximizing your AIS performance.

9.5 Matching the Equipment to the Science

It is a fundamental axiom in engineering that something designed to do a lot of different things doesn't do any of them very well. How many flying cars have you seen lately? If you have a design goal with a very specific purpose, a purpose-built component is the fastest way to achieving the best performance possible. That is why there are so many different telescope configurations, and that is also why you need to design your AIS so that each component contributes positively to the specific goals of your observing program. Sure, a consumer digital single lens reflex (DSLR) is a great general-purpose "daylight" camera, and it can be used to do some excellent astrophotography. But is it the best component for astrophotography? I think you know the answer to that question.

9.5 Matching the Equipment to the Science

There are tradeoffs in the design of any component or subsystem, but to get the best, state-of-the-art performance for the money you are willing to spend, you must minimize features and enhancements that do not contribute to what you need for imaging. For example, all a long-exposure astrocam needs is a very effective cooling system that can cool to 50° (degrees) C below ambient temperature, a very low dark-noise chip with high dynamic range and linearity, a low readout noise electronic system, and a very fast electronic data transfer system—all housed in a tough case that will last 20 years or more. Anything else is fluff as far as the astrophotographer is concerned. This section discusses the details of what you need to meet the goals of various observing programs in terms of equipment and components that make up the AIS.

9.5.1 Planetary Imaging

The characteristics that make an AIS an excellent scientific planetary imaging system are—

1. High-resolution image scale
2. Large-diameter astrograph objective with a long FL
3. High-accuracy tracking mount to maintain the object in the small FOV
4. High-speed (frame rate), high-sensitivity digital video CCD with controllable gain and exposure time.

All of these characteristics contribute to the performance needed to capture bright, very small-size angular objects. A high-resolution image scale is necessary to resolve very fine linear and nonlinear features that today's modern software is capable of revealing. A system FL of at least 4,000 mm (mm), with a focal ratio of at least as slow as $f/20$, is a minimum requirement for the best imaging. A large astrograph primary objective just adds to the potential resolution that you can obtain. The best planetary astrophotographers in the world use systems that have an objective of at least 18 in. (0.45 m) used at a FL of more than 10,000 mm. High-resolution planetary imaging is limited by the seeing that exists at the time of the observation, but a remarkable amount of detail can be resolved by even the most modest AIS equipment (Fig. 9.1). It is important to understand what high-resolution imaging is really about. The definition of high-resolution imaging is that no matter how small or large your astrograph, you can configure your AIS to obtain the maximum performance it is capable of delivering in terms of resolution and detail. You can perform high-resolution lunar imaging using a 100-mm refractor or a 0.4-m Newtonian reflector. The difference of course is the level of detail obtained, but they are both considered high-resolution.

Gathering a very large number of frames at a high frame rate is necessary for the best results. A total number of frames on the order of 2,000–4,000 is a good target for general imaging. This equates to about 60 s of exposure time at 60 frames per second (fps). A mount that is capable of keeping an object within the FOV is most important when taking a large number of frames with very long FLs. For world-class

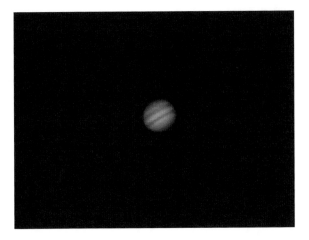

Fig. 9.1 This image of Jupiter taken on November 12, 2011, by amateur astronomer David Abbou demonstrates what is possible with a modest webcam-based CCD camera and an 8-in. SCT (Courtesy of David Abbou)

results, your mount must be able to keep a 3-arcmin FOV in view for at least 2 min; otherwise, manually guiding to keep the planet near the center of the FOV is necessary.

9.5.2 Lunar Imaging

Lunar imaging has the same basic AIS requirements as planetary imaging. The bigger the objective, the more detailed features you can resolve. The only difference operationally between imaging the planet Jupiter and imaging the Moon is that it is generally much easier to get the Moon in the FOV of your camera because it is so much larger. Once that is done, you can easily navigate around the Moon to select the feature for which you want to acquire data. There are a couple of excellent tools designed to help you identify specific features on the lunar surface, but the major one is called the Virtual Moon Atlas (http://ap-i.net/avl/en/start). Created by Christian Legrand and Patrick Chevalley, this program uses bitmap textures of the Moon and lunar orbiter photographs to provide detailed information about those features.

9.5.3 Solar Imaging

Solar imaging is very similar to planetary and lunar imaging but it has a few specific requirements. The same characteristics needed for high-resolution planetary

9.5 Matching the Equipment to the Science

imaging apply, but there are a couple of issues. Think about the differences for a moment. The most glaring difference (sorry about the pun) is the fact that the Sun is the brightest object in the sky, and you must take special precautions when observing it. Here is the standard warning:

> **WARNING: Never** look at the Sun with your naked eye or with a telescope that is not specifically designed to do so. Doing so will **seriously damage** your eyesight and may lead to **permanent blindness**.

You will find a warning similar to this attached to every telescope and astrograph you purchase. Take this warning seriously, and make sure to instruct any visitors who may join you while observing the Sun. In addition, if your non-solar astrograph is to be used as a solar astrograph, you need to add a Sun finder to your equipment list. A Sun finder is a device designed to cast a shadow on a flat plate that is aligned with the optical axis of your astrograph. The finder is designed so that when the shadow is located at a specific location, your astrograph is pointed at the Sun. This prevents you from looking toward the Sun when pointing to it.

There are several indirect methods to observe the Sun—projections, pinholes, etc.—but for your purposes, you will be observing the Sun directly by **FIRST** blocking 99.99999% of the Sun's light before letting it enter your objective. The safest way to observe the Sun is to use a dedicated solar scope. Typically, these use a sophisticated light-blocking device and a tunable narrow band H-α filter. This allows you to directly image the Sun's features in the H-α band. You can also use a white-light filter that attaches to the front of your telescope or astrograph. It blocks most of the light coming into your objective. These filters are made of either glass or a Mylar film and mounted in a round holder that can be attached to your telescope tube. These white-light filters can be used to observe sunspots on the surface of the Sun, and planetary transits.

Once you have reduced the light coming into your astrograph, your AIS is essentially the same configuration as that used for planetary or lunar imaging. All the characteristics needed for high-resolution imaging apply to solar imaging just as they do to planetary and lunar imaging. You should use as large a primary objective as practicable to image very small features. You may have problems finding large enough white-light solar filters, but you can also purchase the Mylar film and construct your own if necessary.

The seeing during the day is typically better than at night, but you must contend with local heating effects that cause the air directly above your astrograph to boil. Staying away from concrete structures and paved areas is important to minimize this effect. Setting up your astrograph in a grassy area helps minimize local heating impacts on your image.

9.5.4 Deep Sky Imaging

The characteristics that make an AIS best for scientific imaging of deep sky objects are—

1. As large a primary objective as possible with a fast focal ratio less than $f/6$ if possible for a wide angle FOV. Slow focal ratios of less than $f/20$ are necessary for small, dim, objects such as remote galaxies.
2. An accurate mount with a capacity to handle 150% of the AIS's designed load.
3. A mount with an intrinsically high-performance tracking system.
4. A drive corrector, auto-guiding system, or adaptive optics guider capable of providing a root mean square (RMS) periodic error (PE) of less than 25% of the measured full-width-at-half-maximum (FWHM) of the star image.
5. An astrograph with a large image circle (greater than 40 mm in diameter) that is fully flat field corrected.
6. A CCD camera with a thermo-electric cooler (TEC) system that cools down to at least 40°C below ambient temperature and a pixel size that provides an image scale that does not under-sample or over-sample the star images. The CCD camera should be capable of providing a linear response over more than 90% of its bit depth.

As you can see, the requirements for a deep sky, long-exposure AIS are a bit more complex than for a planetary AIS. The main reason is the exposure time used for deep sky imaging. Taking 600-s exposures versus 10-ms exposures is almost five orders of magnitude difference in exposure time. Something has to change to accommodate this difference. There are two major changes. The mount must be very accurately set up and configured to intrinsically track with a very small tracking rate error. In addition, the camera must be capable of taking very long exposures without buildup of background noise in the form of dark current.

Therefore, the main differences between a deep sky and a planetary AIS are the mount and the camera. Secondarily, the optical tube assembly (OTA) involved has a large objective and either a fast or a slow focal ratio, depending on the observing program objects. With an astrograph objective size of ≥200 mm at f/8 and an exposure of 180 s, you can typically image objects down to 18th magnitude. Accurate photometric observations (less than 0.01 magnitude uncertainty) are possible of objects 16th magnitude or brighter.

9.5.5 Minor Planet Imaging

For minor planet work, the desired characteristics are very much like those for photographing deep sky objects, except you are somewhat limited in the exposure time available because minor planets move appreciably over the course of an exposure greater than 180 s. However, in the case of minor planet observing, you can relax some of the performance requirements of the mount to pay for the necessary larger astrograph primary objective. Because the typical minor planet exposure

9.6 Typical AIS Configurations

Fig. 9.2 A 30-min unguided exposure (stack of 10 × 180 s) of NEO minor planet (68348) 2001 LO7 taken July 2, 2011 0436 UT with a 0.13-m refractor, go-to GEM, and encoder-based RA drive corrector

time is 60 s to accommodate object movement, and you still want to accurately measure the smaller minor planets that are dimmer than 16th magnitude, you need to use a larger primary objective (Fig. 9.2).

The requirements for the mount change accordingly. You now need a mount with a larger load capacity, but you may not need auto-guiding if the mount has sufficient intrinsic tracking capability. As long as your mount can accurately track for 60 s at a time with very little tracking error and carry the larger OTA you require to reach those dim minor planets, you will meet your design criteria.

9.6 Typical AIS Configurations

The following sections list the typical components needed for each AIS configuration. Use this information only as a starting point in defining the specific AIS for your imaging program. You should add and change items as you see fit to meet your requirements. Several options are available, and it is left to you to modify these component choices as needed.

The AIS configuration tables below list, in general terms, the components needed to effectively image the primary observing program objects shown. This is by no means the final configuration you need to get the best out of your system. Investigate the equipment the various vendors offer. You will more than likely find other components that you want to use that will enhance your efficiency, comfort, quality, and overall results.

9.6.1 Planetary AIS Configuration

Table 9.3 Planetary AIS component configuration and imaging notes

AIS subsystem	Component(s)	Primary observing program objects	Imaging details
Astrograph	10-in. (250-mm) SCT $f/10$ plus a Crayford style focuser, and 2×–4× Barlow lens	Jupiter, Saturn, Mars, Venus, Neptune, Uranus, Callisto, Io, Europa, Ganymede	Acquire 1,000 to 5,000 frames at up to 60 fps. Exposure times typically 10–200 ms depending on the object being observed and filters used
Mount	GEM, 45-lb (20-kg) capacity; Periodic Error Correction (PEC) enabled if desired		
Camera	Webcam, scientific low-light grade, 640×480 resolution and capable of at least 15 fps up to 60 fps. Various filters, including ultraviolet (UV), red, infrared (IR), orange, green, blue		
Support	PC compatible with your webcam; applications such as Registax, AVIStack, AIP4Win, MaximDL, and Photoshop to process your images		

9.6.2 Lunar AIS Configuration

Table 9.4 Lunar AIS component configuration and imaging notes

AIS subsystem	Component(s)	Primary observing program objects	Imaging details
Astrograph	6-in. (150-mm) Refractor $f/15$ plus a Crayford style focuser and 2× Barlow lens	Lunar craters, rimae, mare, mountains, domes, and other topographic features	Acquire 1,000 to 5,000 frames at up to 60 fps. Exposure times typically 1–20 ms depending on the topographic feature, closeness to the terminator, and filters used
Mount	GEM, 45-lb (20-kg) capacity, PEC enabled if desired		
Camera	Webcam, scientific low-light grade, 640×480 resolution and capable of at least 15 fps up to 60 fps. Red filter		
Support	PC compatible with your webcam; applications such as Registax, AVIStack, AIP4Win, MaximDL, and Photoshop to process your image		

9.6.3 Solar AIS Configuration

Table 9.5 Solar AIS component configuration and imaging notes

AIS subsystem	Component(s)	Primary observing program objects	Imaging details
Astrograph	80-mm solar astrograph with built-in light blocking and tunable H-α filter. A Sun finder is also a necessity	Solar features including sunspots, prominences, filaments, spicules, plage, and the chromosphere and solar flares	Acquire 1,000 to 5,000 frames at up to 60 fps. Exposure times typically 1–20 ms depending on the feature and the amount of light available through the tunable filter
Mount	GEM, 45-lb (20-kg) capacity, PEC enabled if desired		
Camera	Webcam, scientific low-light grade, 640 × 480 resolution and capable of at least 15 fps up to 60 fps		
Support	PC compatible with your webcam; applications such as Registax, AVIStack, AIP4Win, MaximDL, and Photoshop to process your images		

9.6.4 Deep Sky AIS Configuration

Table 9.6 Deep sky AIS component configuration and imaging notes

AIS subsystem	Component(s)	Primary observing program objects	Imaging details
Astrograph	12-in. (300 mm) Newtonian f/4.7 with a Paracorr Coma Corrector and add-on Crayford style focuser, and 2x–5x Barlow lens for small angular diameter objects	Large diffuse nebulae, planetary nebulae, galaxies, large and small star clusters, Wolf-Rayet stars, double stars	Typical exposures of 300–1,200 s (or more when using narrowband filters) are used and auto-guiding is typically required. Long exposures are limited by the sky darkness. Narrowband imaging uses the longest exposure times. A minimal calibration sequence, dark subtraction, and flat-fields are used
Mount	GEM, 60-lb (27-kg) capacity, PEC enabled if desired. Auto-guiding hardware. An accurate polar alignment is required		
Camera	Scientific grade TEC CCD camera (with filter wheel) capable of ≥40°C below ambient cooling. Photometric filter set, or LRGB filter. H-α, H-β, OIII, filters		
Support	PC compatible with your CCD camera; applications such as AIP4Win, MaximDL, and Photoshop to process your images. UCAC3 database for astrometry		

9.6.5 Minor Planet AIS Configuration

Table 9.7 Minor planet AIS component configuration and imaging notes

AIS subsystem	Component(s)	Primary observing program objects	Imaging details
Astrograph	8-in. (200-mm) Ritchey-Chrétien Cassegrain $f/8$ with add-on Crayford style focuser, 0.75× focal reducer/field flattener	Main Belt minor planets (asteroids), Jupiter Trojan family asteroids. Near Earth objects (NEO) minor planets. Variable stars, cataclysmic, eclipsing binary, exo-planets	Typically, a standard of 60-s exposures is used for most minor planets. Longer exposures up to 180 s are used for slower moving minor planets. A standard calibration sequence is used of dark subtraction and flat fields. Differential photometry is performed on minor planets, variable stars, and exo-planets to develop a light curve
Mount	GEM, 45-lb (20-kg) capacity, PEC enabled if desired, plus a drive corrector, or auto-guiding as necessary		
Camera	Scientific grade TEC CCD camera with filter wheel capable of ≥40°C below ambient cooling. Photometric filter set. V-band to start with. Blue blocking filter for exo-planets		
Support	PC compatible with your CCD camera; applications such as AIP4Win, MaximDL, and Photoshop to process your images. UCAC3 database for astrometry		

Further Reading

Arditti D (2008) Setting-up a small observatory. Springer, New York
Berry R, Burnell J (2005) The handbook of astronomical image processing. Willmann-Bell, Richmond
Buchheim R (2007) The sky is your laboratory. Springer, Berlin/Heidelberg/New York
Chromey FR (2010) To measure the sky. Cambridge University Press
Covington MA (1999) Astrophotography for the Amateur. Cambridge University Press
Dieck RH (2007) Measurement Uncertainty. The Instrumentation, Systems, and Automation Society, Research Triangle Park
Dragesco J (1995) High resolution astrophotography. Cambridge University Press
Dymock R (2010) Asteroids and dwarf planets and how to observe them. Springer, New York
Harrison KM (2011) Astronomical spectroscopy for amateurs. Springer, New York
Henden AA, Kaitchuck RH (1990) Astronomical photometry. Willmann-Bell, Richmond
Howell SB (2006) Handbook of CCD astronomy. Cambridge University Press, Cambridge

Smith GH, Ceragioli R, Berry R (2012) Telescopes, eyepieces and astrographs. Willmann-Bell
Warner BD (2006) A practical guide to lightcurve photometry and analysis. Springer, New York

Web Pages

http://ap-i.net/avl/en/start/
http://www.minorplanetcenter.net/iau/info/Astrometry.html

Chapter 10

Planning and Executing the AIS Data Acquisition Process

10.1 In the Beginning…

At the beginning, it is important to remember why you are doing all this work: to be able to quickly and efficiently set up your equipment, acquire your images, and break down that equipment—with a vast majority of your time spent imaging objects. Optimally, you should not be spending more than 1 h (once you have arrived at your observing site) to inventory, set up, and calibrate your Astronomical Imaging System (AIS) before proceeding with your observing run. This is important, because you will find that if you can shorten your time for setup and breakdown, you will be more inclined to observe even when the total observing session may be only 4 h rather than the preferred 8 or 10 h.

The goal is to be able to slew from target to target with only minimum adjustment time between targets. If you can obtain this level of performance, then you will be inclined to use your AIS more often. Set a personal goal for the minimum session time for which you will go to the trouble of setting up and breaking down your equipment. It is often said among amateur astronomers (and it is true, for the most part) that the best telescope is the one that you actually use and go through the effort to set up. This is great advice for beginners who, like our intrepid amateur in Chap. 2, have a tendency to jump in with both feet and purchase more than they can handle. The KISS, "Keep It Simple, and Stupid," principle, when applied to the equipment and procedures (not the user), helps the beginner minimize the hassle and the amount of equipment necessary for observing the objects of interest.

This is also the motivation for advanced amateurs who use more sophisticated equipment and is the overarching philosophy of the AIS design. You have to *want*

to set up and observe with your AIS. Anything that gets you to the observing part quicker and easier is what is required. Keep that goal in mind throughout the design and implementation process of your AIS and observing program.

10.2 Initial AIS Setup and System Integration

When you purchase your AIS components, there is an initial set of steps to integrate the equipment. You can do this as you receive your components (I fully understand the fun of getting each component and trying to understand it once you get your hands on it), but the true integration does not occur until you have all the pieces. This is truly your first opportunity to see how everything fits together and how it will operate as an integrated system. The National Aeronautics and Space Administration (NASA) refers to this as "All-Up Testing." It is good to spend as much time as possible in this mode during daylight hours and cloudy times (which are guaranteed to occur when you buy anything astronomically related). The more time you spend getting familiar with your equipment and how it works in the light of day, the less time and frustration you will experience out in the field in the dark of night.

Perform the following tasks (Chap. 12, Field Practical Exercises (FPE) provides a structured format for performing some of this work):

1. Inventory all the components and ensure that all the supporting material is there: owner's manual, software, sub-components (brackets, mounting screws), cables, connectors, and adapters.
2. Physically integrate the components, checking for fit and tightness. If necessary, review the information in Chap. 6 to help in assembling your components. Understand any delicate component issues, i.e., fine-threaded components that are easy to cross-thread, any components that you will wait until you are in the field to assemble (if you want to change your imaging train "on the fly"), and any other components that require special handling while in the field. It is important to assemble your components so that they are firmly attached to each other to minimize flexure, and that they are optically aligned with as little tip/tilt as possible. Having your CCD camera square to the optical axis is vital for obtaining the best imaging data.
3. Measure the details of your imaging train configuration(s) to initially identify focus positions, calculate image scale(s), field of view (FOV), and other measurements related to your configuration. Refer to Appendix 4 for examples of imaging train measurements.
4. Initially install any necessary software tools, making sure that the latest, updated device drivers and support tools are available online, downloaded, and installed.
5. Take the time to understand any cable routing issues that you may have when slewing the telescope. Develop a cable management strategy to ensure your AIS is safe to slew without snagging any cables. Also, ensure that all electronic

10.2 Initial AIS Setup and System Integration

connections are secure, either by physically checking the snugness of fit or by screwing the connectors into their associated components.

6. Perform a standard German equatorial mount (GEM) balance adjustment as necessary. Manually position the astrograph with the imaging train installed. Rotate the astrograph on the right ascension (RA) axis and place it in a horizontal position on the east or west side of the pier. The counterweight bar should be horizontal, i.e., perpendicular to the astrograph's optical axis. Adjust the counterweights to just balance the weight of the astrograph and then slightly unbalance it. Manually move the astrograph by rotating the declination (DEC) axis to a horizontal position. Balance the astrograph by loosening the tube rings and sliding it so that it is balanced in the horizontal position. Move the mount back to the Home position. If you use a fork mount, you should perform the vendor's recommended balancing procedure.
7. Power up and individually fully test (as much as possible) any electronic components while integrated with all the other components of the AIS. Work out any bugs in device driver interaction, excessive CPU usage, and universal serial bus (USB) device management. Make sure you try out and use both your home's 120 V alternating current (VAC) power and any battery power system you may use in the field to power your equipment.
8. Practice starting up your AIS and verify the sequence to start up each subsystem, including the planetarium (mount control) program, ASCOM drivers, camera control programs, and any other support program or device control program you may have.
9. Document any numeric values, specific configurations, device and software settings, and any other hard-to-remember information specific to a particular configuration.

Finally, it is important that you repeat these steps as necessary (you decide the applicability) when you integrate a new piece of equipment later in the life of your AIS. This is a form of regression testing to ensure that adding the new component does not affect the operation of already tested and validated equipment, procedures, etc. Following this disciplined approach to integrating your AIS makes it much easier to change or add any new components.

After you have set up and broken down your AIS a few times, you will find you have choreographed a sequence of events and stored all your components in a specific place to minimize the time to execute these tasks. This comes with increasing knowledge of your equipment and your desire to apply a disciplined approach to these tasks. This is the result you want and can expect. Doing these tasks before you get into the field helps keep your frustration level low and makes you more comfortable with all you do while in the field.

Familiarity with the tasks also helps you to avoid rushing while setting up and breaking down your equipment at the end of the session. Breaking down your AIS is the timeframe when you are at the most risk of losing or damaging a piece of equipment. It is dark, you are tired, and that is when you can make mistakes. A disciplined, choreographed sequence developed during the day helps to protect you and your equipment from any mishaps.

10.3 Planning Your Imaging Session

Before going out and setting up your AIS and starting your observing session, you need to select specific targets that you want to observe. How do you know which targets are good and which ones aren't? That can be a tough question to answer, and it very much depends on your knowledge level and the status of your skills. The more you study the objects that are the subject of your observing program and the more you interact with your fellow observers on the Internet, the more discriminating you become in selecting objects to observe. There are excellent sources on the Internet to help guide you to specific targets. You also want to tailor the number of targets per session to your skill level. Table 10.1 provides a few ideas based on level of knowledge.

As shown in Table 10.1, the first source for object data—location, magnitude, etc.—is your planetarium software. Several good freeware and paid versions are available. These programs come with very good object databases and allow you to add specialty object databases. These programs are also designed to handle professional-level databases of very faint and obscure objects down below 20th magnitude. Internet forums are also an excellent source of information. Most forum members are very helpful and will guide you to the most interesting objects and those that may be of current interest in the community.

Table 10.1 Observing plan sources of information

Planning information for various objects			
Knowledge level	Object type	General source of information	Number of objects
Beginner and advanced observers	Deep sky objects	Planetarium software Deep sky guides books, magazine articles Internet special interest forums on deep sky objects	1–2 objects for beginning observers, several to many objects for advanced observers
	Minor planets	Minor Planet Center website, minorplanet.info Planetarium software with minor planet database Internet special interest forums on minor planets	
	Planetary objects	Planetarium software CalSky.com website Internet special interest forums on lunar, planetary, and solar observing	
	Variable stars	AAVSO website Planetarium software with variable star database Internet special interest forums on variable stars	

10.4 Target Selection and Science Goals

Once you have spent some time observing and imaging various objects with your AIS, and you are obtaining the quality and performance that you want, you will more than likely zero in on the specific characteristics of the objects you are observing. In other words, you will be looking at a specific set of characteristics for each of the objects of interest to answer one or several specific science questions.

It is very interesting to compare and contrast the various features in the objects you are imaging—this is how new scientific information is discovered. In the case of minor planets, comparing the light curves for different asteroids and comparing their rotation rate to their absolute magnitude provides some insight into the population's behavior. Initially you may only want to do follow-up work on an object to see whether you can repeat an observation or measurement that others have performed. This is the best way to validate your AIS procedures in operating your equipment. The Internet forums and websites dedicated to various objects are the best way to find suitable objects for this purpose and to discuss your results in comparison with previous work completed by others.

10.5 The Observing Plan

Once you have decided on a suitable object or list of objects to observe, you should consult your planetarium program to determine when your object is observable in your local sky. There is also dedicated observing plan software available to the amateur geared toward creating your list of objects and will tell you the best time to observe them. This is a very important step, and you should plan to spend some quality time learning the circumstances surrounding your object's observability. Make sure you consider when your object rises and sets, and when it clears a tree line or other obstruction. It is best to choose objects, at least initially, that are in season so that you do not have to wait to observe these objects at 3 a.m. or later. It is up to you, of course, to make that decision, but at least when you are starting out, it may be best to plan to complete your observations between sunset and local midnight. More power to you if you are willing to stay out to the wee hours of the morning.

Document all the relevant facts about each of your objects so that it will be easy to locate and slew to them when the time comes. Double-check times and coordinates; there is nothing more frustrating than slewing to the wrong coordinates and later finding out when processing your images that the object is not within the FOV. This happens to everyone, even the most experienced among us when first starting out.

Again, as discussed previously, try not to overload your plan with too much to do. This tends to lead to rushing through your observing plan. You will not have enough time to complete each of your tasks, and you may not get high-quality results. Spending the time to get the correct data the first time is much faster than finding you have to repeat your observations. Do it right the first time.

Finally, throw some AIS test procedures into your plan if necessary. This is a good practice to follow whenever you get a new piece of equipment or have integrated a new way of using an existing component of your AIS into your procedures. Dedicating a session to just testing your equipment or practicing a specific skill is a necessity, especially when you are starting out and getting familiar with your equipment. In the first year, plan to spend at least half your observing sessions just testing and refining your procedures and skills.

10.6 Imaging Session AIS Setup

Assuming that you followed the advice in Sect. 10.2, the AIS setup in the field should be very familiar to you and should pose very few, if any problems. Ideally, it should be identical to what you have previously practiced indoors. Of course, there will be issues related to the specific location, but you will learn how to deal with them as they occur. For this discussion, you are setting up your AIS at the end of your driveway for your first session; this provides the best location close to home for you to get comfortable with using your system. You would be surprised at the locations where amateurs can use their equipment, even in downtown city locations. It is truly amazing the resourcefulness of amateurs in pursuing their avocation wherever they may be.

Putting aside your target object for this evening's observing session (this is covered in a later section), the immediate goal is to assemble your components to make them easier to set up in the field. In your first few sessions, assemble your imaging train inside and verify its proper configuration. Devise a way to transport it safely as an assembled unit to the field location. If you do this, you will save valuable time in the field and reduce the frustration associated with trying to assemble it in the approaching darkness. In addition, there are probably opportunities to pre-assemble some cabling and other electronic/electrical distribution cables into a harness. This may be good for very complex AIS configurations. However, it may be best to simply route your cables as you are setting up in the field, based on your previously determined plan.

When you arrive at the field location, you want to find a spot on a firm patch of ground, on grass, or on a hard spot such as a driveway or concrete pad. In this example, you are located at the end of your driveway, with a clear view of most of the sky to the north, east, and south. To the west are trees and your house. Initially, when you set up your tripod and mount, you want to set the tripod legs to level your mount on the tripod, and you want the RA axis to point approximately north (within 5–10 degrees (°)). Leveling your mount is not strictly necessary, but it enables you to be able to use your mount repeatedly at the same location without readjusting the mount's Altitude axis. You will initially adjust the Altitude axis with the mount leveled on the tripod during your first session in the field.

After leveling your mount on your tripod, use your compass to determine the direction of *true north*, taking into consideration the *magnetic declination* of your

location. This involves adding (or subtracting) an offset to your compass indication to determine the direction of true north (Fig. 5.2). A positive (+) magnetic declination means that the compass points to the east of the true north direction by the specified amount for the location. On much of the east coast of North America, the magnetic declination is approximately −10°. For example, if your location's magnetic declination is −8°, you need to align your mount to 8° to the east of where the compass is pointing, or a direction of 8° magnetic. See the National Oceanic and Atmospheric Administration (NOAA) website on magnetic declination at www.ngdc.noaa.gov/geomag-web/#declination.

Using your mount's Azimuth adjustment, align your mount to true north using your compass indication to guide you. Your mount is then close to the desired position on the Azimuth axis. Until you can see the North Star, or until you can use the stars to determine the exact Altitude angle, you can set your mount Altitude using the Altitude scale typically found on the base of your mount. The value you set is equal to your latitude. Therefore, if you are located at 38° north latitude, adjust your mount's Altitude indication to 38°. Because this is probably accurate to only ±3°, you will need to refine it later.

It is up to you whether you make the Azimuth and Altitude adjustment with just the mount, or wait until you place your astrograph and counterweights on the mount. Try it both ways and see which is more accurate for your AIS. This process applies equally to both GEM and fork mounts, although the adjustment controls may be different for individual mounts. Even if you make the initial adjustment without the astrograph and weights, you will need to verify the accuracy of the adjustment after you have loaded the mount with your equipment.

Proceed to assemble your AIS using your previously determined process, and get everything started up. Make sure you use the power-up sequence you developed during your system integration to power up your system. Providing power in the field can be a particularly challenging adventure, and putting a lot of thought into how you provide power to your system is a necessity. As discussed in Chap. 6, there are several choices for power, but the best is standard 120VAC service from your home or other hardwired source of power. Battery power can be a good choice also as long as you purchase a battery system that provides enough capacity to power your system for at least 10 h. If you scrimp on the capacity, you will live to regret it the first (or second, or third) time you have to abort a session because the voltage is getting low on your battery system, causing intermittent faults or failures in your AIS equipment.

Once your AIS is powered up and all the equipment is verified as operational, then you can move on to the next step, polar alignment. There are several different methods for performing a polar alignment, but only the two major ones are presented here. The first one presented here, which relies on the equipment incorporated by the vendor into your mount, is performed using an optical telescope called a polar scope. A polar scope is commonly provided by go-to mount vendors and is integrated into the mount's RA axis (Fig. 10.1).

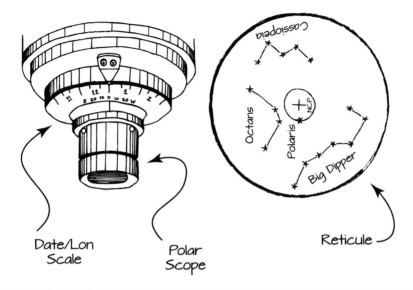

Fig. 10.1 The small finder scope mounted on the right ascension (RA) axis is called the polar alignment scope (Courtesy of Rachel Konopa)

This small finder scope has a reticule etched with stars depicting the north celestial polar region and the south celestial polar region. Following the mount vendor's instructions, you generally perform the following steps:

1. Set the time and date scales on the polar scope according to the vendor's instructions.
2. Rotate your mount manually in RA to orient the reticule display while looking through the polar scope to the corresponding orientation of Polaris (for mounts in the Northern Hemisphere) in the real sky.
3. Locate Polaris in the polar scope and adjust the mount's Altitude and Azimuth controls to move Polaris to the position indicated for Polaris on the polar scope reticule.

This should polar align your mount to within 5 arcminutes (arcmin) of the refracted *North Celestial Pole (NCP)*.

The other method used by astrophotographers to get a *very* accurate polar alignment is called the *Declination Drift Method*. There are a couple of variations of this method, usually differentiated by the way the drift is measured. You can do this visually or by using your main imaging camera system. To speed up the process, you should perform the normal setup of your mount as outlined at the beginning of this section, perform the polar alignment using your polar scope (if the NCP and Polaris are visible), and then use the Declination Drift Method. The following are

10.6 Imaging Session AIS Setup

basic steps for performing a visual declination drift polar alignment. Ensure that the mount has been properly leveled to minimize any interaction between the Altitude axis and the Azimuth axis when making adjustments.

Azimuth Adjustment

1. Fit a guiding eyepiece into your astrograph and slew to a bright star near the Meridian and the Celestial Equator with your mount tracking at the Sidereal rate. Adjust your focus as necessary. Sometimes it is easier to leave the star slightly de-focused to more accurately place it in relation to the cross-hairs on your eyepiece.
2. Turn off the tracking, watch the star drift toward the west, and align one of the cross-hair lines with the drift axis. Observe through the eyepiece such that the E-W axis appears horizontal.
3. Re-center the star with the Sidereal tracking rate turned on and watch the star's motion on the declination axis (vertical axis) toward the north or south. Note the direction of declination drift.
4. If the star moves north in declination, then the star is too far to the left in azimuth and you need to adjust the Azimuth control to move it to the right. Re-center the star in the eyepiece.
5. If the star moves south in declination, then the star is too far to the right and you need to adjust the Azimuth control to move it to the left. Re-center the star in the eyepiece.
6. Repeat steps 3–5 as necessary to reduce the drift to an acceptable level. Generally, if you can detect no motion for 10 min, it is good for most of the scientific imaging you are going to do.

Altitude Adjustment

7. Slew your mount to a bright star to either the east or west near the horizon (within 20°). Ensure your mount is tracking at the Sidereal rate. Focus on the star as you did previously.
8. Turn off the tracking, watch the star drift toward the west, and align one of the cross-hair lines with the drift axis. Observe through the eyepiece such that the E-W axis appears horizontal.
9. Re-center the star with the Sidereal tracking rate turned on and watch the star's motion on the declination axis (vertical axis) towards the north or south. Note the direction of declination drift.
10. If the star moves north or south in declination, adjust the Altitude control to move the star back toward the center position.
11. Repeat Step 10 as necessary to reduce the drift to a level acceptable to you. Generally, if you can detect no motion for 10 min, it is fine for most of the scientific imaging you want to do.

As you may have already realized, the visual method takes a while to reduce the drift to a very small amount. Depending on the precision of your adjustments, and your skill level in estimating the amount to move your Azimuth and Altitude controls,

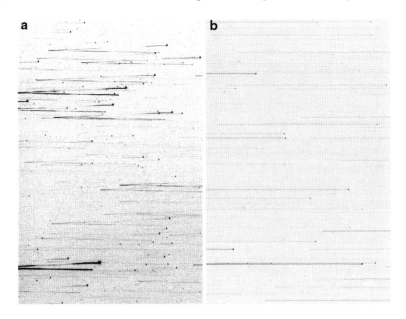

Fig. 10.2 CCD declination drift images using Dr. Hall's methodology: (**a**) before polar alignment (**b**) after polar alignment

it may take four to six iterations to achieve an acceptable level of drift. The good news is that after performing this procedure a few times, you can probably get the number of iterations down to fewer than four. It is possible to get to the point where you are spending less than 30 min doing this procedure. An excellent explanation of how this method works is provided by Peter Kennett at his website: http://www.petesastrophotography.com/index.html.

The alternative to performing the declination drift alignment procedure visually is to use your imaging camera to help measure the amount of drift. This method offers the advantage of providing a recorded image in which to make your measured drift and determine the correction amount and direction. In addition, the main difference between this method and the visual method is that you can actually see the drift over time rather than the real-time position you get visually. This method is described very well by Dr. James E. Hall of the University of California, at Irvine. He has provided an excellent explanation at the minorplanet.info website: http://www.minorplanet.info/ObsGuides/Misc/ccdpolaralignment.htm.

Figure 10.2 provides an example of a drift image using Dr. Hall's methodology.

10.7 Executing the Plan

Just as making a good observing plan is absolutely necessary for the best results, effectively executing the plan is equally important. You have spent time creating your plan for tonight's session—try not to make any changes when you are in the field. Unless you have made a bad mistake in calculations or in determining the objects' coordinates or times of observability, stick with your plan.

Sticking with your plan gives you insight into how effective you were in coming up with the plan and how realistic it is in terms of your current knowledge and skills in using your AIS. It is important that you work through each of the objects on your observing plan to gain a complete picture of how executing your plan actually matches with your expectations. Make detailed notes on what worked, what objects were more difficult to observe, and how smoothly your procedures worked in actual operation. Doing this will speed the development of your skills and knowledge in operating your AIS.

10.8 Phase 1: AIS Alignment and Calibration

In the context of this discussion, AIS alignment refers to a system-level all-sky alignment that takes into account the mount's polar alignment error and the software used to synchronize the sky's position in real time, with the pointing model in the software used to point and slew to targets across the sky. With a perfect polar alignment, when you perform a two- or three-star all-sky alignment, you are synchronizing your software to the sky much as when you set your watch to the correct time. Because the Earth is continuously rotating, the real-time coordinates of the objects in Hour Angle (RA–Local Sidereal Time) continuously change. There are also small discrepancies between the mount's reported position and the actual FOV center in the astrograph. *Cone error* refers to the condition where the astrograph is pointing slightly askew of the desired axis, offset horizontally and/or vertically from the correct astrograph axis (Fig. 10.3).

The correct alignment allows you to direct your astrograph to a specific location in the sky by pointing to an object in your planetarium program and directing your mount to slew to that object, or by specifying the RA and declination of the object. If you have done a good job, you should be able to place an object within 1 arcmin of the center of your camera's FOV. You can see that a wide camera FOV makes it even easier to place an object it. In addition, this alignment should "stick" for the whole session—there will be a small amount of drift but overall, you should be able to slew from target to target over a 4 to 8-h period and not have to re-synchronize the planetarium program. If you ever have to re-synchronize, it is a quick enough action, but it is important to do it when you can still see the object within your FOV and center it appropriately before re-synchronizing.

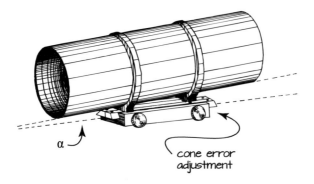

Fig. 10.3 The cone error of an astrograph showing the angle (α) difference between the astrograph axis and the mount axis. The difference is corrected using adjustment screws on the astrograph mounting plate (Courtesy of Rachel Konopa)

The alignment is only five basic steps, with steps 2–4 performed three times, once for each star when doing a three-star alignment. Here are the general steps:

1. Un-park the mount—The mount is pointing in the Home position, which is generally toward the NCP and is locked in position. If you try to move the astrograph, your software should warn you that the telescope is parked.
2. Select an object and slew to it—This sends the coordinates to the mount driver (an ASCOM driver in most cases), and the mount slews to the position that corresponds to the coordinates sent. Usually, bright stars are used for the alignment procedure.
3. Observe the object—Take a photograph and determine the location of the object in the field. Center the object using the manual controls for moving the astrograph, and verify the object is in the center by taking another photograph.
4. Synchronize—Once the object is in the center of the camera FOV, send a synchronize command from the planetarium program to synchronize the mount's position as displayed in the program.
5. Repeat Steps 2–4 for two more objects.

These steps should also be used when employing the standalone hand controller that is delivered with all go-to mounts. This alignment functionality is generally available on all levels of go-to mounts from the beginner Alt-Azimuth mount to the professional observatory mount that can carry 500 lb (227 kg).

If your mount's ASCOM driver supports multiple-point alignment, then take advantage of that feature because it improves the pointing model as you slew to various objects during your observing session. Check your documentation to determine whether your mount supports multiple-point alignment because it ensures a trouble-free session slewing from object to object.

Once you have completed your system-level all-sky alignment, if you are using an auto-guiding system, you need to calibrate that system after you slew to your

first target. The following are general steps for calibrating your auto-guiding system. Refer to your auto-guiding software documents for the specific user interface interactions. The various Internet forums are also an excellent source to help you understand the operation of the auto-guiding software available to the amateur astronomer.

1. Slew to your target.
2. Start the fast image acquisition mode for your guide camera within your auto-guiding software.
3. Select a guide star within your auto-guiding software.
4. Start the calibration mode of your auto-guiding software. The software should start stepping the position by a specific amount, and the software monitors the response from the guide camera to determine how much the object image moves. From this information, the software calibrates the E-W and N-S motion constants for use while auto-guiding. The motion constants are in units of arcseconds/pulse for pulse-guiding mode.
5. Once the calibration is complete, the software most likely reports that fact and then starts the auto-guiding process with an appropriate display showing that the software has locked onto the object for auto-guiding corrections.

Once the auto-guiding software starts the guiding process, you can begin your actual imaging to acquire your target data.

If you use an encoder-based drive rate corrector system, activate that system according to the owner's manual. Generally, it auto-calibrates and starts correcting the drive rate after a short boot and calibration sequence. From that point, you should be able to start your imaging run.

10.9 Phase 2: Data Acquisition

NOTE: *The discussion in this section does not include any information about how to acquire calibration frames for calibrating your long-exposure still frames nor how to perform the calibration. This subject is covered in Chap.* 11*, Sects.* 11.5 *and* 11.6.

All right! This is the point in the operation of your AIS that you have been working to reach. Your AIS is humming along locked onto your guide star and tracking your object perfectly—it's time to open the shutter on your camera and start acquiring data on that tiny, dim, 5-km diameter minor planet that is out there 200 million miles (320 million kilometers) away. Let's back up for a moment and talk about your imaging software and some general housekeeping issues you encounter while using your software.

To keep track of the literally thousands of images that you will take using your AIS, you need to set up a file structure that is easy to implement and also makes it easy to find the data you need at anytime in the future. One tried and true method is to create an overall directory called "Astrophotos" on the root of your data drive

and then create a new directory for each observing session. The name of each session's directory in this method is the date in this format: YYYY-MON-DAY or, for example, "2013-July-16". Any variation on this also works. The important point is to be able to sort by directory and obtain a list that is in a good order for locating a particular observing session. It may be useful to add a suffix to this directory name stating the type or object observed, such as "2013-Aug-21_Lunar", or "2014-Feb-04_DeepSky", or even "2013-May-17_M13".

Once you have established the directory for your session's images, most camera control software allows you to select a mode to auto-name your files with a date/time stamp plus a text string of your choice that will be appended as a prefix or suffix to the filename. Use this feature—it will save time and effort in the future. An example name created by The Imaging Source IC Capture program is—

"Gassendi10003 12-02-03 17-50-59.avi"

On a Microsoft Windows computer, a complete path to this file might look like—

"E:/Astrophotos/2012-Feb-03/Gassendi10003 12-02-03 17-50-59.avi"

Once you have sorted that out, you can start your imaging program's function to acquire images, whether it is a webcam video or a long-exposure astrocam still frame. As discussed in Sect. 11.2, make sure to read the owner's manual for your camera and your image acquisition software before trying to use them in the field.

When you start your imaging run, most software allows you to direct it to acquire X number of images set to an exposure time of Y using filter Z. It is up to you to determine the values for X, Y, and Z. An example for a minor planet might be to make 30 exposures, of 60-s exposure time, using Filter 4 (V-band). Once you say, "Go," you can sit back and watch as your system acquires the 30 frames specified over the next 35 min. This is the point where some of us start a game of Solitaire on our iPad, or go in the house to get warmed up.

It may take you a while to trust in your system and its behavior. It's pretty cool to sit and watch as each image comes in, and monitor the progress of your imaging run for focus shifts, transient cloud effects, and other issues that may crop up. You can also monitor the images for long-term drift to get an idea how good your polar alignment is. At first, it's good to sit with your system and monitor its performance so that you can fully understand its operation. If you have a sufficiently powerful computer, you can even start to do some processing on your images while you are still acquiring them. If you decide to process your images "on the fly," make sure you monitor the operation of your camera and mount so that you do not inadvertently affect some part of the real-time operations of your AIS.

If you have spent the time at the beginning of your session to ensure an accurate polar alignment and verified all your equipment is working properly, you should be able to spend the next 4–8 h slewing from target to target taking all the images you want. While you are doing this, if the temperature seems to be changing more than 2° per hour, you need to verify that your focus is good during your imaging run of each object. Having a thermometer to record local temperatures every 15 min is a way to monitor this change. It is also important to verify your focus when slewing

to each new object. If you have any questions about focusing, review Chap. 6, Sect. 6.10. In addition, checking the focus at the beginning of each imaging run is essential to getting the best data you can. If you do this, you can be assured that your data will be consistently acquired, and your targets will be at the center of each frame, or as you desire.

While your observing session is in progress, make sure you continue to monitor and correct any other environmental impacts that may affect your AIS performance and your own physical performance, especially toward the end of your session. If you are using battery power, it is also important to monitor your system during your session to make sure you will have enough power to finish your planned observations. At a minimum, it will keep you informed of when to begin to shut your system down to avoid complete power failure. There is almost nothing worse than having your AIS shut down in the middle of an exposure. It happens to even the most experienced observers.

10.10 Phase 3: Tying Up Loose Ends

If you were successful in completing all your observing objectives for the session, and/or completing your session before you ran out of power (monitoring as stated previously so that you do not have a power failure during an exposure), then you can perform an orderly shutdown of your AIS. This procedure should have been developed and tested as part of your system integration activities, as discussed in Sect. 10.2. An orderly shutdown process ensures that you do not corrupt or lose any of the precious data you spent valuable time acquiring using a system you have probably spent months building. Be proud of your accomplishment. Give your data the proper respect and protect it. Before shutting down your computer, you may want to look in the directories where you stored your data and assure yourself that it is all there as expected. Checking the time/date stamps on the files is a quick way to do that.

The first step in protecting your data is to make sure your computer shuts down as expected, noting any variation for further investigation at another time. If there is any time that your data may become corrupted, it is during shutdown of the applications or the operating system. Once everything is shut down, remove power from your main power distribution hub—it may be a power extender or other such device. At this point, it becomes safe to start breaking down your AIS (if you are not lucky enough to have a permanent home for your equipment).

10.11 AIS Teardown

You should have practiced your teardown process in the system integration phase of your AIS integration project as discussed in Sect. 10.2. It should be essentially the reverse of your AIS setup routine and should be disciplined in the areas of sequence and location where you place your components and where they are

eventually stored. This has not been discussed previously, but the storage of your components is an important consideration.

The large pieces of your AIS—the astrograph, mount, and camera(s)—usually come with their own storage containers. When you purchase all the other support equipment, it will come in its own individual container. You do not want to continue to use the individual container approach to storage. It is too slow, and each of the containers degrades over time. It is best to think about and purchase larger storage cases for your equipment, grouping the components as you see fit. One approach is to group related components together, for example, group all the optical elements together: eyepieces, Barlow lenses, focal reducers, filters, and adapters. Group all your electronic components together. Group all your cables together.

Another approach is to store components as a subassembly of components that go together as they would as mounted on the AIS. Subassemblies should be grouped, such as your primary imaging train accompanied by the required cables, power adaptors, and any other related mechanical and optical components. Using this technique allows you to pre-assemble and store your components before your imaging session and makes AIS setup and teardown that much quicker.

A specific place for each component and putting each component in its place helps ensure efficient setup and teardown of your AIS. An investment in good quality storage containers protects and maintains the value of all your equipment and makes it much easier to transport your equipment long distances as required.

10.12 Post Imaging Session Critique

Once you have everything packed away or stored as required, you should spend 5 min taking stock of the just completed observing session, going over in your mind (and documenting as you see fit) any problems, what went better than expected, and what was unexpected. Gather up any notes you have written about the operation of the AIS. It is an excellent practice to keep a free-form handwritten observing log to jot down those very pieces of data that are hard to remember; items such as focus positions, software settings, and image acquisition details. By the end of your observing session, you should have a good overall feel for how it went and the quality of your data. This assessment also becomes easier after you have had two or three sessions with any given object type.

No matter how you think you feel at the time, and how excited you are about the success of your data acquisition, resist the temptation to try to process your data immediately after the observing session. This is difficult, but you will feel much better, more relaxed, and more objective in your evaluation of your data if you wait until after you sleep. Generally, after you have completed your observing session is the worst time because you will not assess your data objectively, and you will run out of steam before you get to all your data. Do yourself (and your data) a favor and wait until later to process your data.

10.13 Ad Hoc Imaging Pitfalls and Successes

Sometimes, if you completed all your session objectives and/or you found that your original plan was really bad, or if the weather did not cooperate until much later in the evening, you may need to do some ad hoc planning and observing. This practice can be very successful when approached correctly, or it can become a very frustrating exercise. What it comes down to is to properly plan for emergent issues or ad hoc observing opportunities. What this means is that you create your primary observing plan for tonight's session and then create a plan for some secondary objects and times. Keep in mind any changes to the imaging train that may be needed, a change in location, and/or a change in testing requirements if you are using a new piece of equipment.

Any change in the initial observing plan requires careful consideration of the impact on how your AIS is set up and configured. It is best to minimize changes to the AIS configuration by selecting only those ad hoc objects that are suitable for the configuration you have chosen for your AIS for this session. Changing configurations in the middle of a session is fraught with danger and can become a very frustrating exercise, especially for a beginner. It is best to thoroughly plan any changes before implementing them, and select secondary, ad hoc objects that have the same characteristics as your primary observing objects to minimize or eliminate any change to your AIS configuration.

The only exception is if you have pre-planned configurations documented and ready to go, which adds to your flexibility in being able to handle these ad hoc situations. Anything you can do to pre-plan or pre-stage your configuration and equipment helps lead you to a successful outcome. Many sessions that started out badly have had successful outcomes when the observer has been prepared and has the knowledge and skill to recognize how best to reconfigure his or her AIS on the fly. With proper preparation, you too can be ready for anything that is thrown at you that disrupts your session or presents an emergent opportunity.

Further Reading

Berry R, Burnell J (2005) The handbook of astronomical image processing. Willmann-Bell, Richmond
Buchheim R (2007) The sky is your laboratory. Springer, Berlin/HeidelbergNew York
Chromey FR (2010) To measure the sky. Cambridge University Press
Covington MA (1999) Astrophotography for the amateur. Cambridge University Press
Dragesco J (1995) High resolution astrophotography. Cambridge University Press
Dymock R (2010) Asteroids and dwarf planets and how to observe them. Springer, New York
Harrison KM (2011) Astronomical spectroscopy for amateurs. Springer, New York
Henden AA, Kaitchuck RH (1990) Astronomical photometry. Willmann-Bell, Richmond
Howell SB (2006) Handbook of CCD astronomy. Cambridge University Press

Smith GH, Ceragioli R, Berry R (2012) Telescopes, eyepieces and astrographs. Willmann-Bell, Richmond
Warner BD (2006) A practical guide to lightcurve photometry and analysis. Springer, New York

Web Pages

http://www.ngdc.noaa.gov/geomag-web/#declination/
http://www.petesastrophotography.com/index.html
http://www.minorplanet.info/ObsGuides/Misc/ccdpolaralignment.htm

Chapter 11

Image Acquisition and Calibration

11.1 Organizing Your Data

When you start a session, it is best to have planned how to store your images as you acquire them. There are many ways you can approach this problem. You could store your data based on some specific characteristic, e.g., image format, object observed, chronological order, Automated Imaging System (AIS) configuration, or camera used. However, because the design goal for your storage structure is to be able to easily retrieve the data for future processing and to be able to re-create the processing that was performed on that data, a hierarchical structure is best. Although you can pick any method and structure to organize your data, the following is recommended:

```
Root Directory—"Astrophotography/"
  Master Session Log file—"Master_Session_Log.txt"
  Session Date—"2013_July_22/"
    Observing Log File—"Observing_Log.txt"
    Raw Data files—"Raw/"
      Still Frames—"Stills/"
      Video Frames—"Video/"
    Calibration Data files—"Calibration/"
    Processed Data files—"Processed/"
    Equipment Photo files—"Equipment/"
    Document files—"Documents/"
```

This structure lends itself to efficiently processing your data because it keeps the raw data intact and separate from the calibration data and processed data. It also allows you to gather all the other miscellaneous documents and equipment photos together with the session. You should also get into the habit of keeping an observing log. Many software applications facilitate this by incorporating an observing log as a feature. Ensure that the log can be stored as a separate file within your structure.

If you have never kept an observing log, it is a running narrative of your session that records information such as equipment settings, software settings, and other pertinent facts important to understand when processing your images. It also becomes an excellent "knowledge base" on the operation of your AIS and a goldmine of information when creating or modifying procedures and processes to address changes or additions of components to your AIS. Of course, you can also record anything else you desire in your observing log. Make good use of your log, it will save you time and effort.

In addition, you should keep a high-level log of your observations in a separate "Master Session" file to serve as a reference for future use. This file can be a text file or a spreadsheet file. A list of suggested data fields is—

Session Date
AIS Astrograph
AIS Mount
AIS Camera
Object(s) Observed
Session Start Time
Session End Time
Weather Conditions

Add any other data you feel would be important to be able to sort and select to help find your observations. Be as specific as necessary to help you do your search.

Initially, it may not seem necessary to record all this information or keep your data as organized as outlined, but there will come a time when you are doing your professional-level observations and want to fully document your observing session. This is especially important in establishing your reputation as a credible observer when you write up your latest discoveries to share with the astronomical community. Therefore, it is a good idea to get into the habit of thoroughly documenting your sessions…you never know when a session may be significant, either to you or to someone else.

11.2 Image Naming Conventions

As discussed in Chap. 10, Sect. 10.9, and in the previous section of this chapter, how you name your files has long-term implications for how easily you can find and use your data in the future. It is important to adopt a logical naming convention

for your files so that you recognize immediately what is in the file just by looking at the name. Fortunately, the image acquisition programs available today make this easy by building in auto-naming functions. All you have to do is set a few name parameters and select the date/time format, and the program saves the files as they are captured using the names you defined.

There are several criteria you could use to name your files, but the simplest is to use the object name, any filter you may have selected, a sequence number, and the date/time. Most image acquisition programs automatically add the date/time to the filename if this option is selected. Make sure you coordinate your directory structure with your naming convention so you do not repeat information unnecessarily. This ensures you have the most efficient structure for naming and storing your data for quick sorting and selecting when you are searching for data in the future.

11.3 Image Data Formats

The data that you get from your charge-coupled device (CCD) camera is typically a two-dimensional (2-D) structure of 16-bit numbers or values. Audio video interleave (AVI) files store a sequence of 2-D structures of 8-bit values. These structures are referred to as frames. Think of a frame as a spreadsheet of values with a range of 0–255, or 0–65,535 (Fig. 11.1).

It is stored in a file as a string of values, with the total number of values equal to the number of x-axis values times the number of y-axis values, i.e., 640×480, or 307,200 separate values. For example, the data might look like this in the file:

$$23334, 25332, 23533, 63333, 53311, 53222, 43322, 43211, 33255\ldots.$$

Although this data seems to provide a lot of information, by itself it lacks context. There are several pieces of information you need to know about this data. As just mentioned, the x-axis and y-axis sizes are primary pieces of data. Consider this—a string of 307,200 values could be an x, y structure of size 640×480, 480×640, 960×320, or 320×960…it could be almost anything. It is important to know how this particular data is structured.

A whole host of information describes the data contained in an image file. This descriptive data is sometimes referred to as *metadata*. Metadata are data about data. In a database, metadata describe and define the different fields that make up the database. In an image file, the metadata describe the context or circumstances under which the image was acquired. Information included with the image data includes x and y axis sizes, time/date the image was acquired, length of exposure, camera information such as gain and readout noise level, target coordinates, and other pertinent information. This information aids your software in processing the data and in displaying the information correctly.

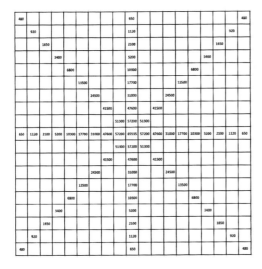
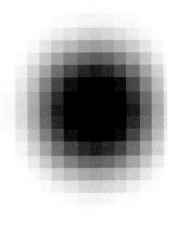

Fig. 11.1 An image of a star stored as a table of 16-bit numbers (0–65,535) as in a spreadsheet

11.3.1 Flexible Image Transport System (FITS) Format

The FITS format, developed by professional astronomers to store their data, is flexible and provides a standard that has stood the test of time. It was developed by the International Astronomical Union (IAU) FITS Working Group (fits.gsfc.nasa.gov) in 1981 to store scientific and other image data. FITS is the most commonly used image format in astronomy and is specifically designed to store scientific photometric, astrometric, and image source metadata. Version 3.0 of this image format was approved by the IAU FITS Working Group in July 2008. The format supports data arrays of arbitrary dimensions and sizes; it also supports extensions to the standard list of keyname/value pairs.

The IAU FITS Working Group website makes available free programs for opening FITS files that have the file extension .fits, or .fit. The website also provides documentation on the standard and how it was developed over the years. If you are serious about scientific imaging, you should become very familiar with this image format and this website. As an introduction, the FITS file format is made up of header and data units. The header unit has a fixed record structure comprising a series of keyname/value pairs and an optional description. Each record in the header unit has a maximum fixed length of 80 characters in the following format:

KEYNAME = value /comment string

The following is an example of the keyname/value pairs that are included in the header unit of a .fits file:

11.3 Image Data Formats

```
SIMPLE    = T
BITPIX    = 16/8 unsigned int, 16 & 32 int, -32 & -64 real
NAXIS     = 2/number of axes
NAXIS1    = 1674/fastest changing axis
NAXIS2    = 1248/next to fastest changing axis
BSCALE    = 1.0000000000000000   /   physical=BZERO+
            SCALE*array_value
BZERO     = 32768.000000000000   /   physical=BZERO+
            SCALE*array_value
DATE-OBS  = '2011-06-28T05:20:45' / YYYY-MM-DDThh:mm:ss
            observation start, UT
EXPTIME   = 300.00000000000000   /   Exposure   time   in
            seconds
EXPOSURE  = 300.00000000000000   /   Exposure   time   in
            seconds
CCD-TEMP  = 24.981929223073166   /   CCD  temperature   at
            start of exposure in C
XPIXSZ    = 10.800000000000001 /Pixel Width in microns
            (after binning)
YPIXSZ    = 10.800000000000001 /Pixel Height in microns
            (after binning)
XBINNING  = 2/Binning factor in width
YBINNING  = 2/Binning factor in height
XORGSUBF  = 0/Subframe X position in binned pixels
YORGSUBF  = 0/Subframe Y position in binned pixels
FILTER    = 'None ' / Filter used when taking image
IMAGETYP  = 'Light Frame' / Type of image
FOCUSPOS  = 1362 /Focuser position in steps
FOCUSTEM  = 29.500000000000000 /Focuser temperature in
            deg C
OBJCTRA   = '20 22 10' / Nominal Right Ascension of
            center of image
OBJCTDEC  = '+40 15 23' / Nominal Declination of center
            of image
OBJCTALT  = ' 69.8573' / Nominal altitude of center of
            image
OBJCTAZ   = ' 76.2313' / Nominal azimuth of center of
            image
OBJCTHA   = ' -1.7339' / Nominal hour angle of center
            of image
PIERSIDE  = 'WEST ' / Side of pier telescope is on
SITELAT   = '38 20 35' / Latitude  of  the  imaging
            location
SITELONG  = '-77 46 10' / Longitude  of  the  imaging
            location
```

```
JD          =   2455740.7227430558 /Julian Date at start of
                exposure
JD-HELIO    =   2455740.7265792545  /Heliocentric  Julian
                Date at exposure midpoint
AIRMASS     =   1.0716015874245266 /Relative optical path
                length through atmosphere
FOCALLEN    =   1610.0000000000000 /Focal length of tele-
                scope in mm
APTDIA      =   203.50000000000000 /Aperture diameter of
                telescope in mm
APTAREA     =   27321.089037689566 /Aperture area of tele-
                scope in mm^2
EGAIN       =   1.0000000000000000 /Electronic gain in e-/
                ADU
SWCREATE    =   'MaxIm DL Version 5.15' /Name of software
                that created the image
SBSTDVER    =   'SBFITSEXT   Version   1.0'   /Version   of
                SBFITSEXT standard in effect
OBJECT      =   ' '
TELESCOP    =   ' ' / telescope used to acquire this
image
INSTRUME    =   'ASCOM QHY9 Driver'
OBSERVER    =   'Gerald R Hubbell'
NOTES       =   ' '
FLIPSTAT    =   ' '
CSTRETCH    =   'Medium ' / Initial display stretch mode
CBLACK      =   4484 /Initial display black level in ADUs
CWHITE      =   8279 /Initial display white level in ADUs
PEDESTAL    =   0 /Correction to add for zero-based ADU
SWOWNER     =   'Gerald  R  Hubbell'  /Licensed  owner  of
                software
INPUTFMT    =   'FITS ' / Format of file from which image
                was read
```

The header unit is followed by the data unit, which contains the image data. The standard allows for several different data types, including 8-bit unsigned integer, 16-bit signed integer, 32-bit signed integer, 32-bit floating point real, and 64-bit floating point real values. You should access the IAU Working Group website and study its documentation if you are interested in learning all there is to know about the FITS image format.

11.3.2 Audio Video Interleave (AVI) Format

The AVI format was developed by Microsoft in 1992 as part of its Video for Windows technology. These image files use the .avi file extension. This format is

used extensively for recording webcam video and is a container format for storing data using different video encoding protocols, also known as *codecs*. There is a variety of codecs, compressed and uncompressed. Typically, .avi files are used to store raw data from planetary, lunar, or solar imaging sessions and are processed using the various solar system image-stacking programs, such as Registax6 and AVIStack.

To get the best data from an AVI file, you should record your data in an uncompressed format. This format consumes more disk drive space but provides the highest quality data for processing. By all means, if you are short on disk space, use a compressed format when storing your files. This is not the best, but until you can provide more space, do the best you can. One of the biggest storage issues you face is that each uncompressed AVI file is often more than 300 megabytes (MB), and a complete session's worth of data can easily exceed 30 gigabytes (GB) for lunar imaging.

Once you have processed the raw data, you may choose to delete the AVI files and keep just the FITS files that were processed from the AVIs. Of course, you give up the possibility of reprocessing your raw AVIs, and that is a decision you must weigh carefully. If possible, you should invest in a disk drive system with a capacity of at least 1 terabyte (TB) to store your data and think about a backup and recovery plan for your data.

11.3.3 Other Image Formats

Many other image formats are used commercially and in the astronomy field. One of the most common formats for sharing processed images is the JPEG format. Created by the Joint Photography Experts Group, which was formed in 1986 and released its first standard in 1992, this format, is probably the most widely used standard in the world for images posted to the Internet. The JPEG format is an 8-bit, compressed, lossy format that degrades the resulting image when saved. It is supported by practically all image-processing programs.

Another widely use format for storing and processing astronomical images is the Tagged Image File format or TIFF. The TIFF is a 16-bit, uncompressed image format that can be used to effectively archive your processed images. It was developed in the early 1990s by Aldus and is owned by Adobe. This format is widely used by commercial imaging professionals and others who need a high-quality image storage format. Like the JPEG format, TIFF is widely supported by most image-processing programs.

11.4 Image Acquisition Software Applications

Many applications are available to you for acquiring and processing your astronomical images; Appendix 5 provides a comprehensive list of software applications. Some are free, some are shareware, and others are professional-level

processors that you must purchase. They all have features in common that are necessary for performing the basics of image processing. Some of these features include—

1. Acquiring and storing images in the FITS format.
2. Displaying FITS image files.
3. Displaying and editing the FITS header.
4. Saving FITS files in a wide range of formats, including JPEG and TIFF.
5. Aligning and combining multiple image files.
6. Performing basic image processing functions, i.e., adjusting levels, contrast, brightness, gamma, rotate, crop, resize, filter, etc.
7. Performing basic batch processing and scheduling image acquisition and processing.
8. Automatically naming captured images.

These are just a few of the basic features that you can expect to find in most, if not all, the astronomical image processing applications available to you. It is important that you learn your application thoroughly before using it in the field so that you do not waste valuable time searching for a feature or trying to decide whether that flag is applicable to your observation. Spend some time reading your application's help file and user's manual. You will find that if you really get to know your applications, they can do a lot of work that you may have thought you had to do manually.

Dig into the manual on those cloudy nights; you may be able to simplify your procedures by taking advantage of an obscure feature that the application designer included for just such a purpose. You will find that the features that are included in the more mature applications are based on feedback from very knowledgeable astrophotographers. Take advantage of every bit of automation you can to make your work easier.

11.5 Image Calibration Basics

Image calibration involves correcting your image data for systematic errors in your measurement system. It is important to do this if you want to get the best results from your data. When you acquire your image, the raw data not only has the information you desire, but also has extraneous information that needs to be removed in a very specific manner to reveal the good information. Bear in mind that image calibration is used primarily for the long-exposure astrophotography employed to acquire images that will be processed for astrometric and/or photometric purposes.

To help you understand the complexity of the concept, the following analogy demonstrates what is involved in calibrating an image. Imagine that you need to find the total weight of a pile of widgets. You do not know how many widgets are in the pile, and each of these widgets is wrapped in some packaging. You want to measure the total weight of the widgets without the packaging, but you are not allowed to remove the packaging. Also, the scale you are using has not been checked for accuracy, so you need to do that also. Therefore, you need not only to check the scale to determine how accurate it is, but you also need to remove the effect of the packaging on your measurement of the widget weight.

11.5 Image Calibration Basics

The reason you need to weigh these widgets is because they are all wrapped up in one big block, and you really do not know how many of them there are. You have an estimate, but you need to know precisely how many there are. You also need to know the total weight of all these widgets. You do have two other pieces of information. You have one of the wrappers used to package the widget, so you can use that as an input to your problem. You also have a reference weight that you know is the same as 100 widgets. So let's lay this out with some simple algebra:

$$
\begin{aligned}
X &= \text{Number of Widgets} \\
Ww &= \text{Weight of 1 Widget} \\
W100 &= \text{Weight of 100 Widgets} \\
Wp &= \text{Weight of 1 Widget Package} \\
Wt &= \text{Total weight of block of Widgets}
\end{aligned}
\tag{11.1}
$$

Therefore, the following equations apply to our problem:

$$
\begin{aligned}
Wt &= X(Ww + Wp) \\
W100 &= 100\,(Ww)
\end{aligned}
\tag{11.2}
$$

That is really all you know at this point. You put the W100 reference on the scale, and it gives a reading of 3,500 units. Okay, that's good; you can calculate the weight of one widget. Using the equation for 100 widgets:

$$
\begin{aligned}
3{,}500\text{ units} &= W100 \\
100\,(Ww) &= 3{,}500\text{ units} \\
Ww &= 3{,}500/100\text{ units} = 35\text{ units}
\end{aligned}
\tag{11.3}
$$

Each widget weighs 3,500 units/100 = 35, so you can normalize the scale to 100 widgets by dividing the reading by 35. Now you place the packaging on the scale and get a reading of 10; the packaging is equal to 10/35 of the widget weight, or 28.6% of the weight of the widget. Consequently, the total package weight is equal to 128.6% of 35 units, or 48.9 units.

Now that you have the total package weight for one widget, you can weigh the block of widgets, figure out how many widgets there are, and determine the total weight of all the widgets. However, there is another problem. You discover that the weight of the block of widgets exceeds the upper limit of the scale. You need to apply a divider value to the scale in order to weigh the block. Okay, you decide on a divider value of 10 so that when you weigh the block the value read on the scale is 1/10th the actual value. In other words:

$$
Ww = 3.5\text{ units}
\tag{11.4}
$$

Now that you have that settled, you place the block of widgets on the modified scale and read a value of 1,770 units. Because you know this is the actual weight

divided by 10, you multiply this value by 10 to get the true weight of 17,700 units. Therefore, the total weight is 17,700 units, and each widget with its package weighs 48.9 units; you can calculate the total number of widgets as:

$$17,700 \text{ units} / 48.9 \text{ units} = 361.96 \qquad (11.5)$$

Your result is not exact but you know that it tells you there are 362 widgets in the block. You have your answer now. In addition, each widget weighs 35 units, so the total weight of the block of widgets without their packaging is:

$$362 \ (35 \text{ units}) = 12,670 \text{ units} \qquad (11.6)$$

In this example, the packaging was an example of a systematic error that you needed to remove to obtain the value you needed. The reference weight is the standard you used to calibrate your scale.

It was necessary to discuss an analogous example of similar complexity to show you that the method that you use to calibrate your images is easily understandable and achievable, as long as the problem is broken down into simple logical steps. If you followed the example above, you will have no problem calibrating your images.

What is meant by the phrase "calibrating your image"? In general terms, an instrument calibration is defined as providing a fixed, known input (reference) to a device; measuring its output; and then comparing that measured output with the expected output. This is usually performed over a range of values to understand the relationship of the input to the output. Table 11.1 provides an example of some calibration data.

This is considered an absolute calibration in that you use an absolute input value that is verifiable and measureable based on a reference standard. There are several ways to define a reference standard, but they are usually defined as we see fit. For example, until recently, the meter was defined by a fixed length metal bar that had been maintained for use as a reference. Now it is defined as the length of a specific number of wavelengths of a specific atomic element. In other words, standards are what we say they are!

One other aspect of calibrations that you need to understand is that the measurement is only valid over a defined range of values. The endpoints of the range are called the ZERO and the SPAN. In Table 11.1, the desired input ZERO is 0% brightness, and the desired input SPAN is 100% brightness. The corresponding desired output Zero is 0 counts and the desired output SPAN is 50,000 counts. In this example, the device is a linear device so a linear equation can be created to describe the relationship between the input and the output. The general form of the linear equation is:

$$Y = mX + B \qquad (11.7)$$

Where:

$Y = $ Output
$X = $ Input
$m = $ Gain or Slope
$B = $ Bias

11.5 Image Calibration Basics

Table 11.1 An example of a device calibration

Calibration data			
Input value (percentage brightness)	Expected output value (counts)	Measured output value (counts)	Error value (counts)
0.00	0	62	+62
25.00	12,500	12,621	+121
50.00	25,000	25,143	+143
75.00	37,500	37,602	+102
100.00	50,000	49,893	−107

In the Table 11.1 example, you can calculate m based on the input and output values:

$$Y = mX + B \qquad (11.8)$$

$$Y - B = mX \qquad (11.9)$$

$$(Y - B) / X = m \qquad (11.10)$$

In this case, the bias value is 0 because when you put 0% brightness in, you get 0 counts out for the desired value. To calculate the gain or slope, you use the SPAN values for the input and output:

$$m = Y / X \qquad (11.11)$$
$$m = 50,000 \text{ counts} / 100 \text{ percent brightness}$$
$$m = 500 \text{ counts} / \text{percentage brightness}$$

Therefore, your gain for the Table 11.1 calibration is 500 counts per percentage brightness.

If you recall, your CCD imager can be considered a multichannel sensor with millions of channels. Seemingly, each channel needs to be calibrated for SPAN and ZERO; however, there is one issue. To calibrate your sensor, you need a calibrated light source. These are expensive. There is an elegant solution to this dilemma though, and the source of the solution relates to how stars are measured and the scale that is used.

If you recall from Chap. 4, the brightness scale of stars is a magnitude scale. It is a logarithmic scale that relates one star's brightness to another—a *relative* scale, not an absolute scale. The magnitude scale relates the brightness of one star to the

brightness of another star that is deemed a standard or reference star. Vega was chosen as the reference standard and is a type A0 star that was defined, much as the old style meter rod, as magnitude 0.00 in the visual band. The fact that Vega has been defined as a reference 0 magnitude star allows us to measure every other star and compare the brightness of those stars with Vega to calculate a magnitude value for those other stars.

Professional astronomers have done just that, and we all have access to a list of standard stars called the Landolt Standard Stars. These have been measured using a series of photometric filters that provide a specific bandwidth through which the starlight is recorded and measured. To use these stars, you would image them and measure the counts received, given a specific exposure time for any size astrograph you choose. The total counts for a given star, or a standard star, is proportional to the exposure time and the size of the astrograph primary objective.

When you compare the total counts for any other star with the counts from the standard star, you obtain the relative brightness difference between the two stars, and therefore, you can calculate the relative magnitude difference between the stars because your CCD is a linear device. The raw count values from the standard and reference stars transformed into a magnitude (mag) scale are referred to as the Raw Instrumental Magnitude. It is calculated using this equation:

$$\text{Raw Instrumental Magnitude} = -2.5 \text{Log (Raw counts)} \quad (11.12)$$

This number is an arbitrary value based on your individual AIS configuration and how you measure the total raw counts. For example, suppose you have measured two stars on your image, and have come up with the following:

$$\begin{array}{lll} & \text{Raw Counts} & \text{Raw Instrumental Magnitude} \\ \text{Star 1:} & 227,334,322 & -2.5\text{Log}(227,334,322) \text{ or } -20.892 \text{ mag} \\ \text{Star 2:} & 374,508,176 & -2.5\text{Log}(374,508,176) \text{ or } -21.434 \text{ mag} \end{array}$$

As you can see, the star with the larger raw counts has the brighter magnitude. To calculate the magnitude difference between the two stars, use the following equation:

$$\Delta \text{ mag} = -2.5 \text{Log (Star1 counts/Star2 counts)} \quad (11.13)$$

Therefore, for this example, the Δ mag would be:

$$\begin{aligned} \Delta \text{ mag} &= -2.5\text{Log}(227,334,322 / 374,508,176) \quad (11.14) \\ &= -2.5\text{Log}(0.607020985) \\ &= 0.542 \text{ mag} \end{aligned}$$

11.5 Image Calibration Basics

What this tells you is that Star 1 is 0.542 magnitudes fainter than Star 2 because the magnitude sign is positive in this case; remember, the magnitude scale is inverted, i.e., the larger the number, the fainter the star.

Once you measure the standard star and any other star, you can figure out the other star's magnitude. Because you know the standard stars measured magnitude, you can calculate the magnitude of the other star by adding the magnitude difference to the standard star's magnitude. Although there are many details that were left out of this discussion, this is the basic method.

Now that you understand stellar brightness measurement using your CCD, does this mean you understand what calibrating your CCD is? Nope. Think about it this way, no matter how many counts your CCD puts out for a given star, be it 20,000 counts or 30,000 counts, as long as you can relate one star's brightness to another, then it really does not make a bit of difference how many counts there are. In other words, the calibration of your CCD does not refer to an absolute calibration of the counts output related to a given brightness input as implied by Table 11.1. What CCD calibration means in this context is that you know the relative relationship between brightness levels. There are only a couple of really necessary characteristics you care about in this regard—the relative output of each of the millions of channels compared with the average output, and the amount of noise or bias at the ZERO point. This should really be called normalization and zeroing, not calibration, which has a very specific meaning in the process control industry.

What you actually do is provide a light source, with certain characteristics that will be discussed later, as an input to your CCD. The primary characteristic of this light source is that it should be uniform in brightness across the field of view (FOV) of the CCD. What you are doing is inputting approximately the same number (close, but not perfect) of photons into each of the millions of individual channels on the CCD and reading out the number of counts outputted by each of these millions of individual channels, based on the number of photons detected. The CCD is not perfect. Each of the channels detects a different number of photons based on its individual performance and physical characteristics.

If you divide the total number of counts output by all the channels by the number of channels, you get the average counts. You normalize all the channels to this average. Each of the channels outputs a count that is either higher or lower than the average. Another way of saying this is that each of the channels has a higher gain or lower gain than the average channel. Recall the gain equation that relates input to output, $m = Y/X$. The calculated gain uses the average counts for X and the measured individual channel count for Y. So for example, if the average count is 43,433 and the individual measured count for a channel is 43,769, then the gain or m value is 43,769/43,433 or 1.0077. This is the relative gain of that individual channel.

This relative gain is what you are after, and it can be measured using any amount of light as long as it does not saturate the pixel and drive its output to the maximum value. The image used in making this measurement is called a *flat frame*. The standard advice is to adjust the brightness of the input light source so that the average counts out of the CCD are about half the maximum value. In the case of a 16-bit camera, this would be a value of about 32,800 counts; for an 8-bit camera, a value

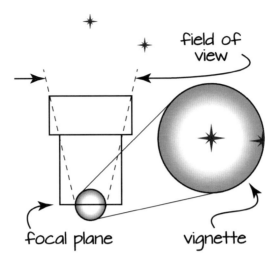

Fig. 11.2 Vignetting occurs when light around the edges of the field of view (FOV) is blocked and partially dimmed by baffles in the astrograph (Courtesy of Rachel Konopa)

of about 128 would suffice. A better result with a higher overall signal to noise ratio (SNR) would be achieved by adjusting the brightness of the light source (or the exposure time) to provide an average output of about 80–90% of the output counts. A few years ago, the cameras available had non-linearity problems near the top end of their output, so it was common advice not to use that part of the output range for "calibrating" the CCD. This is no longer the case, and the vast majority of 16-bit cameras are very linear up to at least 95% of their output range.

Other optical effects also affect the amount of light that reaches the CCD from the uniform light source; chief among these is vignetting. When the FOV of the CCD gets close to, or exceeds the recommended image circle of the astrograph, dimming occurs because some of the light is blocked by the internal edges of the astrograph (Fig. 11.2). A useful comparison can be made with a solar eclipse. The effect is the same. When the Moon partially blocks the Sun, not all the Sun's light gets to you, so you see a partial dimming. This is exactly what happens when light comes into the astrograph near the edges; some of the light is blocked, so not all of it gets to the CCD and it dims. The result is a circular gradient near the edge of the CCD frame (Fig. 11.3). Filters may also cause a non-uniformity of the light impinging on the CCD, and you must compensate for them.

The other major optical defect you will see in your flat frame is dust located on the CCD itself. This shows up as donuts when using a reflecting astrograph that has a central obstruction, and just circles when using a refractor. The dust particle disperses the light, and the result is a shadow on your flat frame (Fig. 11.3). All these effects—vignetting, filter non-uniformity, and dust donuts—are corrected for when applying your flat frame to your raw image data.

11.5 Image Calibration Basics

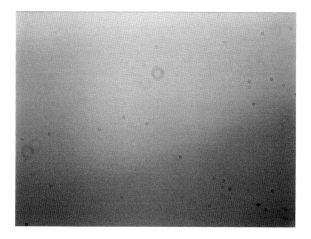

Fig. 11.3 A raw V-band flat frame from a Ritchey-Chrétien Cassegrain reflector

Now that you have a picture of what a CCD calibration is really all about, you can see that a flat frame is really a measurement of how *uniform* the output values are across the entire FOV or frame when exposed to a uniform light source. Consider how useful this really is. You have taken a nice image of a galaxy. The image you have is raw data. You need to measure the brightness of each portion of the galaxy from the outer rim to the core. The issue, of course, is that the output values are not the same across the FOV. However, you have your flat frames you took previously. You have also normalized your flat frame to an average value of 1.000 so that each channel or pixel has a gain associated with it that can be applied to the image frame so that you can compensate for the variation in gain across the CCD. Actual calibration takes place when you apply the flat frame to the image or light frame. You have adjusted the SPAN of each pixel to an average value to flatten the CCD's response to light. This is the purpose of the flat frame.

Now that you have a deep understanding of what a flat frame is and how it works, how do you calibrate the light frame using the flat frame? It is a simple matter of math of course. Depending on how your individual application performs the normalization of the flat frame, the calibration is performed by either dividing the light frame by the flat frame, pixel by pixel, or by multiplying the light frame by the flat frame. If the normalization of the flat frame provides pixels that are brighter than the average with a value greater than 1, then the light frame is divided by the flat frame value because the light frame pixel is brighter than it would normally be otherwise. The alternative is also true. If the normalization provides brighter pixels with a value less than one, then the light frame is multiplied by the flat frame.

There are two other calibration values that you need to measure and apply to your light frame. One is called bias and is applied using a bias frame, and the other

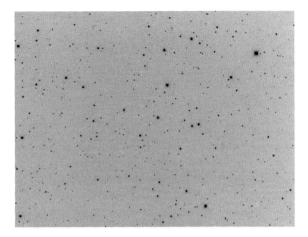

Fig. 11.4 A calibrated frame taken with a Ritchey-Chrétien Cassegrain reflector. The plate center is located at RA 16 32 44.89, DEC+28 18 30.7

is called dark current and is applied using a dark frame. If you recall from Chap. 4, the bias is a fixed amount based on the functioning of the CCD readout electronic circuitry and is called readout noise. The dark current is a time-dependent value and is caused by the thermal electrons being generated within the CCD substrate and is directly correlated with the chip temperature.

Measuring the readout noise or bias is a simple matter. The readout noise is the noise caused only by the amplifier electronic circuitry, which converts the charges stored in each pixel to a voltage for measurement. There is always a bit of amplifier noise, and this needs to be accounted for and subtracted. The way this is measured should be reasonably obvious—if you want to measure only the readout noise with zero signal, you make an exposure of zero seconds and read out the pixel values. It helps to keep any light from impinging on the CCD during this time also. The result is a bias frame that can be used to subtract out the readout noise.

The dark frame is exactly what you would expect. It is a frame taken with the CCD covered so no light impinges on it, using an exposure time that is the same length as that which you used to expose your light frames. This allows you to measure the buildup of thermal noise in the CCD. It is important to recognize that the dark frame includes the bias value also because to get the dark frame, you must read out the data. All frames read out of the CCD include the bias information, so it is not necessary to use the bias frame as long as you use the same exposure times for your dark frames and light frames. The bias frames become necessary with a specific calibration technique when there is a difference in exposure times between your dark frames and light frames.

The three primary image calibration factors are the bias, or readout noise, the flatness or relative gain (g), and the dark current or thermal noise. The light frame

11.5 Image Calibration Basics

Fig. 11.5 A cropped portion of a bias frame showing the random and systematic errors

contains the desired signal, thermal noise, and readout noise; the dark frame contains the thermal noise and the readout noise; and the flat frame contains the information for the relative gain (g). These three factors are related, as follows:

$$\text{Standard Calibrated Frame} = g \, (\text{Light Frame} - \text{Dark Frame}) \quad (11.15)$$

The standard calibration process uses the light frame, dark frame, and flat frame to calibrate your image data. It is a simple three-step process as shown in Eq. 11.15. First you subtract your dark frame from your light frame, and then you multiply (or divide, depending on how your application normalizes) the resulting frame by the normalized flat frame. This results in a calibrated frame (Fig. 11.4).

The actual process is complicated by the fact that you do not want to use individual dark and flat frames when calibrating your image. There is too much noise in the individual frames. What you want to do is take a series (at least 10) of dark and flat frames and then average them together using a simple average or a median process. Using a median process rids the frames of *hot pixels* and *dark pixels*. Hot pixels and dark pixels are defects in your CCD chip or may be caused by high-energy cosmic rays. Once you have the averaged dark and flat frames, then you can use these to calibrate your light frame as discussed. Make sure you read and understand your image processing application help or owner's manual on how to perform the image calibration process.

11.6 Calibration Techniques

The previous explanation of the overall calibration process is generally true. This section discusses the details of how image calibration is actually performed. The discussion starts with a definition of all the pertinent terms needed to understand the simple math behind the calibration. In defining each of these terms, there are contributors that are systematic or random noise or signal sources. The systematic values are fixed, are always present, and are characteristic of your CCD camera or astrograph setup. The random noise is a statistically random value that follows the general rules of Poisson statistics. This random noise can be measured and characterized. The equation notation is as follows:

P = Pixel
B = Bias
D = Dark
T = Thermal
F = Flat
L = Light
N* = Star (Calibrated Pixel)
±U* = Star Uncertainty (Calibrated Pixel)
K = constant
σ = random

These symbols describe each term used in the equations that follow. There is also a term used to scale or convert the electrons accumulated to the actual analog-digital unit (ADU) value provided by the CCD camera. This is called the CCD gain. If you recall from Chap. 4, Sect. 4.3, the gain is usually set to equal the full-well depth divided by the maximum ADU count (255 for 8-bit cameras, 65,535 for 16-bit cameras). Several of the terms used to calculate the pixel value in a frame are in units of electrons (e^-) but the pixel value is in ADUs, so the conversion factor for electrons/ADUs is used. Normally the gain (g) is stated in electrons/ADU so the inverse is used in the equations that follow. Finally, a caution is in order when taking your calibration frames:

CAUTION

To get the most accurate data, all of your calibration frames must be taken at the same temperature as your light frames. Your thermo-electric cooler (TEC) setting must be the same when taking all your frames for use in calibrating your images. See Table 11.2 for suggested temperature settings.

The following is the list of terms used in calibrating an image. These have been discussed previously in a general sense, but here, the precise definition is provided.

Bias Frame—Each pixel in the bias frame contains the following information: a fixed value (systematic), a fixed pattern value (systematic), electronic noise (random), and readout noise (random), as shown in the following equation (Fig. 11.5):

11.6 Calibration Techniques

Table 11.2 Suggested temperature settings when imaging

TEC temperature settings	
Season	TEC setting (°C)
Winter	−40
Spring/fall	−25
Summer	−10

Fig. 11.6 A cropped portion of a 90-s dark frame showing the random thermal noise, hot pixels, and systematic errors

$$P_B(ADU) = 1/g \left[K(e^-) + B_{pattern}(e^-) + \sigma_{electronic}(e^-) + \sigma_{readout}(e^-) \right] \quad (11.16)$$

Dark Frame—Each pixel in the dark frame contains the following information: the accumulated value of thermal electrons (systematic) and a thermal noise value (random). It also contains all the information included in the bias frame as shown in the following equation (Fig. 11.6).

$$P_D(ADU) = 1/g \left[T(e^-) + \sigma_T(e^-) \right] + P_B(ADU) \quad (11.17)$$

Thermal Frame—Each pixel in the thermal frame contains only the information associated with the accumulation of thermal electrons (systematic) and the thermal

electron noise (random). This frame is calculated by subtracting the bias frame from the dark frame and is used to create a *scaled dark frame*. A thermal frame pixel value divided by the exposure time (typically 60 s) can be multiplied by any number of seconds to match it to the desired light frame exposure time. For example, you have acquired your 60-s dark frames, but have exposed your light frames for 180 s. So you would first subtract your bias frame from your 60-s dark frame, and then multiply the resultant thermal frame by 3 and add your bias frame back in to get your scaled dark frame. The equation for the thermal frame is:

$$P_T(ADU) = P_D(ADU) - P_B(ADU) \tag{11.18}$$

Flat Frame—Each pixel in the flat frame includes the information from the bias frame (systematic and random), and the effects of vignetting (B_V), dust donuts (B_{DD}) (systematic), filter non-uniformity (B_F) (systematic), and any other optical defects in your astrograph (systematic). In Eq. 11.19 the effects of the B_V, B_{DD}, and B_F are considered equivalent when combined on the image, so the total electrons are averaged by dividing the sum by three. The flat frame is designed to be used to compensate for all these effects in your light frame data where the result is a uniform response to the light entering the astrograph. Usually, the exposure time for the flat frame is short enough that the effects of thermal electron accumulation and noise are minimal, although you can use a scaled dark frame to process your flat frames if you desire. The normalized flat frame has a real value, with the average of all the pixels equal to 1.000 (Fig. 11.7). The normalized pixel value is calculated by dividing the individual pixel value for each x, y coordinate in the frame by the average of all the pixel values of the frame (F_{avg})(ADU).

$$P_F = 1/g\left[\left(B_V(e^-) + B_{DD}(e^-) + B_F(e^-)\right)/3\right](ADU) / F_{avg}(ADU) \tag{11.19}$$

Note that PF has no units since it is a value used to normalize the pixel value.

Light Frame—Each pixel in the light frame contains the signal data from the object under observation (N*), and all the random and systematic error signals injected by the CCD camera and astrograph.

$$P_L(ADU) = \left[1/g\left[N*(e^-) \pm \sqrt{N*(e^-)}\right] + P_B(ADU) + P_T(ADU)\right]P_F \tag{11.20}$$

Calibrated Frame—The calibrated frame is the light frame with all the random and systematic error signals removed leaving just the wanted data (Fig. 11.4).

$$N* \pm U*(ADU) = P_L(ADU) - P_B(ADU) - P_T(ADU) / P_F \tag{11.21}$$

The uncertainty in the N*(ADU) value is established by the Poisson statistics of the source photons. Recall that the pixel cell converts photons into electrons (e^-), and that the uncertainty is the square root of the measured electrons. Therefore, the uncertainty in the N*(ADU) value is:

11.6 Calibration Techniques

1.010	1.010	1.010	1.010	1.010	1.010	1.010	1.010	1.010	1.010	1.010	1.010	1.010	1.010	1.010	1.010	1.010	1.010	1.010
1.010	1.010	1.010	1.010	1.010	1.010	1.010	1.010	1.000	1.000	1.000	1.010	1.010	1.010	1.010	1.010	1.010	1.010	1.010
1.010	1.010	1.010	1.010	1.010	1.010	1.000	1.000	0.995	0.995	0.995	1.000	1.000	1.010	1.010	1.010	1.010	1.010	1.010
1.010	1.010	1.010	1.010	1.010	1.000	0.995	0.995	0.990	0.990	0.990	0.995	0.995	1.000	1.010	1.010	1.010	1.010	1.010
1.010	1.010	1.010	1.010	1.000	0.995	0.990	0.990	0.995	0.995	0.995	0.990	0.990	0.995	1.000	1.010	1.010	1.010	1.010
1.010	1.010	1.010	1.000	0.995	0.990	0.995	0.995	1.000	1.000	1.000	0.995	0.995	0.990	0.995	1.000	1.010	1.010	1.010
1.010	1.010	1.000	0.995	0.990	0.995	1.000	1.000	1.005	1.005	1.005	1.000	1.000	0.995	0.990	0.995	1.000	1.010	1.010
1.010	1.010	1.000	0.995	0.990	0.995	1.000	1.005	1.010	1.010	1.000	1.005	1.000	0.995	0.990	0.995	1.000	1.010	1.010
1.010	1.000	0.995	0.990	0.995	1.000	1.005	1.010	1.015	1.020	1.015	1.010	1.005	1.000	0.995	0.990	0.995	1.000	1.010
1.010	1.000	0.995	0.990	0.995	1.000	1.005	1.010	1.020	1.020	1.020	1.010	1.005	1.000	0.995	0.990	0.995	1.000	1.010
1.010	1.000	0.995	0.990	0.995	1.000	1.005	1.010	1.015	1.020	1.015	1.010	1.005	1.000	0.995	0.990	0.995	1.000	1.010
1.010	1.010	1.000	0.995	0.990	0.995	1.000	1.005	1.010	1.010	1.010	1.005	1.000	0.995	0.990	0.995	1.000	1.010	1.010
1.010	1.010	1.000	0.995	0.990	0.995	1.000	1.000	1.005	1.005	1.005	1.000	1.000	0.995	0.990	0.995	1.000	1.010	1.010
1.010	1.010	1.010	1.000	0.995	0.990	0.995	0.995	1.000	1.000	1.000	0.995	0.995	0.990	0.995	1.000	1.010	1.010	1.010
1.010	1.010	1.010	1.010	1.000	0.995	0.990	0.990	0.995	0.995	0.995	0.990	0.990	0.995	1.000	1.010	1.010	1.010	1.010
1.010	1.010	1.010	1.010	1.010	1.000	0.995	0.995	0.990	0.990	0.990	0.995	0.995	1.000	1.010	1.010	1.010	1.010	1.010
1.010	1.010	1.010	1.010	1.010	1.010	1.000	1.000	0.995	0.995	0.995	1.000	1.000	1.010	1.010	1.010	1.010	1.010	1.010
1.010	1.010	1.010	1.010	1.010	1.010	1.010	1.010	1.000	1.000	1.000	1.010	1.010	1.010	1.010	1.010	1.010	1.010	1.010
1.010	1.010	1.010	1.010	1.010	1.010	1.010	1.010	1.010	1.010	1.010	1.010	1.010	1.010	1.010	1.010	1.010	1.010	1.010

Fig. 11.7 A depiction of the data values for the pixels around a dust donut in a normalized flat frame image

$$U^*(ADU) = \pm 1/g \sqrt{N^*(e^-)} \quad (11.22)$$
$$= \pm 1/g \sqrt{[g N^*(ADU)]}$$
$$= \pm 1/g \sqrt{g} \sqrt{N^*(ADU)}$$
$$= \pm 1/\sqrt{g} \sqrt{N^*(ADU)}$$

The $N^* \pm U^*(ADU)$ value is the resulting measurement and will be used in calculating the magnitude of the object under study.

This calculation does not quantify the uncertainty value for each of the calibration frames (P_B, P_D, P_T, and P_F). Nevertheless, because the noise is present in each of the frames used, the resulting $\pm U^*(ADU)$ value you calculate from your calibrated frame will include the accumulated uncertainty of all the frames. See Appendix 3

for further explanation of the total uncertainty in your measurement. To minimize the uncertainty in the calibration frames, or in other words, to minimize the noise or standard deviation (σ) values in each of the pixels, you want to average a large number of frames. In statistics, the σ of the noise is a standard way of quantifying the amount of noise in a signal or series of values. When you average several series of values, you can reduce the impact the noise has on the signal. It is reduced according to this equation:

$$\sigma_{resultant} = \sigma / \sqrt{\text{Number of Series}} \qquad (11.23)$$

Therefore, if you have a series of 16 signals with a σ value of ±0.25, and you combine these signals, you reduce the noise by a factor of √16 or 4, so the resultant signal has a σ value of ±0.25/4 or ±0.0625.

Once you have averaged several frames together, the resulting frame is called a master frame. If you require them for your particular calibration method, you will create master bias, dark, and thermal frames for use with your light frame. Generally, you want to use at least 10 frames when creating your master frame, more if you have time to create them. There are two ways to average your frames—an Average Combine and a Median Combine. These two types of multiple image combinations are just as their names imply. Each pixel in the image (specific x, y coordinate) is combined with its brethren from the other frames; to obtain the average, they are summed, and the result is divided by the number of frames. The median calculation is similar except it uses the middle value of the series of pixel values rather than the average value of all the pixel values for the images. The median value is an excellent way of removing the effects of hot pixels and cosmic rays so these extreme values do not affect the calculation as they would the average.

There are different levels of calibration: basic, standard, and advanced. The basic method involves just the light frame and the dark frame and is performed by subtracting the master dark frame from the light frame. This calibration removes the bias and thermal effects on your image but does not remove the effects of vignetting, dust donuts, or filter non-uniformity. It is the simplest and easiest calibration to perform. The dark frame exposure time must match the light frame exposure time. You need to adhere to this requirement or you will get strange artifacts in your images. This method is good for creating the calibrated images used in measuring the position of objects but not for measuring the brightness.

The standard method is used to provide images for use in astrometry and basic differential photometry. This method involves using the light frame, master dark frame, and master flat frame. To calibrate your light frame, you subtract your master dark frame from your light frame and then divide (or multiply) your resultant frame by the (normalized) master flat frame (Fig. 11.8). The standard method is the suggested method for calibrating your images. It enables you to extract the best data for doing basic astrometry and photometry on your objects.

The advanced method uses the bias frame to create a scaled dark frame. This method is used to create a dark frame custom tailored for each image exposure time and can be a very effective method if you have a permanent setup. This method also

11.6 Calibration Techniques

Fig. 11.8 A master flat frame from the imaging train of a Ritchey-Chrétien Cassegrain astrograph

allows you to create your master frames ahead of time, depending on the specific capabilities of your CCD camera. It is important to remember that all of your calibration frames must be made with your CCD camera at the same temperature. The trick to taking your calibration frames ahead of time is to define a couple of temperatures at which you will always image. It might be good to choose three temperatures based on the season. Table 11.2 contains suggested absolute temperature settings (depending on your CCD capabilities, of course).

When you use the advanced method, you perform the standard method but use a custom-created dark frame based on your pre-acquired calibration frames. This method involves using the light frame, the master bias frame, the individual dark frames, the custom master dark frame, the thermal frame, and the master flat frame. The thermal frame is used to create the custom master dark frame. The first step is to create the master dark frame by subtracting the master bias frame from each of your dark frames acquired at a given standard exposure time (typically 60 s). Once you have each of these, you then combine them using either the average or median method; the result is a master thermal frame. The next step is to multiply your master thermal frame by a constant equal to the ratio of the exposure times of your dark frames to your light frames. For example, you created all your dark frames at 60 s, but you have created light frames at 120 and 180 s. In this case, you would create two scaled dark frames by multiplying the master thermal frame by 120/60 and by 180/60 (or 2 and 3, respectively). Once you have these two master thermal frames, you subtract them from your light frame and also subtract the bias frame to get the final calibrated frame (Fig. 11.4).

There are other advanced methods to compensate for changes in CCD temperature and for other changes, but they are outside the scope of this discussion.

Once you have properly obtained your calibrated frame, you can feel confident that the measurements you make will be accurate and provide scientifically valid data. By calibrating your images, you have created not just photographs that are pleasing to the eye, but are also scientifically valid data that can be used for multiple purposes at the time of exposure and far into the future as an historical record.

11.7 Image Acquisition Tips and Techniques

After several years of experience, you will find that you have learned a lot about how you and your AIS perform and the little quirks or issues for which you have to compensate when doing your imaging. Until you get there, here is some advice to keep in mind regarding a few subjects related to acquiring your images.

When setting up your AIS, ensure that all the connectors and cables are tightened and secure. Make sure you balance your astrograph on your mount after you have assembled your configuration for the session and mounted your imaging train onto your astrograph. This includes all the cables and miscellaneous electronic gear that you may mount on your AIS. When you swing your astrograph through the Right Ascension and Declination axes, check to make sure there are no places where the cabling can hang up and snag your system. If you do not do this, the best outcome is that if you are taking an image at the time, you will have to repeat it. The worst is that you could break a connector or pull one loose, which may cause some physical damage or cause you to have to restart your application or even your whole system.

To minimize the vibration transmitted to your AIS during a windy session or even by walking around your AIS, which can generate excessive blurring, set your tripod or pier as low as possible to lower its center of gravity. The tripod is more stable when lower to the ground. Of course, this makes it difficult to use your astrograph visually when looking through a finder, but if the goal is the best data possible then you will learn to lie on the ground and love it! If you have an old blanket or piece of carpet under your system, this will help you to be comfortable lying on the ground. Adding rubber vibration dampening pads to each of your tripods feet when on hard concrete or pavement will help minimize high-frequency vibrations also.

Try to set up your system during the period before sunset to maximize your actual imaging time once it gets dark enough to begin. The 20-min period after sunset is the prime time for capturing *twilight flat frames*. This type of flat frame is obtained by pointing your astrograph to zenith with the drive system off. Ensure that you have set the focus position close to the actual position needed for a normal light frame exposure of the program objects you are going to take. You may also use some sort of diffuser if you want to help create a uniform sky light source. This is easily accomplished by using a white cotton cloth stretched across the front of your astrograph.

You need to set your filters as desired (or no filter for unfiltered light frames) and set your exposure time to get the average pixel value of about 80–90% of your

11.7 Image Acquisition Tips and Techniques

Table 11.3 Image acquisition timeline

AIS setup/calibration frame acquisition timeline

Start time	Task	Notes
−60 min	Set up your AIS hardware. Assemble your imaging train, including all cables and electronic connections. Balance your final configuration and verify there are no cable hang-ups or snags. Verify all connection points are tight	
−20 min	Apply power to your AIS and computer system and verify connectivity and that your image acquisition application starts up and is available for use	Before power up, ensure your power system is warmed up
−5 min	Take a couple of test exposures to verify that your images go to the correct directory on your storage system and that there are no issues with cabling or connectors	
0 min sunset	Start acquisition of your flat frames, sequencing your filters as necessary	Use your image acquisition automatic image sequencing function as desired. Ensure the TEC temperature is set as desired
20 min	Start your bias and dark frame acquisition as necessary	
40 min+	After final polar alignment, and astrograph collimation (as necessary), perform your initial precision focusing and start your light image acquisition	Check and adjust your focus as necessary after slewing to each object

maximum value. You can use the histogram function on your image acquisition program or view the image statistics to obtain your average pixel value. You should take at least 10 flat frame images per filter as required and adjust your exposure time while you are doing so to maintain the average pixel value in the proper range. You only have about 15–20 min to accomplish this, so planning ahead is a necessity. The dark and bias frames can be acquired after the flat frames and as stated previously, can be acquired during a separate session as long as the CCD TEC temperature can be set to a fixed value. The dark and bias frames take at least 20–30 min, depending on the number of frames you want. The nice thing about dark and bias frames is that they do not require you to take them for each filter or even when connected to your astrograph. These frames are totally camera dependent and are not affected by the rest of your imaging train or astrograph.

Depending on the amount of equipment you have to set up, start your setup at least an hour before sunset. It is important to plan ahead and keep to your timeline; otherwise, you will miss your window of opportunity to capture your twilight flats. When first trying to acquire twilight flat frames, you should practice the setup of your AIS specifically for this task and understand the time it takes to complete your setup. Use the timeline shown in Table 11.3 (modified for your equipment of course) to efficiently set up and acquire your calibration frames. The times listed are in reference to the time of sunset.

Image calibration can be a time-consuming and somewhat tedious exercise, but it is a necessity if you want to get the excellent images that will lead to excellent data. Working on and perfecting your procedures goes a long way toward simplifying and being able to easily accomplish the tasks necessary to acquire your calibration frames. You will come to appreciate the excellent results you obtain as a result of the extra effort you expend in this area. If at all possible, collaborate with a more experienced fellow observer to work through the techniques necessary to improve your skills in calibrating your images. As always, make sure you read and understand all the applicable functions of your image acquisition software as listed and discussed in Sect. 11.4.

Further Reading

Berry R, Burnell J (2005) The handbook of astronomical image processing. Willmann-Bell, Richmond

Buchheim R (2007) The sky is your laboratory. Springer, Berlin/Heidelberg/New York

Chromey FR (2010) To measure the sky. Cambridge University Press

Dieck RH (2007) Measurement Uncertainty. The Instrumentation, Systems, and Automation Society, Research Triangle Park

Dymock R (2010) Asteroids and dwarf planets and how to observe them. Springer, New York

Henden AA, Kaitchuck RH (1990) Astronomical photometry. Willmann-Bell, Richmond

Howell SB (2006) Handbook of CCD astronomy. Cambridge University Press

Warner BD (2006) A practical guide to lightcurve photometry and analysis. Springer, New York

Web Pages

http://fits.gsfc.nasa.gov/
http://partners.adobe.com/public/developer/tiff/index.html
http://www.stark-labs.com/craig/articles/articles.html

Chapter 12

Field Practical Exercises: Putting It All into Practice

12.1 Introduction to the FPEs

The *Field Practical Exercises* (*FPE*) give you a head start in putting together a comprehensive set of procedures on how to assemble and operate your Astronomical Imaging System (AIS) for a specific observing session. They are designed in a hierarchical structure made up, at the lower level, of a series of basic tasks that are applicable to most, if not all, AIS equipment. These low-level tasks are performed in a specific sequence to quickly get your AIS assembled, up, and running for your imaging session. The high-level tasks are geared toward a particular object type, whether it is a deep sky object or a solar system object. This high-level information defines the specific AIS components to get the best data for the object you intend to observe (Fig. 12.1).

The first section of this chapter contains all the low-level procedures to perform the common tasks involved with most, if not all, the objects to be observed. These tasks are necessary to get the best possible data from each observing session. The layout of the low-level tasks includes references to the previous chapters, as applicable, to help you in reviewing the relevant discussion on those topics. These low-level tasks are presented in the following standard format:

1. Task Title/Description
2. Task Objective
3. Chapter References
4. AIS Equipment Used
5. Task Checklist
6. Acceptance Criteria.

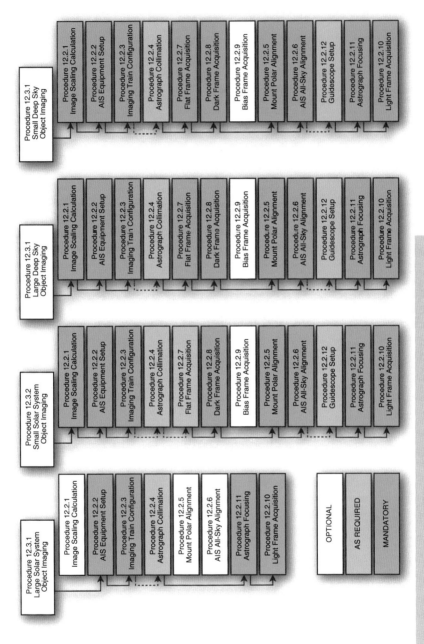

Fig. 12.1 Field practical exercises (FPE) performance structure

12.1 Introduction to the FPEs

If you have met the Acceptance Criteria for the procedure, i.e., if, for example, you know that your astrograph is collimated; then you can skip that procedure. Make sure that you have met the Acceptance Criteria; cheating on this step may cause problems later on when you are acquiring images.

The higher-level FPEs include details on the minimum equipment necessary to accomplish the observing task, equipment operation and maintenance notes, relevant references that discuss that particular object (as applicable), and the steps necessary for acquiring the best imaging data. Also included are notes on how each task affects your imaging data and contributes to the end result. Each of the high-level FPEs has the following standard layout:

1. Object Type/Description
2. Session Objective
3. Chapter References
4. Image Scale Guidelines
5. Minimum Equipment List Description and Design Basis
 (a) Mount
 (b) Astrograph
 (c) Camera
 (d) Support Hardware
 (e) Support Software
6. Session Checklist—Low-Level and Session-Specific Items
7. Session Notes
8. Expected Processing Description

Each of the high-level FPEs in the second section is applicable to more than one specific object and is based on the object type. For the most part, the object type drives the general AIS configuration, with variations in image scale, filter requirements, and exposure settings making up the bulk of the difference in configuration for specific objects. The session checklist provides details on the differences based on the specific object.

You should approach this chapter as a way to practice each of the tasks necessary for configuring, assembling, and operating your AIS in the best way possible. This approach ensures that you are practicing the baseline skills necessary to acquire the best images possible and contributes significantly to your goal of acquiring excellent images that are scientifically useful. You should begin with these procedures and modify them as you see fit. Experiment and learn about the specifics of your equipment. Do not forget to incorporate any other information from your equipment owner's manual that you feel is pertinent and has an impact on your results. If you have the opportunity to work with a mentor, do not hesitate to do so. It will speed up your progress, and you will realize your goals sooner, rather than later.

12.2 Common AIS Equipment Setup Procedures

The following tasks are defined as low-level tasks that address the basic steps necessary for setting up your AIS equipment to get the best performance out of yourself and the AIS.

- 12.2.1 Image Scaling Calculation Procedure
- 12.2.2 AIS Equipment Setup Procedure
- 12.2.3 Imaging Train Configuration Procedure
- 12.2.4 Astrograph Collimation Procedure
- 12.2.5 Mount Polar Alignment Procedure
- 12.2.6 AIS All-Sky Alignment Procedure
- 12.2.7 Flat Frame Acquisition Procedure
- 12.2.8 Dark Frame Acquisition Procedure
- 12.2.9 Bias Frame Acquisition Procedure
- 12.2.10 Light Frame Acquisition Procedure
- 12.2.11 Astrograph Focusing Procedure
- 12.2.12 Guidescope Setup Procedure

Each of the tasks listed can be performed by itself and as part of a larger procedure as described in Sect. 12.3. These low-level procedures are generic in nature and should be changed and added to as necessary to create your own AIS-specific procedures. Take advantage of any procedures included in your AIS component owner's manual. Do not forget to include in the AIS Equipment Used section the details of your own AIS equipment, including Make, Model Number, Description, etc. This will help you to inventory your equipment when assembling your AIS in the field.

12.2.1 Image Scaling Calculation Procedure

Description: This task uses the specifics of the object type as input to determine the best image scaling information to acquire the best data for that object.
Objective: To calculate the image scale for the given object.
Chapter References: Chap. 4, Sects. 4.6 and 4.7, Chapter 7, Sect. 7.2.
AIS Equipment Used: Astrograph, CCD camera, and component equipment manuals.

12.2 Common AIS Equipment Setup Procedures

Task Checklist

Step	Task	Notes
[] 1	**Use** the astrograph and camera manuals to **Record** the following information (a) Camera pixel size, μm (b) Astrograph focal length, mm (c) Camera, number of pixels x and y axis	
[] 2	**Record** the program object to observe	Refer to Chaps. 2 and 15 to help determine your observing program. Refer to Chaps. 3, 4, 5, and 6, as required
[] 3	**Determine** the desired field of view (FOV) and pixel scale for the object recorded in Step 2	
[] 4	**Determine** the initial imaging train configuration desired	
[] 5	**Use** the data from Steps 1 and 3 to **Calculate** the image scale, pixel scale, and FOV for the image train configuration specified in Step 4	Refer to Chap. 4, Sects. 4.6 and 4.7, as required
[] 6	**Ensure** that the backfocus distance and other distances specified for each optical component in the owner's manual are used in configuring the Imaging Train	Refer to the owner's manual for the applicable optical components as described in Chaps. 6 and 7, as required
[] 7	**Add** and/or **Exchange** components in the imaging train to obtain the desired FOV and pixel scale as specified in Step 3	Refer to Chap. 7, as required
[] 8	**Repeat** Steps 5 and 6 as necessary to obtain the required imaging train configuration	

Acceptance Criteria:

The Pixel Scale and FOV are sufficient to image the Program Object specified in Step 2. The expected data acquired will provide the required accuracy in terms of the astrometric and photometric performance for the desired measurement as required by the observing program.

12.2.2 AIS Equipment Setup Procedure

Description: This task steps through the process of assembling the individual components into a complete AIS ready for startup.

Objective: To assemble the AIS to the point of startup.

Chapter References: Chaps. 6, 7, and 9.
AIS Equipment Used: Mount, astrograph, CCD camera, and support components, and user manuals as needed.

Task Checklist

Step	Task	Notes
[] 1	**Inventory** all the desired equipment that makes up the desired AIS configuration	
[] 2	**Assemble** the tripod/pier and mount subassembly (including counterweights). **Place** the mount in the desired location, and **Point** the Right Ascension (RA) axis toward Polaris	Keep the mount as low as possible to minimize vibration levels
[] 3	**Level** the mount according to the user manual	This is important to ensure a repeatable polar alignment without having to adjust the Altitude axis on the mount for every session
[] 4	**Place** the astrograph on the mount's adapter plate as required. **Tighten** the adapter plate fasteners to ensure the astrograph does not move	
[] 5	**Perform Procedure 12.2.3** to determine the components for the imaging train. **Assemble** the imaging train components as specified, including CCD camera, filter wheel, coupling adapters, and other components as necessary	While referring to Chaps. 6 and 7, perform **Procedure 12.2.3** as required.
[] 6	**Install** the imaging train subassembly on the astrograph	
[] 7	**Install** any secondary components on the astrograph (finders, dew shield)	
[] 8	**Install and Connect** any electronic and electrical cabling required by the imaging train components and mount. **Ensure** that the power supplies are fully charged and/or available for use	Installation includes running the cables as necessary to minimize the chance of snagging a cable
[] 9	**Balance** the astrograph with all its component subassemblies in the RA and declination (DEC) axes	Establish a small imbalance in RA and DEC to help minimize the periodic error and backlash effects while imaging. Refer to Chap. 5, Sect. 5.2.2, for information on periodic error
[] 10	**Start up** all AIS control software and **Ensure** that the electronic equipment is operational prior to use	

12.2 Common AIS Equipment Setup Procedures

Acceptance Criteria:
The AIS components are integrated and tightly coupled to their adjacent components. There is *no* play between components. All the cabling is secure and free from snagging when moved about the full range of motion in the RA and DEC axes.

12.2.3 Imaging Train Configuration Procedure

Description: This task steps through the process of assembling the components that make up the specific imaging train for a given observing program object.
Objective: To assemble the imaging train for installation into the AIS.
Chapter References: Chaps. 6 and 7.
AIS Equipment Used: CCD camera, filter wheel, and other major and support optical and mechanical components used to create the complete imaging train.

Task Checklist

Step	Task	Notes
[] 1	IF not already done, **THEN Perform Procedure 12.2.1**	**Procedure 12.2.1** is used to calculate the image scale required for the program object observed and guides you in selecting the required components
[] 2	**Select** all the components that will be used to assemble the imaging train. These components must meet the requirements determined by performing **Procedure 12.2.1**	
[] 3	**Inspect** each major component's interface (threads/barrels/locking screws) for damage and cleanliness. **Correct** any issues before assembly	**CAUTION:** The mechanical connections between components must be free of damage and debris before assembly or permanent damage may occur
[] 4	**Place** each major component and support mechanical and optical component on a clean surface in its proper position as determined by **Procedure 12.2.1**	
[] 5	**Assemble** the imaging train as laid out in Step 4, carefully tightening each component as necessary to avoid damaging the interfacing threads/barrels/locking screws	Refer to Chaps. 6 and 7, as required
[] 6	**Verify** that the measurements for backfocus distance and the placement for the optical components meet the requirements of the optical component in the owner's manual	Refer to Chaps. 6 and 7, as required

[] 7	**Inspect** the final assembly for completeness, tightness, and orientation. **Correct** any issues before installation of the imaging train	The orientation of the imaging train on the AIS should be considered before mounting it on the AIS to ensure that the imaging train components do not interfere with the slewing of the astrograph
[] 8	**Place** the imaging train in a safe location until ready to install on the AIS	

Acceptance Criteria:

The imaging train is configured according to the requirements determined in the performance of Procedure 12.2.1. The imaging train is assembled as required to perform the observations as desired and specified in Procedure 12.2.1. The imaging train is rigid and does not exhibit any flexure or motion when applying slight pressure to the components. The CCD camera is square to the mounting point as desired, where the imaging train meets the astrograph focuser.

12.2.4 Astrograph Collimation Procedure

Description: This task steps through the various processes used for collimating the astrograph.
Objective: To collimate the astrograph.
Chapter References: Chaps. 6 and 7.
AIS Equipment Used: Astrograph, Cheshire eyepiece, medium focal length (FL) eyepiece, imaging train, and/or collimation software used in conjunction with CCD images acquired for this objective.

Task Checklist

Step	Task	Notes
[] 1	**NOTE:** The collimation procedure is generally only regularly applicable to a reflector type astrograph. Refractors do not normally require re-collimation on a regular basis. Refer to the owner's manual to determine the need to collimate a refractor **IF** not already done, **THEN Perform Procedure 12.2.2. IF** you are doing a visual collimation using a collimation mask, **THEN Substitute** a medium FL eyepiece for the imaging train in Step 6 of Procedure 12.2.2. **IF** using a CCD camera to perform the collimation, **THEN Go To** Step 6	**Procedure 12.2.2** is a prerequisite for performing the visual astrograph collimation because you MUST have an operational AIS before collimation

12.2 Common AIS Equipment Setup Procedures

[] 2 **NOTE:** This step should be performed indoors in order to easily see the internal components of the astrograph
Point the astrograph at a bright, white surface. Using a Cheshire eyepiece in place of the medium FL eyepiece specified in Step 1, **Identify** the internal concentric components of your astrograph according to the astrograph owner's manual.
Perform an initial collimation using the Cheshire eyepiece

 Refer to the astrograph owner's manual, as required, for the specific steps and adjustments necessary for the proper initial and final collimation of your astrograph

[] 3 **Insert** a medium FL eyepiece into your astrograph's focuser. **Slew** your astrograph to a bright star and **Adjust** the focus so that the star is out of focus. When the focus is inside or outside the optimal focus, the star appears as a donut-shaped object when using an astrograph with a central obstruction, or as a disk when using a refractor

 Observing the donut-shaped star image, or disk (as applicable) within the medium FL eyepiece allows you to determine the amount of offset in the collimation and guide you in the fine adjustment of the secondary of your astrograph

[] 4 **Adjust** the astrograph's collimation controls as necessary to bring the star image to a concentric image shape according to the astrograph owner's manual to achieve optimal collimation

[] 6 **CAUTION:** It is necessary to have a CCD camera in your imaging train that is capable of high image acquisition rates, and/or sub-frame imaging to complete the adjustment in a timely manner
Perform Procedures 12.2.1, 12.2.2, and 12.2.3 before performing the collimation using a CCD camera

 It is necessary to have available an operational AIS, including an imaging train that can be used for collimation purposes to perform **Procedures 12.2.1, 12.2.2, and 12.2.3**

[] 7 **Ensure** that the applicable CCD camera imaging software is running and available for use. Before use, **Functionally Test** the imaging software to ensure its proper operation

[] 8 **Adjust** the imaging software to acquire images at a rate necessary to provide adequate feedback on the adjustments made during the collimation process. **IF** a proper update frequency cannot be obtained, **THEN** use the sub-frame features of the imaging software to increase the image acquisition rate

 Usually a rate of at least 1 frame per second (fps) is necessary to receive adequate feedback on your adjustments. Slower rates should be avoided. Refer to the imaging program owner's manual as required

[] 9	**Adjust** the focus so that the star is out of focus. When the focus is inside or outside the optimal focus, the star appears as a donut-shaped object or disk (as applicable)	Observing the star image using the imaging software allows you to determine the amount of offset in the collimation and guides you in the fine adjustment of the secondary mirror, or primary refractive element of your astrograph
[] 10	**Adjust** the astrograph's collimation controls as necessary to bring the star image to a concentric image shape on the imaging software's display. **Adjust** the image according to the astrograph owner's manual to achieve optimal collimation	Refer to the imaging program owner's manual, as required. Look for any special features the imaging program may have to aid in the collimation of the astrograph

Acceptance Criteria:
The image provided by the medium FL eyepiece or the imaging software depicts a properly collimated astrograph as described and depicted in the astrograph owner's manual. Other depictions of a properly collimated astrograph are also available on the Internet.

12.2.5 Mount Polar Alignment Procedure

Description: This task steps through the process of performing an accurate polar alignment of the AIS mount using the CCD Drift Method.
Objective: To polar align the AIS mount using the CCD Drift Method.
Chapter References: Chaps. 5, 7, and 10. Refer to http://canburytech.net/DriftAlign/index.html for a thorough explanation of the drift alignment method.
AIS Equipment Used: Complete AIS system, including imaging train.

12.2 Common AIS Equipment Setup Procedures

Task Checklist

Step	Task	Notes
[] 1	**IF** not already done, **THEN Perform Procedures 12.2.1, 12.2.2, and 12.2.3** before performing the polar alignment using a CCD camera. **Perform** a collimation as necessary using **Procedure 12.2.4**	A fully functional AIS imaging train is necessary to perform an accurate polar alignment
	NOTE: There are several different methods for performing a high-precision polar alignment but this procedure uses the Drift Method. This procedure can also be performed visually using a cross-hair eyepiece instead of the CCD camera, although it is easier to monitor progress with the CCD camera. Ensure that the FOV of the camera is at least 20×20 arcminutes for the initial exposure	Refer to Chap. 5, Sect. 5.3. Refer to the mount's owner's manual or the mount's ASCOM driver manual for proper operation of the mount controller Generally, you can expect excellent image data if you expose your light frames at one half the total exposure time (TET) used to polar align your mount with this method
[] 2	**NOTE:** The following steps are used to determine the direction and amount of drift necessary for determining the adjustment needed on the **Azimuth Axis** of the mount **Slew** the astrograph to point to a relatively bright star near the Meridian and the Celestial Equator. **Enable** the Sidereal Tracking Rate on the mount controller if necessary	
[] 3	**Adjust** the position of the mount to center a star in the CCD camera's FOV. **Enable** the cross-hair feature of the imaging software. **Set** the imaging software to **Acquire** images at a suitable rate to monitor the position of the star	Refer to the imaging software owner's manual. A rate of at least 1 fps is suggested for image acquisition during this portion of the procedure
[] 4	**Disable** the Sidereal Tracking Rate on the mount controller and **Monitor** the direction of star drifts on the display	
[] 5	**Rotate** the imaging train as necessary to **Align** the long edge of the CCD camera and cross-hair with the drift axis. This is the RA axis **NOTE:** The image edge corresponding to the direction the star is drifting toward is the **WEST**	
[] 6	**Enable** the Sidereal Tracking Rate on the mount controller	
[] 7	**Re-Position** the star to the **eastern** edge of the image FOV using the RA and DEC buttons on the mount controller as necessary	

[] 8	Center the star on the DEC axis of the image. Note the direction the star moves on the image display when moving the mount in the north direction (Pressing the North Controller button)	
	NOTE: The image edge corresponding to the direction toward which the star is drifting is the SOUTH	
[] 9	Set the imaging software to acquire a 60-s exposure. Set the Slew Rate for the RA axis on the mount controller to 2x Sidereal	The purpose of the long exposure is to be able to acquire a star trail that enables you to graphically see the difference between the polar axis and the mount's RA axis
[] 10	Monitor the timer for the exposure. After the following elapsed times, Perform the actions specified	
[] 11	Start the 60-s exposure	
[] 12	After 10 s (elapsed)—Disable the Sidereal Rate on the mount controller	
[] 13	After 35 s (elapsed)—Press and Hold the mount controller W button to Slew the mount to the WEST at the set rate of 2x Sidereal	
[] 14	After 60 s (elapsed)—At the completion of the exposure, Release the mount controller W button and Enable the Sidereal Rate	
[] 15	Examine the image to verify that you have a horizontal, long, V-shaped star trail with a bright star image at the beginning of one of the legs in the V (Fig. 12.2). Determine the direction of DEC drift	
	IF the V leg without the bright star is toward the SOUTH edge, THEN the star drifted SOUTH, otherwise it drifted NORTH.	
[] 16	NOTE: IF performing this correction when located in the Southern Hemisphere, THEN Reverse the Azimuth axis directions (EAST should be WEST and vice versa)	
	Adjust the mount's Azimuth axis control a small amount to move the mount toward the EAST if the star drifted NORTH	
	Adjust the mount's Azimuth axis control a small amount to move the mount toward the WEST if the star drifted SOUTH	
[] 17	Re-Position the star to the eastern edge of the image FOV and to the center on the DEC axis	

[] 18	**Repeat** Steps 9–17 to close the gap between the legs in the V-shaped star trail. **Adjust** the TET in Steps 9 and 11 from 60 s up to 600 s as necessary to obtain the polar alignment accuracy required. **IF** the exposure time is greater than or equal to the following calculated value, **THEN** a portion of the V-shaped trails will not be within the FOV of the CCD camera. This will not affect the adjustment; simply perform Step 16 as specified	
	NOTE: **Adjust** the elapsed time (ET) in seconds for Steps 13 and 14 as follows to expose equal star trail lengths on each of the legs of the V	
	Step 13 ET sec = 10 + ((TET − 10)/2) sec	
	Step 14 ET sec = TET sec	
[] 19	**NOTE:** The following steps are used to determine the direction and amount of drift necessary for determining the adjustment needed on the **Altitude axis** of the mount	The eastern horizon is preferred because the stars are rising and the effects of refraction are lessened while doing the adjustment
	Slew the astrograph to point to a relatively bright star to the EAST (90° Azimuth) or WEST (270° Azimuth), 20–30° above the horizon. **Enable** the Sidereal Tracking Rate on the mount controller if necessary	
[] 20	**Re-Position** the star to the **eastern** edge of the image FOV using the RA and DEC buttons on the mount controller as necessary	
[] 21	**Center** the star on the DEC axis of the image	
[] 22	**Set** the imaging software to acquire a 60-s exposure. **Set** the Slew Rate for the RA axis on the mount controller to 2x Sidereal	The purpose of the long exposure is to be able to acquire a star trail that enables you to graphically see the difference between the polar axis and the mount's RA axis
[] 23	**Monitor** the countdown timer for the exposure. After the following elapsed times, **Perform** the actions specified	
[] 24	**Start** the 60-s exposure	
[] 25	**After 10 s (elapsed)**—**Disable** the Sidereal Rate on the mount controller	
[] 26	**After 35 s (elapsed)**—**Press and Hold** the mount controller W button to **Slew** the mount to the **WEST** at the set rate of 2x Sidereal	
[] 27	**After 60 s (elapsed)**—At the completion of the exposure, **Release** the mount controller W button and **Enable** the Sidereal Rate	

[] 28	**Examine** the image to verify that you have a horizontal, long, V-shaped star trail with a bright star image at the beginning of one of the legs in the V. **Determine** the direction of DEC drift. **IF** the V leg without the bright star is toward the **SOUTH** edge, **THEN** the star drifted **SOUTH**, otherwise it drifted **NORTH**	
[] 29	**NOTE: IF** performing this correction when located in the Southern Hemisphere, **THEN Reverse** the Altitude axis directions (**NORTH** should be **SOUTH** and vice versa)	Depending on the case, perform A, B, C, or D

(A) **IF** the star drifted NORTH, **AND** the star pointed to is on the eastern horizon, **THEN Adjust** the mount's Altitude axis control a small amount to **LOWER** the mount toward the ground

(B) **IF** the star drifted SOUTH, **AND** the star pointed to is on the eastern horizon, **THEN Adjust** the mount's Altitude axis control a small amount to **RAISE** the mount toward the sky

(C) **IF** the star drifted NORTH, **AND** the star pointed to is on the western horizon, **THEN Adjust** the mount's Altitude axis control a small amount to **RAISE** the mount toward the sky

(D) **IF** the star drifted SOUTH, **AND** the star pointed to is on the western horizon, **THEN Adjust** the mount's Altitude axis control a small amount to **LOWER** the mount toward the ground

[] 30	**Re-Position** the star to the eastern edge of the image FOV and to the center on the DEC axis
[] 31	**Repeat** Steps 22–30 to close the gap between the legs in the V-shaped star trail. **Adjust** the TET in Steps 22 and 24 from 60 s up to 600 s as necessary to obtain the polar alignment accuracy required. **IF** the exposure time is greater than or equal to the following calculated values, **THEN** a portion of the V-shaped trails will not be within the FOV of the CCD camera. This will not affect the adjustment; just perform Step 29 as specified

NOTE: Adjust the ET in seconds for Steps 26 and 27 as follows to expose equal star trail lengths on each of the legs of the V

Step ET sec = 10 + ((TET − 10)/2)

Step ET sec = TET

12.2 Common AIS Equipment Setup Procedures

Fig. 12.2 Declination drift image

Acceptance Criteria:
At the end of the total exposure time, the imaged star trails overlap each other, indicated by having no widening of the trail at either end. This indication is applicable only for the longest exposure time required by the program object to be imaged. The longest exposure time used in doing the polar alignment should be two times the longest expected light frame exposure time.

12.2.6 AIS All-Sky Alignment Procedure

Description: This task steps through the process of performing an all-sky alignment (synchronization) to ensure the mount points to the RA and DEC coordinates commanded by the mount controller. The all-sky alignment compensates for bias, orthogonal, and cone errors in the astrograph–mount interface.
Objective: To synchronize the AIS pointing to the true sky coordinates.
Chapter References: Chap. 5, Sect. 5.2.
AIS Equipment Used: AIS, mount, mount hand controller, and mount's hand controller owner's manual, planetarium program or database for reference coordinates, and/or astrometric software.

Task Checklist

Step	Task	Notes
[] 1	**IF** not already done, **THEN Perform Procedures 12.2.1, 12.2.2, and 12.2.3** before performing the all-sky alignment using a CCD camera. **Perform** a collimation as necessary using **Procedure 12.2.4**	A fully functional AIS imaging train is necessary to perform an accurate all-sky alignment
[] 2	**NOTE:** A three-star synchronization corrects for bias, orthogonal, and cone errors in the astrograph-mount interface. There are two ways to do the all-sky alignment—using the mount controller automation, and performing a manual three-star all-sky alignment. This procedure provides the steps for both **IF** a visual alignment using a cross-hair eyepiece and the mount's hand controller is required, **THEN Proceed** to the next step. Otherwise, for an accurate CCD all-sky alignment, **Proceed** to Step 8	Most hand controllers for go-to mounts provide a built-in procedure for doing a two- or three-star alignment. This is usually performed using the astrograph visually with an eyepiece
[] 3	Using the mount's hand controller, **Select** the three-star alignment procedure	Refer to the mount's hand controller owner's manual as required
[] 4	Using the mount's hand controller, **Select** and **Slew** to the first star of the alignment procedure	
[] 5	Using the astrograph finder and cross-hair eyepiece, **Center** the star in the FOV, and when prompted by the hand controller, **Synchronize** to the coordinates of the star selected	
[] 6	**Repeat** Steps 4 and 5 for the next two stars	
[] 7	**Follow** the hand controller's prompts to complete the three-star alignment procedure, **THEN** go to Step 15	Refer to the mount's hand controller manual for instructions on performing a three-star alignment
[] 8	**Ensure** that the mount's ASCOM or other proprietary controller software and the planetarium or other program used to select star coordinates are up and running	Refer to the mount's ASCOM and other driver information in the mount's owner's manual
[] 9	**Connect** the planetarium program or other star coordinate program to the mount. **Functionally Test** the Un-park, Park, and Slew commands using the program interface	
[] 10	**Start** the imaging train's imaging software. **Set** the imaging software to **Acquire** images at a suitable rate to monitor the position of the star	Refer to the imaging software owner's manual. A rate of at least 1 fps is suggested for image acquisition during this portion of the procedure

12.2 Common AIS Equipment Setup Procedures

[] 11	**Un-Park** the mount and **Slew** to the first (of three stars to perform the all-sky alignment	If using a planetarium program to control your mount, this is usually accomplished by pointing and clicking on the target star and selecting the SLEW TO command
[] 12	**Enable** the cross-hair feature of the imaging software. Using the mount's controller, **Center** the star image in the cross-hair display **NOTE:** As an alternative to centering the image of the star, use the astrometric software to **Perform** a Plate Solve and **Transfer** the coordinates to the planetarium program (in the next step). In this case, at least a 30–60-s exposure is required to acquire enough stars in the image to perform the Plate Solve	Refer to the image acquisition and planetarium program owner's manual for information on how to use the Plate Solve functions of the program(s) if available
[] 13	Select **SYNC** in the planetarium program to synchronize the star's position and transfer the coordinates to the planetarium program	
[] 14	**Repeat** Steps 11–13 for two more stars	
[] 15	**Select and Slew** to a bright target and **Verify** that the target is within the FOV of the CCD camera or eyepiece as necessary	

Acceptance Criteria:

The mount's pointing is successfully synchronized using three stars with the mount's hand controller or the planetarium software. The mount can successfully point to a selected target by slewing the astrograph to the required coordinates by verifying that the selected target is near the center of the FOV of the eyepiece or CCD camera as required.

12.2.7 *Flat Frame Acquisition Procedure*

Description: This task steps through the process of acquiring the flat frames used to calibrate the raw imaging data acquired in the light frames.
Objective: To acquire the calibration flat frames.
Chapter References: Chap. 11, Sects. 11.5 and 11.6.
AIS Equipment Used: AIS, imaging train, flat frame light source, light diffuser.

Task Checklist

Step	Task	Notes
[] 1	**NOTE:** This procedure must be done with the complete imaging train attached to the astrograph. The flat frame includes data to compensate the light frame for systematic and random errors, including bias, vignetting, filter non-uniformity, and other defects. There are two sources of light for taking the flat frame, a light panel and the twilight sky. This procedure is applicable to both sources of light **IF** not already done, **THEN Perform Procedures 12.2.1, 12.2.2, and 12.2.3. Perform** a collimation as necessary using **Procedure 12.2.4**	A fully functional AIS imaging train is necessary when acquiring flat frames for image calibration
[] 2	**Adjust** the focuser to a position close to the expected focus position that will be used for acquiring the light frames	Record the focus position when making light frame exposures and refer to these positions when adjusting the focuser for this procedure
[] 3	**Set** the CCD camera temperature to the desired value depending on the season. **Enable** the CCD camera temperature controller software to maintain this temperature	Refer to the CCD camera temperature control section in the imaging software's owner's manual as required
[] 4	**Record** the temperature value in the observing log	
[] 5	**Un-Park and Slew** the astrograph position to zenith if acquiring twilight sky-flats, or to point to the flat light source, as desired	
[] 6	**Place** a light diffuser over the front of the astrograph as desired	
[] 7	**CAUTION:** If the CCD camera has a mechanical shutter, an exposure time of at least 5 s is necessary to mitigate the effects of shadowing (gradients) when exposing the CCD at too low a shutter speed **Set** the exposure time in the imaging software to **Acquire** images to provide a MAX ADU equal to 80–90% of full-well depth, or 50,000–55,000 ADUs (205–230 for an 8-bit CCD)	If taken during twilight, exposures in the range of 3–10 s should be expected
[] 8	**Define and Create** the directory (as necessary) where the flat frames are to be stored during this imaging session	

12.2 Common AIS Equipment Setup Procedures 213

[] 9	**Start** the image capture process and **Acquire** at least 10 images at the desired ADU value	
[] 10	**Open and Examine** (as necessary) one of the flat frames for quality	
[] 11	After acquiring all the images desired, **Park** the mount	

Acceptance Criteria:
A minimum of 10 flat frames were acquired, each with a MAX ADU count of at least 80% of full-well depth and checked for quality.

12.2.8 Dark Frame Acquisition Procedure

Description: This task steps through the process of acquiring the dark frames used to calibrate the raw imaging data acquired in the light frames.
Objective: To acquire the calibration dark frames.
Chapter References: Chap. 11, Sects. 11.5 and 11.6.
AIS Equipment Used: Astrograph coupled to the fully configured imaging train.

Task Checklist

Step	Task	Notes
[] 1	**NOTE 1:** The dark frame includes data to compensate the light frame for systematic and random errors, including bias and thermal dark current electrons **NOTE 2:** This procedure can be performed without mounting the imaging train on the astrograph and indoors as long as the TEC temperature setting is set to a specific value that will be used when acquiring light frames **OPTIONAL: IF** not already done, **THEN Perform Procedures 12.2.1, 12.2.2, and 12.2.3. Perform** a collimation as necessary using **Procedure 12.2.4**	A fully functional AIS imaging train is necessary when acquiring dark frames for image calibration

[] 2	**OPTIONAL: Adjust** the focuser to the in-focus position close to the expected focus position used for acquiring the light frames	
[] 3	**Set** the CCD camera temperature to the desired value depending on the season. **Enable** the CCD camera temperature controller software to maintain this temperature	Refer to the CCD camera temperature control section in the imaging software's owner's manual as required
[] 4	**Record** the temperature value in the observing log	
[] 5	**Set** the CCD camera imaging software to keep the shutter closed (as necessary) and **Cover** the astrograph with the dust cover to block all light from entering the CCD camera	
[] 6	**Set** the exposure time to 60 s in the imaging software to **Acquire** the dark frame images	
[] 7	**Define and Create** the directory (as necessary) where the dark frames are to be stored during this imaging session	
[] 8	**Start** the image capture process and **Acquire** at least 10 images	
[] 9	**Open and Examine** (as necessary) one of the dark frames for quality	

Acceptance Criteria:
A total of at least 10 dark frames were acquired and checked for quality.

12.2.9 *Bias Frame Acquisition Procedure*

Description: This task steps through the process of acquiring the bias frames used to calibrate the raw imaging data acquired in the light frames.
Objective: To acquire the calibration bias frames.
Chapter References: Chap. 11, Sects. 11.5 and 11.6.
AIS Equipment Used: Astrograph coupled to the fully configured imaging train.

12.2 Common AIS Equipment Setup Procedures

Task Checklist

Step	Task	Notes
[] 1	**NOTE 1:** The bias frame includes data to compensate the light frame for systematic errors **NOTE 2:** This procedure can be performed without mounting the imaging train on the astrograph and indoors as long as the TEC temperature setting is set to a specific value that will be used when acquiring light frames **OPTIONAL: IF** not already done, **THEN Perform Procedures 12.2.1, 12.2.2, and 12.2.3. Perform** a collimation as necessary using **Procedure 12.2.4**	A fully functional AIS imaging train is necessary when acquiring bias frames for image calibration
[] 2	**OPTIONAL: Adjust** the focuser to the in-focus position close to the expected focus position used for acquiring the light frames	
[] 3	**Set** the CCD camera temperature to the desired value depending on the season. **Enable** the CCD camera temperature controller software to maintain this temperature	Refer to the CCD camera temperature control section in the imaging software's owner's manual as required
[] 4	**Record** the temperature value in the observing log	
[] 5	**Set** the CCD camera imaging software to keep the shutter closed (as necessary) and **Cover** the astrograph with the dust cover to block all light from entering the CCD camera	
[] 6	**Set** the exposure time to zero (0) seconds in the imaging software to **Acquire** the bias frame images	
[] 7	**Define and Create** the directory (as necessary) where the bias frames are to be stored during this imaging session	
[] 8	**Start** the image capture process and **Acquire** at least 30 images	
[] 9	**Open and Examine** (as necessary) one of the bias frames for quality	

Acceptance Criteria:
A minimum of 30 bias frames were acquired and checked for quality.

12.2.10 Light Frame Acquisition Procedure

Description: This task steps through the process of acquiring the light frames containing the raw data for the object under study. This procedure is performed in conjunction with the applicable higher order procedure in Sect. 12.3.

Objective: To acquire the program object raw data.
Chapter References: Chap. 11, Sects. 11.3, 11.4, and 11.7.
AIS Equipment Used: Complete AIS as configured for acquiring program object images.

Task Checklist

Step	Task	Notes
[] 1	**IF** not already done, **THEN Perform Procedures 12.2.1, 12.2.2, and 12.2.3**. **Perform** a collimation as necessary using **Procedure 12.2.4**	A fully functional AIS imaging train is necessary for this procedure
[] 2	**Adjust** the focuser to the in-focus position close to the expected focus position used for acquiring the light frames	
[] 3	**IF** available, **Set** the CCD camera temperature to the desired value depending on the season **Enable** the CCD camera temperature controller software to maintain this temperature	Refer to the CCD camera temperature control section in the imaging software's owner's manual as required
[] 4	**Record** the temperature value in the observing log as required	
[] 5	**Define and Create** the directory (as necessary) where the light frames are to be stored during this imaging session	
[] 6	**Perform Procedure 12.2.11** upon initial setup and periodically during the imaging session	Checking and adjusting the focus periodically ensures that the best data is being acquired
[] 7	**Set** the exposure time to the desired value in the imaging software to **Acquire** the light frame images. **Set** the video gain, exposure time, and frame rate for the camera as necessary when using a webcam type CCD camera	Refer to Chap. 9 for recommendations on the exposure times for various objects
[] 8	**Start** the image capture process as needed according to the specific observing program object requirements	
[] 9	**Monitor** the data acquisition process to ensure that the light frames are of the required quality	

Acceptance Criteria:
The light frames are acquired and checked for the required quality.

12.2.11 Astrograph Focusing Procedure

Description: This task steps through the process of adjusting the astrograph focuser to achieve an accurate focus to acquire the best imaging data possible.

12.2 Common AIS Equipment Setup Procedures

Objective: To adjust the astrograph focuser to achieve an accurate focus.
Chapter References: Chap. 6, Sect. 6.10, and Chap. 3, Sect. 3.3.
AIS Equipment Used: AIS, AIS focuser and applicable focusing software, focusing mask, and imaging software.

Task Checklist

Step	Task	Notes
[] 1	**NOTE:** There are two ways to focus a star accurately using the AIS focusing subsystem. Using the statistics of the star image directly (FWHM, and Peak ADU), and by using a focusing mask **Perform Procedures 12.2.1, 12.2.2, and 12.2.3** before performing the all-sky alignment using a CCD camera. **Perform** a collimation as necessary using Procedure 12.2.4	A fully functional AIS imaging train is necessary when focusing an image using the image acquisition software
[] 2	**Un-Park** the mount and **Slew** the astrograph to a bright star	
[] 3	**Ensure** that the applicable CCD camera imaging software is running and available for use. Before use, **Functionally Test** the imaging software to ensure its proper operation	
[] 4	**Enable** the cross-hair feature of the imaging software. Using the mount's controller, **Center** the star image in the cross-hair display. **Place** the focusing mask on the front of the astrograph if using that method	
[] 5	**Adjust** the imaging software to acquire images at a rate necessary to provide adequate feedback of the adjustments made during the focusing process. **IF** a proper update frequency cannot be obtained, **THEN** use the sub-frame features of the imaging software to increase the image acquisition rate	Usually a rate of at least 0.2 fps (5-s interval between frames) is necessary to receive adequate feedback on your adjustments. Slower rates should be avoided. Refer to the imaging program owner's manual as required
[] 6	**Select** the star on the display and **Monitor** the imaging programs statistics feature providing the **FWHM** and **Peak ADU** value for the star used to focus the astrograph. Alternatively, **Observe** the diffraction lines that the focusing mask creates to aid in focusing the star image	Many imaging programs provide a special dialog box showing a selected star's statistics used for focusing. Refer to the imaging programs owner's manual for this specific feature

Step	Task	Notes
[] 7	**Adjust** the astrograph focuser position to **MINIMIZE** the FWHM value and/or **MAXIMIZE** the Peak ADU value for the star under study. Alternatively, **Adjust** the focuser to bring the diffraction lines of the focusing mask to the proper position	Refer to the focusing mask instructions to learn how the image should appear when properly focused
[] 8	Once the focuser is adjusted for best focus, **Lock Down** the focuser using the focuser's lock-screw	

Acceptance Criteria:

The star is properly focused as indicated by the value of the FWHM of the star being MINIMIZED, and/or the Peak ADU being MAXIMIZED. As specified in the owner's manual, the focusing mask view depicts a properly focused star image.

12.2.12 Guidescope Setup Procedure

Description: This task steps through the process of setting up and initial calibration of the guidescope.
Objective: To set up and calibrate the guidescope subsystem.
Chapter References: Chaps. 3 and 4; Chap. 5, Sects. 5.1 and 5.3; Chap. 6, Sects. 6.11, 6.13, and 6.14.
AIS Equipment Used: AIS, mount, guidescope, and auto-guiding application software.

Task Checklist

Step	Task	Notes
[] 1	**IF** not already done, **THEN Assemble** the components that make up the guidescope subsystem	The components are the guidescope, guide camera, associated power and signal cabling, and mounting system
[] 2	**IF** not already done, **THEN Mount** the assembled guidescope subsystem onto the AIS	
[] 3	**IF** not already done, **THEN Apply** power to the guidescope subsystem	

[] 4	IF not already done, **THEN Startup and Connect** to the guide camera using the auto-guiding software	There are several different sources for auto-guiding software, standalone and integrated into image acquisition software
[] 5	**Select** a bright star and **Slew** the astrograph to the star	
[] 6	**Center** and **Focus** the star's image in the guide camera using the guidescope's focuser. **Adjust** the frame rate as necessary to obtain the best image	
[] 7	**NOTE:** The auto-guiding system calibration is dependent on the side of the Meridian to which the guidescope is pointed because of the Meridian flip that occurs when crossing the Meridian. Refer to the auto-guiding software owner's manual for detailed instructions on calibrating the system **Start** the auto-guiding system's software calibration routine to **Calibrate** the mount control response to the guider's inputs	Whenever the German equatorial mount (GEM) performs a Meridian flip, recalibration of the auto-guiding system is required
[] 8	**Select and Lock** onto a star to guide on using the auto-guiding software's controls	

Acceptance Criteria:

The successful completion of the calibration process leads to the successful guiding on a selected star using the auto-guiding software and guidescope.

12.3 Specific Object Type Observing Procedures

The following tasks are defined for observing the four main object types and include information necessary for setting up and completing the observations in an efficient and timely manner, and for obtaining the best data possible from your AIS.

12.3.1 Large Solar System Object Imaging Procedure
12.3.2 Small Solar System Object Imaging Procedure
12.3.3 Large Deep Sky Object Imaging Procedure
12.3.4 Small Deep Sky Object Imaging Procedure

Each of these high-level object-based procedures is complete for each object type. Be sure when you research the object that you plan to image that you think about what differences there may be for imaging this object versus what is typical for the object. If the object is particularly large, such as the Andromeda Galaxy, you may have some special requirements that put it outside the normal specified parameters. The image scale may exceed what is available to you. Keep in mind the limits of your AIS and choose objects that are within its capabilities; however, do not be afraid to use your AIS to its limits.

12.3.1 Large Solar System Object Imaging Procedure

Object Type Description: A Large Solar System Object is a body that moves among the stars; its position must be calculated from moment to moment. These objects include the Sun, Moon, planets, and natural satellites that resolve into a disk. They do not include minor planets because these require long exposures to detect and measure.

Session Objective: To target, acquire, and image the Sun, Moon, planets, and natural satellites for scientific study.

Chapter References: Chaps. 3 and 4
Chapter 5, Sects. 5.1.2, and 5.2.3
Chapter 6, Sect. 6.3
Chapter 7, Sect. 7.2.2
Chapter 8, Sect. 8.1.2
Chapter 9, Sects. 9.5.1, 9.5.2, 9.5.3
Chapter 10, Sects. 10.3, 10.4, 10.5, and 10.6
Chapter 11, Sects. 11.3, 11.4, 11.5, and 11.6
Chapter 12, Sect. 12.3.2

Image Scale Guidelines: The Sun, Moon, major planets, and natural satellites require an image scale in the range 0.1 arcsec/pixel to 0.5 arcsec/pixel. This is dependent on the size and the resolving ability of the astrograph.

Minimum Equipment List:

Equipment	Description and design basis
Mount	Any mount will suffice because the objects imaged are bright and require a fast shutter speed and high frame rate. Consequently, accurate tracking is not strictly required, although it makes imaging these objects much easier and leads to much better results. For best results, use a GEM or fork mount
Astrograph	To obtain the best results, the minimum size for a refractor is 5 in. (127 millimeters (mm)) and for a reflector 8 in. (200 mm). The larger reflectors provide better resolving power
CCD camera	These objects are bright and are affected by the movement of the atmosphere; therefore, they require a fast exposure and a high frame rate to "freeze" the effects of the atmosphere. A webcam-based digital camera is the preferred camera in this case. A frame rate of at least 15 fps and a shutter speed adjustable to 0.001 s (1 millisecond (ms)) is required. Cameras that are sensitive at the red end of the spectrum are best
Support hardware	The various lunar and planetary filters are useful for discriminating many features on the planets. A red filter is good for lunar imaging when the seeing is not the best (greater than 3 arcseconds (arcsec)). Solar imaging requires a special solar filter or a dedicated solar astrograph for imaging
Support software	Dedicated video processing software is required to align, select, and stack the best video frames from the raw video to resolve the finest details in the data

12.3 Specific Object Type Observing Procedures

Session Checklist

Step	Task	Notes
[] 1	**Select** the Solar System Object to observe for which you want to acquire data	This choice is based on the requirements of the Observing Program being worked
[] 2	**Determine** the position and aspects of the Solar System Object for the desired time of observation by using the planetarium program, ephemerides, solar system database, or other data source as required	Use www.calsky.com as a source
[] 3	**OPTIONAL: Perform Procedure 12.2.1**, Image Scaling Calculation	See Procedure 12.2.1 Acceptance Criteria for applicability
[] 4	**Perform Procedure 12.2.2**, AIS Equipment Setup	**Verify** the configuration and condition of the AIS power supply. **Ensure** that the power supply is fully charged and/or available for use
[] 5	**Perform Procedure 12.2.3**, Imaging Train Configuration	
[] 6	**AS REQUIRED: Perform Procedure 12.2.4**, Astrograph Collimation	See Procedure 12.2.4 Acceptance Criteria for applicability
[] 7	**OPTIONAL: Perform Procedure 12.2.5**, Mount Polar Alignment	Performance of this procedure ensures the best results for taking high numbers of frames and minimizing object movement within the FOV of the CCD camera
[] 8	**OPTIONAL: Perform Procedure 12.2.6**, AIS All-Sky Alignment	Performance of this procedure ensures faster target acquisition independent of using a finder
[] 9	**Select and Slew** to a bright star near the Solar System Object selected in Step 1 using the planetarium program or the mount's ASCOM or hand controller	This step prepares the astrograph for initial focusing
[] 10	**Perform Procedure 12.2.11**, Astrograph Focusing, upon initial setup and periodically during the imaging session	Checking and adjusting the focus periodically ensures that the best data is being acquired
[] 11	**Slew** to the Solar System Object selected in Step 1 using the planetarium program or the mount's ASCOM or hand controller	
[] 12	**Perform Procedure 12.2.10**, Light Frame Acquisition	
[] 13	**Monitor** the performance of the AIS during the imaging session. **Anticipate and Resolve** issues as they occur if possible. **Use** the procedures in Steps 4 and 5 to help resolve any issues that occur	
[] 14	**IF** you are planning to image more than one program object, **THEN Repeat** Steps 9–13 as necessary to complete the imaging session	

Session Notes:

Use the video camera imaging software controls to maximize the quality of the images acquired by adjusting the gain, exposure, and frame rate controls. Use the histogram feature to set the best values for these parameters.

Expected Processing Description:

Video images captured in .avi files are processed using programs that align, select, sort, and stack the individual frames in the video. This is necessary to get the best frames that provide the highest resolution result from the data acquired. These programs also provide a wavelet filtering algorithm that brings out the highest resolution detail available in the processed image.

12.3.2 Small Solar System Object Imaging Procedure

Object Type Description: A Small Solar System Object is a body that moves among the stars; its position must be calculated from moment to moment. These objects include minor planets, small natural satellites, and manmade satellites because all of these require long exposures to detect and measure. These objects are not resolvable into disks as the other solar system objects are.

Session Objective: To target, acquire, and image the minor planets, small natural satellites, and manmade satellites for scientific study.

Chapter References: Chaps. 3 and 4

Chapter 5, Sects. 5.1.1 and 5.1.2

Chapter 6, Sects. 6.3 and 6.6

Chapter 7, Sect. 7.2.1

Chapter 8, Sect. 8.1

Chapter 9, Sects. 9.5.5 and 9.6.5

Chapter 10, Sects. 10.3, 10.4, 10.5, and 10.6

Chapter 11, Sects. 11.3.1 and 11.4

Image Scale

Guidelines: The minor planets, small natural satellites, and manmade satellites require an image scale of 1–2 arcsec/pixel to obtain accurate astrometric and photometric results.

12.3 Specific Object Type Observing Procedures

Minimum Equipment List:

Equipment	Description and design basis
Mount	An accurately tracking mount is required for this imaging task because of the long (\geq60 s) exposures needed to obtain the data. Use a guidescope subsystem as necessary. For best results, a GEM or fork mount is suggested, although an Alt/Az mount can be used with a field rotator
Astrograph	To obtain the best results, the minimum size for a refractor is 5 in. (127 mm) and for a reflector 8 in. (200 mm). The larger reflectors have better light-gathering capability for detecting and measuring dimmer objects
CCD camera	A long-exposure CCD camera with thermo-electrically cooled CCD chips is necessary to obtain the highest quality data. Exposure times from 60 to 180 s are typical. Exposures up to 300 s may be used for slow-moving objects
Support hardware	A V-band photometric filter is typically used for accurate photometry measurements of these small solar system objects. Other photometric filters (U, B, R, and I) can be used to obtain other data on aspects of these objects as desired. Use a Flat Field Optic to obtain the best astrometric results
Support software	The standard imaging software used to acquire long exposure time images

Session Checklist

Step	Task	Notes
[] 1	**Select** the Solar System Object to observe and for which you want to acquire data	This choice is based on the requirements of the Observing Program being worked
[] 2	**Determine** the position and aspects of the Solar System Object for the desired time of observation by using the planetarium program, ephemerides, solar system database, or other data source as required	Use www.calsky.com as a source
[] 3	**Perform Procedure 12.2.1**, Image Scaling Calculation	
[] 4	**Perform Procedure 12.2.2**, AIS Equipment Setup, including an auto-guiding subsystem as required	**Verify** the configuration and condition of the AIS power supply. **Ensure** that the power supply is fully charged and/or available for use

[] 5	**Perform Procedure 12.2.3**, Imaging Train Configuration	
[] 6	**AS REQUIRED: Perform Procedure 12.2.4**, Astrograph Collimation	See Procedure 12.2.4 Acceptance Criteria for applicability
[] 7	**AS REQUIRED: Perform Procedure 12.2.7**, Flat Frame Acquisition	
[] 8	**NOTE:** This step may be performed at another time as necessary **Perform Procedure 12.2.8**, Dark Frame Acquisition	
[] 9	**NOTE:** This step may be performed at another time as necessary **OPTIONAL: Perform Procedure 12.2.9**, Bias Frame Acquisition	
[] 10	**Perform Procedure 12.2.5**, Mount Polar Alignment	Performance of this procedure ensures the best results for taking long exposure time (60–300 s) images
[] 11	**Perform Procedure 12.2.6**, AIS All-Sky Alignment	Performance of this procedure is mandatory to target and acquire objects that cannot be detected visually
[] 12	**Select and Slew** to a bright star near the Solar System Object selected in Step 1 using the planetarium program or the mount's ASCOM or hand controller	This step prepares the astrograph for initial focusing
[] 13	**AS REQUIRED: Perform Procedure 12.2.12**, Guidescope Setup procedure if required	**IF** your mount is not capable of accurate tracking in terms of periodic error correction, **THEN Install** and **Setup** a guidescope subsystem to obtain the best results
[] 14	**Perform Procedure 12.2.11**, Astrograph Focusing, upon initial setup and periodically during the imaging session	Checking and adjusting the focus periodically ensures that the best data is being acquired
[] 15	**Slew** to the Solar System Object selected in Step 1 using the planetarium program or the mount's ASCOM or hand controller	
[] 16	**Perform Procedure 12.2.10**, Light Frame Acquisition	
[] 17	**Monitor** the performance of the AIS during the imaging session. **Anticipate and Resolve** issues as they occur if possible. **Use** the procedures in Steps 4 and 5 to help resolve any issues that occur	
[] 18	**IF** you are planning to image more than one program object, **THEN Repeat** Steps 12–16 as necessary to complete the imaging session	

12.3 Specific Object Type Observing Procedures

Session Notes:
For best results perform Steps 6–11 to the best of your ability; these steps have a direct impact on the quality of the data you obtain.

Expected Processing Description:
The processing for the image data acquired typically consists of a standard image calibration as described in Chap. 11, Sect. 11.6. Read and fully understand the features described in your image processing program owner's manual used in calibrating your image data.

12.3.3 Large Deep Sky Object Imaging Procedure

Object Type Description: A Large Deep Sky Object is a large (less than 60 arcminutes (arcmin) and greater than 5 arcmin) interstellar, intragalactic mass of gas and dust, or a close galaxy showing resolvable structure and form. Because these objects are very dim, they require long exposures to record and measure the scientific data required to meet the observing program goals.

Session Objective: To target, acquire, and image Large Deep Sky Objects for scientific study.

Chapter References: Chaps. 3 and 4
Chapter 5, Sect. 5.1.1
Chapter 6, Sects. 6.2, 6.4, and 6.6
Chapter 7, Sect. 7.2.1
Chapter 8, Sect. 8.1
Chapter 9, Sects. 9.5.4 and 9.6.4
Chapter 10, Sects. 10.3, 10.4, 10.5, and 10.6
Chapter 11, Sects. 11.3.1 and 11.4

Image Scale

Guidelines: The Large Deep Sky Objects require an image scale of 0.5–2 arcsec/pixel to obtain accurate astrometric and photometric results, depending on the object size and seeing level.

Minimum Equipment List:

Equipment	Description and design basis
Mount	An accurately tracking mount is required for this imaging task because of the long (≥300 s) exposures needed to obtain the data. Use a guidescope subsystem as necessary. For best results, a GEM or fork mount is suggested, although an Alt/Az mount can be used with a field rotator

Astrograph	To obtain the best results, the minimum size for a refractor is 5 in. (127 mm) and for a reflector 8 in. (200 mm). The larger reflectors have better light-gathering capability for detecting and measuring dimmer objects but the FOV may not be suitable unless a large CCD camera is used
CCD camera	A long exposure CCD camera with thermo-electrically cooled CCD chips is necessary to obtain the highest quality data. Exposure times from 300 to 600 s are typical. Exposures up to 1,200 s may be used for very dim objects or when using narrow-band filters
Support hardware	Narrow-band filters are typically used when imaging Large Deep Sky Objects. Unfiltered exposures are also done. Use a Flat Field Optic to obtain the best astrometric results
Support software	The standard imaging software used to acquire long exposure time images

Session Checklist

Step	Task	Notes
[] 1	**Select** the Deep Sky Object to observe and for which you want to acquire data	This choice is based on the requirements of the Observing Program being worked
[] 2	**Determine** the position and aspects of the Deep Sky Object for the desired time of observation by using the planetarium program, ephemerides, or other data source as required	
[] 3	**Perform Procedure 12.2.1**, Image Scaling Calculation	
[] 4	**Perform Procedure 12.2.2**, AIS Equipment Setup, including an auto-guiding subsystem as required	**Verify** the configuration and condition of the AIS Power Supply. **Ensure** that the power supply is fully charged and/or available for use
[] 5	**Perform Procedure 12.2.3**, Imaging Train Configuration	
[] 6	**AS REQUIRED: Perform Procedure 12.2.4**, Astrograph Collimation	See Procedure 12.2.4 Acceptance Criteria for applicability
[] 7	**Perform Procedure 12.2.7**, Flat Frame Acquisition	
[] 8	**Perform Procedure 12.2.8**, Dark Frame Acquisition	
[] 9	**OPTIONAL: Perform Procedure 12.2.9**, Bias Frame Acquisition	
[] 10	**Perform Procedure 12.2.5**, Mount Polar Alignment	Performance of this procedure ensures the best results for taking long exposure time (300–1,200 s) images

12.3 Specific Object Type Observing Procedures

[] 11	**Perform Procedure 12.2.6**, AIS All-Sky Alignment	Performance of this procedure is mandatory to target and acquire objects that cannot be detected visually
[] 12	**Select and Slew** to a bright star near the Deep Sky Object selected in Step 1 using the planetarium program or the mount's ASCOM or hand controller	This step prepares the astrograph for initial focusing
[] 13	**AS REQUIRED: Perform Procedure 12.2.12**, Guidescope Setup procedure if required	**IF** your mount is not capable of accurate tracking in terms of periodic error correction, **THEN Install** a guidescope subsystem to obtain the best results
[] 14	**Perform Procedure 12.2.11**, Astrograph Focusing, upon initial setup and periodically during the imaging session	Checking and adjusting the focus periodically ensures that the best data is being acquired
[] 15	**Slew** to the Deep Sky Object selected in Step 1 using the planetarium program or the mount's ASCOM or hand controller	
[] 16	**Perform Procedure 12.2.10**, Light Frame Acquisition	
[] 17	**Monitor** the performance of the AIS during the imaging session. **Anticipate and Resolve** issues as they occur if possible. **Use** the procedures in Steps 4 and 5 to help resolve any issues that occur	
[] 18	**IF** you are planning to image more than one program object, **THEN Repeat** Steps 12–16 as necessary to complete the imaging session	

Session Notes:

For best results perform Steps 6–11 to the best of your ability; these steps have a direct impact on the quality of the data you obtain.

Expected Processing Description:

The processing for the image data acquired typically consists of a standard image calibration as described in Chap. 11, Sect. 11.6. Read and fully understand the features described in your image processing program owner's manual used in calibrating your image data.

12.3.4 Small Deep Sky Object Imaging Procedure

Object Type Description: A Small Deep Sky Object is a small (less than 5 arcmin) interstellar or intragalactic mass of gas and dust, or a galaxy showing resolvable

structure and form. Because these objects are very dim, they require long exposures to record and measure the scientific data required to meet the observing program goals.

Session Objective: To target, acquire, and image Small Deep Sky Objects for scientific study.

Chapter References: Chaps. 3 and 4

Chapter 5, Sect. 5.1.1

Chapter 6, Sects. 6.2, 6.4, and 6.6

Chapter 7, Sect. 7.2.1

Chapter 8, Sect. 8.1

Chapter 9, Sects. 9.5.4 and 9.6.4

Chapter 10, Sects. 10.3, 10.4, 10.5, and 10.6

Chapter 11, Sects. 11.3.1 and 11.4

Image Scale

Guidelines: The Small Deep Sky Objects require an image scale of 0.2–1 arc-sec/pixel to obtain accurate astrometric and photometric results depending on the resolving capability of the astrograph, the object size, and quality of the seeing.

Minimum Equipment List:

Equipment	Description and design basis
Mount	An accurately tracking mount is required for this imaging task because of the long (≥300 s) exposures needed to obtain the data. Use a guidescope subsystem as necessary. For best results, a GEM or fork mount is suggested, although an Alt/Az mount can be used with a field rotator
Astrograph	To obtain the best results, the minimum size for a refractor is 5 in. (127 mm) and for a reflector 8 in. (200 mm). The larger reflectors have better light-gathering capability for detecting and measuring dimmer objects
CCD camera	A long exposure CCD camera with thermo-electrically cooled CCD chips is necessary to obtain the highest quality data. Exposure times from 300 to 600 s are typical. Exposures up to 1,200 s may be used for very dim objects, or when using narrow-band filters. Because of the small object size, any TEC CCD camera can be used
Support hardware	Narrow-band filters are sometimes used when imaging Small Deep Sky Objects. Unfiltered exposures are also typically used. Use a Flat Field Optic to obtain the best astrometric results. Use a Barlow lens to provide the proper image scale
Support software	The standard imaging software used to acquire long exposure time images

12.3 Specific Object Type Observing Procedures

Session Checklist

Step	Task	Notes
[] 1	**Select** the Deep Sky Object to observe and for which you want to acquire data	This choice is based on the requirements of the Observing Program being worked
[] 2	**Determine** the position and aspects of the Deep Sky Object for the desired time of observation by using the planetarium program, ephemerides, or other data source as required	
[] 3	**Perform Procedure 12.2.1**, Image Scaling Calculation	
[] 4	**Perform Procedure 12.2.2**, AIS Equipment Setup, including an auto-guiding subsystem as required	**Verify** the configuration and condition of the AIS power supply. **Ensure** that the power supply is fully charged and/or available for use
[] 5	**Perform Procedure 12.2.3**, Imaging Train Configuration	
[] 6	**AS REQUIRED: Perform Procedure 12.2.4**, Astrograph Collimation	See Procedure 12.2.4 Acceptance Criteria for applicability
[] 7	**Perform Procedure 12.2.7**, Flat Frame Acquisition	
[] 8	**Perform Procedure 12.2.8**, Dark Frame Acquisition	
[] 9	**OPTIONAL: Perform Procedure 12.2.9**, Bias Frame Acquisition	
[] 10	**Perform Procedure 12.2.5**, Mount Polar Alignment	Performance of this procedure ensures the best results for taking long exposure time (300–1,200 s) images
[] 11	**Perform Procedure 12.2.6**, AIS All-Sky Alignment	Performance of this procedure is mandatory to target and acquire objects that cannot be detected visually
[] 12	**Select and Slew** to a bright star near the Deep Sky Object selected in Step 1 using the planetarium program or the mount's ASCOM or hand controller	This step prepares the astrograph for initial focusing
[] 13	**AS REQUIRED: Perform Procedure 12.2.12**, Guidescope Setup procedure if required	**IF** your mount is not capable of accurate tracking in terms of periodic error correction, **THEN Install** a guidescope subsystem to obtain the best results
[] 14	**Perform Procedure 12.2.11**, Astrograph Focusing, upon initial setup and periodically during the imaging session	Checking and adjusting the focus periodically ensures that the best data is being acquired

[] 15	**Slew** to the Deep Sky Object selected in Step 1 using the planetarium program or the mount's ASCOM or hand controller
[] 16	**Perform Procedure 12.2.10**, Light Frame Acquisition
[] 17	**Monitor** the performance of the AIS during the imaging session. **Anticipate and Resolve** issues as they occur if possible. **Use** the procedures in Steps 4 and 5 to help resolve any issues that occur
[] 18	**IF** you are planning to image more than one program object, **THEN Repeat** Steps 12–16 as necessary to complete the imaging session

Session Notes:

For best results perform Steps 6–11 to the best of your ability; these steps have a direct impact on the quality of the data you obtain.

Expected Processing Description:

The processing for the image data acquired typically consists of a standard image calibration as described in Chap. 11, Sect. 11.6. Read and fully understand the features described in your image processing program owner's manual used in calibrating your image data.

Further Reading

Arditti D (2008) Setting-up a small observatory. Springer, New York
Berry R, Burnell J (2005) The handbook of astronomical image processing. Willmann-Bell, Richmond
Buchheim R (2007) The sky is your laboratory. Springer, Berlin/Heidelberg/New York
Byrne CJ (2005) Lunar orbiter photographic atlas of the near side of the moon. Springer, New York
Chromey FR (2010) To measure the sky. Cambridge University Press, Cambridge
Covington MA (1999) Astrophotography for the amateur. Cambridge University Press, Cambridge
Dragesco J (1995) High resolution astrophotography. Cambridge University Press, Cambridge
Dymock R (2010) Asteroids and dwarf planets and how to observe them. Springer, New York
Harrison KM (2011) Astronomical spectroscopy for amateurs. Springer, New York
Henden AA, Kaitchuck RH (1990) Astronomical photometry. Willmann-Bell, Richmond
Howell SB (2006) Handbook of CCD astronomy. Cambridge University Press, Cambridge
Shirao M, Wood CA (2010) The Kaguya lunar atlas. Springer, Berlin
Smith GH, Ceragioli R, Berry R (2012) Telescopes, eyepieces and astrographs. Willmann-Bell, Richmond
Warner BD (2006) A practical guide to lightcurve photometry and analysis. Springer, New York
Warner BD (2010) The MPO user's guide. BDW Publishing, Colorado Springs

Part III

Scientific Image Data Analysis and Advanced Amateur Scientific Projects

Chapter 13

Scientific Image Data Uses and Innovations in AIS Components and Systems

13.1 Citizen Science and Your AIS

Over the past decade, the participation of amateur astronomers in the professional astronomical community has grown exponentially. For amateurs with the desire and inclination, there are opportunities galore to contribute data for use by amateur and professional astronomers in their day-to-day work discovering and understanding the universe. If you have studied not only the tools and techniques for acquiring data but also the science behind the objects you are studying, you are considered a citizen scientist. A citizen scientist in the astronomical field has a unique opportunity because astronomy is a wholly observational science. The objects that make up the bulk of the observable universe are open and available for anyone and everyone to study. Very few areas in science are based on observations alone; most other scientific endeavors deal with materials and processes that are directly manipulated here on Earth—not so with the heavenly bodies. (Only in the past few decades have scientists on Earth been able to touch a very small sampling of the material that makes up objects outside the Earth's atmosphere.) Because you as a citizen scientist have access to the very same objects the professionals study, you too can contribute. Consider the amateur astronomers in the past who contributed fundamental knowledge to the science. Typically, these amateurs were very wealthy and had the disposable income and the drive and desire to observe the heavens. That same drive and desire, coupled with the affordable, high-quality equipment available to today's large population of amateur astronomers, makes this a great time to be a citizen scientist.

Consider professional astronomers—they have access to the best equipment in the world…but not every day, nor when they want it necessarily. Amateurs, on the other hand, do not have the best equipment (although it is getting better all the time)…but they own their own equipment, operate it as they see fit, and can choose any object they want to study at any time (within observational constraints of course). This is a distinct advantage when observing emergent astronomical events. It is also an advantage in that you can do very thorough and long-term follow-up work on objects that professionals only wish they had the time to do. As the "observatory director," you can make a difference by doing the work that no other professional can do. Once you have the knowledge, skills, tools, and time, you too can be a citizen scientist.

13.2 How Useful Is Your Data?

The data you extract from your images is unique because unless you are making observations as a part of a larger observing campaign on the same object, you are the only one on Earth observing that particular object at that particular time. This alone makes your data valuable and useful to others. If you have made very good measurements and submitted them to a professional body for peer review and acceptance, then your observations are made available to every professional in the world who is interested in that particular object. Your long-term observations provide a history of that object that otherwise would not exist. Your observations also say something about the knowledge, skills, tools, and techniques that you used to acquire the data. This is not only useful, but also essential to establish your credibility as an observer, and as a citizen scientist.

Because you can provide excellent data on objects that are not regularly observed, you help to fill in the gaps for the professionals when they are making hypotheses about how an object was formed or how its lifecycle may change over time. Having a large number of observations of a specific population of a particular object type leads to a better understanding of that object type. A few citizen scientists who have toiled away for years and sometimes decades on a particular object type are providing the most useful data of all. You should strive to become familiar with a wide variety of objects, and image as many as you can. In this way, you can determine what you are truly interested in, and not only provide useful data, but also enjoy yourself immensely in the process.

13.3 Who Can Use Your Data?

As mentioned in the previous section, depending on the quality of your data, advanced amateur and professional astronomers alike are very interested in using your data. The worst thing you can do as a citizen scientist is not share your data with the larger amateur and professional astronomical community. Remember and

respect the work and effort you put forth to design and construct your Astronomical Imaging System (AIS), develop your skills, and increase your knowledge in the operation of your AIS and the techniques of scientific imaging. Couple this effort with the time spent in the wee hours of the morning acquiring images and recording data, analyzing the data, and discovering great things about the universe. Can you imagine after all that effort, taking your data and putting it on a shelf somewhere, where only you know about it, and only you have access to it? It would really be a shame not to get credit for your efforts. It is understandable that you would think that the journey and the personal knowledge obtained was well worth the effort, but you should consider how much more your effort would be worth if you shared your data with the astronomical community. You owe it to yourself to gain the credit and acknowledgment from your peers for the good work and efforts you expend in this endeavour.

Your data is truly more useful than you think at this point. There are too few of us, and too many objects to study to let any of the recorded data from thousands of amateur astronomers go to waste sitting on a shelf or on a hard disk somewhere. Make the effort to learn about the various organizations that will take your data. These amateur and professional organizations are discussed further in Chap. 15.

13.4 Processing Your Data for Multiple Uses and Users

To make your data useful to the most users and for multiple purposes, it is important to use the processing techniques outlined in this book, use professional-level data sources, and store your data in a useful form. There are a few very basic things you can do to make the most use of your data. These are not specific to an object type, software vendor, or any specific component that you may use as part of your AIS. These are common-sense activities that you can easily develop on your own given a few minutes of thought. First, you should use the professional standards and data sources available to the astronomical community when acquiring and storing your data. Standards such as Flexible Image Transport System (FITS), the Landolt Photometric Standard Stars, and professional-level object catalogs such as the US Naval Observatory (USNO) CCD Astrometric Catalog 4 (UCAC4) are examples. You should study and use the techniques for calibrating and measuring your data that the professionals use, as described in this book. Using the standard processing techniques that professionals use leaves no room for questions about how your data was acquired and processed.

Maintain your standards of excellence when acquiring and calibrating your images. If the data does not look good, discard it and try again. All your efforts mean nothing if the results are not up to your standards. Learn your AIS inside and out. Understand its capabilities and limitations. Providing data to your peers, along with some explanation of the limits and boundaries of the data and the equipment used to acquire it, goes a long way toward establishing a good reputation and credibility when someone questions your results. It also enables those who are interested

in your data to understand how useful it may be for their purposes. Being creative in processing your images with new and/or different techniques does not help your case in the scientific realm. This may be a good idea for maximizing the esthetics of those "pretty picture" images, but it is a "no-no" when processing scientific data. The more you can do that is well established and standardized in the professional community, the better off you will be. This alone maximizes the usefulness of your data for multiple purposes and users.

13.5 Data Accuracy and Uncertainty Considerations

Data accuracy and uncertainty are important topics that should not be overlooked when recording and reporting your data. The combined accuracy and precision of your data is really a measure of how certain you are (Fig. 13.1), or to look at it another way, the total error value is a measure of how uncertain you are about the measured value. Nothing is perfect, and so it is with your measurements. It is important to communicate that fact and the magnitude of the uncertainty to those who will use your data in the future. When making measurements, you are providing two things. The first is the value, including the units of measure. The second is the accuracy and precision of those values. Photometric or astrometric measurements such as 13.2 mag or RA 14h24m32.3s are useful values to have, but how accurate are they? How precise are they really?

The following is a quick review of the difference between accuracy and precision. A measured value is considered accurate if, when it is compared with a known good standard value, the measured value closely matches the standard value to a given tolerance or uncertainty. Typically, the tolerance or uncertainty limit is stated as a percentage of the range of the instrument, or a percentage of the value measured. You might find that for a given instrument, the accuracy is stated as the valid range ± 0.1% (of range), for example, 0–100 mVdc ± 0.2% (0.2 mVdc). Therefore, in this case, the instrument was tested, and standard values were input over the 0–100 mVdc range such that output values were expected to be within 0.2% or 0.2 mVdc. For an instrument with a linear response, the standard values selected, called the *cardinal points*, are distributed evenly—typically 0, 25, 50, 75, and 100% values.

Precision, on the other hand, is a measure of the repeatability of an instrument function or the ability of the instrument to respond with the same value every time a given input is received (Fig. 13.2). It is expected that when you input a given value to an instrument, it will give you the correct and same output every time. The correct (accuracy) and the same (precision) output are two sides of the same coin. The inaccuracy of an instrument (for single readings) may be caused by the precision of its output, or it may simply be out of tolerance. The precision of an instrument can only be measured by repeatedly inputting a specific value and determining whether the instrument outputs the same result. For example, you have a charge-coupled device (CCD) camera that you have configured so that a laser is pointed into the

13.5 Data Accuracy and Uncertainty Considerations

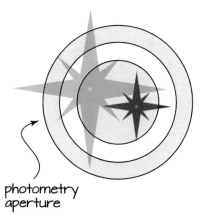

Fig. 13.1 Based on your measurement, how certain are you that you have identified the correct star? Is it the red star or the blue star?

Fig. 13.2 A precise measurement is a very repeatable measurement over several frames for the same object

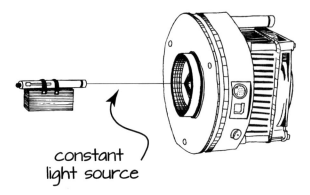

Fig. 13.3 A precise light source illuminates a fixed location on the CCD camera, providing a constant signal level to the pixels (Courtesy of Rachel Konopa)

camera. This is just a hypothetical situation, don't do this with your CCD camera! (Fig. 13.3). The laser is adjusted so that the same amount of energy is deposited on the CCD chip all the time. You take repeated (short) exposures and find that the pixels exposed have the following values: 12332, 12354, 12343, 12133, 12311, and 12345. The average of these values is 12303. The variation of these values around the average is the precision of the value. Usually the variation is measured by taking the standard deviation of the values. In this case, the standard deviation is ±84.6. Therefore, one way to state the precision of this instrument is to calculate the percentage of the reading (12303) that the standard deviation represents and state it as: The precision of this instrument is ±0.69% of reading.

To further illustrate this idea, the laser was set to provide an input that should output a desired value of 12500 from the instrument. The instrument accuracy is ±1.0%. Therefore, the output value should be 12500±125. In this case, the value read out should be in the range 12375–12625. The actual value was 12303. Therefore, the instrument was out of tolerance and not considered accurate in this regard. If the precision was stated as ±1% (or typically, as repeatability), then the instrument was within the specified value. An instrument can be accurate but not precise, precise but not accurate, accurate and precise, or not accurate nor precise. It is important to keep this distinction clear in your head.

In the case of astrometric measurements, you can see that having an accurate reference standard is necessary to measure both the accuracy and the precision of your measurement. If you have made a series of position measurements of a given object and the average is very close to the standard or accepted position (within 0.2 arcseconds (arcsec)), then that is the accuracy. If, on the other hand, the variation of the individual measurements is ±0.7 arcsec, then that is the precision of the measurement. This can be considered (along with the accuracy value measured) as the accuracy of the individual measurements. To make this clearer, the uncertainty of the individual measurement is the combination of the precision of the group of

measurements and the accuracy of the average measurement. The precision of the measurement represents the random uncertainty of the measurement. The accuracy represents the systematic uncertainty of the measurement. A standard way to combine these two values to arrive at an uncertainty value for an individual measurement is to take the "square root of the sum of the squares." The equation is—

$$\text{Individual Uncertainty (IA)} = \sqrt{(\text{precision}^2 + \text{accuracy}^2)} \qquad (13.1)$$

In this case, the individual reading uncertainty would be:

$$\begin{aligned} \text{IA} &= \pm\sqrt{(0.7^2 + 0.2^2)} \\ &= \pm\sqrt{(0.53)} \\ &= \pm\, 0.73 \text{ arcsec} \end{aligned} \qquad (13.2)$$

So, the position in Declination (DEC) for this individual measurement would be stated:

$$\text{DEC} +23°46'21.3'' \pm 0.73''$$

In general, this is a good approach for explaining and stating your measurement errors. If your measurement is a photometric one, then you may state your measurement like this:

$$\text{V-band Magnitude } 12.32 \pm 0.024 \text{ mag}$$

Many software programs provide measurements with uncertainties, so it is vital that you study your program's owner manual to understand how these measurements and uncertainties are calculated (if an explanation is provided, of course). You can contact the vendor for your program and discuss how certain numbers are calculated and provided to you. It is important that you understand the source for any uncertainty value that is provided with the values you are reporting to a professional organization.

13.6 Long-Term Data Storage and Archiving

A primary requirement for making your observations available to the greater astronomical community is storing your raw and processed data, not just your results. Storing your raw data, along with the processed results, allows you to revisit and reprocess your data when you acquire new software or learn new techniques for processing your images. There is probably little risk when sharing your results that anyone will question them. However, it is always a possibility when breaking into a new area of research that some of the results you provide may be a little out of

the ordinary. In that case, it is always good to have the raw data available to reprocess, or even share with an independent observer so that your results can be verified. Raw discovery images of comets and minor planets should always be saved in case a question comes up regarding the accuracy of your astrometry or the date of discovery. Most professional groups that take observations from amateur astronomers have validation programs to help with this process. They usually do not take your data until it has been validated in some way.

Submitting your observations to a professionally recognized organization, such as the International Astronomical Union Minor Planet Center (IAU MPC) or the Association of Lunar and Planetary Observers (ALPO), nearly guarantees that your results will be around for a long time (more than 100 years). The American Association of Variable Star Observers (AAVSO) has observations that were recorded more than 100 years ago.

The observations that you submit become part of the permanent record for the objects that you observed. This takes care of posterity; you just have to store for yourself what you want to keep. For short-term storage (2–5 years, depending on how fast you fill it up), a good solution is a duplicate (backup) hard drive that stores all your data from your observing sessions from your primary hard drive system. One-terabyte (TB) drives, which can be purchased for about $100 or less, provide adequate storage for all your data. Optical disks that store more than 10 gigabytes are expensive. These disks do not provide enough space to efficiently store all your data long term (more than 10 years). It is probably not necessary to store your raw data this long, but if you want to, the most economical way would probably be to purchase a few 1 to 5-TB hard drives in the future and not use them other than for very long-term storage. You would not power these drives up unless you needed to get some specific data from the distant past. The alternative to all this is to use an Internet archiving service that provides the space needed. That may be prohibitive because 10–25 years of subscription fees for a few tens of TBs worth of data would become very expensive.

In addition to storage availability, the ability to transfer data from an existing medium to any new media types becomes a maintenance issue for your data. After accumulating 5–10 years' worth of data, it might be worth the effort to transfer your data to the latest technology. Doing this every 10 years may be the only choice you have.

The computer industry is still working on a long-term (more than 10 years) storage solution for important digital data, so expectations are that within the next few years, a viable solution will present itself. As long as the data you have is stored in very well-documented, well-established standard formats (FITS for example), then the data should be in a usable format for the next 100 years. If you need very long-term storage of more than 100 years, then your only choice is to print the data out. This would of course only apply to your end results and not to any of the raw data or even intermediate processing results. Archival paper and inks are available for use with today's inkjet printers, although not all printers support those inks. However, the hardcopy route may be the best bet for your particular purposes. Unfortunately, long-term data storage for raw data will be an issue for at least the next decade and maybe even longer.

13.7 Innovative Professional Imaging Techniques

Professional astronomers have at their disposal large budgets, engineering staffs, and the best universities in the world working on the latest and greatest technology. Some technology transfer takes place from the professional level down to the amateur level, driven by the rapid pace of electronic technology development. Most important, of course, is the rapid improvement in personal computer systems and software. Today's amateurs have access to technology originally developed for the military and then for commercial and personal use, including image processing, high-resolution measurement systems, robotics technology, CCD cameras, computer numerically controlled (CNC) manufacturing, optical design and manufacturing, just to name a few. The astronomical image processing software available to amateurs today is nothing short of amazing, and coupled with the CCD cameras available today, is the main driver for the professional-level work that amateurs are capable of now.

Image processing techniques and technologies developed over the decades since the 1960s have been finely tuned, and professional and amateur software developers have provided the tools that use these techniques and technologies for observatories all over the world.

13.7.1 Lucky Imaging

Since the 1960s, professionals have used a process called lucky imaging, which is based on the idea that if you took short exposures of objects in the sky, you should be able to "freeze" the atmospheric effects and acquire sharp images (Fig. 13.4). Originally, this hypothesis was not thought to be valid because most astronomers thought that no matter how fast the exposure time, the atmosphere would still smear the image of the object. This was proven untrue when an effect called atmospheric scintillation was discovered. The atmospheric scintillation effect causes the atmosphere to move but also provides moments of perfect clarity that can be captured. In 1966, American astronomer David L. Fried developed a technique called speckle imaging, a fast exposure imaging technique that effectively freezes the atmosphere. Originally, this technique was developed to image double stars to obtain a diffraction-limited view with large telescopes. Lucky imaging is a way for professionals and amateurs alike to obtain diffraction-limited views of objects ranging from double stars to planetary surfaces.

13.7.2 Time Delay and Integration (TDI)

Professionals push the envelope in creating CCD cameras that are capable of the most amazing things. Increasing the sensitivity and other performance factors is always the goal in this regard. Other ways of taking images are always being

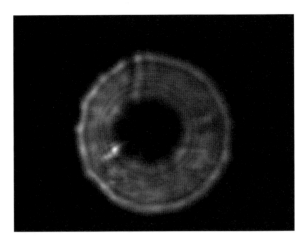

Fig. 13.4 The frozen defocused image of a star in a reflector astrograph taken at 1/60th of a second

investigated to provide a way to compensate for limitations in equipment. A special configuration for the operation of a CCD chip was developed to help in the detection of moving objects that are dim and would not be detectable using a standard CCD configuration. The technique is called time delay and integration (TDI), also known as drift scanning. In this technique, the CCD chip's electronics is designed to transfer charges from one line to the next at the same rate the object is moving. This allows the CCD chip to record data longer for the given object to more readily detect it. Think of it as an internal tracking function built into the CCD camera. Use of drift scanning increases the capacity of a given astrograph mount to track objects more effectively and acquire images of them. A good presentation discussing drift scanning is available on the Internet at:

http://nexsci.caltech.edu/workshop/2005/presentations/Rabinowitz.pdf

The Santa Barbara Instrument Group (SBIG) company makes a CCD camera that is capable of performing TDI and is available to the amateur community. The website www.driftscan.com provides software and other resources used to perform this function, and you may find it useful in learning about TDI and drift scan imaging.

13.8 Innovation Within the Amateur Community

During the first decade of the twenty-first century, there have been many innovations in the processes, software, and equipment amateur's use in making their observations. There are a few notable examples. Primary among them is the use of webcams for planetary imaging and the software to process the resulting video

13.8 Innovation Within the Amateur Community

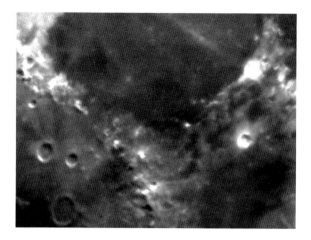

Fig. 13.5 A raw individual astrocam image of the lunar surface taken on April 4, 2009

files. Before the advent of the webcam-based CCD camera, traditional CCD astrocams were used to acquire images individually, and the best ones were selected and saved. Individual frames can provide good detail, but you are at the mercy of the atmosphere when trying to capture the best detail (Fig. 13.5). It is a very time-consuming and tedious process. You cannot capture high-resolution, diffraction-limited images using this process. The process that amateurs use can be considered a version of the lucky imaging process that professional astronomers have used since the 1960s (see Sect. 13.7.1). This method uses software to select, align, and stack the best fraction of the hundreds or thousands of images acquired to minimize the integration of bad images into the result. Most atmospheric effects take place in the 50–1,000 millisecond (ms) timeframe. Exposures faster than 50 ms are used to capture the sharpest images, and the best are selected using measurement techniques developed over the decades that are built into the software used by amateurs today. Until the advent of webcams and digital processing methods, this technology was not available to the amateur.

Another area of innovation in amateur astronomy is the use of high-resolution robotics technology in the design and construction of mounts. Affordable high-resolution stepper motors and their controllers, along with the software used to drive these mounts, have enabled amateurs to point their astrographs more precisely than ever before. Super high-resolution encoders with resolutions of less than 0.2 arcseconds are providing never before realized capabilities to make measurements and control the tracking rates necessary for the long exposures amateurs can take today.

You can innovate and improve the operation of your AIS, and take advantage of the available software and hardware components in several ways. This will add to your capabilities and further increase the quality of your data and the results you obtain with your AIS. The concept of the amateur telescope maker (ATM) has been

around for centuries. Up until the nineteenth century, except at a very few institutions, astronomers had to construct their own equipment. In the twentieth century, telescope making became a robust and vital area of the amateur experience. However, in the 1990s, amateur telescope making took a back seat for the vast majority of people getting into astronomy because a large number of companies were taking over the role of manufacturing equipment and components for the amateur astronomer. In the twenty-first century, a new type of ATM is emerging. These ATMs are more system and component integrators, and electronic hardware and software designers and builders. The concept of designing and building your AIS makes you a modern version of the ATMs who constructed their own tools and equipment in the past. Consider yourself a "digital age" ATM—use the best of the new and old in designing and building your AIS and innovate wherever you can.

Further Reading

Arditti D (2008) Setting-up a small observatory. Springer, New York
Buchheim R (2007) The sky is your laboratory. Springer, Berlin/Heidelberg/New York
Chromey FR (2010) To measure the sky. Cambridge University Press
Covington MA (1999) Astrophotography for the amateur. Cambridge University Press
Dieck RH (2007) Measurement Uncertainty. The Instrumentation, Systems, and Automation Society, Research Triangle Park
Dragesco J (1995) High resolution astrophotography. Cambridge University Press
Dymock R (2010) Asteroids and dwarf planets and how to observe them. Springer, New York
Harrison KM (2011) Astronomical spectroscopy for amateurs. Springer, New York
Warner BD (2006) A practical guide to lightcurve photometry and analysis. Springer, New York

Web Pages

http://nexsci.caltech.edu/workshop/2005/presentations/Rabinowitz.pdf
http://www.driftscan.com/
http://www.explorescientific.com/jerry_hubbell/

Chapter 14

An Introduction to Scientific Image Data Analysis

14.1 Basic Image Feature Analysis

Charge-coupled device (CCD) images, as discussed previously, are made up of pixels, each of which has an 8-bit or 16-bit value associated with it. However, the real question is: what do these values represent in the real world? The values, of course represent the objects you are observing, but you need to understand how these objects are represented on the image. Recall the Airy disk from Chap. 4, Fig. 4.9, which shows how the astrograph resolves a point source of light such as a star. The data along a cross-section of the Airy disk (Fig. 14.1) can be pictured as a bell-shaped, Gaussian curve as a first approximation. Two measurements are associated with this curve, the peak value, and the full width at half maximum (FWHM) discussed in Chap. 4, Sect. 4.7 (Fig. 4.10, point spread function (PSF)). When measuring the position of a star or other "stellar-like" object, how would you go about it? Would you just look for the peak pixel value and use its x, y values for the location?

You will realize that this is problematic after a couple of minutes of thought because the resolution provided by each pixel location is only on the order of 14 arcsec (arcsec) or worse. In addition, you would be relying on only one pixel's worth of data to determine the star's position even though you have a lot of data for that particular object. Because stars are rendered as extended objects on the CCD image, the light gathered over those pixels represents not only the brightness of the object, but also the specific location to a small fraction of a pixel. The center value for a two-dimensional object is found by performing a calculation called the centroid calculation. These values can represent any quantity: weight, brightness, etc. The centroid (Fig. 14.2) of a star's Airy disk profile, as rendered on the CCD image

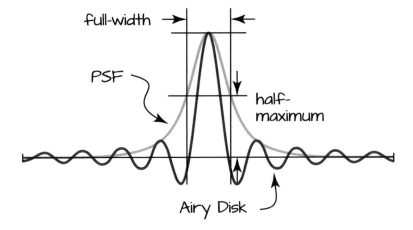

Fig. 14.1 The Airy disk cross section (*red*) is estimated using a Gaussian curve (*blue*) to calculate the full-width-at-half-maximum (FWHM) (Courtesy of Rachel Konopa)

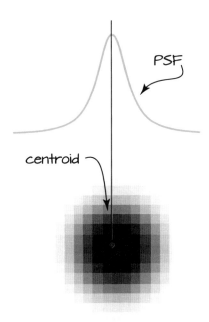

Fig. 14.2 By calculating the centroid of a star's point spread function (PSF) one can measure the star's position to a high degree of accuracy (Courtesy of Rachel Konopa)

14.1 Basic Image Feature Analysis

CENTROID Calculation									
				CCD Pixels					
Σ xi (Pi – S):	11625	1283	1283	1	321	434	343	129	56
Σ (Pi – S):	5130	3832	1916	2	487	721	498	146	64
Centroid x:	2.266	3975	1325	3	340	454	354	132	45
Σ yi (Pi – S):	11895	1980	495	4	132	144	154	34	31
Σ (Pi – S):	5130	555	111	5	22	32	12	29	16
Centroid y:	2.319			y/x	1	2	3	4	5
					1302	1785	1361	470	212
					1302	3570	4083	1880	1060

Fig. 14.3 A spreadsheet showing the results of the centroid calculation on some example data

(PSF) and represented in the two-dimensional data values, can be calculated to within a fraction of a pixel location. This remarkable technique provides a wealth of data that normally would seem to be out of the reach of small astrographs and their owners. It is possible to measure a star's position to within 0.07 arcsec or better with the astrographs that amateurs use today.

Determining the centroid of the image is a simple three-step process. First, you determine the area, usually circular, that encompasses the star. Then the mean pixel value (S) of the area is determined as a value to distinguish the star pixels from the sky pixels. The program uses this value to determine which pixels and x, y location values to use in the calculation. Finally, an equation called the Moment Equation is used to determine the actual x, y location of the centroid. P_i is the pixel value, x_i and y_i are the pixel locations, S is the mean pixel value of the area measured, and x and y are the centroid coordinates:

$$x = \Sigma\, x_i (P_i - S) / \Sigma\, (P_i - S) \tag{14.1}$$

$$y = \Sigma\, y_i (P_i - S) / \Sigma\, (P_i - S) \tag{14.2}$$

Your astrometric software performs this calculation for you and is the key to determining very precise coordinates with an accuracy only limited by the catalog you use for the reference coordinates. Figure 14.3 shows an example spreadsheet of the centroid calculation. The values for the centroid x and y positions are biased toward the pixel location 2, 2 where the peak pixel value of 721 is located. The centroid for this example is located at coordinates 2.266, 2.319. Centroid measurements are a fundamental part of the astrometry process and are influenced by how good your calibration is. Always try to calibrate your images with the best dark and flat frames you can obtain; otherwise, your astrometric positions will be inaccurate.

Another fundamental process used in measuring your images is to create a circular region-of-interest (ROI) around an object such as a star and sum the values of all the pixels located within that ROI to obtain a relative value for brightness. This is the basis for CCD photometry measurements and is called *aperture photometry*. Using an image that has been calibrated with the standard method discussed in Chap. 11, Sect. 11.5, two apertures are created surrounding the star image (Fig. 14.4). They are an annulus around the outside of the star and a circle that encloses the star. The annulus is used to measure the background sky brightness, and the circle is used to measure the star's brightness *and the background sky brightness*. Remember that the star's image not only includes its light, which has traveled hundreds or thousands of light years, but also the sky background caused by local sky conditions. This latter light must be subtracted out to obtain only the star's light measurement.

This process was developed over the past 20 years to obtain the best photometric measurement of the object and the sizing of the central circle and annulus have a major impact on the accuracy of your measurement. The central circle should be sized to have a radius of at least 3.0 times your FWHM value to capture all the light from the star. For normal use, the annulus should be sized to start at 4.0 times the radius and extend out until the annulus area in pixels is equal to the area covered by the central circle, which is about 5.0 times the radius. This size can be adjusted to be smaller if necessary to increase the signal to noise ratio (SNR), but you must adjust the other sizes also. Values of 1.5, 2.0, and 2.5 FWHM can be used for very dim objects. The general sizing parameters for the radii are (Fig. 14.5):

$$\text{Central Circle Radius} = 3.0 \text{ FWHM (pixels)}$$
$$\text{Inner Annulus Radius} = 4.0 \text{ FWHM (pixels)} \quad (14.3)$$
$$\text{Outer Annulus Radius} = 5.0 \text{ FWHM (pixels)}$$

This ensures an equal area for your photometric measurement apertures. As an example, if your measured FWHM is 3.4 arcsec and your image scale is 1.24 pixels per arcsec, then your aperture would be sized:

$$\text{Central Circle Radius} = 3.0 \ (3.4 / 1.24 \text{ pixels})$$
$$= 8.2 \text{ pixels}$$
$$\text{Inner Annulus Radius} = 4.0 \ (3.4 / 1.24 \text{ pixels}) \quad (14.4)$$
$$= 11.0 \text{ pixels}$$
$$\text{Outer Annulus Radius} = 5.0 \ (3.4 / 1.24 \text{ pixels})$$
$$= 13.8 \text{ pixels}$$

When you apply the standard magnitude equation (discussed in more detail in Sect. 14.3) to the sum of the pixel analog-to-digital unit (ADU) values (counts) within the aperture and annulus, you calculate what is known as the Instrumental Magnitude (IM):

14.1 Basic Image Feature Analysis

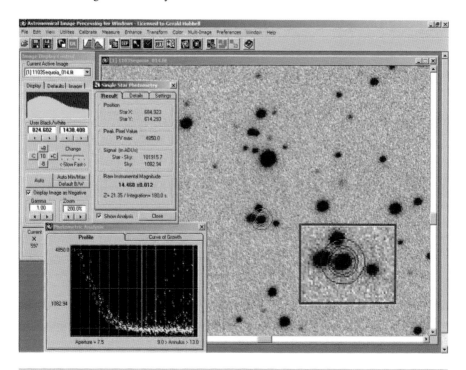

Fig. 14.4 A photometric aperture around the region-of-interest (ROI). The inset shows how the central circular aperture surrounds the star image and the annulus aperture encompasses the background

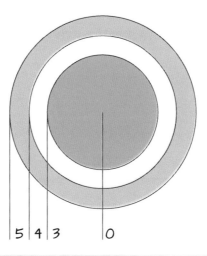

Fig. 14.5 The photometry aperture annulus and center area sizing

$$\text{Given}: \Sigma \text{ Star ADU (Central Circle)} = 1{,}323{,}554$$
$$\Sigma \text{ Background ADU (Annulus)} = 2{,}645 \tag{14.5}$$

$$\begin{aligned}\text{Star Signal ADUs} &= \Sigma \text{ Star ADU} - \Sigma \text{ Background ADU} \\ &= 1{,}323{,}554 - 2{,}645 \\ &= 1{,}320{,}909 \text{ ADU}\end{aligned} \tag{14.6}$$

$$\begin{aligned}\text{IM} &= -2.5 \text{ Log (Star Signal ADU)} \\ &= -2.5 \text{ Log }(1{,}320{,}909) \\ &= -15.302 \text{ mag}\end{aligned} \tag{14.7}$$

This value for IM has not been adjusted for the actual zero point or sky background value. The following can be done as a relative measurement compared with the sky background. This calculation is only meant as a quick way to understand how much brighter the star is than the sky background in terms of magnitude:

$$\text{Given}: \Sigma \text{ Star ADU (Central Circle)} = 1{,}323{,}554$$
$$\Sigma \text{ Background ADU (Annulus)} = 2{,}645 \tag{14.8}$$

$$\begin{aligned}\text{IM} &= -2.5 \text{ Log }(\Sigma \text{ Star ADU} / \Sigma \text{ Background ADU}) \\ &= -2.5 \text{ Log }(1{,}323{,}554 / 2{,}645) \\ &= -2.5 \text{ Log }(500) \\ &\approx -6.7 \text{ mag}\end{aligned} \tag{14.9}$$

This means that the object is about 6.7 magnitudes brighter than the sky background.

Another way to calculate a relative IM is to create an image of an artificial star and include it on the image and use it as a comparison (comp) star. Several image-processing programs can create an artificial star (Fig. 14.6) for inclusion in your images when processing photometric images of variable stars or other objects that vary in brightness over time. MaximDL provides a plug-in that will create the image of a Gaussian-shaped artificial star with a maximum intensity of 65,535.

Other features of your images are measured by your astronomical image processing programs. These include maximum and minimum pixel values, and mean pixel values for a region defined by an ROI with a rectangular or circular aperture. Statistical data for individual pixels and for the whole image are usually provided, including the standard deviation, variance, mean, and SNR. You can measure distances on your images to calculate the sizes of craters or other lunar and planetary features. Displaying and measuring profiles are also possible, and you can use this function to examine the light profile of stars and extended objects such as galaxies, nebulae, and planetary features. Read and understand the image analysis functions that your astronomical image processing program provides; there is a lot of information there for you to use when analyzing your images.

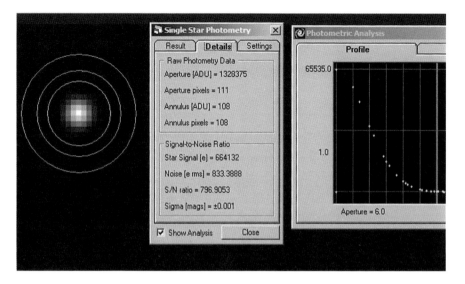

Fig. 14.6 A photometric measurement of an artificial comparison star used as a reference for any differential measurements made for an object star

14.2 Astrometry

Astrometry is the science of measuring the position and movement of astronomical objects. These objects include not only the stars, galaxies, and nebulae, but also solar system objects, including the major and minor planets, comets, and moons. Astrometry also allows you to measure where your astrograph is pointing to a high degree of accuracy to find even those objects that are invisible to the naked eye. Astrometry can be used in several projects, including measuring the position of comets and minor planets, measuring the proper motion of close stars, measuring the parallax of stars, and determining the orbits of minor planets and comets. Determining the plate constants of your images using astrometry programs also allows you to accurately measure the effective focal length of your Astronomical Imaging System (AIS) imaging train.

Astronomical science was founded by early observers who noted the movement of the planets (wanderers) among the "fixed" stars. They were curious, wanted to understand the larger meaning of objects' movements, and so began keeping track of their positions among the stars. The slowly changing view of the stars moving across the sky as the year progressed also caught these early observers' interest. They made measurements of the position and relationship of the stars and created stories and projected figures upon the heavens. The constellations were created, and then tools were produced to help more accurately measure the positions of the planets and stars.

Fig. 14.7 A copperplate engraving of the title page of Johann Bayer's Uranometria star atlas published in 1603 (Courtesy of the US Naval Observatory (USNO) Library, public domain image)

By Hipparchos' time (about 150 BC), there was detailed position information on at least 850 stars and measurements of the planetary movement among them. Star catalogs were created, and observations were added over the centuries until 1603, when Johann Bayer produced the star atlas Uranometria (Fig. 14.7). A literal translation of the title is "measuring the sky." This atlas has some very advanced features for its time. The source of the data was Tycho Brahe's list of more than 1,000 stars. Each of the atlas' 51 plates includes a grid to read the position of each star to a fraction of a degree. In addition, included in the atlas are detailed drawings depicting each of the constellations (Fig. 14.8).

Modern stellar catalogs include data on magnitude in various pass-bands, position uncertainty of less than ±0.05 arcsec (or ±50 milli-arcseconds (mas)), proper motion data, and other data on literally hundreds of millions of stars. All of this object data is used to accurately chart the position of these stars and to measure the position of the various solar system objects that you can image.

14.2.1 Software and Reference Data

Modern technology has enabled you, the amateur astronomer and citizen scientist, to acquire data and make measurements that are on a professional level even with the smaller astrographs that you typically use. Modern software can do wonders in

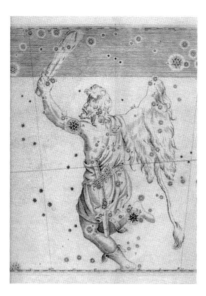

Fig. 14.8 A copperplate engraving of the Orion constellation chart page of Johann Bayer's Uranometria star atlas published in 1603 (Courtesy of the US Naval Observatory Library, public domain image)

processing and analyzing your images and making measurements of the objects you want to observe and track. Table 14.1 lists the applications available for you to use. All but one of these applications must be purchased, and some are quite expensive. All of them can use the modern professional-level catalogs listed in Table 14.2, and a few supply them with the program. Appendix 5 contains a list of astrometric and other types of software that are available to you for integration into your AIS. Of special note is Astrometry.net (Fig. 14.9).

This website and service is an astrometry engine that allows you to submit practically any image with minimal information (you must know the image scale or field of view (FOV)), and it will perform a blind solve and return the plate center coordinates and other information. It will also return the World Coordinate System (WCS) constants for the image in a Flexible Image Transport System (FITS) header file, and an updated image file with the FITS header updated with the WCS information. This service can be used as a quick way to synchronize your planetarium program using the coordinates returned for the image…that is if you have access to the Internet from your observatory location.

Search the Internet for information on each of these applications and catalogs. There is a wealth of information on each, and a dedicated website devoted to each application provided by the respective companies. Search the various astronomy forums for user feedback on each of these applications. You will find that the makers of these applications are generally available through these online forums and via their websites or email.

Table 14.1 Available astrometric analysis applications

Astrometric analysis programs

Program	Distributor	Cost	Experience level
AIP4Win 2.4.2	Willmann-Bell, Inc.	$100	Beginner to intermediate
MaximDL 5.15+ DC3 PinPoint	Diffraction Limited, Inc., DC3, Inc.	$200–$670	Expert
MPO Canopus 10.3.0.0	BDW Publishing, Inc.	$65	Expert
Astrometrica 4.6	Herbert Raab	$35	Beginner to intermediate
Astrometry.net	University of Toronto and New York University	Free	Beginner

Table 14.2 Listing of recommended astrometric catalogs

Astrometric catalogs

Catalog	Source	Number of objects	Limit, accuracy
Tycho-2	USNO and Copenhagen University	2.5 million	V=11.5, 10–100 mas
HIPPARCOS	European Space Agency	118,218	V=7.3, 3 mas
UCAC 3	USNO	>101,000,000	V=16, 20–70 mas
USNO B1.0	USNO	1,042,618,261	V=17, 200 mas

The catalogs listed in Table 14.2 contain a very diverse set of data. The most useful catalog at this time is the USNO UCAC3 catalog. It contains enough stars to get a very good astrometry result even with images as small as 10 × 15 arcminutes, but without being too large for local storage on your computer. The Astrometry.net (www.astrometry.net) website is the easiest and quickest to use, plus it is free, which is always a nice bonus. You can get started with Astrometry.net to learn about the WCS coordinates and how astrometry results look for your images before considering purchasing any of the other programs.

14.2.2 The Plate Solving Process

If you are familiar with creating flowcharts or drawings using graphic primitives such as lines, rectangles, circles, ovals, and polygons in Microsoft Paint or other photo processing programs, then you already know the basis for plate solving an image. Consider the actions that you can perform using a basic electronic drawing program. You can create a rectangle and adjust its properties. You can enlarge (scale) it and shrink it, and rotate it clockwise or counterclockwise to any angle you please (Fig. 14.10). Consider taking an astrophotograph and pasting it into one

14.2 Astrometry

Fig. 14.9 The Astrometry.net website

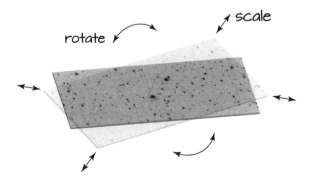

Fig. 14.10 An image can be rotated and scaled as desired (Courtesy of Rachel Konopa)

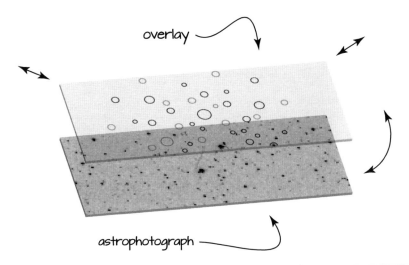

Fig. 14.11 The catalog of reference star positions can be plotted, rotated, and scaled to fit the astrophotograph precisely for use in measuring the positions of objects in the image (Courtesy of Rachel Konopa)

rectangle in your graphics program and then overlaying that rectangle with another that contain circles that represent the coordinates of the reference catalog stars (Fig. 14.11). The manual positioning of the second rectangle by rotating, flipping horizontally or vertically, and sizing allows you to align the circles of the reference catalog over each of the stars in the astrophotograph. This is the basic process used to calculate the plate constants for your images.

Two basic equations describe the relationship between the plate coordinates of your image and the standard coordinates of the reference catalog. These two equations are used to scale the image using the focal length of your astrograph so that the two coordinate systems are exactly aligned (X and Y are standard coordinates, x, y are measured coordinates, and F is the focal length):

$$X = x/F \qquad (14.10)$$

$$Y = y/F \qquad (14.11)$$

Because the coordinates are never aligned exactly, and there are always rotation and offset differences, the equations are more complex and take into account those factors (X, Y are standard coordinates, and x, y are measured coordinates, F is the focal length, r is the rotation angle). This is a simple linear relationship:

$$X = x(\cos(\rho)/F) - y(\sin(\rho)/F) - x_{\text{offset}}/F \qquad (14.12)$$

$$Y = x(\sin(\rho)/F) - y(\cos(\rho)/F) - y_{\text{offset}}/F \qquad (14.13)$$

14.2 Astrometry

To simplify the transformation of the coordinates between the two systems, a general linear form of these equations is used, and the resultant terms are called the plate constants. Equations 14.12 and 14.13 are re-formed as:

$$X = ax + by + c \tag{14.14}$$

$$Y = dx + ey + f \tag{14.15}$$

The values for X and Y, and x and y come from the catalog and measured values, respectively. Three star positions are used to solve for the three unknowns on each axis. These three positions are selected by you, and the measured and catalog (known) values are used to calculate the three (unknown) plate constants for each axis. Your astrometry application uses standard algebraic methods to solve the three simultaneous equations for each axis using the values from the three stars. The values for a, b, c, d, e, and f are the defined plate constants and are *not* stored with the processed image in the FITS header. Instead, the plate constants are transformed and stored as WCS constants in the FITS header. Here is an example of the FITS header entries for the WCS constants for an image:

```
CTYPE1    ='RA---TAN'/X-axis coordinate type
CRVAL1    =2.87928194151E+002/X-axis coordinate value
CRPIX1    =1.67400000000E+003/X-axis reference pixel
CDELT1    =-3.25540408821E-004/[deg/pixel] X-axis plate scale
CROTA1    =2.39430308680E-001/[deg] Roll angle wrt X-axis
CTYPE2    ='DEC--TAN'/Y-axis coordinate type
CRVAL2    =3.42174378025E+001/Y-axis coordinate value
CRPIX2    =1.24800000000E+003/Y-axis reference pixel
CDELT2    =-3.25570619333E-004/[deg/pixel] Y-Axis Plate scale
CROTA2    =2.39430308680E-001/[deg] Roll angle wrt Y-axis
CD1_1     =-3.25537566407E-004/Change in RA---TAN along X-Axis
CD1_2     =1.36050591635E-006/Change in RA---TAN along Y-Axis
CD2_1     =-1.36037967160E-006/Change in DEC--TAN along X-Axis
CD2_2     =-3.25567776656E-004/Change in DEC--TAN along Y-Axis
```

The WCS constants include the center coordinates, rotation, and the change in axis and scale. This is all that is needed by your astrometry program to calculate the standard coordinates for any object on your image.

14.2.3 Practical Considerations and Typical Results: (1103) Sequoia

There are practical considerations when acquiring images on which you are going to perform astrometric measurements. If the object of your observation is a moving

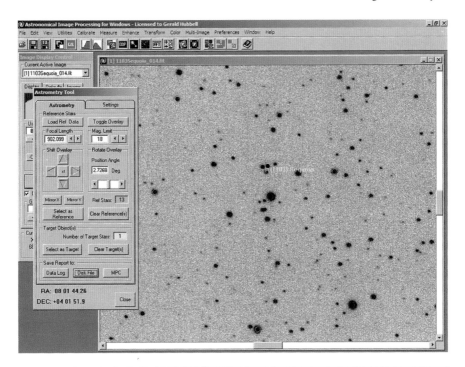

Fig. 14.12 An astrometric analysis of minor planet (1103) Sequoia using AIP4Win and the UCAC 2 astrometric catalog

object, then it is even more essential that you provide accurate timing of the image. Usually a Global Positioning System (GPS) receiver is used to provide an accurate time signal for time-stamping your image. It is very important that the midpoint time of your image be accurately recorded (by your image acquisition program) to within ±0.5 s. Any reports you make to a professional data archive group require that level of accuracy. In addition, for accurate moving object position measurement, the total exposure time must not be so long that it causes the object to trail appreciably. Although this makes it difficult to accurately measure the true position of the object at the midpoint time of exposure, there may be capabilities built into your astrometric program that make it is possible to measure the trailed object via an oval measuring aperture versus a circular aperture.

To obtain accurate position measurements, the image should, at a minimum, be dark field subtracted as a calibration step. A flat field should also be applied to calculate the most accurate center position of the object. In addition, capturing a larger FOV in your image provides the best chance to use the most reference objects available from the reference catalog for measuring your image. When you use your astrometry program (Fig. 14.12) to analyze an image, it typically provides a report that details the selected reference objects and the image objects.

14.2 Astrometry

The position of these objects is listed, and the astrometric center of the image is calculated; the focal length of the AIS imaging train that acquired the image is also included. The following is a typical report using AIP4Win and the UCAC2 catalog for minor planet (1103) Sequoia:

```
Astronomical Image Processing Astrometry Tool
  AIP4Win Licensed to: Gerald Hubbell
    AIP4Win version: 2.4.2
 Folder containing image: E:\Astrophotos\08Jan2010
    Astrometric Image: 1103Sequoia_014.fit
    Target object(s): (1103) Sequoia
UT date of obs, YYYY MM DD: 2010-01-09
 UT time of obs, HH MM SS: 05:52:09.000
    X pixel size [mm]: 0.0047
    Y pixel size [mm]: 0.0047

REFERENCE STARS
  USNO CCD Astrometric Catalog (UCAC2)
  Proper motion applied to UCAC2 coordinates.
  Coordinate epoch: 2000.0
Ref      RAS       DEC     Mcat |   X       Y     Mpho   RArms   DErms
#    hh mm ss.sss +dd mm ss.ss  |pixels  pixels          arcsec  arcsec
R1  08 01 52.13 +03 57 40.0 14.67 |562.631 652.981 12.34 -0.123 +0.015
R2  08 01 59.79 +04 04 24.0 13.95 |472.941 268.344 11.48 -0.006 -0.003
R3  08 01 32.93 +04 01 43.6 12.88 |843.780 436.839 10.44 -0.062 +0.015
R4  08 01 44.71 +03 55 09.1 11.83 |660.534 799.800 09.56 -0.367 +0.024
R5  08 02 15.93 +04 02 44.9 12.03 |240.912 351.044 09.79 -0.012 +0.055
R6  08 01 53.75 +04 07 38.7 14.37 |566.612 089.517 11.94 -0.060 -0.142
R7  08 01 13.88 +04 02 09.5 13.47 |1112.719 425.265 11.17 +0.233 -0.027
R8  08 02 04.12 +03 55 35.3 14.34 |388.463 762.269 11.99 -0.234 -0.030
R9  08 01 42.63 +04 03 55.8 13.41 |713.018 306.264 11.26 +0.027 -0.029
R10 08 02 02.92 +04 00 33.7 13.10 |418.648 482.570 10.65 -0.295 +0.057
R11 08 02 02.49 +03 58 14.0 16.13 |417.093 614.329 13.33 +1.088 -0.137
R12 08 01 49.72 +04 05 05.6 14.94 |616.658 236.017 12.41 -0.199 +0.146
R13 08 01 45.09 +04 01 47.1 14.27 |672.711 425.469 11.87 +0.011 +0.054

TARGET OBJECT(S)
Target name     X       Y    Mpho|   RAS       DEC      Mag
or number     pixels  pixels     | hh mm ss.sss +dd mm ss.ss
(1103) Sequoia 684.923 423.630 11.97| 08 01 44.23 +04 01 49.7 14.43

ASTROMETRIC SOLUTION
 Top left pixel: (0, 0)
 Plate center X:  695.50 [pixels]
 Plate center Y:  519.50 [pixels]
```

```
PA of +Y axis:    2.73 [degrees]
Plate center RA: 08 01 43.19
Plate center DEC: +04 00 08.9
Focal length: 902.099
Residual in RA: 000.397 [arcsec rms]
Residual in DEC: 000.085 [arcsec rms]
```

The report also gives you the residual error as the Root Mean Square (RMS) value. This is the combination of all the errors in position in declination (DEC) and right ascension (RA) for each of the objects in quadrature, or the "square root of the sum of the squares" error value. This value is discussed in Chap. 13, Sect. 13.5. The residual error is a good indication of the quality of your astrometric position measurement of the object. In this case, (1103) Sequoia's position was measured as:

$$\begin{aligned} &\text{RA}: \quad 08\text{h}01\text{m}44.23\text{s} \pm 0.397 \text{ arcsec} \\ &\text{DEC}: \quad +04°01'49.7" \pm 0.085 \text{ arcsec} \\ &\text{MAG}: \quad 14.43 \text{ mag} \pm 0.2 \text{ mag} \\ &\text{TIME}: \quad 2010-01-09 \ 05:52:09 \text{ UT} \end{aligned} \quad (14.16)$$

This compares very favorably with the Minor Planet Center (MPC) calculated position at that time using the current orbital elements for (1103) Sequoia. These values are:

$$\begin{aligned} &\text{RA}: \quad 08\text{h}01\text{m}44.20\text{s} \\ &\text{DEC}: \quad +04°01'50" \\ &\text{MAG}: \quad 14.5 \text{ mag} \\ &\text{TIME}: \quad 2010-01-09 \ 05:52:09 \text{ UT} \end{aligned} \quad (14.17)$$

The difference in RA in arcsec is 15(44.23–44.20), or +0.45 arcsec, and in DEC it is 01'49.7"–01'50.0", or –0.3 arcsec. The RA is off by 0.03 s in time, and at an image scale of 1.06 arcsec per pixel, the DEC is off by about 0.32 pixels. A similar measurement (Fig. 14.13) using Astrometrica and the UCAC3 catalog results in a measurement as follows. In this case, 156 stars were used in the measurements:

$$\begin{aligned} &\text{RA}: \quad 08\text{h}01\text{m}44.23\text{s} \pm 0.17 \text{ arcsec} \\ &\text{DEC}: \quad +04°01'49.5" \pm 0.13 \text{ arcsec} \\ &\text{MAG}: \quad 14.47 \text{ mag} \pm 0.15 \text{ mag} \\ &\text{TIME}: \quad 2010-01-09 \ 05:52:09 \text{ UT} \end{aligned} \quad (14.18)$$

Again, the result is very close to that expected based on the values provided by the MPC.

14.3 Photometry

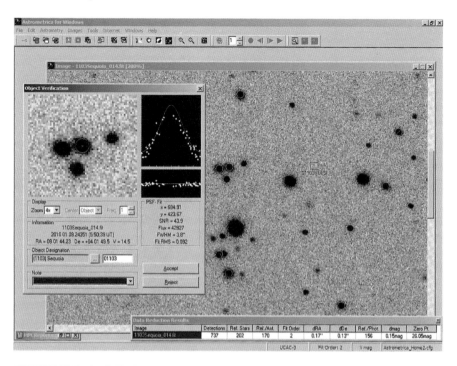

Fig. 14.13 An astrometric and photometric analysis of minor planet (1103) Sequoia using Astrometrica and the UCAC 3 astrometric catalog

14.3 Photometry

Photometry is the science of measuring the brightness of celestial objects, mainly stars and other un-resolvable "stellar-like" objects such as minor planets and the moons of major planets. Photometric measurements are the relative measurements of the flux, or intensity, of an astronomical object's electromagnetic radiation. The flux measurements are taken for various wavelength pass-bands using filters. The measurement is a relative measurement, not an absolute one in that you compare an unknown object's brightness value with a known brightness value or values for catalog objects. This is known as a differential measurement—you only care about the difference between a reference star or group of reference stars and the object you are studying. These are sometimes referred to as V-C measurements, or Variable object minus Comparison star measurements. Comparison stars are stars used as references that are assumed not to change during the observation period. It is important to ensure that your comparison stars are non-variable. Amateurs have actually discovered new variable stars while using them as comparison stars for other "known" variable star observations.

Photometric measurements of stars and solar system objects are almost as old as astronomy itself. After astrometry, photometry was the next great measurement science. As mentioned in Chap. 4, Hipparchos was very much involved in that he created the first photometric measurement scale. So that he could start comparing the brightness of various stars, he created the first magnitude scale for star brightness. He binned stars into six classes or magnitudes from 1 to 6. He cataloged more than 850 stars in about 150 BC and recorded their relative position and brightness. For these measurements, he, of course, used his naked eye, sensitive in the 4,000–7,000 Å (visual) range.

As discussed in Chap. 4, Sect. 4.2, in 1856, Norman Pogson, an English astronomer, noted that the brightness ratio between magnitudes 1 and 5 was equal to 100 on a linear scale. He formulated the relationship between the linear brightness of a stellar object and its magnitude as: 1 magnitude difference is equal to the fifth root of 100, or $100^{1/5}$, or 2.512. Therefore, each magnitude is 2.512 times brighter or dimmer than the next one. The magnitude scale is an exponential function, so it is expressed on a logarithmic scale. The relative magnitude is calculated and more formally stated as:

$$\text{Differential Magnitude } (\Delta \text{ mag}) = -x \text{ Log (Brightness Ratio)} \quad (14.19)$$

The x value is negative because the magnitude scale is an inverse scale. What this means is that the brighter magnitude values are less than the dimmer magnitude values. Therefore, for the observation that Pogson made, 5 magnitudes is equal to a 100 brightness ratio:

$$\begin{aligned} 5 \text{ mag} &= -x \text{ Log}(100/1) \\ 5 \text{ mag} &= -x \, (2) \\ 5/2 &= -x \\ x &= -2.5 \end{aligned} \quad (14.20)$$

This results in the following general magnitude equation for brightness ratios measured and compared from your data:

$$\Delta \text{ mag} = -2.5 \text{ Log (Object / Ref)} \quad (14.21)$$

As a reminder, note that this value of 2.5 is not the same as the 2.512 brightness change for each magnitude. This value is the relationship between the log of the brightness ratio and the magnitude change; in other words, a log change of 2 is equal to a 5 magnitude change.

Modern photometry was developed during the twentieth century and is based on an instrument response to light. Photometric systems were developed starting in the 1950s to provide a standard measurement system with which to compare measurements made by a diverse community of instruments and astrographs. The first standard was developed in 1953 by Johnson and Morgan using a set of filters and a photoelectric photometer based on the RCA IP21 photomultiplier tube detector. The combination of the ultraviolet, blue, and visual (UBV) band filters with the response of the IP21 photomultiplier tube, created the first photometric standard.

Later on in the 1970s, astronomer Alan Cousins performed work in the red and infrared bands, creating the RcIc photometric standards. The UBV standard was combined with the RcIc standard to create the UBVRcIc standard. Today, the standard is available and in use by professional and amateur observers around the world who use a set of filters that are independent of the measuring instruments. Photometric photometers based on a solid-state PIN diode are also available to the amateur astronomer. These photometers are single-channel instruments similar to the old instruments based on the RCA IP21 photomultiplier tube. In 1992, astronomer Arlo Landolt published a list of photometric standard stars and their measured brightness in each of the UBVRcIc bands. These are available to anyone who needs a high-quality list of standard reference stars to calibrate his or her photometric instruments. These stars are distributed along the celestial equator throughout the year so they are available when making observations at any time.

Today, amateurs and professionals alike use the CCD as a high-throughput multi-channel photometer. Using calibrated images and other techniques for high-resolution brightness measurements, amateurs are taking measurements of exoplanet transits, some of which require a precision of less than 0.005 magnitudes. This is the pinnacle of photometric measurements for those who want to do the best science.

14.3.1 Software and Reference Data

The first four software programs listed in Table 14.1 also provide very good tools for performing photometric measurements. These programs use the methodology or slight variations of the methodology discussed in Sect. 14.1 to measure the relative brightness of objects in your images. There is also a very nice photometric measurement program available at no charge called the Aperture Photometry Tool (APT). This application was written by scientists at the Infrared Processing and Analysis Center (IPAC) on behalf of the National Aeronautics and Space Administration (NASA). Their goal was to create software for educational purposes that provide professional-level capabilities and functionality for use in the classroom. This software is available at aperturephotometry.org.

The catalogs listed in Table 14.2 are good general-use catalogs for photometric references. If you want to make high-precision differential measurements, then the USNO UCAC3 or UCAC4 catalog is the best overall choice if you have a wide range of objects you want to measure. If you want to do absolute or all-sky photometry, then you must use the Landolt Standard Stars. These stars are fully documented in the research paper submitted by Arlo Landolt to the *Astronomical Journal of the American Astronomical Society*. You can search the Internet for the title of the paper "UBVRI Photometric Standard Stars Around the Celestial Equator: Updates and Additions," dated April 2, 2009. Other websites on the Internet give you quick access to the various fields where these standard stars are located; make sure you search for these sites.

14.3.2 Relative and Differential Photometry

Several measurements are used when conducting photometric analysis of the objects in your images. It can become quite confusing sometimes. Remember that the fundamental photometric measurement is a relative measurement comparing an unknown object's brightness to a known object's brightness. As discussed briefly in Sect. 14.3, the object under study is referred to as the V, or variable (var) object, and the known object is referred to as the C, or comparison (comp) object. A third object is referred to as the K, or check object. The K is used to verify the non-variance of the C. The other very important feature of the measurement is that you must use a photometric filter to ensure that you are acquiring data that matches your reference catalog values. A V-band photometric filter ensures that when you use the comparison star's V-magnitude, it is valid for your data.

Differential magnitudes are calculated using the measured values for the V object and the C object. As outlined in Sect. 14.1, one way to do this is to calculate the instrumental magnitudes of each object (V and C) and then subtract the C from the V:

$$\Delta \text{ mag} = -2.5 \text{ Log (V ADU)} + 2.5 \text{ Log (C ADU)} \quad (14.22)$$

You can also perform the differential calculation directly:

$$\Delta \text{ mag} = -2.5 \text{ Log (V ADU / C ADU)} \quad (14.23)$$

To calculate the relative magnitude of the V object, it is a simple matter of adding the differential magnitude (D mag) to the catalog magnitude of the C object. The relative magnitude is used when reporting your observations to professional groups for use by the amateur and professional communities:

$$\text{Relative Magnitude (RM)} = \Delta \text{ mag} + \text{C mag} \quad (14.24)$$

As discussed in Chap. 11, Sect. 11.5, the differential magnitude is the magnitude value for an object as calculated from the magnitude of the stars in the FOV of the object being measured. Chapter 6, Sect. 6.2.1, also gives an example of a simple differential magnitude measurement and calculation.

One way to calculate the uncertainty of your photometric measurement is to use the "square root of the sum of the squares" of the V measurement and the C measurement SNR. This is a one sigma (1σ) uncertainty value. What that means is that if you were to make the V and C measurement tens or hundreds of times, the value you would obtain should fall within the uncertainty range 67% of the time. Therefore, if you measure your V star D mag as 1.432 and the uncertainty is ±0.01 mag, then 67% of the time you can expect the value measured to be between 1.422 and 1.442. This is a statistical measurement. A two sigma (2σ) value is equal to 95%, and a three sigma (3σ) value is equal to 99.7%. Usually one sigma values are used when reporting your uncertainty values. Your photometry program should give you the values for your V and C SNR. The equation for the uncertainty of the measurement is:

$$\text{Uncertainty} \left(1\sigma\right) \text{mag} = \pm \sqrt{\left(1/V_{\text{SNR}}\right)^2 + \left(1/C_{\text{SNR}}\right)^2} \text{ mag} \quad (14.25)$$

As an example, if your V SNR is 218.5 and your C SNR is 83.55, then the Uncertainty of your measurement is:

$$\begin{aligned}
\text{Uncertainty}\,(1\sigma)\,\text{mag} &= \pm\ \sqrt{(1/218.5)^2 + (1/83.55)^2} \\
&= \pm\ \sqrt{(0.004577)^2 + (0.011969)^2} \\
&= \pm\ \sqrt{0.000020946 + 0.000143254} \\
&= \pm\ \sqrt{0.0001641999} \\
&= \pm\ 0.01281\ \text{mag}
\end{aligned} \quad (14.26)$$

Several sources on the Internet show you how the uncertainty calculation is derived from the CCD equation. An excellent start is at the AAVSO website. The CCD Photometry handbook is available at www.aavso.org/sites/default/files/CCD_Manual_2011_revised.pdf. This handbook has a wealth of tips and details that are only touched on here.

14.3.3 Absolute Photometry

Absolute photometry is the photometric measurement of objects that are referenced to the absolute standards as defined in the papers by Arlo Landolt and discussed in Sect. 14.3.1. There are additional challenges when performing absolute photometry—or as it is also known—all-sky photometry. Two additional steps are needed when doing all-sky photometry. First, you must calibrate your imaging train using the Landolt standard stars. These are usually located in a different FOV from your object under study or V object. The other challenge is that you have to calculate the extinction factor caused by atmospheric extinction in the wavelength pass-bands you are using. Think of the extinction factor as the amount of light from your object that the atmosphere absorbs given the amount of atmosphere the light is passing through.

Consider the shape and form of the atmosphere (Fig. 14.14). It can be characterized as a series of layers stacked one upon the next, with each layer absorbing the light. The angle at which the light passes through the atmosphere is called the zenith angle and is equal to 0° at zenith, all the way up to 90° at the horizon in the altitude axis. The distance from the observer through the atmosphere at a given zenith angle is called the airmass. The airmass value at a 0° zenith angle is equal to 1.000. As you increase the angle, the airmass value increases as a function of the secant of the angle α (1/cos α) as a first approximation, which is good to a maximum zenith angle of about 60° (30° above the horizon). More precise equations are available for calculating the airmass that take into account the curvature of the Earth. These are available on the Internet and in the book *The Handbook of Astronomical Image Processing* by Richard Berry and James Burnell. Table 14.3 depicts the airmass versus altitude and zenith angle using the simple secant calculation.

Described here is a simple version of all-sky photometry that does not take into account the color correction of your instrument for the differences between the

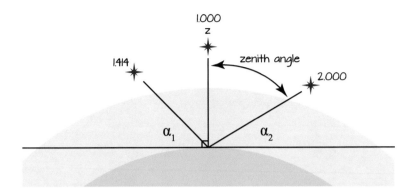

Fig. 14.14 The atmosphere acts as several layers of light-absorbing material each with its own characteristics. The total mass of air that the starlight travels through is called the airmass (Courtesy of Rachel Konopa)

Table 14.3 Airmass for different altitudes and zenith angles

Airmass versus altitude and zenith angle

Zenith angle (degrees)	Altitude (degrees)	Airmass
0	90	1.000
5	85	1.004
10	80	1.015
15	75	1.035
20	70	1.064
25	65	1.103
30	60	1.155
35	55	1.221
40	50	1.305
45	45	1.414
50	40	1.556
55	35	1.743
60	30	2.000
65	25	2.366
70	20	2.924

standard stars and the object under study. The discussion in this section is meant only to get you started doing absolute photometry and is not a comprehensive explanation. Several good books are available that explain all the details needed for the best all-sky photometry. Suffice it to say, this is a beginner's manual and does not intend to teach you all there is to know about this subject. Very few amateur astronomers spend their time doing all-sky photometry. It is a somewhat tedious

14.3 Photometry

process and really requires a permanent observatory setup for your AIS. The information in this section gives you a basic understanding of some of the elements involved in performing all-sky photometry. Having said that, it is a good idea to at least do a simple experiment to measure your V-band extinction coefficient to see how closely it compares with a nominal value presented below.

The way the airmass value is used to calculate the extinction coefficient is very simple. Using a photometric filter, you make a magnitude measurement on a Landolt standard star when the star is located at two different locations with two different airmass values. A good range is to image the star at an airmass of less than 1.05 (zenith angle less than 20°) and an airmass greater than 2.00 (zenith angle greater than 60°). This gives you a good range to calculate the coefficient. The coefficient is the linear value for the slope of the change in magnitude versus the change in airmass. As an example, here are two measurements for a given Landolt standard star:

Zenith angle	Airmass	V mag measured
16.4	1.0424	14.343
62.3	2.1513	14.614

The extinction coefficient is equal to the change in magnitude divided by the change in airmass. Therefore, for the values above, you have the following:

$$\text{Extinction Coefficient (k)} = (14.614 - 14.343) / (2.1513 - 1.0424)$$
$$= 0.271 \text{ mag} / 1.1089 \text{ airmass} \quad (14.27)$$
$$= 0.2444 \text{ mag} / \text{airmass}$$

Once you have the extinction coefficient value, then it is a simple matter to calculate the absolute magnitude of your V object. First, you calculate the differential magnitude, or V-C value, and then calculate the relative value based on the catalog value of the comparison star(s). Finally, calculate the zenith angle at the time of exposure, calculate the airmass value, and then apply that to the calculation of the absolute magnitude, taking into account the extinction coefficient of the Landolt standard star. Apply all these values using the following equations:

$$\text{Zenith Angle} = 90 - \text{Altitude} \quad (14.28)$$

$$\text{Airmass} = 1 / \cos (\text{Zenith Angle}) \quad (14.29)$$

$$\Delta \text{ mag} = -2.5 \text{ Log (V ADU / C ADU)} \quad (14.30)$$

$$\text{Extinction Value} = k \text{ (airmass)} \quad (14.31)$$

$$\text{Extinction Corrected V} = V - \text{Extinction Value} \quad (14.32)$$

$$RM = \Delta \text{ mag} + C_Landolt_mag \qquad (14.33)$$

$$\text{Absolute Mag} = \text{Extinction Corrected RM} \qquad (14.34)$$

Here is an example worked out for you using a Landolt standard star as the C object:

Given:
$$\begin{aligned} C_Landolt_mag &= 14.287 \\ V_Alt &= 36°51'06" \\ C_Landolt_Alt &= 62°08'51" \\ k &= 0.2444 \text{ mag / airmass} \\ V \text{ ADU} &= 2{,}433{,}564 \\ C_Landolt_ADU &= 994{,}831 \end{aligned} \qquad (14.35)$$

1. Calculate the Zenith Angles in decimal degrees for each of the objects (V, C, and C_Landolt):

$$\begin{aligned} V_\text{Zenith Angle} &= 90 - \text{Altitude} \\ &= 90.0000 - (36°51'06") \\ &= 90.0000 - (36.851666) \\ &= 53.148333 \text{ degrees} \end{aligned} \qquad (14.36)$$

$$\begin{aligned} C_Landolt_\text{Zenith Angle} &= 90 - \text{Altitude} \\ &= 90.0000 - (62°08'51") \\ &= 90.0000 - (62.1475) \\ &= 27.8525 \text{ degrees} \end{aligned} \qquad (14.37)$$

2. Calculate the Airmass for each of the objects (V, C, and C_Landolt):

$$\begin{aligned} V_\text{Airmass} &= 1 / \cos(V_\text{Zenith Angle}) \\ &= 1 / \cos(53.148333) \\ &= 1 / 0.59974542 \\ &= 1.667 \end{aligned} \qquad (14.38)$$

$$\begin{aligned} C_Landolt_\text{Airmass} &= 1 / \cos(C_\text{Zenith Angle}) \\ &= 1 / \cos(27.8525) \\ &= 1 / 0.88415326 \\ &= 1.131 \end{aligned} \qquad (14.39)$$

3. Calculate the Extinction Value for each of the Objects (V and C):

$$\begin{aligned} V_\text{Extinction} &= k (V_\text{Airmass}) \text{ mag} \\ &= 0.2444 (1.667) \text{ mag} \\ &= 0.4074 \text{ mag} \end{aligned} \qquad (14.40)$$

$$C_Landolt_Extinction = k\ (C_Landolt_Airmass)\ mag$$
$$= 0.2444\ (1.131)\ mag \qquad (14.41)$$
$$= 0.2764\ mag$$

4. Calculate the Δ mag between V and C_Landolt:

$$\Delta\ mag_C_Landolt = -2.5\ Log\ (V_ADU\ /\ C_Landolt_ADU)$$
$$= -2.5\ Log\ (2{,}433{,}564\ /\ 994{,}831)$$
$$= -2.5\ Log\ (2.446208) \qquad (14.42)$$
$$= -2.5\ (0.388493)$$
$$= -0.9712\ mag$$

5. Calculate the RM of V based on C_Landolt_mag:

$$RM = \Delta\ mag_C_Landolt + C_Landolt_mag$$
$$= -0.9712 + 14.287 \qquad (14.43)$$
$$= 13.316\ mag$$

6. Calculate the Extinction corrected V_RM based on the difference in Extinction between the V and the Landolt object, in this case the C_Landolt object (the V object was dimmer because the Extinction was greater for the V object):

$$V_RM_Corrected = V_RM - (Landolt\ Ext. - V\ Ext.)$$
$$= 13.316 - (0.4074 - 0.2764)$$
$$= 13.316 - (0.131) \qquad (14.44)$$
$$= 13.185\ mag$$

7. Calculate the V object Absolute magnitude:

$$V\ Absolute\ mag = V_RM_Corrected \qquad (14.45)$$
$$= 13.185\ mag$$

Using the previous equations in the sequence shown allows you to calculate the absolute magnitude within a few thousandths of the true magnitude value when using a properly calibrated image as the data source for your input values. Various applications allow you to measure individual objects; these programs do the calculations for you based on your inputs when configuring the program (Fig. 14.15).

14.4 Spectroscopy

Spectroscopy is the third major area of astronomical science, and in some respects, it is the most important and fruitful area of research. That is because compared with astrometry and photometry, spectroscopy allows you to get down into the materials

Fig. 14.15 MaximDL requires a variety of imaging train and astrograph parameters to make astrometric and photometric measurements

that make up these objects and has allowed astronomers in the nineteenth, twentieth, and now the twenty-first centuries to learn the lifecycle of stars and how they behave. It has been estimated that more than 80% of the astronomical discoveries made have been achieved using the spectroscope. For most amateurs today, spectroscopy is a recent addition to the scientific techniques available to learn and discover new things about the stars and planets. Spectroscopes break up light into its constituent wavelengths. This allows you to examine closely the elements that directly make up the stars and other objects you observe. Think of the spectrum of a star as the "barcode" that you can use to identify the type of star and the elements that make up that star (Fig. 14.16).

In the eighteenth century, several scientists, including Thomas Melvill, John Dollond, and William Herschel, worked with light and prisms to understand the properties and the measurement of light. William Hyde Wollaston and Joseph von Fraunhofer were the first to construct a version of the modern spectroscope. The

14.4 Spectroscopy

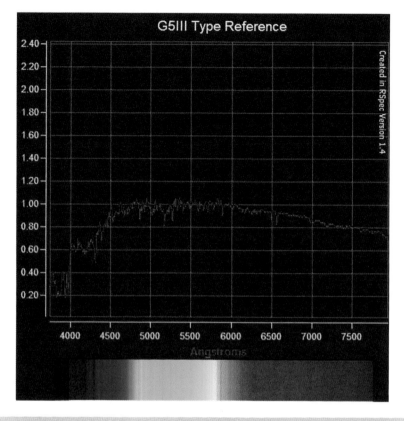

Fig. 14.16 The colorful barcode spectrum of a G5III type star

first recorded observations of bright stars were produced at this time. In the mid-nineteenth century, William Huggins was one of the first amateur astronomers to build and apply the spectroscope in making observations. He observed the heavens for 40 years using his instruments and developed new techniques for calibrating those instruments using a reference spectrum. In 1872, Henry Draper succeeded in taking a photograph of the spectrum of Vega, which showed the hydrogen absorption lines.

In the twentieth century, the professional astronomical community used the better and larger spectroscopes to untangle the mysteries of astrophysics and the lifecycle of the star. Amateur spectroscopy took a hiatus until the 1970s when spectrographic gratings became available to the amateur astronomer. There are a few manufacturers of amateur spectroscopic equipment today, and the future looks bright for this field of research for amateur astronomers.

Two major types of spectroscopic instruments are available to the amateur today: slit spectrographs and spectroscopic gratings (Fig. 14.17). The major provid-

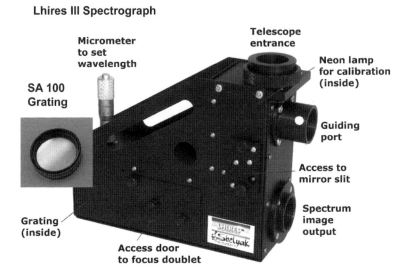

Fig. 14.17 The Shelyak Instruments Lhires III Slit Spectrograph and the Paton Hawksley Star Analyzer 100 (SA100) Spectroscopic Grating (Courtesy of Olivier Thizy, Jerry Hubbell)

ers and models of slit spectrographs are the Baader Instruments Dados, the Santa Barbara Instrument Group DSS7 and SGS, and the Shelyak Instruments Lhires III. Two popular spectrographic gratings are available to the amateur: the Rainbow Optics Spectroscope 200 l/mm (RO200) and the Paton Hawksley Star Analyzer 100 l/mm (SA100). Gratings are a great way to get into using a spectroscope without spending a lot of money. The SA100 is particularly suited for use with the typical small instruments and cameras that most amateurs use today. The difference between the SA100 and the RO200 grating is a result of the dispersion or the length of the spectrum as projected on the CCD. The RO200 stretches the spectrum twice as long as the SA100 and therefore theoretically has twice the resolution. Unfortunately, this is not the reality when put to practice. Because of field curvature and other minor effects, the performance of the RO200 grating is limited to about the same as a 100 l/mm grating. The other problem with the larger dispersion is that it is more difficult to place the zero order star image along with the spectrum on the CCD. The RO200 is more suitable than the SA100 for visual use because the additional dispersion helps in observing the spectrum using an eyepiece.

14.4.1 Software and Reference Data

Considering that the rebirth of the amateur use of spectroscopes is a relatively recent phenomenon, there is quite a bit of information, data, and programs available

14.4 Spectroscopy

on the Internet for your use. Several applications can be used to process your spectrum images, but the two most popular available today are RSpec (www.rspec-astro.com) developed by Tom Field of Field Tested Software, and Visual Spec (www.astrosurf.com/vdesnoux) developed by Valérie Desnoux of the AUDE Association. Both of these applications enable you to process your raw or calibrated spectrum images to obtain a spectroscopically calibrated graphical representation of the star or other object's spectrum.

A large database of reference and observed spectra is available on the Internet, provided by several universities in Europe. This database, called the MILES Stellar Library (miles.iac.es), contains a wealth of data on stars and their spectra. The active amateur spectroscopic community also supports a number of Internet forums. The amateurs and professionals that are members of these forums are available to help and answer your questions.

14.4.2 Spectroscopic Data Acquisition

Acquiring spectroscopic images using your AIS is not that different from obtaining ordinary image data. The normal process used in obtaining accurate data is applicable, including performing a proper polar alignment, acquiring and applying your calibration frames, and storing and archiving your data. The difference occurs in processing the image. When using a spectroscopic grating—one that is mounted in a standard filter holder—the imaging train is configured to provide the proper distance between the grating and the CCD. This is done so that the dispersion value at the CCD does not exceed the resolution of the grating and so that the full spectra fits within the FOV of the CCD, including the zero order image of the star. A raw or calibrated image not only contains the familiar star image, but also the spectrum of the star spread out along the axis of the grating (Fig. 14.18).

The instructions that come with your grating help you understand how to integrate it into your AIS imaging train. There is also a spreadsheet available on the astronomical spectroscopy yahoo user's group forum:

groups.yahoo.com/group/astronomical_spectroscopy/files

This spreadsheet, provided by Ken Harrison, is called TransSpecV2_1.xls and is located in the directory listed above. Tom Field also has provided a simplified spreadsheet called SimpleCalc.xls located in the Yahoo RSpec group files section. These two spreadsheets help you understand the spacing of the grating from your CCD camera and the expected dispersion value. When acquiring your data, it is important to orient your grating to obtain the best data. Rotating the grating so that it is parallel to your camera CCD's long axis helps to obtain the most accurate data. When processing your image, you must orient the spectrum horizontally along the x-axis so that the program can properly calculate the brightness values along the spectrum. If you have not acquired the image with the spectrum parallel to the CCD axis, then you need to rotate the image using the software, and the interpolation of the pixel data that is performed by the software reduces the precision of the

Fig. 14.18 A stack of 55 (monochrome) images showing the zero order star and the raw spectrum of Epsilon Delphinus obtained using the Star Analyzer 100 (SA100)

measurement. To get the best resolution and finest images, use a monochrome CCD camera for acquiring your spectra.

14.4.3 Spectroscopic Analysis

The analysis of the stellar or object spectrum is straightforward. Examine the profile of the stretched out starlight to look for any dips or spikes in the spectrum that indicate individual elemental features. To identify the various features in this profile, you first must calibrate the spectrum (Fig. 14.19). This is very similar to a zero and span calibration because the spectrum is relatively linear over the visual range (4,000–7,000 Å). The zero order of the spectrum is the spike in the profile where the star is located, and you need to be able to identify a prominent Hydrogen Balmer line such as the H_b line at 4861.33 Å. Using these two points, you can calibrate the spectrum and find the value for Angstroms per pixel: In Fig. 14.19, the value for Angstroms per pixel is 9.4.

Once you have determined the spectral scale for your imaging train setup, then you can use this value for any of the spectra you obtain using this setup. The spectrum in Fig. 14.19 has not been normalized to the instrument's response. The normalized spectrum shown in Fig. 14.20 (also Fig. 6.5) has been adjusted to the CCD camera's response curve.

Once you have a calibrated spectrum that has been normalized to the CCD camera's response curve, you can compare the spectrum with a reference spectrum to examine the features that make up that type of star. The spectrum in Fig. 14.19 is

14.4 Spectroscopy 275

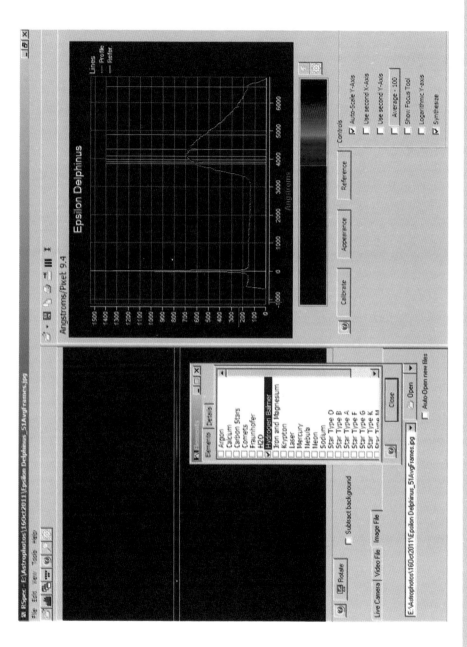

Fig. 14.19 Calibration of the raw image depicted in Fig. 14.18 of Epsilon Delphinus. The image scale of 9.4 Å per pixel is shown at the top

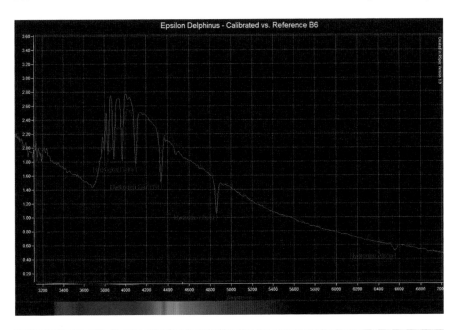

Fig. 14.20 The calibrated and normalized spectrum of Epsilon Delphinus. The spectrum (*red line*) was normalized to the instrument response measured via the SA100 and RSpec software. This spectrum is compared with the reference B6 star type spectrum (*blue line*) in the RSpec application

of Epsilon Delphinus, a Type B star. There is no end to the projects you can do once you have mastered the acquisition of spectra using the simple spectrographic grating. You can examine the features of exotic Wolf-Rayet stars, detect the methane bands in Neptune and Uranus, measure the spectrographic red shift of a quasar (QSO 3C 273), and measure the spectra of supernovae, comets, and minor planets. These projects and others like them can form the basis for a lifetime of imaging and enrich your observing program immensely.

14.5 Planetary Topography and Feature Analysis

Since the beginning of the space age in the late 1950s, a treasure trove of close-up images has been available first to the professionals and then to amateur astronomers. The 1960s was a very active time for lunar imaging, driven by the race to the Moon between the United States of America and the Soviet Union. The first detailed studies of the lunar surface were done to prepare for manned lunar landings. It was important to understand the topography and local features of the lunar surface to properly design the landing vehicles and to understand the possible

mobility issues the astronauts and cosmonauts might face. It was also imperative to be able to select landing sites that would provide the best material to bring back to Earth so that the science would be maximized for each trip to the Moon. In the 1960s, the first lunar and planetary probes, such as Mariner, Surveyor, and the Lunar Orbiter series, enabled us to get the first images of Mercury and the Moon. Earth-based telescopes were also busy acquiring the best lunar images available at that time using film-based cameras and large telescopes and astrographs. The Pic du Midi observatory in the French Pyrenees was very active in gathering this data.

In the 1970s, planetary probes were sent out to Mars, Jupiter, and Saturn. In 1976, the Viking Lander made the first successful observations and measurements from the surface of another planet. The Voyager and Pioneer missions to Jupiter, Saturn, Neptune, and Uranus were very successful in giving us our first look at those gas giants. It is amazing that the technology available to the amateur astronomer today enables you to acquire images that rival those obtained by these space probes of the 1960s and 1970s. This is a testament to the knowledge, skill, and dedication that amateur astronomers exhibit today. It ensures that the data you acquire today is useful in the long-term monitoring and observation of these planetary bodies. Improvements in technology and in the processing of images using innovative techniques will continue to make the amateur astronomer relevant for a long time to come.

Several programs are available to the amateur that use professional-level techniques and data to help understand the physical properties of the landscapes and atmospheres of planetary bodies. A combination of techniques and acquired data help to put together an overall picture of the changing environment around the various planetary bodies. Making yourself aware of what information and data are available is a major step toward being able to find an interesting project or to contribute your insight into a given problem that might lead to a breakthrough in understanding.

14.5.1 Software and Reference Data

Solar, lunar, and planetary imaging are thoroughly discussed in Chaps. 7 and 9. Learning and using the techniques discussed in those chapters and doing the exercises in Chap. 12 that pertain to lunar and planetary imaging are the first step in understanding the capabilities of the software tools that are available for image acquisition. There are other useful and probably indispensible programs that are needed when analyzing those processed images. For lunar work, two really fit that indispensable description. The first is the Virtual Moon Atlas (ap-i.net/avl/en/start). Written by Christian Legrand and Patrick Chevalley, this program provides a very convenient way to locate and understand the basic topographic features on the Moon with detailed ephemeris information about the Moon, including the phase; co-longitude; illumination; libration; rise, transit, and setting times; and other useful information. A detailed description of the various topographic features is also included. The depicted lunar surface provides overlays and clickable close-up

images of the various features described. This excellent electronic atlas provides all the data you need to understand and study any feature you image.

The other program that provides the amateur selenographer with a tool that is truly at the professional level is the Lunar Terminator Visualization Tool (LTVT) (ltvt.wikispaces.com). Written by Jim Mosher and Henrik Bondo, this tool allows you to map your lunar images to a virtual spherical lunar surface. With it, you can make very precise calculations and measurements of the Sun angle, shadow lengths, and other topographic feature interactions with the sunlight. This lets you measure feature heights, angles, and coordinates to a high level of accuracy. A Digital Elevation Map (DEM) is included that allows you to look at the actual elevation of certain features depicted in your images. The LTVT and the Virtual Moon Atlas use data from the various lunar orbiter programs that have been launched since 1960s. Clementine, Lunar Observer, and Lunar Orbiter data is made available with these programs. Studying the lunar surface at such a level of detail allows you to understand the finer points of lunar structure formation. An excellent source of lunar data and information is provided by Chuck Wood, a very famous selenographer who worked for NASA. He has created a website, Lunar Photo of the Day (LPOD) (lpod.wikispaces.com), that includes an enormous amount of data and images and descriptions of features that not only relate the physical description but the specifics of how they were formed. Take advantage of this major resource.

Another website that provides a significant service to the amateur and professional astronomy community and covers all the solar system equally, is CalSky (www.calsky.com). This website was created in 1991 by Arnold Barmettler to offer astronomers a new way to plan their observing sessions. The ephemeris data and the depictions of the planets are very useful tools when comparing the data you acquire with what is expected. This helps you to identify new features or changes in existing features that may constitute a new discovery.

Another interesting, free application is WinJUPOS (jupos.org). This has been a long-term project started by Hans-Jörg Mettig in 1989 as a simple database in which to collect the position of objects in Jupiter's atmosphere. In 1992, Grischa Hahn, another Jupiter observer, joined Hans-Jörg and took over the development of the programs. Eventually, WinJUPOS was created to record the observations and positions of objects on any of the planets in the solar system to keep track and analyze the changes on those planets. On the website, it is described as a "WinJUPOS—Database for object positions on planets and the Sun." This program has many features you can use to record and analyze your images and observations.

14.5.2 Lunar Topographic Analysis

Having the ability to sit back here on the Earth, use instruments to acquire high-resolution lunar images, and then process those images and study them using state-of-the-art technology is one of the most amazing things you can do as an amateur astronomer. Think about it. In the 1960s, governments spent hundreds of millions

14.5 Planetary Topography and Feature Analysis

Fig. 14.21 The lunar crater Gassendi taken on January 7, 2012, using a 0.13-m refractor

of dollars to acquire and study images of the same quality that you can make personally for a one-time investment of only a few thousand dollars and some time to learn the skills. The opportunity for learning and discovery is unprecedented.

Studying the lunar topography using the LTVT is a very interesting experience. This tool helps you learn and understand the various features on the Moon and their relationship with each other. Studying the interaction between the lunar terrain, the shadows, and sunlight gives you an intuitive sense of the features and a sense of being there in orbit around the Moon. Measuring the heights and sizes of features, mountain ranges, crater rims, rilles, and volcanic domes, to name a few, is an exciting endeavour.

For example, the crater Gassendi is a very interesting crater on the edge of Mare Humorum (Fig. 14.21). There is a lot of information about it that you can discover for yourself and compare with the published information. The diameter of the Gassendi image in the figure, measured using the LTVT program, is 110 kilometers (km) (65 miles), and the center is located at 40.03°W and 17.64°S. This compares favorably with the accepted diameter of 114 km (67 miles), and a

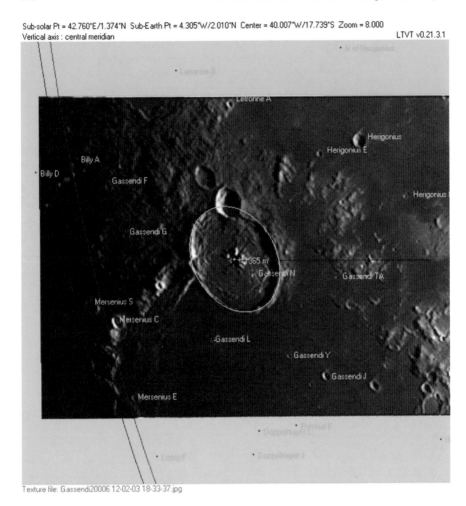

Fig. 14.22 The peak at the center of the crater Gassendi measured using the Lunar Terminator Visualization Tool (LTVT). The measured value is 1,365 meters (m). This image was taken on February 3, 2012, 18:33:37 UT

location of 39.9°W and 17.5°S. The accepted height of the central peaks is 1,200 meters (m); the measured value, as shown in Fig. 14.22, is 1,365 m. You can also compare your own photographs with those taken by the various lunar probes and landers and with the Lunar Aeronautical Charts (LAC) (www.lpi.usra.edu/resources/mapcatalog/LAC).

Rimae Sirsalis is a very prominent feature when compared with the LAC 74 Grimaldi chart (Fig. 14.23). Several features can be compared and contrasted with the chart to learn the resolution limits of your images. The Crater Clavius is the largest crater or more accurately, a walled plain on the near side and is 231 km (136

14.5 Planetary Topography and Feature Analysis

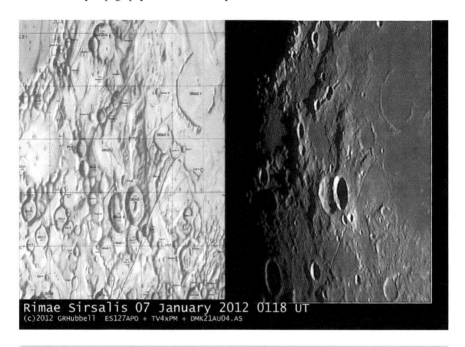

Fig. 14.23 The lunar feature Rimae Sirsalis taken on January 7, 2012, 0118 UT using a 0.13-m refractor and the corresponding Lunar Aeronautical Chart (LAC) LAC 74 Grimaldi

miles) in diameter. Clavius is near the southern limb of the Moon, and mountains near the crater Cabeus are prominent (Fig. 14.24). The high-resolution image in Fig. 14.24 shows what you can achieve with a 5-in. refractor and processing using Registax6.

Studying and learning the location and names of the prominent lunar craters and other features is interesting, and understanding the formation of the Moon and its various features is very rewarding also. The Association of Lunar and Planetary Observers (ALPO) (alpo-astronomy.org) has a wealth of information relating to the topographical study of the Moon and the lunar surface. The website and magazine *Selenology Today* (digilander.libero.it/glrgroup) is a clearinghouse for the current work and research on the topographical study of the Moon and its features. It is presented by the Geologic Lunar Research Group (GLR) (www.glrgroup.eu/old/home.htm), founded by Raffaello Lena and Piergiovanni Salimbeni. You will find that most of the well-known lunar researchers and astrophotographers are members of the GLR. There are some very accomplished lunar astronomers and astrophotographers who are role models for all amateurs who want to image the lunar surface at the highest quality their AIS allows. Chief among them are Chuck Wood, Patrick Moore, Alan Friedman, Damien Peach, Wes Higgins, and Mike Wirths. Search out their work on the Internet, learn from the information posted, learn their techniques, and strive to be the best so that you can discover new things about the lunar surface.

Fig. 14.24 The lunar south polar region featuring the crater Clavius, Moretus, and a mountain near Cabeus called M3 peeking above the lunar horizon

14.5.3 Planetary Feature Analysis

As mentioned in Sect. 14.5.1, WinJUPOS is a very powerful program to study and record the features on the planetary bodies within the solar system. Jupiter (Fig. 14.25) is a very worthwhile object for your study, as are Mars and Saturn. Jupiter has a very complex and interesting atmosphere that is always changing. The Great Red Spot is readily visible, as are the various markings called "Barges," which are long oval structures that take on the shape of sausages floating in Jupiter's atmosphere. By monitoring the motion of these markings, you can measure the rotation rate of Jupiter and how it varies depending on the belt latitude. Venus also makes a very interesting subject for study in following the changing phases as it circles the Sun. Up until the 1980s, it was thought that the cloud features on Venus were not visible and could not be imaged from the Earth, but that all changed once CCD cameras and ultraviolet filters became available. Now it is expected that amateurs can readily image the cloud features on Venus. An interesting project might be to try to follow the movement of any atmospheric

14.5 Planetary Topography and Feature Analysis

Fig. 14.25 The planet Jupiter taken on November 24, 2011, using a 0.13-m refractor

features you can image and determine the rotation rate of Venus—a very tough challenge but doable.

The surface of Mars is also readily observable and can be imaged using various filters. As discussed in Chap. 6, Sect. 6.3, a red filter can enhance the dark features on the surface, and a blue filter can help bring out the atmospheric haze and polar caps. It is easy to monitor the atmospheric dust storms on Mars, which present as a red haze that obscures all the dark markings on the surface. The Sun presents a different challenge when attempting to acquire images of the surface and chromosphere surrounding the Sun. As discussed in Chap. 6, Sect. 6.3, several features can be observed and recorded, such as prominences, filaments, spicules, plages, and solar flares.

There are a few truly expert and world-class planetary astrophotographers; most notable are Donald Parker, Damien Peach, and Christopher Go. They dedicate their time to following the day-to-day changes of Jupiter, Mars, and Saturn. They have recorded thousands of observations and photographs and made them available to the astronomical community. By studying their photographs and methods, you can learn a lot about these planets and their behavior over the years. On the ALPO website, there are several freely available observing forms for each of the solar

system objects so that you can record your observations in a standard format. This will help once you decide whether your data is up to the standards that the ALPO needs so you can submit your observations.

Studying features on the planets can become a life-long pursuit, and if you dedicate your observatory to just these objects, you will be in very good company. If that is your path, then pursue it with the goal to be the best you can be, and enjoy every session.

Further Reading

Arditti D (2008) Setting-up a small observatory. Springer, New York
Berry R, Burnell J (2005) The handbook of astronomical image processing. Willmann-Bell, Richmond
Buchheim R (2007) The sky is your laboratory. Springer, Berlin/Heidelberg/New York
Byrne CJ (2005) Lunar orbiter photographic atlas of the near side of the Moon. Springer, New York
Chromey FR (2010) To measure the sky. Cambridge University Press
Dieck RH (2007) Measurement Uncertainty. The Instrumentation, Systems, and Automation Society, Research Triangle Park
Dymock R (2010) Asteroids and dwarf planets and how to observe them. Springer
Harrison KM (2011) Astronomical spectroscopy for amateurs. Springer
Henden AA, Kaitchuck RH (1990) Astronomical photometry. Willmann-Bell, Richmond
Howell SB (2006) Handbook of CCD astronomy. Cambridge University Press
Shirao M, Wood CA (2010) The Kaguya lunar atlas. Springer, New York
Smith GH, Ceragioli R, Berry R (2012) Telescopes, eyepieces and astrographs. Willmann-Bell
Warner BD (2006) A practical guide to lightcurve photometry and analysis. Springer
Warner BD (2010) The MPO user's guide. BDW Publishing, New York

Web Pages

http://www.astrometry.net/
http://www.aperturephotometry.org/
http://www.aavso.org/sites/default/files/CCD_Manual_2011_revised.pdf
http://www.minorplanetcenter.net/
http://minorplanet.info/
http://www.rspec-astro.com/
http://www.astrosurf.com/vdesnoux/
http://miles.iac.es/
http://groups.yahoo.com/group/astronomical_spectroscopy/files/
http://ltvt.wikispaces.com/
http://www.calsky.com/
http://jupos.org/
http://www.lpi.usra.edu/resources/mapcatalog/LAC/
http://alpo-astronomy.org/
http://digilander.libero.it/glrgroup/
http://www.glrgroup.eu/old/home.htm

Chapter 15

Your Scientific Imaging Program and How to Submit Your Data to Scientific Organizations

15.1 The Modern, State-of-the-Art (Amateur) Observatory

As you have learned from the previous chapters, a modern, state-of-the-art amateur observatory (Fig. 15.1) is more than capable of doing professional-level work and easily allows you to provide professional-level results for submittal to astronomical associations and groups. This submittal process is discussed later in this chapter. As you have also learned, integrating a typical modern amateur telescope with professional-level tools, components, processes, and procedures provides the structure and discipline for turning your personal observations into results that can be shared with the wider professional and amateur astronomical community. Think of your observatory as an integrated system where all the components are there to work toward one goal: obtaining the best images for the given astronomical object you are observing.

Having a modern amateur observatory not only means you have the most up-to-date equipment based on your budget, but also that you integrate, operate, and maintain that equipment using a well-defined and documented process. Your Astronomical Imaging System (AIS) should be well maintained and stored if it is a portable system, and configured for immediate use if it is set up in a permanent observatory. One of the main benefits of a modern amateur observatory is having the ability to set up your AIS, complete your calibrations, and start imaging within an hour (or less with a permanent observatory). Having your AIS components configured and ready to go for a given observing program is an excellent way to minimize the setup time.

Fig. 15.1 A modern, portable, state-of-the-art amateur observatory located in Locust Grove, Virginia (Minor Planet Center observatory code I24)

15.2 Your Science Program Goals

When beginning the initial design of your observing program, you may not really know what you are interested in, or more accurately, you may not know *exactly* what you are interested in and what you want to accomplish. Having a mission statement focuses your program's goals. Such a statement could be: "To acquire excellent minor planet images for precision astrometric and photometric measurements of position and brightness." If you really are just starting out and you do not know what the main goal of your observing program may be, then you should create a mission statement that supports your AIS design as a learning system. This creates an AIS that is more comprehensive in scope, allowing you to more easily figure out what you are interested in because you have a lot of equipment that can do a lot of things. A mission statement such as: "To learn how to acquire excellent images for various astronomical objects and to learn how to perform precision astrometric and photometric measurements of these various astronomical objects" would fit such a situation.

It is up to you, of course, but the better you can focus your observing goals, and mission, the more cost effective and efficient your AIS will be. It may be best to look at the following list of object types and focus on one to begin:

1. Wide Field Long Exposure—Deep Sky Nebulae
2. Narrow Field Long Exposure—Deep Sky Galaxies, Planetary Nebulae
3. Lunar Video—Wide and Narrow Field
4. Planetary Video—Narrow Field
5. Solar Video—Wide and Narrow Field

Table 15.1 is a checklist to help you decide on your observing program and constitutes your Observing Program Design Basis (OPDB). The Value field for each item

15.2 Your Science Program Goals

Table 15.1 Observing Program Design Basis (OPDB) checklist

Optional	Parameter	Value	Limit
No	*1.0 Program name*		NA
No	1.1 Mission statement (linked to science goals)		NA
No	1.2 Program object characteristics		NA
No	1.3 Program goals		
No	*2.0 Measurement performance* (select at least one below, and provide a Value and Limit as required)	NA	NA
Yes []	2.1 Differential photometry		
Yes []	2.2 Relative photometry		
Yes []	2.3 Absolute photometry		
Yes []	2.4 Astrometry residual error		
Yes []	2.5 Time reference error		
Yes []	2.6 Solar system object Rotation rate uncertainty		
Yes []	2.7 Solar system object Orbital parameter uncertainty		
No	*3.0 Program databases* (select at least one below, and provide a Value and Limit as required)	NA	NA
Yes []	3.1 Photometric reference catalog		
Yes []	3.2 Astrometric reference catalog		
Yes []	3.3 Minor planet reference catalog		
Yes []	3.4 Double star reference catalog		
Yes []	3.5 Deep sky object reference catalog		
Yes []	3.6 Lunar reference atlas		
Yes []	3.7 Planetary reference atlas		
No	*4.0 Observing program objects*		
No	*5.0 Observing program operations* (select at least one below, and provide a Value and Limit as required)	NA	NA
Yes []	5.1 Expected observations per week		
Yes []	5.2 Expected observing opportunities per week		
Yes []	5.3 Expected total images acquired per week		
No	*6.0 Weather limits*	NA	NA
No	6.1 Sky conditions (select at least one below, and provide a Value and Limit as required)	NA	NA
Yes []	6.1.1 Cloud cover (percent)		
Yes []	6.1.2 Transparency		
Yes []	6.1.3 Seeing (arcseconds)		
No	6.2 Environmental impact		
Yes []	6.2.1 Temperature		
Yes []	6.2.2 Humidity		
Yes []	6.2.3 Location		

is the goal you wish to reach with your imaging, the Limit is the bounding value that you think that your AIS is capable of. An example of a Value and a Limit for 2.2 Relative Photometry would be 17th magnitude, with an uncertainty or limit of ±0.1 magnitude. The items marked "No" in the Optional column are required, the items marked "Yes" are optional, and NA means Not Applicable.

Once you have solidified your OPDB, then use all the information presented in Chap. 2 through 13 to build your AIS so that it meets the requirements of your OPDB. Take it a subsystem at a time, starting with your CCD camera. Treat that camera as a customer of your astrograph and your mount. Remember that data is king, and your CCD camera is the item that provides that data. Everything about your astrograph and mount should support the data requirements of your observing program.

15.3 A Structured Approach

By using the OPDB, and documenting your science and observing program mission and goals, you are providing a good bit of structure to your efforts. This will focus your work in designing your AIS and selecting the components necessary to acquire the data you need to accomplish your mission. In addition, you will be able to answer the tough questions, such as: Will this component meet my scientific data requirements and budget? Will this component meet the interface requirements for integration into my existing AIS? Build your AIS from the ground up by integrating your components into subsystems and then integrating the subsystem into your AIS. Identify all the interfaces between your components and subsystems so that you can identify problem areas when they occur. Problems usually occur at the component or subsystem interface.

By modularizing your AIS design, you can isolate and test the various parts of your AIS, which helps later on with troubleshooting issues. Link and design your processes based on professional standards, on how your components, and subsystems are designed and how they function and operate. You should be vigilant in identifying problems with your AIS by being particularly sensitive to unexpected results and by trying to isolate the functions that are giving you those problems. You must understand the impacts on your data when problems arise with your AIS.

15.4 Recognizing and Measuring Success

Success in this business can mean many things to many people. One measure of success is demonstrated through the accomplishment of your observing program goals. Having an objective way to measure your success in reaching your goals is vital in a tactical way because you can use your objective measures to identify and resolve issues in the day-to-day operations of your AIS. Success in a more funda-

mental and subjective sense is not so clear and is open to interpretation. For example, if you are accomplishing all your operational goals for each session, but the data you are acquiring does not meet your overall expectations, there may be a design flaw you have not detected previously. You may need to consider whether your OPDB is self consistent or "makes sense" in a common-sense way. Does it have contradictory requirements? Is the level of performance of your design inconsistent across the various subsystems and components? You get the idea.

Sometimes a bad component selection can not only affect the immediate subsystem on which that component is installed, but also the overall performance of your AIS. A mount component design flaw may only reveal itself through the images your take. Issues may be disguised and present themselves as symptoms that will lead you astray. Be aware of these distractions and always search for the fundamental component that is common to any problems that may be occurring. Try not to shortchange your efforts by accepting results that do not seem to be as good as you would have expected based on the level of effort, component performance, and other parameters that would suggest otherwise. Be focused, disciplined, and open to unexpected explanations for problems that may occur.

One of the human performance tools used in the nuclear industry is called STAR: Stop, Think, Act, and Review—it is equally applicable here. This tool is designed to help you become disciplined when performing operations on equipment. Before you do anything with your equipment that is critical (slew to an object, start an imaging run, copy all your images to a backup system), Stop and Think about the action you are about to take. Understand the expected result. Perform the Action. Finally, Review the results of your action and evaluate whether it met your expectations. This human performance tool will help you consistently perform successfully and ensure you are successful in everything you do with your AIS.

15.5 A Disciplined Commitment to Your Program

Having invested hundreds of hours in your training and operations, and thousands perhaps tens of thousands of dollars in your AIS, you naturally have developed a certain level of discipline and commitment. If this becomes more like work than fun, then that is not good. You should enjoy and take pride in the investment in time you have made to understand and operate your AIS to the best of your ability and your equipment's performance. All this leads to a disciplined commitment to your observing program and can lead you to discover many things about the universe that no one else may have discovered. This is the payoff for all your hard work. This is the reason you started down this path.

Try to keep yourself fresh by trying new things—observing new objects and object types. Find ways to reuse and repurpose your data. It is always exciting to discover new things in data you may have taken 2 months or even 2 years ago. Share your results with like-minded astronomers. Share your enthusiasm and

excitement in doing the science your AIS allows you to do. Newcomers need to see that there is more to astronomy than peering through eyepieces at dim, fuzzy objects or bright planets that come along only once a season. Show them the subtle changes that occur every day in these seemingly "unchangeable" objects. Doing this keeps you interested, motivated, and instills in you a deep commitment that will keep you going at 3 a.m. in the dead of winter while sitting in 20° temperatures. You gain an understanding of why you are there and what the potential reward is. Have fun while acquiring the excellent image data that will make a difference to you and hundreds of other amateur and professional astronomers around the world.

15.6 Sharing Your Data

As discussed in Chap. 13, making your data useful to others and sharing it through the various organizations that will take your processed measurements is a very gratifying endeavour. Submitting your data and adding it to the compiled dataset available for amateur and professional use may lead to making great discoveries. Another key reason to share your data is to show others the caliber of work you are capable of—sharing it will establish a high level of credibility. This is especially important when you do make that discovery and you want everyone to know about it. You do not want to be the pitiable observer who always "cries wolf," claiming a discovery without any hard evidence or good data.

Please consider joining one or more of the groups discussed in this chapter and contributing your processed results to them. It would be a shame that the results of all the hard work and time you expend ends up sitting on a hard drive somewhere in the back of a closet, only to be ignobly tossed in the trash heap after 20 years. *Sharing your data is important.* Enough said.

15.7 Data Formatting

The various groups that take your data want it formatted in a very specific way. This is similar to any other standard for data storage, FITS, AVI, TIFF, for example. The only difference here is that for the most part, the data provided to these groups is the end result, or bottom-line data. For example, the Minor Planet Center just wants the facts: some header information and the object designator, date, position, and brightness. Here is a single line for a given object:

01103 C2010 01 28.14265 07 35 33.42 +02 21 11.8 14.6 C XXX

The required format is described in great detail in each group's submittal requirements documentation found on its respective website and is discussed in the following sections.

15.8 Minor Planet Center

The Minor Planet Center (minorplanetcenter.net) is located at the Smithsonian Astrophysical Observatory (SAO) in Cambridge, Massachusetts. The Center operates under the guidance of Division III of the International Astronomical Union (IAU) (iau.org). The Center is responsible for the collection, computation, validation, and dissemination of astrometric data and for the designation of comets, minor planets, and natural satellites. In addition, it is responsible for the calculation of the orbital parameters for these objects.

The Center's website provides several services and documents to support the amateur and professional research of comets, minor planets, and natural satellites. It publishes peer-reviewed observations in a variety of formats, electronic and hardcopy. The Minor Planet Circulars (MPC), also known as Minor Planets and Comets, are generally published near the date of each full Moon. They contain the astrometric observations, orbital parameters, and ephemerides of minor planets and comets. The minor planet observations are summarized by Observatory Code, and the full listing of observations is provided in the MPC Supplement. Publication of these documents began in 1947.

The Minor Planet Circulars Orbit Supplements (MPO) contain the full information about the orbits of newly numbered, linked, and identified minor planets The orbital parameters also include the residual measurement errors. The Minor Planet Electronic Circulars (MPEC) contains information on unusual objects, including Near Earth Objects (NEO) and trans-Neptunian objects. Observations that first appear in the MPECs are finalized and published in the MPCs.

The Center's website provides several services to easily search the various databases for information on a particular object. In addition, a very good overview of how to perform minor planet astrometry and how to submit your observations to qualify for your observatory code is located at:

http://www.minorplanetcenter.net/iau/info/Astrometry.html

15.9 American Association of Variable Star Observers (AAVSO)

The American Association of Variable Star Observers (AAVSO) (aavso.org) was founded in 1911 to gather and coordinate the observation of variable stars. These observations were and are performed principally by amateur astronomers and were initially made for the Harvard College Observatory. AAVSO was incorporated in 1918 as a non-profit and educational organization. The members of AAVSO come from all over the world and include amateur and professional astronomers. The mission of AAVSO is to observe and analyze variable stars, collect and archive observations, create collaboration opportunities between amateurs and professionals, and promote scientific education and study regarding variable stars and the data collected on them.

For more than 100 years, AAVSO has been collecting and storing observations for use around the world. The organization coordinates, evaluates, compiles, processes, publishes, and disseminates variable star observations to the astronomical community. The AAVSO website offers various services, documents, and educational material in the field of visual and instrument variable star observations. AAVSO regularly publishes a peer-reviewed collection of papers on variable star topics in *The Journal of the AAVSO*. It is available in both electronic and hardcopy versions. The quarterly *AAVSO Newsletter* is also available to members.

AAVSO is actively involved with outreach and education activities, including the Carolyn Hurless Online Institute for Continuing Education in Astronomy (CHOICE) program. The CHOICE program is a recent initiative to provide informal, online short courses on topics to help members better contribute to science and accomplish their scientific observing goals. Through contact with Mike Simonsen, Membership Director, and Development Officer, I took part in the pilot CHOICE course on *Developing a Visual Variable Star Observing Program*, first as a student, and subsequently as the online instructor. As of June 2012, the CHOICE program offers several courses of interest that apply directly to using your Astronomical Imaging System (AIS) for observing variable stars: *Variable Star Classification and Light Curves, CCD Image Calibration,* and *Uncertainty about Uncertainty*. These and others will be offered from time to time over the next few years. AAVSO has a companion website specifically geared toward citizen science called the Citizen Sky Project (citizensky.org). It is specifically designed to enlist the help of amateur astronomers in specific scientific investigations dealing with variable stars.

15.10 Association of Lunar and Planetary Observers (ALPO)

Association of Lunar and Planetary Observers (ALPO) (alpo-astronomy.org) was founded by Walter H. Haas in 1947 and incorporated in 1990. It was formed to advance and conduct work by both professionals and amateurs in solar system object observations. Specifically geared toward lunar and planetary astronomy, ALPO is an excellent place to learn and enhance your observational skills and knowledge of solar system objects. The membership is an international group of students who study the Sun, Moon, planets, asteroids, meteors, and comets. The group's goal is to coordinate and promote the study of these objects using methods and instruments available to both the amateur and professional community.

ALPO is subdivided into Sections, each with a Section Coordinator who collects observations, corresponds with observers, and contributes to reports in the ALPO journal, *The Strolling Astronomer*. The ALPO Sections include Comets, Eclipse, Jupiter, Lunar, Mars, Mercury, Meteorite, Meteors, Minor Planets, Remote Planets, Saturn, Solar, Transit, and Venus. There are also special Sections on Computing, Historical, Publications, Training, and Youth Programs. The ALPO website has various documents to help in learning how to do lunar and planetary observations and topographical studies.

Most Sections have a monthly or quarterly newsletter detailing the activities of that Section. The Image Archive contains is a large database of images for reference and study. ALPO is a one-stop shop if you are interested in doing observations and contributing to the premier group in lunar and planetary science.

15.11 MinorPlanet.Info Website

Created by Brian D. Warner, the MinorPlanet.Info website (minorplanet.info) is a clearinghouse for asteroid photometric data. As host to the *Minor Planet Bulletin*, the official newsletter of the ALPO Minor Planet Section, the website offers observation data for those interested in comparing their photometric data with data reported in the past. The Asteroid Lightcurve Database (LCDB) is a compilation of published results that include period/amplitude parameters for more than 4,000 minor planets (as of June 2012). The Collaborative Asteroid Lightcurve Link (CALL) is a service that allows observers to announce their targets under study so that others can contribute data in a collaborative way. Many asteroids require continuous observations that are difficult for any one observer to cover in a timely manner, so it is necessary to rely on others to provide overlap in getting the data for a given target. In other instances, it is sometimes necessary to select a target that others are not observing to avoid duplication.

MinorPlanet.Info has links to documents and other resources such as databases of asteroids from the National Aeronautics and Space Administration's (NASA) Jet Propulsion Laboratory (JPL) and Lowell Observatory. If you want to contribute your observations, the *Minor Planet Bulletin* accepts your asteroid lightcurve reports for peer review and publication.

15.12 Society for Astronomical Sciences (SAS)

The Society for Astronomical Sciences (SAS) (socastrosci.org) is a group of amateur and professional astronomers dedicated to conducting astronomical research in several different areas, including, but not limited to, variable stars, minor planets, exo-planets, and cataclysmic stars. The SAS mission is to foster astronomical research by backyard astronomers and to encourage publication of research results in recognized journals. SAS also works to facilitate collaborations between amateurs and professionals through an annual Symposium on Telescope Science. SAS was formed from two major groups. The first group, formed in 1980, was the International Amateur-Professional Photoelectric Photometry (IAPPP). In 1998, a western wing of the IAPPP was formed and held symposiums in coordination with the Riverside Telescope Makers Conference (RTMC). In 2003, the two wings of the IAPPP joined forces, and the organization was renamed the Society for Astronomical Sciences (SAS) as a non-profit educational corporation.

SAS's main event is the annual symposium where amateurs and professionals come together to give presentations on a wide variety of topics of interest to astronomers everywhere. Topics on instrumentation, astrometry, spectroscopy, photometry, and the various observing targets are standard fare at each symposium. Each year, the proceedings of the SAS are published, and a newsletter is published about once a quarter to keep members up to date. If you want to rub elbows with professional and amateur astronomers that "do science," this is the place to be every year.

15.13 British Astronomical Association (BAA)

Formed in 1890, the British Astronomical Association (BAA) (britastro.org) has a rich history of observational and scientific work. The mission of BAA includes the encouragement of all aspects of observational astronomy; promotion of a general interest in astronomy for beginners and advanced alike; circulation of current astronomical and observational material; support of modern techniques, data handling, and scientific publications; and reward and recognition of those who make outstanding contributions to astronomy. Similar to the ALPO, BAA has Sections and Groups that cover all object types to observe and specific technical areas.

BAA offers a large selection of documents and data available to the amateur and professional members. They include the *BAA Journal*, the *Annual Handbook*, an almanac of observational data and ephemerides, e-bulletins, and paper circulars that provide notification of special events. BAA also sells a large selection of star charts, posters, and specialized booklets. Most Sections also issue individual newsletters for those who are interested in the specific work done by that section.

BAA is also like your local astronomy club in that it holds meetings every month except July or August. The proceedings include papers prepared by members and talks on current topics and observing techniques. There are also more formal presentations by experts and professional astronomers. BAA has had some very famous members over the decades, none probably more famous than Sir Patrick Moore. Moore is a very well-known amateur astronomer, astronomy popularist, and expert lunar observer. He has dedicated his life to amateur astronomy and has written and edited hundreds of books. He has presented more than 700 episodes of his celebrated and long-lasting BBC series *Sky at Night*.

15.14 International Society of the Mars Observers (ISMO)

The International Society of the Mars Observers (ISMO) (www.mars.dti.ne.jp/~cmo/ISMO.html) now hosts the *Communications in Mars Observations* (CMO) previously provided by the Oriental Astronomical Association (OAA). Before 2010, this service was provided by the Kyoto University Kwasan and Hida Observatories headquarters for the OAA. The website provides Mars observations

and commentary about the apparitions during every opposition from 2001. The best planetary observers all over the world provide data to this website and make it available to amateurs and professionals alike. If you are interested in Mars observations, this website and society may be for you. The CMO is an international journal of Mars observations that are published monthly or semi-monthly by ISMO.

Further Reading

Arditti D (2008) Setting-up a small observatory. Springer, New York
Berry R, Burnell J (2005) The handbook of astronomical image processing. Willmann-Bell, Richmond
Buchheim R (2007) The sky is your laboratory. Springer, Berlin/Heidelberg/New York
Chromey FR (2010) To measure the sky. Cambridge University Press
Dieck RH (2007) Measurement Uncertainty. The Instrumentation, Systems, and Automation Society, Research Triangle Park
Dymock R (2010) Asteroids and dwarf planets and how to observe them. Springer, New York
Harrison KM (2011) Astronomical spectroscopy for amateurs. Springer, New York
Warner BD (2006) A practical guide to lightcurve photometry and analysis. Springer, New York
Warner BD (2010) The MPO user's guide. BDW Publishing, Colorado Springs

Web Pages

http://minorplanetcenter.net/
http://www.iau.org/
http://www.minorplanetcenter.net/iau/info/Astrometry.html
http://www.aavso.org/
http://www.citizensky.org/
http://alpo-astronomy.org/
http://www.minorplanet.info/
http://www.socastrosci.org/
http://www.britastro.org/
http://www.mars.dti.ne.jp/~cmo/ISMO.html

Chapter 16

Amateur Astronomer Access to Professional-Level Observatories

16.1 The Remote Access Revolution

Imagine having access to a professional astrograph in the 0.5–1.0-m class, with a very high-resolution camera (16 megapixels) and a full set of Ultraviolet-Blue-Visual-Red-Infrared (UBVRI) photometric filters. Plus, this instrument is located in one of the premier dark sites—the New Mexico or Arizona desert, or in South America. This instrument is capable of discovering minor planets down to 20th or 21st magnitude. It can also take long exposures that resolve the faint details of nebulae, galaxies, and other deep sky objects. Now, imagine not only having access, but *remote access* from anywhere in the world. This is all made possible because of the computer revolution, high-technology communications, and the Internet. The fundamental communications infrastructure and high-speed computing have been a long time coming, and everything finally came together in the first decade of the twenty-first century.

For an amateur astronomer to have access to state-of-the-art astronomy technology is a godsend for those who cannot afford to build their own Astronomical Imaging System (AIS), or for those who may have a disability that precludes them from operating an AIS. It enables more amateur astronomers to get a taste of scientific image processing and data acquisition before they start down that path of designing and building their own AIS. It also makes more instruments available to those who are studying astronomy as a vocation and gives those students the valuable hands-on time to prepare them for using the large professional instruments that will be part of their careers in astronomy. This is truly a revolutionary time for astronomical pursuits and the potential to discover new and wonderful things.

16.2 Professional Telescopes for the Astro-Masses

Several entrepreneurs and others have created remote telescope systems for use by amateur and professional astronomers alike. These astronomical visionaries have relied on several fundamental technologies to forge their systems, including, but not limited to, the Internet; high-speed, low-cost, computing; high-precision robotics technology; high-resolution charge-coupled device (CCD) chip cameras; ASCOM interface driver standards; and remote control and automated scheduling programs. Couple these technologies with the revolution in large telescope design and construction, and you have a match made in heaven (literally). Maintaining standards for the design, construction, and operation of this equipment helps keep the price down and the productivity up. The near mass production of the fundamental components and subsystems of these AISs helps to bring about construction of more of these systems. More systems means more time available for anyone who wants to image the night sky. Several systems are available to the amateur astronomer. Table 16.1 lists a few of the many services available and information on their astrographs.

The Sierra Stars Network (sierrastars.com) and the LightBuckets Telescope Network (lightbuckets.com) charge a fee for usage. The AAVSOnet (www.aavso.org/aavsonet) is an Association of Variable Star Observers (AAVSO) members-only research telescope network. Members create observing proposals for use of the astrographs much like the procedure used in professional circles. These systems

Table 16.1 Remote observatories and astrographs

Remote observatory systems				
Service	Service type	Astrographs available	Location	Operator
The Sierra Stars Observatory Network	Schedule	0.61-m Cassegrain 0.82-m Cassegrain 0.37-m Cassegrain	Markleeville, California Mt Lemmon, Arizona Sonoita, Arizona	Rich Williams
LightBuckets Telescope Network	Full control and schedule	0.80-m Astelco Astrograph 0.43-m Dall-Kirkham 0.11-m APO Refractor 0.18-m APO Refractor	Moydans, France Moydans, France Moydans, France Moydans, France	Marc Bretton, CEO
AAVSOnet	Schedule	0.28-m SCT 0.31-m SCT 0.36-m SCT 0.46-m Corrected Prime Focus 0.06-m APO Refractor BSM	Astrokolkhoz, New Mexico	Arne Hendon, Director AAVSO

and others like them provide a very good service to their customers and are available as of June 2012. The British Astronomical Association (BAA) also contracts with the SierraStars Observatory Network (SSON) to provide its members with discounted access to a high-quality remote observatory.

16.3 Using the Sierra Stars Observatory Network (SSON)

The SSON (sierrastars.com) is one of the premier, remotely operated observatory networks on the planet. Rich Williams and his wife Kathleen Fox-Williams, run this network from Markleeville, California, the home of the first astrograph placed in service—the Sierra Stars Observatory Optical Mechanics 0.61-m Nighthawk CC06 Classical Cassegrain. This astrograph is equipped with a Finger Lakes Instruments ProLine 9000 CCD camera and ProLine CFW-4-5 filter wheel with four scientific grade Astrodon Johnson-Cousins photometric filters (BVRI) (Fig. 16.1). This

Fig. 16.1 The Sierra Stars Observatory 0.61-m Cassegrain imaging train (Courtesy of Rich Williams, SSON Founder)

professional-level astrograph with a huge fork mount is housed in a 15-ft diameter Technical Innovations Pro-Dome. Over the years, the Sierra Stars Observatory has been used to image newly discovered minor planets and deep sky objects, and provided countless university students with practical experience using a professional-level AIS. Rich Williams also contributes his time supporting the Space Science for Schools (SS4S) (ss4s.org) non-profit corporation dedicated to the education of teachers, parents, and students. The group provides "hands-on interactive teaching materials, volunteer astronomers, and on-going tutorial programs to help students excel in science." The SSON is an SS4S resource.

The astrographs of the SSON operate robotically via a custom scheduling program developed by Rich and Kathleen and refined over the years. Steve Ohmert also works on programming projects to improve the Talon Telescope operating system and telescope network. One of the unique aspects of the SSON is that you pay only for the imaging time. SSON astrograph setup and targeting time (slewing the astrograph) are free. In addition, you only pay for the images that have the data you requested. If there are any problems with your data resulting from clouds or other imperfections, then Rich refunds your credits for you to try again. He guarantees satisfaction.

The basic operation involves buying credits, scheduling your observations on any of the three available astrographs, and then waiting for the data. When you schedule an observation, you specify the object, the right ascension and declination coordinates, the date and time of the exposure, the filters to use, and the length of the exposure. You can also select an object from their extensive catalog of solar system and deep sky objects, and the information for that object is automatically filled in on the request form for you. Your account includes a login identity to a File Transfer Protocol (FTP) site where your images are stored after processing. All your images are delivered calibrated (Fig. 16.2), and you have access to the raw images and calibration frames if you want to do the calibration yourself. Another nice feature is that you own the images you schedule and download—the copyright belongs to you. SSON only provides and owns the equipment and service you use to acquire your images. The FITS image header includes information listing you as the official observer so there is no doubt about who the observer is.

The 0.81-m Schulman telescope on Mount Lemmon at the Mount Lemmon SkyCenter (http://skycenter.arizona.edu) at the University of Arizona's Steward Observatory Field Station is truly a gift to the amateur astronomer community, and you should take advantage of it if you get the chance. This astrograph is equipped with a Santa Barbara Instrument Groups (SBIG) STX KAF-16803 camera that has a 4096×4096 pixel Kodak CCD chip. It also has a six-position filter wheel holding Astrodon red, green, blue, luminance, and 4.5 nm Ha filters.

The third astrograph member of the SSON is the Rigel Telescope provided by the University of Iowa as part of the Iowa Robotic Telescope Facility (IRTF). It is a 0.37-m *f*/14 classical Cassegrain equipped with a Finger Lakes Instruments ProLine KAF-16803 CCD-chip Camera and ProLine filter wheel with red, green, blue, clear, and Ha filters. The MPC Observatory codes for the SSON astrographs are G68-Sierra Stars Observatory, G84-Mount Lemmon Schulman Telescope, and 857-Rigel Astrograph. The SSON provides excellent service for the amateur astronomer and citizen scientist alike.

Fig. 16.2 One of several 60-s calibrated images of the field containing minor planet (4150) Starr taken by the author using the Sierra Stars Observatory 0.61-m Cassegrain reflector. This image was taken on April 8, 2010, at 10:20:30.72 UTC. The plate center is located at RA 13:06:24.6 DEC -01:24:50.7

16.4 The Future of Remote Astronomical Observatories

As the cost of AIS components and subsystems comes down, and the performance of CCD cameras goes up, it becomes cost effective to create remote observatories with astrographs in the 0.1–0.3-m range. Presently, this is the typical size that advanced amateurs use in their observatories, and there is great interest in providing remote access services for these AISs. Imagine an amateur scientist having access to a standard AIS design that includes remote access services. This would be a turnkey system that could be purchased as a complete package, including installation and commissioning services. Once such a system was up and running and operating as designed, it could be used remotely, with the amateur taking over the operations and maintenance of the observatory.

Another possibility is that an entrepreneur could use a reference AIS design to build several copies of that system and place them all over the world for continuous coverage of a given object. Imagine being able to image the same object at the same time from several locations to obtain uninterrupted light curves for minor planets, supernovae, or variable stars, including exo-planets. This would provide a very powerful capability for the amateur ranks. If a good general-purpose remotely oper-

ated AIS could be mass produced and purchased for less than $10,000, it would go a long way toward getting professional-level equipment into the hands of a lot more amateur astronomers.

Orion Telescopes (telescope.com) already offers (as of 2012) a few pre-configured AISs for purchase to help the beginner in putting together an observing program. This, of course, provides the *equipment* that you learned about in the last 14 chapters—but that is only half the battle in obtaining the best images you can for scientific purposes. You, *the astronomer*, provide most of the value when operating your AIS to get excellent data. Do not let anyone tell you otherwise—you cannot buy your way into excellent images. You must use your skills and knowledge to process your data to get real results. Having access to a remote observatory that you designed and built yourself really puts your production into high gear, but it takes the necessary funding to build a permanent observatory that you can use every clear night regardless of the temperature or the season. Perhaps one day you *can* have that "perfect AIS" that is there any time you want it, begins imaging within 5 min after you access it, covers a whole slew of objects, and provides a lifetime of enjoyment, learning, and discovery.

Further Reading

Arditti D (2008) Setting-up a small observatory. Springer, New York
Berry R, Burnell J (2005) The handbook of astronomical image processing. Willmann-Bell, Richmond
Buchheim R (2007) The sky is your laboratory. Springer, Berlin/Heidelberg/New York
Byrne CJ (2005) Lunar orbiter photographic atlas of the near side of the Moon. Springer, New York
Chromey FR (2010) To measure the sky. Cambridge University Press, Cambridge
Covington MA (1999) Astrophotography for the amateur. Cambridge University Press, Cambridge
Dragesco J (1995) High resolution astrophotography. Cambridge University Press, Cambridge
Dymock R (2010) Asteroids and dwarf planets and how to observe them. Springer, New York
Harrison KM (2011) Astronomical spectroscopy for amateurs. Springer, New York
Henden AA, Kaitchuck RH (1990) Astronomical photometry. Willmann-Bell, Richmond
Howell SB (2006) Handbook of CCD astronomy. Cambridge University Press, Cambridge
Shirao M, Wood CA (2010) The Kaguya lunar atlas. Springer, New York
Smith GH, Ceragioli R, Berry R (2012) Telescopes, eyepieces and astrographs. Willmann-Bell, Richmond
Warner BD (2006) A practical guide to lightcurve photometry and analysis. Springer, New York
Warner BD (2010) The MPO User's Guide. BDW Publishing, Colorado Springs

Web Pages

http://www.sierrastars.com/
http://www.lightbuckets.com/
http://www.aavso.org/aavsonet/
http://www.ss4s.org/
http://skycenter.arizona.edu/
http://www.telescope.com/

Appendix 1: Acronyms

μm	Micron
2-D	Two-Dimensional
AAVSO	Association of Variable Star Observers
ADC	Analog-to-Digital Converter
ADU	Analog-to-Digital Units
AIS	Astronomical Imaging System
ALPO	Association of Lunar and Planetary Observers
AOC	Active Optics Corrector
API	Application Programming Interface
APO	Apochromatic
APT	Aperture Photometry Tool
AR	Angular Resolution
Arcmin	Arcminute
Arcsec	Arcsecond
ATM	Amateur Telescope Maker
ATP	Air Transport Pilot
AVI	Audio Video Interleave
BAA	British Astronomical Association
BFA	Bayer Filter Array
BLOBS	Big, Lousy OBjectS
CALL	Collaborative Asteroid Lightcurve Link
CCD	Charge-Coupled Device
CFA	Color Filter Array
CHOICE	Carolyn Hurless Online Institute for Continuing Education in Astronomy
CMO	Communications in Mars Observations
CNC	Computer Numerically Controlled
DEC	Declination

(continued)

(continued)

DEM	Digital Elevation Map
DSLR	Digital Single Lens Reflex
EMR	Electromagnetic Radiation
ET	Elapsed Time
FITS	Flexible Image Transport System
FL	Focal Length
FOV	Field of View
FPE	Field Practical Exercise
fps	Frame Per Second
FR	Focal Ratio
FTP	File Transfer Protocol
FWHM	Full-Width-at-Half-Maximum
g	Gain
GB	Gigabyte
GEM	German Equatorial Mount
GLR	Geologic Lunar Research Group
GPS	Global Positioning System
GSO	Guan Sheng Optical
HC	Hand Controller
Hz	Hertz
H-α	Hydrogen Alpha
H-β	Hydrogen Beta
IAPPP	International Amateur-Professional Photoelectric Photometry
IAU	International Astronomical Union
IFR	Instrument Flight Rules
IM	Instrumental Magnitude
IPAC	Infrared Processing and Analysis Center
IRTF	Iowa Robotic Telescope Facility
ISMO	International Society of the Mars Observers
JPL	Jet Propulsion Laboratory
km	Kilometer
LAC	Lunar Aeronautical Chart
LCDB	Asteroid Lightcurve Database
lpmm	Lines Per Millimeter
LPOD	Lunar Photo of the Day
LRBG	Luminance, Red, Green, and Blue
LTVT	Lunar Terminator Visualization Tool
m	Meter
mag	Magnitude
mas	Milli-arcsecond
MB	Megabyte
MC	Motor Controller
mm	Millimeter
MPC	Minor Planet Center
MPEC	Minor Planet Electronic Circular

(continued)

(continued)

MPO	Minor Planet Circulars Orbit Supplement
ms	Millisecond
NASA	National Aeronautics and Space Administration
NCP	North Celestial Pole
NEO	Near-Earth Object
NII	Nitrogen 2
nm	Nanometer
NOFS	Naval Observatory Flagstaff Station
O&M	Operations and Maintenance
OAA	Oriental Astronomical Association
OAG	Off-Axis Guider
OE	Operational Experience
OEM	Original Equipment Manufacturer
OIII	Oxygen-3
OPDB	Observing Program Design Basis
OSC	One-Shot-Color
OTA	Optical Tube Assembly
PE	Periodic Error
PEC	Period Error Correction
POSS	Palomar Observatory Sky Survey
PSF	Point Spread Function
QE	Quantum Efficiency
RA	Right Ascension
RC	Ritchey-Chrétien
RCOS	RC Optical Systems
RGB	Red, Green, and Blue
RMS	Root Mean Square
ROI	Region-of-Interest
RPM	Revolutions/Minute
RTMC	Riverside Telescope Makers Conference
SAO	Smithsonian Astrophysical Observatory
SAS	Society for Astronomical Sciences
SBIG	Santa Barbara Instrument Group
SCP	South Celestial Pole
SCT	Schmidt-Cassegrain Telescope
SII	Sulfur-2
SMOP	Simple Matter of Physics
SNR	Signal-to-Noise Ratio
SRSS	Square-Root-of-the-Sum-of-the-Squares
SSC	Structures, Systems, and Components
SS4S	Space Science for Schools
SSON	SierraStars Observatory Network
TB	Terabyte
TDI	Time Delay and Integration
TDM	Telescope Drive Master

(continued)

(continued)

TE	Tracking Error
TEC	Thermo-Electric Cooler
TET	Total Exposure Time
UCAC	USNO CCD Astrograph Catalog
UCAC3	USNO CCD Astrometric Catalog 3
USNO	United States Naval Observatory
UVB	Ultraviolet, Blue, and Visual
UVBRI	Ultraviolet-Blue-Visual-Red-Infrared
VFR	Visual Flight Rules
WCS	World Coordinate System

Appendix 2: Field Practical Exercises: Training Syllabus

This syllabus allows you to record and monitor the progress of your activities in designing, building, and operating your Astronomical Imaging System (AIS). It is designed to be used along with the guidance of a mentor, who can help you quickly progress through your training. [K] and [S], respectively, indicate whether the lesson is knowledge or skill based.

Lesson	Chapters	Completion date
1. [K] AIS design	Part I, Chapters 1–8	
2. [K] OPDB specification	Chapter 15	
3. [K],[S] AIS construction	Part II, Chapter 9	
4. [K],[S] AIS operations	Part II, Chapter 10	
5. [K] Image calibration	Part II, Chapter 11	
6. [S] AIS operation—FPEs	Part II, Chapter 12.2	
7a. [S] Image scaling calculation	FPE 12.2.1	
7b. [S] AIS equipment setup	FPE 12.2.2	
7c. [S] Imaging train configuration	FPE 12.2.3	
7d. [S] Astrograph collimation	FPE 12.2.4	
7e. [S] Mount polar alignment	FPE 12.2.5	
7f. [S] All-sky alignment	FPE 12.2.6	
7g. [S] Flat frame acquisition	FPE 12.2.7	
7h. [S] Dark frame acquisition	FPE 12.2.8	
7i. [S] Bias frame acquisition	FPE 12.2.9	
7j. [S] Light frame acquisition	FPE 12.2.10	

(continued)

(continued)

Lesson	Chapters	Completion date
7k. [S] Astrograph focusing	FPE 12.2.11	
7l. [S] Guidescope setup	FPE 12.2.12	
8. [S] Program objects—FPEs	Section II, Chapter 12.3	
8a. [S] Large solar system object	FPE 12.3.1	
8b. [S] Small solar system object	FPE 12.3.2	
8c. [S] Large deep sky object	FPE 12.3.3	
8d. [S] Small deep sky object	FPE 12.3.4	
9. [K],[S] Scientific data analysis	Part III, Chapter 14	
10. [K] Submitting data	Part III, Chapter 15	
11. [K] Remote astrograph operations	Part III, Chapter 16	

Appendix 3: Photometric Uncertainty Calculations

Recall that Chap. 12, Sect. 12.6, Calibration Techniques, contains a thorough mathematical explanation of the calibration, and the light, and calibrated frames. The uncertainty of the resultant calibrated frame included all the accumulated error of the calibration frames. The following is an example calculation and further discussion of the uncertainty of each of the calibration frames.

Recall the following equations:

Bias Frame

The bias frame includes a constant value plus pattern noise, random electronic noise, and random readout noise.

$$P_B(ADU) = 1/g \left[K(e^-) + B_{pattern}(e^-) + \sigma_{electronic}(e^-) + \sigma_{readout}(e^-) \right]$$

Using the following values, the P_B (ADU) and the uncertainty U_{PB} can be calculated:

$$g\ (e^-/ADU) = 0.4$$
$$K\ (e^-) = 55 \pm \sqrt{55}$$
$$= 55 \pm 7.4$$
$$B_{pattern}\ (e^-) = 15 \pm \sqrt{15}$$
$$= 15 \pm 3.9$$
$$\sigma_{electronic}\ (e^-) = \pm 2$$
$$\sigma_{readout}\ (e^-) = \pm 5$$

Note that the random noise sources are plus or minus a value. In addition, the K and $B_{pattern}$ values have uncertainties associated with them based on Poisson statistics equal to the square root of the respective value.

The sum of all the values is:

$$55 + 15 \pm (7.4 + 3.9 + 2 + 5) \text{ or, } 70 \pm 18.3$$

This is not quite right, however, because random errors add in quadrature, or the square-root-of-the-sum-of-the-squares method. The random error or uncertainty is:

$$U_{PB}(e^-) = \pm \sqrt{(7.4^2 + 3.9^2 + 2^2 + 5^2)}$$
$$= \pm \sqrt{(55 + 15 + 4 + 25)}$$
$$= \pm \sqrt{99}$$
$$= \pm 10$$

Based on this result, the bias frame pixel value is:

$$\text{Bias Frame Pixel}\ (e^-) = 70 \pm 10\ (e^-)$$

Finally, to determine the equivalent ADU value for the bias frame pixel value, the gain is applied:

$$P_B(ADU) = 1/g\ \text{Bias Frame Pixel}\ (e^-)$$
$$= 1/0.4\ (70 \pm 10)$$
$$= 2.5\ (70 \pm 10)$$
$$= 175 \pm 25$$

The U_{PB} (ADU) value is ± 25.

Dark Frame

The dark frame includes a time-based thermal value depending on the exposure time, a random thermal noise value based on Poisson statistics, and the P_B (ADU) value (including the U_{PB} value).

Appendix 3: Photometric Uncertainty Calculations

$$P_D(ADU) = 1/g \left[T(e^-) + \sigma_T(e^-) \right] + P_B(ADU)$$

Using the following values, the P_D (ADU) and the uncertainty U_{PD} can be calculated. Because the thermal value is time dependent, a value of 0.05 (e⁻/s) is used, along with an assumed 60-s exposure:

$$g\ (e^-/ADU) = 0.4$$
$$T(e^-) = 3$$
$$\sigma_T(e^-) = \pm\sqrt{3}$$
$$= \pm 1.7$$
$$P_B(ADU) = 175 \pm 25$$

The uncertainty or U_{PD} is calculated as before using the square-root-of-the-sum-of-the-squares method after we apply the gain. Note that the P_B value is not included yet because its units are ADU not e⁻:

$$U_{PD}(e^-) = \pm 1.7$$

To obtain the equivalent value in ADU, apply the gain:

$$\text{Dark Frame Pixel (ADU)} = \left[1/g\ \text{Dark Frame Pixel}(e^-) \right] + P_B(ADU)$$
$$= \left[1/0.4\ (3 \pm 1.7) \right] + 175 \pm 25$$
$$= 7.5 + 175$$
$$= 182.5$$

The uncertainty values in units of ADU add in quadrature as before after the application of the gain:

$$U_{PD}(ADU) = \pm\sqrt{(1.7/0.4)^2 + 25^2}$$
$$= \pm\sqrt{(3/0.16) + 625}$$
$$= \pm\sqrt{643}$$
$$= \pm 25$$

$$P_D(ADU) = 182.5 \pm 25$$

The U_{PD} (ADU) value is ±25 (ADU).

Thermal Frame

The thermal frame includes the previously discussed dark frame and the bias frame. The value calculated above for the dark frame was for a 60-s exposure. It is important to recognize that this exposure value applies only to the dark frame value not the bias frame. The purpose of the thermal frame is to provide a frame that can be scaled to any exposure time for subtraction from the light frame. Therefore, once P_{T60} (ADU) is calculated for the dark frame exposure time, it must be divided by the exposure time to obtain a value for P_T (ADU/s).

$$P_{T60}(ADU) = P_D(ADU) - P_B(ADU)$$
$$P_T(ADU/sec) = [P_D(ADU) - P_B(ADU)]/60$$

The value of the U_{PT} is also be reduced accordingly.

$$\begin{aligned} P_T(ADU/sec) &= [182.5 \pm 25 - 175 \pm 25]/60 \\ &= [182.5 - 175]/60 \\ &= 7.5/60 \\ &= 0.125 \end{aligned}$$

The uncertainty values add in quadrature and are also divided by 60 s:

$$\begin{aligned} U_{PT}(ADU/sec) &= \pm\sqrt{(25^2 + 25^2)}/60 \\ &= \pm\sqrt{(625+625)}/60 \\ &= \pm\sqrt{1250}/60 \\ &= \pm 35.4/60 \\ &= \pm 0.59 \end{aligned}$$

The U_{PT} (ADU/s) value is ±0.59.

It is important to recognize that while the uncertainty value for U_{PT} is greater than the actual value for the thermal rate P_T, it is used in a different way when calculating the total uncertainty for the calibrated light frame and does not apply directly to the thermal rate.

Flat Frame

The flat frame includes bias values for vignetting, dust donuts, and filter effects. Each of these terms has an associated uncertainty based on the Poisson statistics of the value measured as is the case with the other signals measured. The difference is that the flat frame values are large, so the signal to noise ratio (SNR) becomes better the more electrons you collect—the fuller the well is filled on each pixel the

Appendix 3: Photometric Uncertainty Calculations

better the result. An adjustment is also made because the three effects (B_V, B_{DD}, and B_F) are combined on the flat frame.

$$P_F = 1/g\left[\left(B_V(e^-) + B_{DD}(e^-) + B_F(e^-)\right)/3\right]/F_{avg}(ADU)$$

The following values are used to calculate P_F, the normalization factor for a pixel:

$$g\ (e^-/ADU) = 0.4$$
$$B_V(e^-) = 19{,}333 \pm \sqrt{19{,}333}$$
$$= 19{,}333 \pm 139.0$$
$$B_{DD}(e^-) = 19{,}185 \pm \sqrt{19{,}185}$$
$$= 19{,}185 \pm 138.5$$
$$B_F(e^-) = 19{,}492 \pm \sqrt{19{,}492}$$
$$= 19{,}492 \pm 139.6$$
$$F_{avg}(ADU) = 48{,}817.4243$$
$$\text{CCD Pixel Count} = 8{,}356{,}608\ \text{pixels}$$

The $F_{avg}(ADU)$ uncertainty is equal to the square root of the value of $F_{avg}(ADU)$ divided by the square root of the number of pixels in the frame:

$$U_{Favg} = \pm\sqrt{F_{avg}(ADU)}/\sqrt{\text{Number of Pixels (ADU)}}$$
$$= \pm\sqrt{48{,}817.4243}/\sqrt{8{,}356{,}608}$$
$$= \pm\ 220.94665/2890.7798$$
$$= 0.076432$$

Because of the sheer number of values averaged, the uncertainty of the $F_{avg}(ADU)$, is very small. The P_F for this pixel is calculated as:

$$P_F = 1/0.4\ [(19{,}333 + 19{,}185 + 19{,}492)/3]/48{,}817.4243$$
$$= 2.5[58{,}010/3]/48{,}817.4243$$
$$= 2.5[19{,}336.67]/48{,}817.4243$$
$$= 48{,}341.67/48{,}817.4243$$
$$= 0.9902544$$

The U_{PF} (ADU) is equal to the square-root-of-the-sum-of-the-squares of the values calculated by:

$$U_{PF}(ADU) = \pm\sqrt{1/g} \left((139.0^2 + 138.5^2 + 139.6^2)/\sqrt{3}\right)$$
$$= \pm\sqrt{1/0.4} \left((19321 + 19182 + 19488)/1.732\right)$$
$$= \pm\sqrt{2.5} \left(57991/1.732\right)$$
$$= \pm\sqrt{83705}$$
$$= \pm 289.318$$

The U_{PF} is the U_{PF} (ADU) divided by the square root of the number of pixels multiplied by the average ADUs (F_{avg}) used to calculate the P_F:

$$U_{PF} = \pm 289.318/\sqrt{8,356,608 \cdot 48,817.4243}$$
$$= \pm 289.318/638708.1$$
$$= \pm 0.000453$$

The end result is that the P_F value for the pixel is equal to:

$$P_F = 0.9902544 \pm 0.000453$$

The U_{PF} value is equal to ± 0.000453.

Total Impact on Measurement

In summary, the uncertainty values for the pixels in each of the different frames can be added in quadrature using the square-root-of-the-sum-of-the-squares methodology to come up with a total uncertainty for your photometric measurement. The end result is calculated:

Given:

The U_{PB} (ADU) value is ± 25.
The U_{PD} (ADU) value is ± 25.
The U_{PT} (ADU/s) value is ± 0.59.
The U_{PF} value is equal to ± 0.000453.

And,

A 60-s exposure is assumed, and the U_{PF} is equal to a flat correction gain of 1.0000 ± 0.000453:

$$U_{analytic}(ADU) = \pm 1.000453 \sqrt{\left(25^2 + 25^2 + (60 \cdot 0.59)^2\right)}$$
$$= \pm 1.000453 \sqrt{(625 + 625 + 1253)}$$
$$= \pm 1.000453 \sqrt{2503}$$
$$= \pm 1.000453 (50.03)$$
$$= \pm 50.05$$

Appendix 3: Photometric Uncertainty Calculations

The methodology in Chap. 14 uses the following equation (using an assumed star pixel brightness equal to the flat frame brightness: 48,817):

$$U^*(ADU) = \pm 1/\sqrt{g} \sqrt{N^*(ADU)}$$
$$= \pm 1/\sqrt{0.4} \sqrt{48,817}$$
$$= \pm 1.58114 \, (220.945)$$
$$= \pm 349.346$$

This value, when added to the analytically derived error from the calibration frames, yields the following (added in quadrature):

$$U_{total}(ADU) = \pm \sqrt{U_{analytic}^2(ADU) + U^{*2}(ADU)}$$
$$= \pm \sqrt{(50.05^2 + 349.346^2)}$$
$$= \pm \sqrt{2,505.00 + 122,042}$$
$$= \pm \sqrt{124,548}$$
$$= \pm 352.913$$

When the U_{total} (ADU) value is compared with the empirically derived value of U^* (ADU), you can see that there is very little difference in the uncertainty. This is a good thing in that for casual measurements, the difference will not amount to a great deal. When doing precise measurements however, the percentage difference is significant:

$$\text{Percentage Difference} = 100\left((U_{total} - U^*)/U_{total}\right)$$
$$= 100\left((352.913 - 349.346)/352.913\right)$$
$$= 100(0.010107)$$
$$= 1.0107\%$$

On a magnitude basis, this value is equal to 0.01 magnitude at an SNR equal to:

$$SNR = 48,817/353$$
$$= 138$$

For a dim object where the ADU value is approximately 6,000, the difference would be equal to:

$$\text{Percentage Difference} = 100\left((U_{total} - U^*)/U_{total}\right)$$
$$= 100\left((352.913 - 349.346)/352.913\right)$$
$$= 100(0.010107)$$
$$= 1.0107\%$$

$$U_{total}(ADU) = \pm \sqrt{U_{analytic}^2(ADU) + U*^2(ADU)}$$
$$= \pm \sqrt{(50.05^2 + 126.72^2)}$$
$$= \pm \sqrt{2,505.00 + 16,057.5}$$
$$= \pm \sqrt{18562.5}$$
$$= \pm 136.24$$

$$\text{Percentage Difference} = 100\left((U_{total} - U*)/U_{total}\right)$$
$$= 100\left((136.24 - 126.72)/136.24\right)$$
$$= 100(0.06987)$$
$$= 6.987\%$$

On a magnitude basis, this is equal to 0.07 magnitude at an SNR equal to:

$$SNR = 6423/136$$
$$= 47.2$$

The lesson here is that although the added error from the calibration frames makes a small difference for bright objects, it makes a significant difference for dim objects. The better you can calibrate your images when observing dim objects, the better off you will be.

Appendix 4: Example Imaging Train Setups and Measurements

Lake of the Woods Observatory (MPC I24)

AIS Imaging Train Setups—Updated 05 July 2011

System 1

Primary	AT8RC/QHY9m + FW + FF/FR
Secondary	ES 127 ED APO Triplet CF/ATIK 314e + FF
Alternate primary	AT8RC/QHY9m + FW + FF

Primary Train (0 (zero) position on Focuser) Nominal 1,218[a] mm FL F/6.0 Imaging Train Sequence:
AT8RC + (25 mm ext OR 50 mm ext) + AT8RC Moonlite Focuser + AT8RC FF/FR + 30 mm T-extension + FW T-adapter + QHY FW + QHY9m TEC CCD

Component	Length	Length
25 mm extension	0 mm	25 mm
50 mm extension	50 mm	0 mm
AT8RC Moonlite Focuser—adapter	38 mm	38 mm
AT8RC Moonlite Focuser—body	46 mm	46 mm

(continued)

(continued)

Component	Length	Length
AT8RC Moonlite Focuser—tube	9 mm	9 mm
AT8RC Flat fielder/0.75 focal reducer	6 mm	6 mm
30 mm T-thread extension	30 mm	30 mm
QHY FW T-thread adaptor	4 mm	4 mm
QHY Filter wheel	23 mm	23 mm
QHY9m TEC CCD Camera backfocus	15 mm	15 mm
FF/FR Distance to image plane (required)	72 mm	72 mm
Total zero focuser length	221 mm ± 1 mm	196 mm ± 1 mm
Total max focuser length (+ 38 mm)	259 mm ± 1 mm	234 mm ± 1 mm
Nominal focus position at 223 mm measured BF	483 counts (2 mm)	6,521 counts (27 mm)
Measured focal length	1,220 mm ± 1 mm	
Fixed length—AT8RC Focuser		
Fixed length—QHY9m/FW with FF/FR		
[a]Measured back focus distance with FF/FR		

Secondary Train (0 (zero) position on Focuser) Nominal 950[a] mm FL F/7.5 Imaging Train Sequence:

ES127 ED APO CF + ES127 2.5″ Moonlite Focuser + AT2FF + Orion Flip Mirror + ATIK 314e TEC CCD

Component	Length
ES127EDAPOCF Moonlite flange extension	41 mm
ES127EDAPOCF Moonlite Focuser—adaptor	42 mm
ES127EDAPOCF Moonlite Focuser—body	59 mm
ES127EDAPOCF Moonlite Focuser—tube	9 mm
2-in. ATFF Refractor flat fielder	35 mm
Orion 2-in. flip mirror	80 mm
ATIK 314e TEC CCD Camera backfocus	12 mm
Total zero focuser length	278 mm ± 1 mm
Total max focuser length (+ 114 mm)	392 mm ± 1 mm
Nominal focus position at 282 mm required BF	387 counts (4 mm)
[a]Measured focal length with AT2FF	

Alternate Primary Train (0 (zero) position on Focuser)
Nominal 1,624 mm FL F/8.0
Imaging Train Sequence:
AT8RC + (50 mm ext OR 75 mm ext) + AT8RC Moonlite Focuser + AT2FF + 30 mm T-extension + FW T-adapter + QHY FW + QHY9m TEC CCD

Component	Length	Length
25 mm extension	25 mm	0 mm
50 mm extension	50 mm	50 mm
AT8RC Moonlite Focuser—adapter	38 mm	38 mm
AT8RC Moonlite Focuser—body	46 mm	46 mm
AT8RC Moonlite Focuser—tube	9 mm	9 mm
2″ AT2FF Refractor flat fielder	35 mm	35 mm
7 mm T-thread extension	7 mm	7 mm
QHY FW T-thread adaptor	4 mm	4 mm
QHY Filter wheel	23 mm	23 mm
QHY9m TEC CCD Camera backfocus	15 mm	15 mm
Total zero focuser length	252 mm ± 1 mm	227 mm ± 1 mm
Total max focuser length (+ 38 mm)	290 mm ± 1 mm	265 mm ± 1 mm
Nominal focus position at 245 mm required BF	N/A	4,348 counts (18 mm)
Fixed length—AT8RC focuser		
Fixed length—QHY9m/FW with FF		

System 2

Primary	ES 127 ED APO Triplet CF/QHY9m + FW + FF

Primary Train (0 (zero) position on Focuser) Nominal 950[a] mm FL F/7.5
ES127EDAPOCF + ED127 2.5" Moonlite Focuser + AT2FF + 7 mm T-extension + FW T-adapter + QHY FW + QHY9m TEC CCD

Component	Length
ES127EDAPOCF Moonlite flange extension	41 mm
ES127EDAPOCF Moonlite focuser—adaptor	42 mm
ES127EDAPOCF Moonlite focuser—body	59 mm
ES127EDAPOCF Moonlite Focuser—tube	9 mm
2-in. ATFF refractor flat fielder	35 mm

(continued)

(continued)

Component	Length
7 mm T-thread extension	7 mm
QHY FW T-thread adaptor	4 mm
QHY Filter wheel	23 mm
QHY9m TEC CCD camera backfocus	15 mm
FF Distance to image plane	49 mm
Total zero focuser length	235 mm ± mm
Total max focuser length (+ 114 mm)	349 mm ± 1 mm
Nominal focus position at 282 mm required BF	1,1300 counts (47 mm)
Fixed length—ES127EDAPOCF 2.5″ focuser	
Fixed length—QHY9m/FW with FF	
[a]Measured focal length with AT2FF	

Fig. A4.1 A typical imaging train setup on an AIS used for scientific imaging

Appendix 4: Example Imaging Train Setups and Measurements 321

Fig. A4.2 A photovisual imaging train setup using a flip mirror

Appendix 5: Available AIS Software List

The author has installed and used the following software on his Astronomical Imaging System.

Program	Publisher	Source
AIP4Win	Willmann-Bell	www.willbell.com/aip/index.htm
Alignmaster	Garzarolli	www.alignmaster.de
Artemis software	ATiK Camera	www.atik-cameras.com
ASCOM device drivers	Various	ascom-standards.org
ASCOM Platform 6	ASCOM initiative	ascom-standards.org
Astrometrica	Herbert Raab	www.astrometrica.at
AstroPlanner V2	iLanga, Inc.	www.astroplanner.net
C2A	Philippe Deverchére	www.astrosurf.com/c2a
Cartes du Ciel V3.7	Patrick Chevalley	www.ap-i.net/skychart
CCDInspector2	CCDWare	www.ccdware.com
CNebulaX	Jose R. Torres	www.uv.es/jrtorres/CNebulaX.htm
Craterlet 1.0	Stark labs	www.stark-labs.com/craterlet.html
DeepSkyStacker	Sander pool	deepskystacker.free.fr
EQMOD ASCOM driver V1.24	Open source project	tech.groups.yahoo.com/group/EQMOD eq-mod.sourceforge.net
FITS	NASA/GSFC	fits.gsfc.nasa.gov/fits_utility.html

(continued)

(continued)

Program	Publisher	Source
FITS Liberator 3.0	ESA/ESO/NASA	www.spacetelescope.org/projects/fits_liberator
GPS time and test v1.5	Brigsoft.com	www.abstime.com/atomic-clock-sync/#GPSTIME
Guide star catalog 1.1	NASA	tdc-www.harvard.edu/catalogs/hstgsc.html
Guidemaster V2.0	Garzarolli	www.guidemaster.de
IC Capture.AS 2.2	The imaging source	www.astronomycameras.com/products/software/iccaptureas
MaxIm DL V5	Diffraction limited	www.cyanogen.com/maxim_main.php
LTVT V0.21	Jim Mosher	ltvt.wikispaces.com
MaxIm DL essentials edition	Diffraction limited	www.cyanogen.com
MegaStar V5	Willmann-Bell	www.willbell.com/SOFTWARE/MEGASTAR/index.htm
MetaGuide	Frank Freestar8n	www.astrogeeks.com/Bliss/MetaGuide
MPO Canopus	Brian D. Warner	www.minorplanetobserver.com/MPOSoftware/MPOCanopus.htm
Nebulosity 2	Stark labs	www.stark-labs.com/nebulosity.html
PHD Guiding 1.13	Stark labs	www.stark-labs.com/phdguiding.html
PinPoint astrometric engine	DC-3 Dreams	pinpoint.dc3.com
Registax6	Cor Berrevoets	www.astronomie.be/registax
RSpec Version 1.4	Field tested software	www.rspec-astro.com
TDM TE Recorder V1	Jerry Hubbell	www.explorescientific.com/jerry_hubbell
UCAC 3 Catalog	United States Naval Observatory	www.usno.navy.mil/USNO/astrometry/optical-IR-prod/ucac
Virtual moon AtlasV5.1	Patrick Chevalley	ap-i.net/avl/en/start
Visual Spec V3.8	Valerie Desnoux	www.astrosurf.com/vdesnoux
Weather Ninja	CCDWare	www.ccdware.com/downloads
wxAstroCapture 1.8	M.Burri C.Arnholm	arnholm.org/astro/software/wxAstroCapture

Index

A
AAVSO. *See* American Association of Variable Star Observers (AAVSO)
AAVSOnet, 116, 298
AAVSO Newsletter, 292
ABG. *See* Anti-blooming gate (ABG)
Absolute photometry, 265–269, 287
Acceptance criteria, 195, 197, 199, 201, 202, 204, 209, 211, 213–216, 218, 219, 221, 224, 226, 229
AccuWeather.com, 122, 132
Active optics corrector (AOC), 61
Adapter, 82, 93–95, 136, 137, 152, 166, 200, 314, 315
ADC. *See* Analog to digital converter (ADC)
ADUs. *See* Analog to digital units (ADUs)
AG optical, 27, 28
Airmass, 174, 265–269
Airy disk, 48–50, 245, 246
Airy, G., 48
AIS. *See* Astronomical Imaging System (AIS)
All-sky alignment, 161, 162, 198, 209–211, 217, 221, 224, 227, 229, 306
All-sky photometry, 263, 265–267
All-sky synchronization, 209
Alluna optics, 27
ALPO. *See* Association of Lunar and Planetary Observers (ALPO)
Alt-azimuth mount, 27, 59, 61, 62, 162
Altitude, 56, 60, 61, 63, 88–90, 120, 156–160, 173, 207, 208, 265–268

American Association of Variable Star Observers (AAVSO), 116, 154, 240, 265, 291, 292, 298
Analog to digital converter (ADC), 36, 38
Analog to digital units (ADUs), 34–37, 40, 174, 186–189, 212, 213, 217, 218, 248, 250, 264, 267–269, 307–312
Angular resolution (AR), 47, 48, 50, 53
Angular separation, 42–46, 53
Annulus, 248–250
Anti-blooming gate (ABG), 33, 34
Anti-dewing system, 25
AOC. *See* Active optics corrector (AOC)
Aperture photometry, 248, 249
Aperture photometry tool (APT), 263
API. *See* Application programming interface (API)
APM, 27
Apochromatic refractor (APO), 24, 25, 27, 28, 115, 298, 314–316
Application programming interface (API), 71
APT. *See* Aperture photometry tool (APT)
AR. *See* Angular resolution (AR)
ASA. *See* Astro Systeme Austria (ASA)
ASCOM. *See* Astronomy Common Object Model (ASCOM)
ASCOM standard, 73, 75
Association of Lunar and Planetary Observers (ALPO), 240, 281, 283, 284, 292–294
Association of Variable Star Observers, 116, 298

Asteroid Lightcurve Database (LCDB), 293
Astrocam, 10, 38, 40, 141, 164, 243
Astrograph, 14, 21, 43, 55, 83, 103, 129, 141, 153, 180, 197, 242, 245, 288, 297
Astrometry, 12, 24, 31, 46, 51, 52, 104, 105, 107, 138, 139, 147, 148, 190, 240, 247, 251–262, 269, 287, 291, 294
Astrometry.net, 253–255
Astronomical Imaging System (AIS), 2, 9, 26, 39, 55, 82, 103, 125, 135, 151, 169, 195, 233, 251, 285, 297
Astronomy Common Object Model (ASCOM), 72–75, 99, 100, 153, 162, 174, 205, 210, 221, 222, 224, 227, 229, 230, 298, 317
Astronomy technologies/Astro-tech, 27, 28, 91, 112, 113, 297
Astrophotography, 1–5
Astro-Physics, 27, 28, 72, 73, 271
Astro Systeme Austria (ASA), 70
Atmospheric dispersion, 89, 90
Atmospheric dispersion corrector, 88–90
Atmospheric refraction, 51, 60, 88
Atmospheric seeing, 41, 48, 50, 51, 53, 92, 110, 119, 120
AUDE association, 86, 273
Audio video interleave (AVI) file (s), 171, 174, 175, 222
Auto-guider, 99–100
Auto-guiding, 15, 17, 65–67, 116, 140, 144, 145, 147, 148, 162, 163, 218, 219, 223, 226, 229
Average combine, 190
AVI file (s). *See* Audio video interleave (AVI) file (s)
Azimuth, 56, 59, 61, 63, 157–160, 173, 205–207

B
BAA. *See* British Astronomical Association (BAA)
BAA Annual Handbook, 294
BAA Journal, 294
Backfocus distance, 52, 113, 199, 201
Bahtinov mask, 92
Barlow lens, 52, 87, 94, 95, 109–111, 117, 146, 147, 166, 228
Barlow, P., 87
Barmettler, A., 278
Battery, 101, 102, 129, 153, 157, 165
Bayer filter array (BFA), 38
Bayer, J., 252, 253
Berry, R., 265
BFA. *See* Bayer filter array (BFA)

Bias, 67, 96, 97, 179, 181, 183–188, 190, 191, 193, 198, 209, 210, 212–215, 224, 226, 229, 306–310
Big lousy objects (BLOBS), 48, 50
Bit depth, 34–37, 40, 144
BLOBS. *See* Big lousy objects (BLOBS)
Blooming, 33
Bondo, H., 278
Brahe, T., 252
Bretton, M., 298
Brian, D.W., 293, 317
Brightness, 12, 26, 32–34, 37, 38, 64, 79, 82, 92, 111, 115, 120, 124, 139, 176, 178–183, 190, 245, 248, 250, 261–264, 273, 286, 290, 311
Bright Star Monitor (BSM), 116, 298
British Astronomical Association (BAA), 294, 299
BSM. *See* Bright Star Monitor (BSM)
Budget, 3, 11, 13–18, 27, 29, 73, 75, 81, 135–137, 241, 285, 288
Burnell, J., 265

C
Calibrated frame, 184, 185, 188–192, 307
Calibration frame, 107, 163, 186, 189–191, 193, 194, 273, 300, 307, 312, 313
CALL. *See* Collaborative Asteroid Lightcurve Link (CALL)
CalSky, 154, 278
Canadian Meteorological Center (CMC), 122–124
Carolyn Hurless Online Institute for Continuing Education in Astronomy (CHOICE), 292
CCD. *See* Charge-coupled device (CCD)
CCD drift method, 204
CCD photometry handbook, 265
Celestial equator, 56, 63, 159, 205, 263
Celestial meridian, 58
Celestial sphere, 65
Celestron, 10, 25, 27, 28, 73
Centroid, 245–247
Ceravolo optical systems, 27, 29
CFA. *See* Color filter array (CFA)
Charge-coupled device (CCD), 3, 9, 21, 31, 55, 77, 103, 120, 137, 152, 171, 198, 235, 245, 288, 298
Checklist, 113–115, 195, 197, 199–202, 205, 210–218, 221–226, 286, 287
Check object, 264
Cheshire eyepiece, 202, 203
Chevalley, P., 142, 277, 317

CHOICE. *See* Carolyn Hurless Online Institute for Continuing Education in Astronomy (CHOICE)
Christian legrand, 142, 277
ChronosMount, 70
Chuck, W., 278, 281
Clear Sky Chart, 122–124
Cloudy nights, 124, 128
CMC. *See* Canadian Meteorological Center (CMC)
Cold weather, 126–130
Collaborative Asteroid Lightcurve Link (CALL), 293
Collimation, 29, 91, 98, 193, 198, 202–205, 210, 212, 213, 215–217, 221, 224, 226, 229, 306
Co-longitude, 277
Color, 38, 40, 79–80, 110, 122, 135, 265
Color filter array (CFA), 80
Coma, 25, 51, 90
Coma corrector, 26, 90–91, 147
Comparison star, 79, 250, 251, 261, 264, 267
Cone error, 61, 161, 162, 209, 210
Cousins, A., 78, 263
Crayford focuser, 91, 93, 146–148
Critically sample, 51, 115
Cross-threading, 114

D
Dall-Kirkham Cassegrain, 107, 108
Danko, A., 122, 123
Dark current, 34, 37, 38, 96, 97, 144, 184, 213
Dark frame, 184, 185, 187, 188, 190, 191, 193, 198, 213–214, 224, 226, 229, 306, 308, 309
Dark noise, 34, 35, 37, 41, 141
Dark pixel, 185
Data acquisition, 9, 117, 128, 151–167, 216, 273–274, 297
Dawes limit, 49
Declination (DEC), 56, 62–67, 69, 71, 73, 76, 99, 100, 102, 117, 153, 156–161, 173, 184, 192, 200, 201, 205–209, 239, 257, 259, 260, 300, 301
Declination axis, 62, 153, 159
Declination drift, 56, 65, 67, 76, 117, 159, 160, 209
Declination drift method, 158
Deep sky imaging, 38, 55–56, 105–109, 120, 121, 144
DeepSky instruments, 27
Dehydration, 126
DEM. *See* Digital elevation map (DEM)

Deserts, 126, 297
Desnoux, V., 86, 273, 317
Dew point, 122
D&G optical, 27, 28
Differential magnitude, 79, 262, 264, 267
Diffraction, 48, 50, 85, 92, 112, 217, 218, 241, 243, 254, 317
Diffraction limit, 112
Digital elevation map (DEM), 278
Digital single-lens reflex (DSLR), 41, 140
Digitization level, 34, 35
Direct-drive mount, 70
Dollond, G., 87
Dollond, J., 270
Draper, H., 271
Drive corrector, 15, 17, 72, 100, 144, 145, 148
Drive rate error, 60
DSLR. *See* Digital single-lens reflex (DSLR)
Dust donut, 98, 182, 188–190, 310
Dynamic range, 26, 33–36, 112, 141

E
Ecliptic, 10, 12
ECMWF. *See* European Centre for Medium-Range Weather Forecasts (ECMWF)
Edward Skinner King, 60
Edwin, H., 22
Electromagnetic radiation (EMR), 31, 261
Encoder, 56, 60, 65, 66, 72, 73, 100, 101, 145, 163, 243
Ephemerides, 221, 223, 226, 229, 291, 294
EQMOD, 75, 317
European Centre for Medium-Range Weather Forecasts (ECMWF), 122
Exo-planet, 52, 79, 115, 148, 263, 293, 301
Explore scientific, 27, 28, 73
Extinction value, 267, 268
Eyepiece projection, 111

F
Field curvature, 25, 87, 88, 139, 272
Field flatness, 25, 107
Field flattener, 25, 52, 87–89, 107, 113, 115, 139, 148
Field of view (FOV), 11, 18, 21, 25, 42, 48, 51, 53, 56, 57, 62, 63, 67, 86, 88, 90, 92, 100, 104–109, 115, 117, 137, 139, 141, 142, 144, 152, 155, 161, 162, 181–183, 199, 205–208, 210, 211, 221, 226, 253, 258, 264, 265, 273
Field practical exercise (FPE), 2, 59, 63, 87, 101, 115, 152, 195–230, 306

Field rotation, 62–63, 66
Field, T., 86, 273
Field tested software, 86, 273, 317
File naming, 171
File structure, 163
Filter non-uniformity, 182, 188, 190, 212
Filter wheel, 15, 38, 40, 74, 75, 82, 83, 93, 96, 147, 148, 200, 201, 299, 300, 314–316
FITS. *See* Flexible image transport system (FITS)
FITS files, 172
FL. *See* Focal length (FL)
Flat field light-box, 96
Flat field panel, 96–99
Flat frame, 98, 99, 181–183, 185, 188–193, 198, 211–213, 224, 226, 229, 306, 310–311
Flexible image transport system (FITS), 40, 172–176, 235, 240, 253, 257, 290, 300, 317
Flexure, 60, 61, 94, 95, 100, 152, 202
Flux measurement, 31, 261
Focal length (FL), 15, 17, 21, 26, 39, 42–47, 52, 56–57, 86, 87, 90, 91, 104–110, 115, 117, 137, 139, 141, 174, 199, 202–204, 251, 256, 259, 260, 314–317
Focal plane, 25–27, 42, 43, 47, 48, 61, 93, 94, 111, 136, 137, 139
Focal ratio (FR), 4, 26–29, 57, 64, 87, 106–110, 117, 137, 141, 144, 314
Focal reducer, 52, 86–88, 106, 107, 113, 138, 148, 314
Focus drift, 25
Focuser, 15, 26, 27, 40, 74, 91–93, 96, 108, 111, 113, 114, 136, 146–148, 173, 202, 203, 212, 214–219, 314–316
Focusing mask, 92, 217, 218
FocusMax, 93
Forecasts, 121, 122, 124
Fork mount, 10, 25, 59, 61, 63, 75, 153, 220, 223, 225, 228, 300
FOV. *See* Field of view (FOV)
FPE. *See* Field practical exercise (FPE)
FR. *See* Focal ratio (FR)
Frame rate, 40, 100, 110, 117, 141, 216, 219, 220, 222
Friedman, A., 281
Full-well depth, 34, 36, 37, 51, 186, 212, 213
Full-width-at-half-maximum (FWHM), 50, 51, 92, 144, 217, 218, 245, 246, 248

G
Gain, 12, 14, 19, 30, 34, 35, 37, 96, 111, 120, 125, 141, 161, 171, 174, 179, 181, 183–186, 216, 222, 235, 290, 308, 311
Gaussian distribution, 50
Gear run-out, 60
GEM. *See* German Equatorial Mounts (GEM)
Geologic Lunar Research Group (GLR), 281
German Equatorial Mounts (GEM), 25, 27, 40, 59, 61–63, 68, 75, 145–148, 153, 157, 219, 220, 223, 225, 228
Global Positioning System (GPS), 77, 129, 258, 317
GLR. *See* Geologic Lunar Research Group (GLR)
Go, C., 283
Go-to system, 10
GPS. *See* Global Positioning System (GPS)
Guan Sheng optical (GSO), 27
Guide camera, 66, 99, 100, 163, 218, 219
Guidescope, 56, 65, 66, 72, 99, 100, 104, 198, 218–219, 223–225, 227–229, 306

H
Haas, W.H., 292
H-α filter. *See* Hydrogen alpha (H-α) filter
Hahn, G., 278
Hall, J.E., 160
Handbook of Astronomical Image Processing, 265
Hand controller (HC), 14, 71, 162, 209–211, 221, 222, 224, 227, 229, 230
Harrison, K.M., 273
Hartman mask, 92
H-β filter. *See* Hydrogen beta (H-β) filter
HC. *See* Hand controller (HC)
Header, 172, 174, 176, 253, 257, 290, 300
Hendon, A., 298
Henry, D., 271
Herschel, W., 270
Higgins, W., 281
Hipparchos, 32, 33, 252, 262
Histogram, 111, 193, 222
Hot pixel, 185, 187, 190
Hot weather, 125–126, 128–129
Hubble, E., 22, 139
Hubble Guide Star Catalog, 139
Huggins, W., 271
Hydrogen alpha (H-α) filter, 81, 85, 143, 147
Hydrogen beta (H-β) filter, 81, 147

Index

I
IAU. *See* International Astronomical Union (IAU)
Image calibration, 96, 105, 139, 140, 176–186, 194, 212, 213, 215, 225, 227, 230, 292, 306
Image plane, 26, 43–45, 47, 50, 95, 136, 137, 314, 316
Image processing, 5, 46, 50, 72, 92, 175, 176, 185, 225, 227, 230, 241, 250, 259, 265, 297
Image scale, 17, 18, 42–48, 51–53, 104–110, 115–117, 138–141, 144, 152, 197–199, 201, 219, 220, 223, 225, 228, 248, 253, 260, 275
Image scaling, 4, 5, 31–53, 198–199, 221, 223, 226, 229, 306
Image session planning, 154
Image shift, 25, 26
Image stacking, 120, 175
Image train configuration, 199
Imaging circle, 25, 26, 107
Imaging train, 15, 25, 29, 47, 50, 52, 55, 69, 82, 83, 87, 88, 93–96, 98, 100, 105, 111, 113–115, 117, 130, 138, 152, 153, 156, 166, 167, 191–193, 198–205, 210–217, 221, 224, 226, 229, 251, 259, 265, 270, 273, 274, 299, 309, 314–316
Infrared band, 263
Infrared Processing and Analysis Center (IPAC), 263
Insect repellant, 125
Intellicast.com, 122, 132
International Astronomical Union (IAU), 172, 174, 191
International Society of Mars Observers (ISMO), 294–295
iOptron, 72, 73
Iowa Robotic Telescope Facility (IRTF), 300
IPAC. *See* Infrared Processing and Analysis Center (IPAC)
IRTF. *See* Iowa Robotic Telescope Facility (IRTF)
ISMO. *See* International Society of Mars Observers (ISMO)

J
James E.H., 160
Jet Propulsion Laboratory (JPL), 293
JMI Mobile, 93
Johnson, H., 78
Joint Photography Experts Group, 175
Journal of the AAVSO, 292

JPEG Files, 176
JPL. *See* Jet Propulsion Laboratory (JPL)

K
Kennett, P., 160
King rate, 60, 89

L
LAC. *See* Lunar Aeronautical Chart (LAC)
Landolt Reference Stars, 79
LCDB. *See* Asteroid Lightcurve Database (LCDB)
Legrand, C., 142, 277
Lena, R, 281
Lena, R., 281
Libration, 277
Lightbuckets Telescope Network, 298
Light frame, 98, 99, 173, 183–186, 188, 190–192, 198, 205, 209, 211–216, 222, 224, 227, 230, 309
Light pollution, 35, 64, 81, 82, 124
Linearity, 32–34, 37, 141, 182
Line filter, 81, 82, 85
Load capacity, 18, 67–70, 75, 136, 137, 140, 145
Logarithmic function, 32
Losmandy, 14, 136, 137
Lowell Observatory, 293
LPOD. *See* Lunar Photo of the Day (LPOD)
LRGB filter, 79–81, 147
LTVT. *See* Lunar Terminator Visualization Tool (LTVT)
Luminance, red, green, blue filter, 77–83
Lunar Aeronautical Chart (LAC), 21, 23, 280, 281
Lunar filter, 83
Lunar imaging, 17, 38, 56–57, 83, 87, 109–112, 116–117, 121, 126, 141–143, 175, 221, 243, 276–278
Lunar Photo of the Day (LPOD), 278
Lunar rate, 117
Lunar Terminator Visualization Tool (LTVT), 278–280, 317
Lunt and Coronado, 84

M
Magnetic declination, 63, 64, 156, 157
Maksutov-Newtonian, 26, 28
Master flat frame, 190, 191
Master session file, 169, 170
Maxim DL, 5, 93, 113, 146–148, 174, 250, 254, 270, 317

MC. *See* Motor controller (MC)
MDA-telescoop LLC, 60, 73
Meade, 25, 27, 28, 73, 84
Median combine, 190
Melvill, T., 270
Mentor, 1, 2, 197, 306
Meridian flip, 62, 68, 219
Metadata, 171, 172
Mettig, H.-J., 278
MILES Stellar Library, 273
Minor planet, 9, 10, 12, 18, 24, 40, 48, 52, 61, 79, 80, 82, 100, 113, 127, 139, 144–145, 148, 154, 155, 160, 163, 164, 220, 222, 223, 240, 251, 258, 259, 261, 276, 286, 287, 290–293, 297, 300, 301
Minor Planet Bulletin, 293
Minor Planet Center (MPC), 12, 154, 260, 290, 291
Minor Planet Circulars, 291
Minor Planet Circulars Orbit Supplement (MPO), 254, 291, 317
Minor Planet Electronic Circular (MPEC), 291
Minor planet imaging, 82, 144–145
Minorplanet.info, 154, 160, 293
Moment equation, 247
Monochrome, 79–81, 83, 110, 274
Moon, 5, 41, 56, 72, 83, 111, 120, 124, 135, 142, 182, 220, 251, 261, 276–279, 281, 291, 292
Moonlite, 93, 113, 114, 314–316
Moore, P., 281, 294
Morgan, W., 78, 262
Mosher, J., 278, 317
Motor controller (MC), 71
Motor drive system, 26
Mount, 3, 10, 25, 38, 55, 82, 104, 129, 135, 153, 170, 197, 242, 288, 300
Mount controller, 71–72, 117, 205–207, 209, 210
Mount Lemmon, 300
MPC. *See* Minor Planet Center (MPC)
MPEC. *See* Minor Planet Electronic Circular (MPEC)
MPO. *See* Minor Planet Circulars Orbit Supplement (MPO)
Mylar, 84, 143

N
Narrowband filter, 77–83, 147, 226, 228
National Aeronautics and Space Administration (NASA), 152, 263, 278, 293, 317
Naval Observatory, 24, 139, 235, 252, 253, 317

NCP. *See* North Celestial Pole (NCP)
Nebula filter, 81
Noise, 34–38, 40, 41, 48, 104, 112, 120, 141, 144, 171, 181, 182, 184–190, 248, 307, 308
Non-periodic errors (Non-PE), 59, 60, 64, 65, 67
North Celestial Pole (NCP), 56, 57, 59, 61–64, 158, 162
Nosepiece, 82, 83, 93–95, 137
Notch filter, 82
Nyquist theorem, 50

O
OAG. *See* Off-axis guider (OAG)
Objective, 16, 25, 26, 28, 29, 42, 43, 46–50, 83, 86, 87, 99, 105–109, 117, 130, 141–145, 165–167, 180, 195, 197–199, 201, 202, 204, 209, 211, 213, 214, 216–218, 220, 222, 225, 228, 288
Observatory, 3, 17, 21, 22, 24, 60, 66, 80, 120, 123, 128, 131, 137, 138, 162, 234, 241, 253, 267, 277, 284–286, 291, 293, 294, 297–302, 314, 317
Observing log, 166, 169, 170, 212, 214, 216
Observing program, 2, 3, 11–14, 21, 29, 30, 55, 103, 105, 135–137, 140, 141, 144, 145, 152, 154, 199, 201, 216, 221, 223, 225, 226, 228, 229, 276, 285–289, 292, 302
Observing program design basis (OPDB), 12, 103, 135, 136, 286–289, 306
OE. *See* Operational experience (OE)
Off-axis guider (OAG), 99, 100
Off-axis guiding system, 56
O&M. *See* Operations and maintenance (O&M)
One shot color (OSC), 38, 80, 81
One shot color (OSC) camera, 38, 81
OPDB. *See* Observing program design basis (OPDB)
Operational experience (OE), 17
Operations and maintenance (O&M), 17–19, 301
Optical corrector, 90, 107
Optical tube assembly (OTA), 15, 29, 144, 145
Orion, 27, 28, 48, 52, 73, 75, 93, 107, 113, 253, 302, 315
Orthogonal error, 65, 209, 210
OSC. *See* One shot color (OSC)
OTA. *See* Optical tube assembly (OTA)
Over-sampling, 50, 51
Oxygen 3 filter, 81

Index

P
Palomar Observatory Sky Survey (POSS), 21, 22
Paton Hawksley, 85, 272
PE. *See* Periodic error (PE)
Peach, D., 281, 283
Peak ADU, 217, 218
PE correction (PEC), 65, 66, 146–148, 224, 227, 229
Periodic error (PE), 56, 59, 60, 64–67, 70, 72, 114, 144, 146, 200
Photometer, 31, 262, 263
Photometric calibration, 78
Photometric filter, 38, 78–79, 82, 104, 147, 148, 180, 223, 264, 267, 297, 299
Photometry, 12, 31, 52, 104, 139, 148, 190, 223, 248, 249, 261–269, 287, 288, 293, 294
Pic du Midi, 21, 22, 277
Picture element, 34
Pier, 57–58, 68, 75, 153, 173, 192, 200
Pinhole camera, 43–45
Pixel, 18, 31, 57, 96, 104, 139, 173, 199, 238, 245, 300
Pixel binning, 51
Pixel scale, 18, 47, 48, 50, 52, 53, 106, 107, 199
Planetarium program, 72, 155, 161, 162, 209–211, 221–224, 226, 227, 229, 230, 253
Planetary imaging, 17, 27, 56–57, 109–112, 121, 126, 141–142, 242, 277
Planewave, 27, 29
Plate scale, 42, 257
Plate solve, 211
Pogson, N., 26, 33, 262
Pogson's ratio, 33
Pointing accuracy, 18, 48, 104, 140
Pointing effects flexure, 60, 61
Point spread function (PSF), 50, 245–247
Poisson noise, 35
Poisson, S.D., 35
Polar alignment, 10, 18, 56, 60, 62–66, 101, 117, 137, 147, 157,–161, 164, 193, 198, 200, 204–209, 221, 224, 226, 229, 273, 306
Polaris, 63, 158, 200
Polar scope, 137, 157, 158
Position, 12, 18, 24–26, 42, 43, 47, 48, 52, 57, 58, 65, 67, 68, 71, 89, 91–93, 99–111, 113, 114, 129, 139, 152, 153, 157–163, 166, 173, 190, 192, 201, 205, 210–212, 214–216, 218, 220–223, 226, 229, 238, 239, 245–247, 251, 252, 256–262, 278, 286, 290, 300, 314–316
POSS. *See* Palomar Observatory Sky Survey (POSS)
Post-processing software, 110
Power supply, 101–102, 128, 130, 200, 221, 223, 226, 229
Prime focus, 104, 108, 298
PSF. *See* Point spread function (PSF)

Q
Quantum efficiency (QE), 32, 38

R
RA drive corrector, 100–101, 145
Random noise, 35, 48, 186, 188, 307
Raw instrumental magnitude, 180
Rayleigh criterion, 49
RC optical systems (RCOS), 27, 28
Readout noise, 34–37, 40, 41, 104, 141, 171, 184–186, 307
Red green blue (RGB) filter, 80, 300
Reflector, 18, 24, 25, 52, 56, 83, 87, 98, 113, 139, 141, 183, 184, 202, 220, 223, 226, 228, 242, 301
Refractor, 9, 11, 21, 24, 25, 27, 28, 52, 62, 83, 87, 109, 115, 130, 139, 141, 145, 146, 182, 202, 203, 220, 223, 226, 228, 279, 281, 283, 298, 315, 318
Region-of-interest (ROI), 248–250
Relative gain, 96, 181, 184, 185
Remote observatory systems, 298
Renishaw encoder, 72
Resolution, 5, 17, 18, 21, 34, 36, 38, 40, 48, 50, 51, 53, 56, 57, 59, 66, 72, 73, 81, 83, 87, 91, 104, 105, 108–112, 116–117, 126, 131, 141–143, 146, 147, 222, 241, 243, 245, 263, 272–274, 278, 280, 281, 297, 298
Reticule, 63, 158
RGB filter, 80
Rigel telescope, 300
Right ascension (RA), 59, 99, 117, 153, 158, 173, 192, 200, 260, 300
Ritchey-Chrétien reflector, 24, 183
ROI. *See* Region-of-interest (ROI)
Root mean square, 144, 260
RSpec, 86, 273, 276, 317

S
Salimbeni, P., 281
SAO. *See* Smithsonian Astrophysical Observatory (SAO)
SAS. *See* Society for Astronomical Sciences (SAS)

Scaled dark frame, 188, 190, 191
Schmidt-Cassegrain Telescope (SCT), 10, 25, 27, 52, 104, 106, 108, 109, 142, 146, 298
Scintillation, 48, 60, 61, 123, 241
SCP. *See* South Celestial Pole (SCP)
SCT. *See* Schmidt-Cassegrain Telescope (SCT)
Secondary mirror, 204
Seeing, 41, 48, 50–53, 83, 92, 104, 107, 109, 110, 112, 115–117, 119, 120, 122–126, 138, 141, 143, 221, 225, 228, 287
Seeing effects, 83, 109
Selenology Today, 281
Setup procedures, 198–219, 224, 227, 229
Sidereal day, 59
Sidereal rate, 60, 71, 117, 159, 206, 207
Sierra Stars Observatory Network (SSON), 80, 298–301
Signal to noise ratio (SNR), 34, 35, 37, 50, 104–106, 108, 112, 115, 120, 182, 248, 250, 264, 265, 310, 312, 313
Simonsen, M., 292
Skippysky, 124
Sky at night, 294
Sky background, 120, 248, 250
Skyglow, 81, 82
Sky noise, 34, 35
Sky-watcher, 27, 69, 73, 75
Smithsonian Astrophysical Observatory (SAO), 291
SNR. *See* Signal to noise ratio (SNR)
Society for Astronomical Sciences (SAS), 293–294
Solar astrograph, 143, 147, 221
Solar filter, 83, 84, 143, 221
Solar imaging, 87, 142–143, 175, 221
Solar scope, 143
South Celestial Pole (SCP), 63
Span, 96, 178, 179, 183, 274
Spectrographic grating, 271, 272, 276
Spectroscopic grating, 85–86, 131, 271–273
Spectroscopy, 31, 61, 86, 269–276, 294
Spur gear, 69, 70
Star instruments, 27, 28
Starlight instruments, 93
Stellar-based feedback, 65
Stellarvue, 28
The Strolling Astronomer, 292
Sulfur 2 (SII) filter, 81
Sun finder, 143, 147
Synta, 27, 73–75
Systematic noise, 187

T
T-adapter, 93, 94, 314–316
Takahashi, 27–29
Target selection, 155
TE. *See* Tracking error (TE)
Teardown, 165–166
TEC. *See* Thermo-electric cooler (TEC)
Telescope Drive Master (TDM), 60, 73, 101
Televue, 27, 28, 111
Temperature controller software, 212–216
Temperature difference, 122
Testing, 11, 153, 156, 167
Thermal noise, 184, 185, 187, 308
Thermo-electric cooler (TEC), 38, 40, 104, 144, 186, 187, 193, 213, 215
Three-star synchronization, 210, 211
TIFF files, 175
Tilt/Tip error, 95
Time-stamping, 258
TMB, 27
T-mount, 94, 136, 137
Tracking error (TE), 65, 66, 76, 101, 136, 145, 317
Tracking rate, 56–61, 65, 67, 72, 99, 100, 117, 144, 159, 205, 207
Transit, 115, 143, 263, 277, 292
Transparency, 120, 124, 126, 287
TransSpec, 273
T-ring, 94
Tripod, 14, 57–58, 68, 75, 156, 192, 200
Troposphere, 119
Twilight flat frame, 192, 194

U
UBVRI standard. *See* Ultraviolet blue visual red infrared standard (UBVRI standard)
UBV system. *See* Ultraviolet blue visual system (UBV System)
UCAC. *See* USNO CCD Astrograph Catalog (UCAC)
Ultraviolet blue visual red infrared standard (UBVRI standard), 139, 263
Ultraviolet blue visual system (UBV System), 78
Uncertainty, 5, 104, 105, 144, 186, 188–190, 236–239, 252, 264, 265, 287, 288, 292, 307–312
Undersampling, 50, 51
United States Naval Observatory (USNO), 24, 139, 235, 252, 254, 259, 263
Uranometria, 252, 253
USNO CCD Astrograph Catalog (UCAC), 24, 139, 147, 148, 235, 254, 258,–261, 263, 317

Index

V
Valerie Desnoux, 317
V-band photometric filter, 38, 82, 104, 223, 264
V-C measurement, 261
Vibration, 57, 58, 140, 192, 200
Vignetting, 25, 98, 99, 107, 182, 188, 190, 212, 310
Virtual moon atlas, 142, 277, 278, 317
Visual magnitude scale, 33
Visual spec, 86
Vixen, 14, 27, 73, 136
von Fraunhofer, J., 270

W
Warner, B.D., 293, 317
Wavelet filtering algorithm, 222
WCS. *See* World Coordinate System (WCS)
Weather, 9, 13, 105, 119–130, 167, 170, 287, 317
Weather channel, 122
Weather.com, 122
Weather.gov, 122
Weatherunderground.com, 122
Webcam, 4, 10, 27, 36, 38, 40, 41, 56, 110, 117, 142, 146, 147, 164, 175, 216, 220, 242, 243
White-light filter, 143
Williams, R., 298–300
WinJUPOS, 278, 282
Wirths, M., 281
Wollaston, W.H., 270
Wood, C., 278, 281
World Coordinate System (WCS), 253, 254, 257
World Meteorological Organization, 122
Worm gear, 64, 65, 69
Worm wheel, 64, 65, 69, 70

Z
Zenith angle, 265–268

Made in the USA
Lexington, KY
19 November 2012